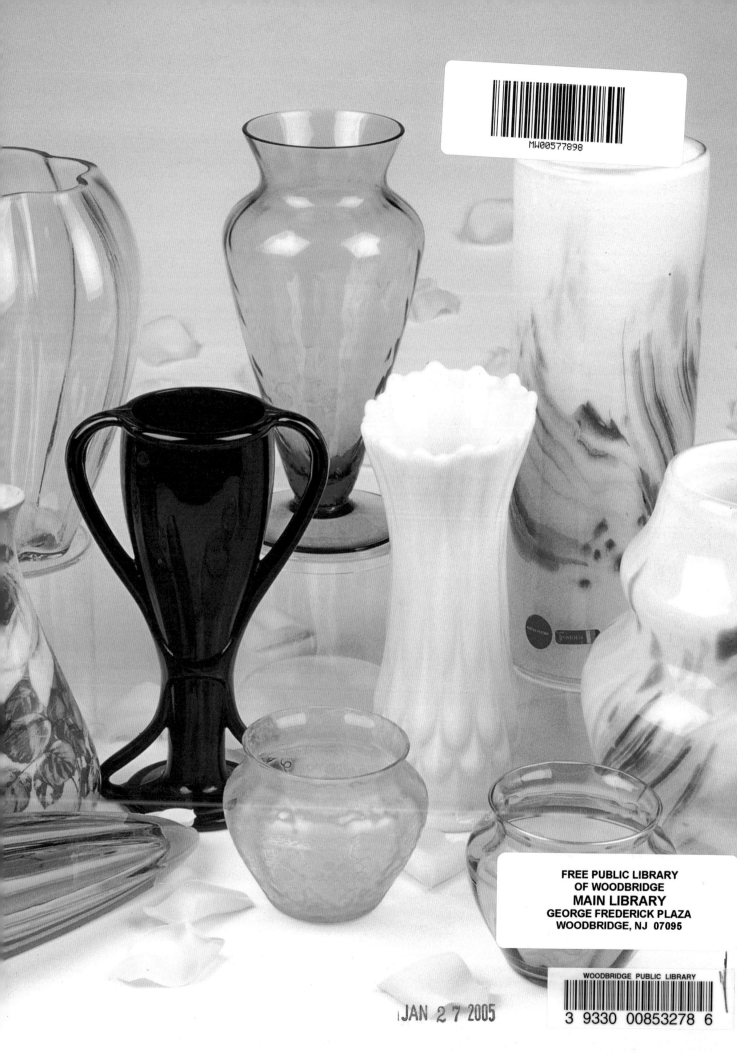

FOSTORIA GLASS

Scarce, Unique, and Whimsies

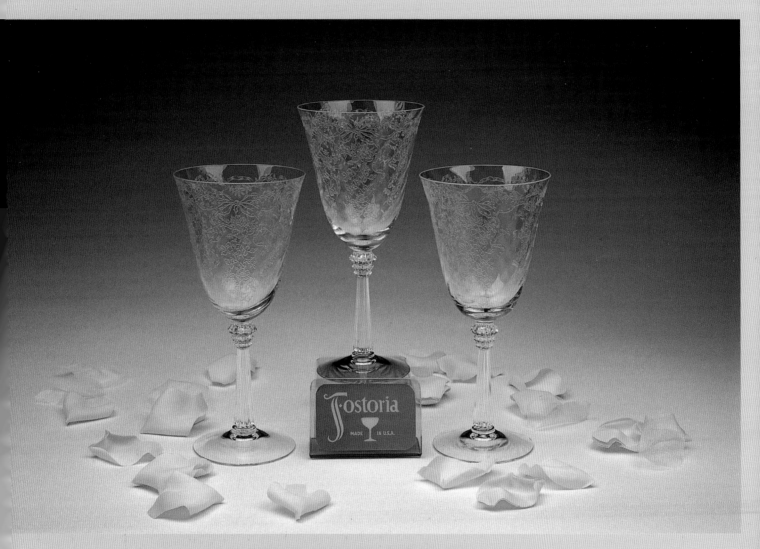

Juanita L. Williams

4880 Lower Valley Road, Atglen, PA 19310 USA

Dedication

I dedicate this book to my three generations of family members who shared in the heritage of working at Fostoria Glass Company 1910-1987 for their contributions to the legacy of Fostoria Glass for future generations.

In Loving Memory of:
My father, Harry A. Miller
My Grandmothers, Millie Adams Miller
and Essie Harris Hill
Their gifts of treasured glassware presented to me as a small child sparked the passion in my heart and romance of collecting glass.

With Heartfelt Dedication to:
My Children: Jennifer, Anthony, Jeffrey, and Jonathan
My Daughter-in-law: Holly Williams
My Grandchildren: Izabel Skyler,
Justice Briana, and Larz Jamison

My Beloved and Wonderful Soul Mate:
John Fallihee
I thank you for all the beautiful photography in this book, for your love, and encouragement in all facets of this project.
And he, in turn, joins me in thanking our mothers
Alta Hill Miller and Inez Fallihee
For their inspiration, encouragement and love.

In Memory of Dad and My Grandmothers.

Designed by John P. Cheek
Cover Design by Bruce Waters
Type set in Shelley Allegro BT/Korinna BT

ISBN: 0-7643-1974-4
Printed in China
1 2 3 4

Published by Schiffer Publishing Ltd.
4880 Lower Valley Road
Atglen, PA 19310
Phone: (610) 593-1777; Fax: (610) 593-2002
E-mail: Info@schifferbooks.com

For the largest selection of fine reference books on this and related subjects, please visit our web site at
www.schifferbooks.com
We are always looking for people to write books on new and related subjects. If you have an idea for a book please contact us at the above address.

This book may be purchased from the publisher.
Include $3.95 for shipping.
Please try your bookstore first.
You may write for a free catalog.

In Europe, Schiffer books are distributed by
Bushwood Books
6 Marksbury Ave.
Kew Gardens
Surrey TW9 4JF England
Phone: 44 (0) 20 8392-8585; Fax: 44 (0) 20 8392-9876
E-mail: info@bushwoodbooks.co.uk
Free postage in the U.K., Europe; air mail at cost.

Special Acknowledgment

Special acknowledgment and praise for our US Troops, Operation Iraqi Freedom: My son, Spc. Anthony Williams US Army (*at the time of this writing is serving in Iraq*). My nephews and godsons: SSgt. Ryan Miller USMC and Sgt. Eric Miller USMC. ET2 Stephen Hixson US Navy (*son-in-law of Debbie & Randy Coe*). Sgt. James Robinson, 1092nd Parkersburg W. VA National Guard (*at the time of this writing serving in Kuwait & Iraq*). *James is the son of Kenneth and Clara Robinson whose Fostoria family history is featured in this book.* Words cannot express the gratitude and praises of the sacrifices you have made in protecting our homeland and our freedom. You have shown America your bravery, courage and valor. To each of you and those who are serving with you, my prayers that God will continue to watch over you, keep you safe from harm, and bring you home soon!

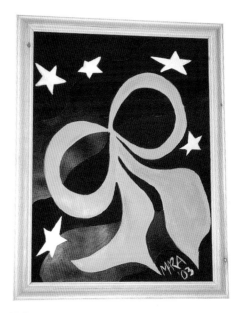

Yellow Ribbon Painting in support of our US Troops, Operation Iraqi Freedom, 2003 by California artist Mara McWilliams. Mara dedicated this painting to my son, Anthony Williams US Army. Profits from these works of art support our USO.

Acknowledgments

To the Fostoria Glass Company factory workers, designers and craftsmen 1887-1986 who produced the finest quality American handmade glass that graces the pages of this book. My gratitude for the legacy you have provided in the history of American Glassmaking. Without your endeavors this book would not have been possible.

To Debbie and Randy Coe, my sincere appreciation for the encouragement to realize my dreams in presenting this book to collectors. Your incredible knowledge of and efforts towards the preservation of American glass heritage, together with the never-ending energy you share is an inspiration beyond measure. I thank you for your assistance on many aspects of this book including researching, photography, and cheerleading. To Janine and Joanne Bender, Julie Binkley, and Mark Drier, outstanding Fostoria enthusiasts with extraordinary knowledge of Fostoria glassware; your friendships have been a special blessing in my life. I thank each of you for your dedication to preserving Fostoria history, your assistance in researching and proofreading manuscripts for this project.

To Jon Saffell, distinguished American sculptor and Fostoria's last designer, my sincere thanks for sharing your acquired knowledge of Fostoria with me for more than a decade on my quest to preserve Fostoria's design art history for collectors. I am happy to introduce

collectors to a closer look at the legacy of your design talents in Chapter Two of this book featuring your personal journey from Fostoria to Fenton.

To my cousins Barb and Bob Suarez, Cameron, West Virginia who share the heritage of three generations of our family working at Fostoria. I am grateful for your inspiration and your support of my endless research projects of Fostoria to help preserve the legacy for future generations.

To my family members who have shared a lifetime of tolerance of my glass collecting, not always understanding my fascination with this, but always supporting my efforts, my heartfelt thanks to you: My brother and sister-in-law, Gene and Leslie Miller; My sister, Hara Miller. Special thanks to my brother, Alan Miller for your computer knowledge and assistance in this project. To my son, Jonathan loving thanks for your help with the typing, proofreading and editing manuscripts.

My deepest gratitude to all the collectors and dealers who lent me their support and shared in so many ways for this project. Many people opened their homes to allow John and I to have access to their personal glassware collections. Due to the amount of glass portraits to capture and our tight work schedule we were often there for several days. They provided a place to sleep and provided meals so we could continue working and photographing for the project. Several dealers and

collectors shipped unique glass items to my home studio for photography sessions. If it were not for the generosity of the people who opened their homes and shipped glass to be photographed, this book could not have been completed. Many collectors and former workers of Fostoria provided access to their personal collections of old correspondence, factory production records and old catalogs for research. Many dealers shared inventory records and recent sale prices to assist with values for this book. Most heartwarming was our opportunity to travel to West Virginia and visit with former factory workers to tape record their memories of Fostoria, thus allowing an expanded documentation of the much overlooked legacy of the skilled Fostoria glassworkers, never before documented for collectors. This definitely has been a comprehensive project that was enhanced by the support of so many wonderful Fostoria glass enthusiasts. **My heartfelt gratitude to:** Dale and Joanne Bender, Janine Bender, Julie Binkley, Al and Carol Carder, Mary Pat Castiglioni, Brenda Cearley, Doris and Ken Cearley, Karen Cearley, Jessica Cearley, Patricia Ann Christiansen, Darlene and Gordon Cochran, David Dalzell, Jr., Robert Davenport, Lorraine Kovar, Charlotte and Dave Krauch, Mark Dreier, Linda Dufelmeier, Cindy Frank, Bonnie and Sidney Grisell, Jeffrey Greenlees, Bill Harmon, Robert Henicksman, Melody King, Debora and Ed Lane, Kay and Swede Larsson, Don Livermore, Philip and Sarina MacMillan, Bea and Terry Martin, Louise Matejka, Holly McClusky, Donna and Ron Miller, Robby Miller, John and Sandy Murphy, Paul Myers, Dave and Barb Ownbey, Patricia Papesh, Bill and Wanda Rice, Clara Robinson, Carolyn and Jon Saffell, Garland and Roberta Shinn, Jim Schafer, Orville and Elsa Trover, Fred S. Wilkerson, Fred W. Wilkerson, Carolyn Williams, Jevena Word, Leegh and Michael Wyse.

Besides the individuals above, who shared so much, I was allowed to photograph at the following shows: All American Glass Show, sponsored by the Pacific Northwest Fenton Association, Hillsboro, Oregon; Southern Oregon Antique and Collectible Show, Medford, Oregon. And at the following antique malls: Main Antique Mall, Medford, Oregon and Dexter City Antique Mall, Dexter City, Ohio.

To Lancaster Colony Corporation, for permission to use Fostoria Glass Catalogs and Fostoria advertising materials to help preserve the factory history for collectors of this outstanding glassware.

My appreciation to Fenton Art Glass Company; Frank M. Fenton, George and Nancy Fenton, and Dr. James Measell, Historian. I thank you for sharing your knowledge of the Fostoria factory glassworkers and production stories; union activities and whimsies information with me for this project. Photography taken at Fenton Art Glass shown in Chapter 2- Fostoria Designer, Jon Saffell used by Courtesy of Fenton Art Glass Company, Williamstown, West Virginia.

It would be impossible to name all the Fostoria friends I have met through out my many years of collecting this wonderful glass. In some way they have all made a contribution to my efforts by virtue of sharing a kindred spirit and friendships. I am grateful to all of you who have shared with me in the joy of collecting.

Last by not least, special thanks to my editors, Ginny Parfitt and Nancy Schiffer. I have enjoyed working with you on this book project. I sincerely appreciate your willingness to assist promptly with any need, sharing your time and many talents. I would also like to thank the staff at Schiffer Publishing who helped to put this book together so beautifully. Your publishing expertise and your contributions to this project are greatly appreciated.

I would love to hear from other collectors, former factory workers and/or your discoveries about Fostoria Glass. If you would like to share your collection with me for future edition, I would welcome the gesture. I appreciate letters and comments from those who utilize and read this book. If you have questions or would like to write to me, please include a self-addressed stamped envelope if you wish a hand written reply.

In striving to get accurate information, I am always looking for additional catalogs, original advertisements, and brochures. If you have any of these items you would like to sell, I would be very interested in obtaining them.

Preface
My Sentimental Journey

As I traveled recently to Moundsville, West Virginia to meet with former Fostoria workers and their families for this book project, I couldn't help but recall pleasures of my childhood days with memories living along the Ohio River, and thoughts of three generations of my relatives who worked at Fostoria Glass 1910-1987. My mother was born in 1923 in Moundsville, West Virginia in a small house just a block away from the Fostoria Factory where her relatives worked. My parents, Harry A. Miller and Alta Hill-Miller were both serving in the military during WWII; they married January 3, 1945. Both my parents had extraordinary large families living in Bellaire and Moundsville, and many relatives found work at the glass factories.

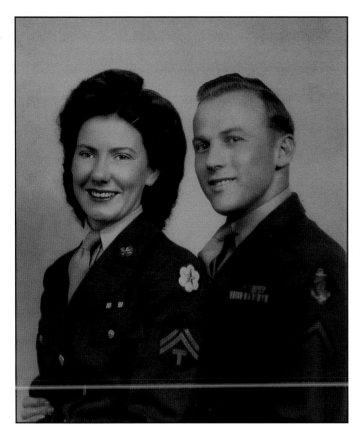

Harry A. Miller and Alta Hill-Miller wedding photo, January 3, 1945.

There are fond memories as a small child living in Bellaire with my Grandma Millie Miller. With lack of toys in those days, I found much joy in playing with grandma's glass. Although I always got a spanking for doing so, that never seemed to diminish the pleasure I found in the glassware. I liked the look of the sunlight shining through the glass, and the smooth cool feel of the glass. As a child, I would dig for shards of glass around the Imperial and Fostoria factories. With my older brother and cousins, we would play along the rivers edge in front of grandmas house, where the coal trains moved up and down the river. In our land of make believe, we regarded these shards of glass and found lumps of coal as great treasures! Although the factories had closed, as an adult, I took my children back home to experience the dig for shards of glass in the dirt around the factories and hunt for glass treasures. We made a game out of guessing what time period the glass came from judging from its color or design. One doubts if a lump of coal and a broken shard of glass would excite the children of today, however these sparkling bits of glass link to the past and evoke fond memories of yesterday.

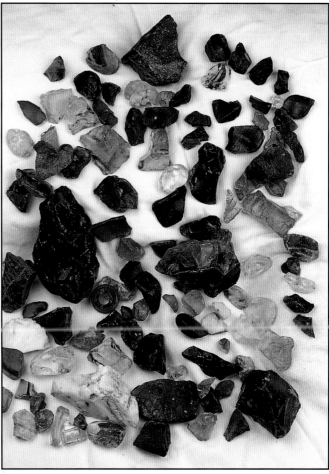

Shards of Glass.

In 1957 we moved from Bellaire to Los Angeles, California (I was eight years old at that time). My Grandma Millie Miller gave me special gifts of her glass to take with me. Our first trip back to my hometown was in the summer of 1966 when I was seventeen. My Grandma Essie Hill decided to give me her vintage Fostoria glassware at this time. On this visit home I was old enough to tour the Imperial and Fostoria factories. Watching the glass being made sparked a passion for collecting that began this summer of my youth and has never diminished.

Grandma Millie Miller had eleven children. My aunt and many cousins worked at Imperial 1920-1984, doing carry-in and carry-over, cutting, decorating, packing and/or shipping ware. Cousin Walton Hepe was an excellent glasscutter; he had his apprentice at Fostoria and also cut ware for Imperial and Roderfer-Gleason.

Grandmother Essie Harris-Hill was born in 1894; she had ten children and more grandchildren than one can count! Grandma Hill had two brothers and several cousins working at Fostoria from 1910 to the late 1930s. Back in those days, boys began catching turns in the glass houses at the young age of ten years old. My cousins, Barb (Newell) and Bob Suarez provided the history of Fostoria workers on their side of the family tree: Grandfather, William D. Newell began work at Fostoria at the age of eleven years old in 1911; he worked there for 52 years as a glassworker. Grandma Ella Newell had four brothers, and their children, along with dozens of cousins and family members who worked at the Fostoria factory 1911 to 1986, doing a variety of jobs: carry in and carry over, cleaning moulds, cutting, decorating, etching, finishing, and pressing ware. Barb's father, Robert Newell was a talented glassworker and union representative; he worked at Fostoria from 1938 to 1956. In 1956 Robert Newell became International Representative for the American Flint Glassworkers Union (AFGWU) and moved to Toledo, Ohio where the office was. In 1961, he was elected 1st Vice-President of the AFGWU, an office he held until his retirement in 1989.

My cousin, Bob Suarez began work at Fostoria March 8, 1966 and worked until April 24, 1987. During his twenty-one year employment he did various jobs, carried over and carried in the plant, mould cleaning, polishing, and sand blasting. He filled in for other workers during vacation times in plant maintenance, order, and shipping clerk. When Fostoria closed in February 1986, Lancaster Colony asked Bob to stay on with a handful of workers to continue the process of closing out the factory. Bob was officially the very last worker to leave the plant April 24, 1987. Affectionately, Bob is our Fostoria Hero, thus ending a family heritage of three generations of glassworkers at Fostoria.

This sentimental journey is only the beginning; this book pays tribute to all families and factory workers, who share in the heritage and legacy of working at this great factory, 1887-1986.

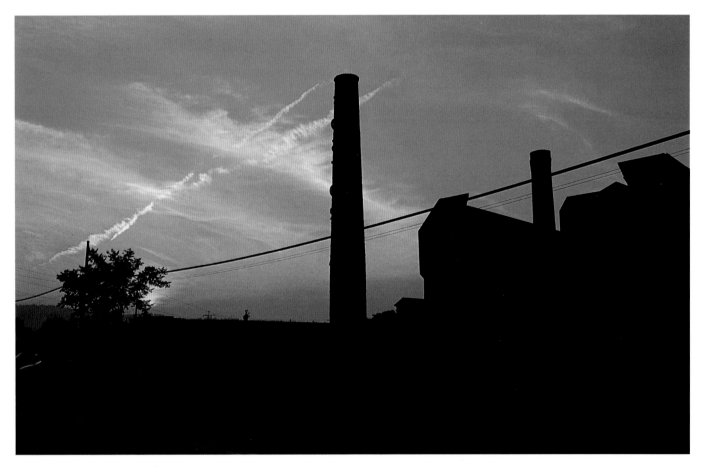

Sunset on the old Fostoria Factory and smokestack.

Contents

Introduction

Collecting Fostoria Glass is a life-long passion I am happy to share with others. Through many years of collecting, researching, writing news articles and study guides, and presenting educational seminars on Fostoria Glass to many collector clubs, my personal collection of Fostoria Unique and Whimsies has continued to grow. Many collectors were fascinated with the stories associated with the whimsies and unique glass items made at Fostoria and for several years have asked me to write a book on the subject. It has been through the encouragement of Fostoria friends, support of family, many dealers and collectors who have shared their treasured collections that I have been able to present this book to provide an expanded reference base of genuine Fostoria glass for collectors.

This book is devoted primarily to the design art of Fostoria Glass, the design history, identification and documentation of "Fostoria Glass, Scarce, Unique, and Whimsies" items produced for nearly a century at Fostoria Glass Company in Moundsville, West Virginia. I classify the "scarce" and "unique" Fostoria glassware as decorative tableware, elusive fruits, figurines, giftware,

limited editions, sample colors, sample etchings, special order items, and/or items known to be produced for less than five years. The scarce and unique are items seldom seen, and by their definition, infrequently found or hard to find patterns and figurals that are sought after by collectors for their unique quality of design.

The Fostoria "Whimsies" are something quaint, fanciful, and one-of-a kind art objects of Fostoria. These are non-production items that were made at the Fostoria factory on lunch hours and off hours. These glass items left the factory daily with the workers who made them as gifts for family and friends. Many whimsies were made from regular production lines such as Coin, American, and Colony patterns; many others were custom designed paperweights. I am convinced that the Fostoria paperweights, created with the outstanding crystal gather of Fostoria glass, belong high in the history of Fostoria Art Glass, and delighted to document these Fostoria treasures for collectors featured in the chapters of paperweights and whimsies.

Fostoria glassware was lovingly handmade for nearly one hundred years; handcrafted by skilled artist one item at a time, no two items are exactly alike when they come out of the mould. That is the beauty found in collecting handmade glass; each item offers a unique quality to behold. Some of the glass items shown in the book are extremely scarce, but they can be found on the marketplace today. Because the term "rare" often times becomes argumentative when referring to handmade glassware, I made the personal decision not to use this term in identifying glassware in this book.

It is known that Fostoria Glass Company was a leader in the glass industry for nearly one hundred years. Fostoria was called "The Crystal for America." Fostoria was a family oriented business, providing job opportunities to several generations of families in Moundsville over its long production history. Most often the factory workers are overlooked in glass collector books. Each person working at Fostoria has contributed to the legacy; their spirit is the heart and soul of the factory, without whom there would be no glassware to enjoy. Although I have only met a few of the families whose stories I will be sharing throughout this book, I wish I could know more. For their job, no matter how big or how small, played an important role in the heritage of glassworkers and has touched our lives by virtue of the glassware we choose to bring into our homes.

Fostoria's Unique Glass, Whimsies, Swans, Paperweights and Vases.

This book is not intended to be a catalog, nor does it attempt to include every single piece of glass ever produced. With the enormous variety of glass produced by Fostoria, one can never capture it all in one edition of a glass book. I believe there will always be one elusive piece of the Fostoria puzzle that is incomplete, and therein lies the hope and inspiration for a new generation of glass collectors to continue the passion and quest for learning and appreciation of how great Fostoria Glass Company was and its contribution to the history of glass making in America. My goal is to pay tribute to the talents of the many men and women of Fostoria who made this glassware and to present a variety of unique Fostoria Glass, some of which have gone previously unrecorded, thus affording an expanded reference base for collectors.

I love the romance of Fostoria Glass and marvel in the talents of those who created it. When I look at a piece of Fostoria and hold it in my hands, I don't just see a piece of old glass. I behold the artistry of designs lovingly handcrafted by a skilled artist of a by gone era and feel a passion for the beauty of Fostoria. My challenge in putting this book together was two fold; the first was how to present these items as I behold the art of handcrafted Fostoria Glass, and not as a catalog page. The second was how to divide the images of the glass into a format that would be pleasing to the reader and easy to understand.

The first part of this challenge became a reality as my very talented partner began to capture the romance of Fostoria Glass in classic portraits for this book. Although John is a talented professional photographer, the art of capturing the glass on film was a unique new undertaking. The lighting, the texture, the transparency, the posing of the objects to be included in this book was a learned process, but the challenge was met. The portraits of Fostoria's artistry in glass are ones I hope you will enjoy as much as we have enjoyed bringing these images together for you.

The second challenge of presenting this wonderful collection came to me as I reflected over past history of Fostoria, the advertising and marketing. In all of the Fostoria advertisements beginning in the late 1920s, the reader was encouraged to send for *The Little Book About Glassware,* 1925 or updated version *The New Little Book About Glassware,* 1926. A housewife of the era could send for the booklets to get ideas on how Fostoria Glass is made, and how to use her Fostoria glassware in the home. The booklets contained several subjects like "Crystal and Clear," "Color of Glass," "Subject of Stemware," "Harmony of Glass and Flowers," and "Fostoria as Gifts." I was inspired to divide the "Fostoria Glass, Scarce, Unique and Whimsies" into various chapters reminiscent in the original booklet *The Little Book About Glassware* circa 1926. This provides today's reader with a glimpse of the advertising of a by gone era, while presenting the beautiful art of Fostoria that falls within each chapter.

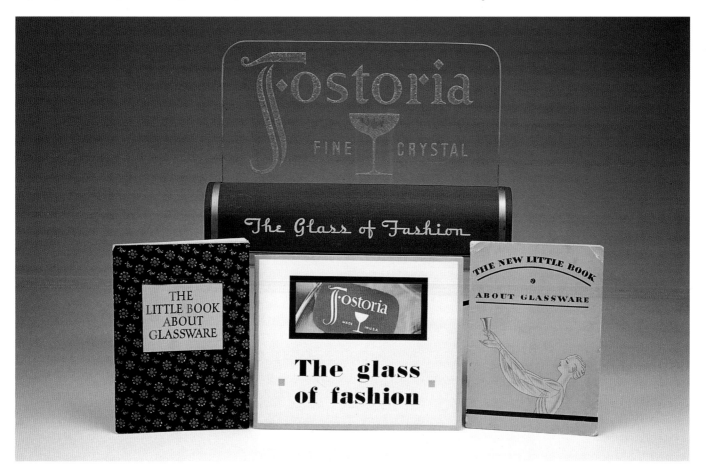

Fostoria lighted store display and popular booklets. **Left to right:** *The Little Book About Glassware,* 1925; *Fostoria the Glass of Fashion,* 1930; *The New Little Book About Glassware,* 1926.

I have tried to be consistent in utilizing the known Fostoria line numbers and/or alphabetical listing of patterns shown in this book. Because of the variety of items and patterns, it is not possible for me to include all items from the same pattern line in the same chapter. Therefore, you will find all portraits of Fostoria have been divided into the category chapter that best represents the picture of the item shown.

For those that sell Fostoria, the advance collector who knows the in-depth history of the Fostoria factory, or the novice, my desire is that you will be inspired by a fresh look at Fostoria Glass, and appreciate its beauty and unique design qualities, and perhaps find a new treasure to seek out for your collection. My hope is that you will enjoy a look into the heart and soul of the Fostoria factory, and the opportunity to touch the pulse of the workers who designed, created, moulded, crafted, etched, produced, and distributed Fostoria Glass—they did it with pride and left a legacy for us to treasure!

Wherever you happen to be reading this book, pause and look around. Practically everything you see, feel. or touch is expressive of our mechanical age. The dress you wear is no longer of a hand woven fabric; the chair you sit in is machined piece-by-piece. The automobile in your garage, the computer, or the electric refrigerator in the kitchen are significant of our intricate technology. Yet, the Fostoria crystal on your table is an exciting link with an era long before the machine age. The history of Fostoria Glass is steeped in a century of romance, the finest quality crystal lovingly handcrafted by skilled artist of a by gone era. Pour yourself a nice cup of tea, relax, and enjoy the exploration of Fostoria's treasures, the wonderful photography, and your travel back through time as you enjoy a glimpse of the finest Fostoria glassware and its makers. My hope is that you will enjoy the romance of *Fostoria Glass, Scarce, Unique, and Whimsies* one heart beat at a time!

How to Use this Book

The main body of the book is a collection of individual items chosen to be included in the book for their unique contribution to the history of Fostoria Glass Company, be it scarce, unique, or whimsies. Use the book for the fun of learning and adding new treasures to your collection. Use this book as an expanded reference base for genuine Fostoria Glassware, unique catalog items, scarce production, sample pieces, and whimsies. Explore the wonderful variety of Fostoria shown, and enjoy the introduction to some of its makers.

The individual items featured in this book have been divided by content of what they are and arranged according to categories they fall into within the various chapters. Fostoria produced a great variety of patterns that were lovingly made for many years, such as the American pattern, Colony, Baroque, and others, however you may find only a small representation of these pattern that fall within the criteria of this book being scarce, unique, or whimsies.

The introduction of individual chapters includes my commentary about the types of glass items to be featured within that chapter, and/or quotes from the original *The Little Book About Glassware,* 1925 and *The New Little Book About Glassware,* 1926; or Fostoria's advertising from various time periods to showcase the items featured within the chapter. All quotes are italicized.

Where possible, I tried to be consistent within each chapter to showcase the items by known Fostoria line numbers and/or alphabetical pattern name. I maintain Fostoria's spelling of the word "Mould" as this is the proper spelling according to the designers and glass historians.

Each entry has been treated in a common format that includes the description, attribution, color, measurement, and value.

Descriptions are derived from personal collections of Fostoria catalogs, advertising materials, manufacturing production data, and sales brochures.

Attributions made with each item shown are as accurate as I have documentation for. I have avoided making any statements that I cannot document. Attributions made regarding sample wares, sample colors, seldom seen items, or one-of-a-kind items, are made from documentation sources of designer's collections, former factory workers, manufacturing and sales records shared with me for purpose of research for this book.

Measurements given with each item were taken directly from the item in the picture. Each item was carefully measured as we photographed. As each item is handcrafted, the exact size of the item does not always match the catalog listing. Slight variations in size are normal with hand pressed, hand blown, and hand crafted glassware.

Values are explained in the Value Guide for this book; paperweight values and Fostoria Melamine values are explained in great detail in the appropriate chapter of the book. Ultimately the value is in the eye of the beholder, what YOU, the collector, deems fair price for a wonderful piece of unique Fostoria that captures your heart.

Value Guide

The author decided to give one value in this book instead of a price range. Prices in the Value Guide were derived from current prices seen at antique malls, antique shows and sales, recent auctions, dealer input for various parts of the country, and on line auction sales. Values are based on what a knowledgeable buyer would pay a knowledgeable seller for scarce, unique, or whimsies Fostoria Glass items.

Values given are for items in MINT condition. Items with any damage, such as nicks, chips, or cracks are worth less than the given price, depending on the severity.

Melamine Values: There is an in depth description of the Fostoria Melamine items by original catalog listing number and current market values given in the dinnerware chapter of this book. Values are based on in-depth study of Fostoria Melamine and current published pricing on 1950s collectible plastic and melamine items.

Paperweight Values: There is an in-depth description of values given for the paperweights featured in the paperweight chapter of this book. There are many criteria to be considered when pricing these items; this information will help you understand how we derived the current values for each of the featured paperweights.

Whimsies Values: Values given individual whimsies were derived from known sales of similar items from two decades of personal collecting in this field. Recent auctions and dealer input assisted in putting a current value on these items.

Many of the wonderful, unique, and extremely scarce items featured in this book are believed to be one of kind items, with no previous sales to determine value. Therefore, if no value is given certain items, the author had none to compare. **(NDV)**

Whimsies and paperweights have never been documented before, therefore many bargains can still be found in fun to search places, yard sales and flea markets. There are wonderful resources never before published on the scarce and unique in this book; Fostoria collectors should familiarize themselves with these. There are differences in prices depending on regional markets; some areas have a higher market than others. Ultimately this comes down to supply in demand, what a collector is willing to pay for an item and what a dealer is willing to sell it for.

Please note that these values are only a guide. They are not intended to set prices for the Fostoria marketplace. Neither the author nor publisher assumes any responsibility for transactions that may occur because of this book.

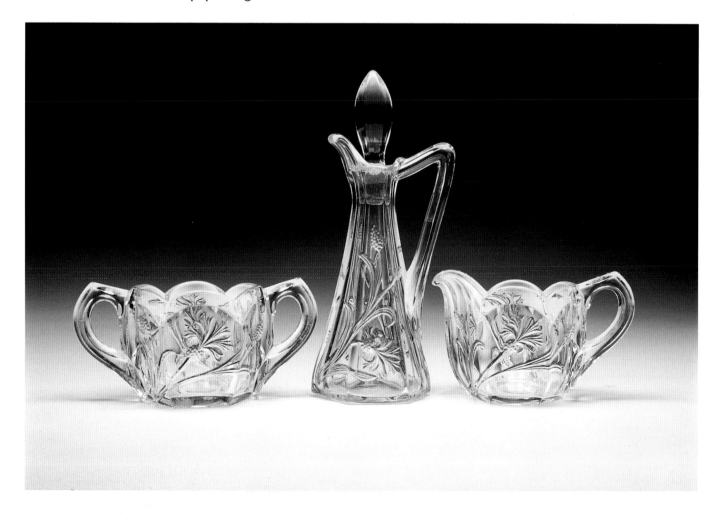

Chapter One
The Romance of Fostoria Glass

The history of glass is steeped in centuries of romance. *Once upon a time, when haughty Venice had reached the apex of her glory, it's crafting was the most closely guarded secret of the Old World. In that Renaissance period, Venetian glass was the envy of European royalty. Despite every precaution, the secret spread throughout Europe, and then to America. All this rich handcrafting art of the past was known, utilized and basically unchanged at Moundsville, West Virginia where Fostoria Glass Company produced the most elegant and useful glassware for our home for nearly 100 years. (*Quoted from a Fostoria Advertisement Booklet)

Webster defines "Romance" as a story dealing with a love affair; a passion, powerful emotion, love, joy, and object of ones desire. Certainly this is true of my love for, joy of, and passion with collecting Fostoria Glass. My romance with glass began as a child and my passion for beautiful glass has never wavered. It all started once upon a time in my hometown Bellaire, Ohio (home of Imperial Glass Company). The City of Bellaire lies in the rich fertile valley of the Ohio, bounded on the east by the mighty Ohio River and on the west by beautiful rolling hills, which have earned Eastern Ohio the title of "Switzerland of Ohio." It was the river, with its facilities for passenger and cargo traffic, which determined the location of the city in the beginning. The year 1854 saw the completion of the Central Ohio Railroad from Columbus and in 1871, a bridge was completed across the river that connected the Central Ohio rail-

road and the B & O railroad. The completion of this bridge increased the market for coal that had become a well-established enterprise and brought about the glass industry which in turn contributed greatly to the economy of the communities on both sides of the river. At the turn of the century there were fourteen glass houses working in this city that sits on the river just across from Wheeling, West Virginia. Bellaire was nicknamed "The All American City of Glass." The Bellaire glassworkers played a large part in the early beginning of Fostoria Glass Company in Fostoria, Ohio.

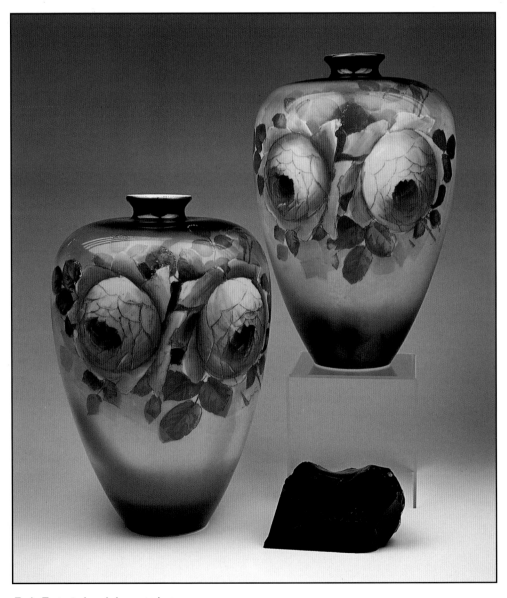

Early Fostoria hand decorated vases.

The city of Fostoria, Ohio was created when the two small villages of Risdon and Rome were unified in 1854. The new town was named in honor of C.W. Foster, a prominent pioneer whose son Charles later became the governor of Ohio and secretary of the U.S. Treasury. During the late 19th and early 20th centuries, Fostoria was the home of several glass manufacturing plants. Although their furnaces are now cold, collectors will find the local glass companies and the craftsmanship for which they were known are remembered at the Glass Heritage Gallery in this city.

Fostoria Glass Company
History a Century in the Making...

There is a beauty of Fostoria crystal, lovingly handcrafted by skilled artist of a by gone era, whose primary methods used since man first discovered that the matrimony of fire and sand, spiced with a few basic chemicals, gave birth to a lovely, lucent material called glass. The romance of Fostoria Glass Company was nearly a century in the making. Fostoria Glass started in Fostoria, Ohio in 1887. The town made an offer of free land and cheap gas. Original founders William Brady and Lucien B. Martin had extensive knowledge and experience in the glass industry. William Brady had been manager of Riverside Glass Works, Wellsburg, West Virginia and Lucien B. Martin; First President of Fostoria, came from Hobbs, Brockunier and Company, Wheeling, West Virginia. Melvin L. Murray, noted historian and author of *Fostoria, Ohio Glass II,* published in 1992, credits Mrs. Sarah (Hildreth) Brady, wife of William Brady as being the largest holder of stock in the Fostoria Glass Company in 1887. Sarah's brother was B.M. Hildreth, the first sales manager at Fostoria. Appropriately, when the first piece of glass, a salt dip #93 pattern was pressed at the plant, it was given to Mrs. Sarah Brady. With Mrs. Brady's number of shares, everyone around the directors' table was undoubtedly ecstatic about the honor of the first pressing going to her. A romantic gesture as well, for the desires of American women were always the number one consideration of Fostoria.

This beautiful example #575 Carmen Salt Dip was among those first produced, circa 1889. 1.75" diameter.

In June 1887, the Bellaire, Ohio newspaper reported that twenty workers would be departing that community for Fostoria, Ohio for jobs in the Fostoria glass factory; this included several members of the Crimmel Family, Hayes O'Neal, and Deacon Scroggins. The Jessie Crimmel family is believed to be the first mixers at Fostoria. By 1891 the supply of natural gas decreased and Fostoria major shareholders with homes in West Virginia decided to move the factory to Moundsville, West Virginia. The company negotiated an agreement with the Moundsville Mining and Manufacturing Company to purchase coal, which could be converted into gas, for fifty cents a ton. There was a coal mine located just west of the factory on First Street. In the early years, small cars pulled by donkeys hauled the coal from the tipple of its mine to the factories coal-burning sites.

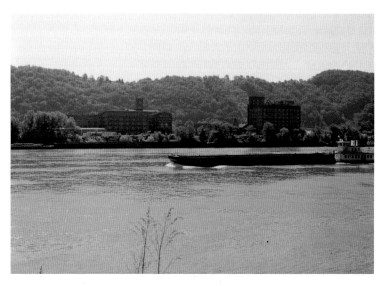

Coal barge sailing up the Ohio River as you're looking towards West Virginia.

The Upper Ohio River Valley region, Wheeling, West Virginia was a major industrial hub at this time period and had several outstanding glass manufactures that contributed so much to the history of the American glass industry. Wheeling's riverfront is a window on the Ohio River, one of America's most scenic waterways, known as the northern panhandle, which continues into Pennsylvania to the east and Ohio to the west.

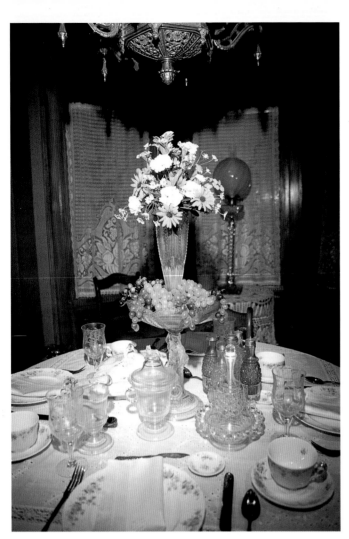

Moundsville is located just twelve miles below Wheeling sitting on the Ohio River. The Ohio River was a major transport avenue in this area, with hundreds of steamboats docked at the Wheeling wharf, ferry boats to transport goods and travelers, and the railroad traveling through the area from larger cities such as Cleveland, Chicago, and Detroit. The lure of cheap coal required for the furnace and an abundance of sand, the major ingredient of glass making, proved the move for Fostoria Glass from Fostoria, Ohio to Moundsville, West Virginia to be the promise of a sound future for the young company.

Oglebay Institute early display of Central, Hobbs Brockunier, Northwoods, and Sweeny Glass. *Used by permission of Oglebay Institute, Wheeling, West Virginia.*

Elegant early Fostoria. Left to Right: #183 Victoria, #2106 Vogue Toothpick, #1490 Candlestick, #1515 Lucere Toothpick and #789 Wedding Bells Ware, circa 1887-1920.

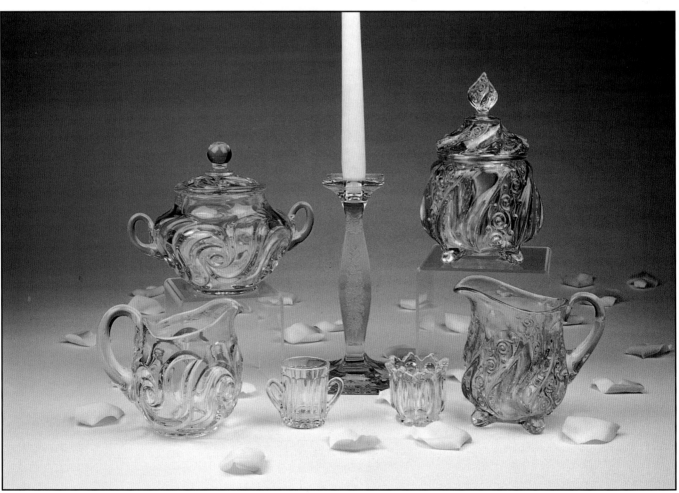

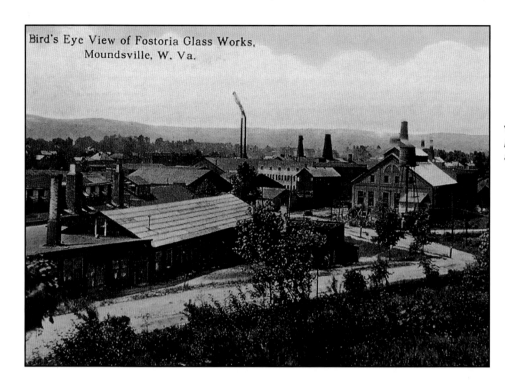

Bird's Eye View of Fostoria Glass Works, Moundsville, W. Va.

View of the Fostoria Factory, Moundsville, West Virginia from an old factory postcard.

In 1892 Fostoria's new plant was established in Moundsville. L.B. Martin and W. S. Brady managed it for about ten years. Shortly after the move, Fostoria began manufacturing a large variety of decorated lamps. Fostoria also made tableware for hotels and clubs and catered to middle and upper income households all over the western hemisphere. In 1901, William Alexander Baxter Dalzell (who preferred to use the initials "W.A.B." before his surname) left the National Glass Company in Findlay, Ohio to become manager of Fostoria Glass Company. W.A.B. Dalzell was the son of a Pittsburgh Ferryboat Captain. He was a self-educated man with great energy and perseverance. Dalzell was elected president in January 1902. He was the first of several Dalzell men to lead Fostoria's fortunes. W.A.B. Dalzell was a religious man, and like his father, a ferryboat captain—he liked to run a tight ship on a good schedule. People tell me that W.A.B. enjoyed walking to work daily, and always took walks at the exact same time through the factory each day to observe his craftsmen. Calvin Roe worked with W.A.B. at National Glass and made the move with him to Moundsville to manage the new Fostoria location. They worked closely together setting new standards in the industry.

W.A.B. had two sons, Harry and William. Harry G. Dalzell became the Sales Manager of Fostoria's Chicago office; he was instrumental in establishing the sales force and new marketing ideas. William F. Dalzell, came to work at Fostoria from Allegheny College in 1912. William began working as a chemist, and as such, emphasized the importance of standards of purity and color. He was full of ideas to improve the plate etching process and was very instrumental in pushing for the full lines of colored tableware and many new etching pat-

terns. Their pioneering ideas of being the first glass house to open a research laboratory in 1913 to work on development of colored glass and improving the quality of glass production, as well as the recognition of the importance of having an in-house designer, had firmly established Fostoria as a leader in the American glass industry.

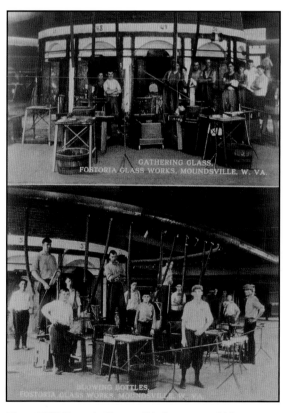

Circa 1910 Fostoria Factory Workers; two old factory postcards.

15

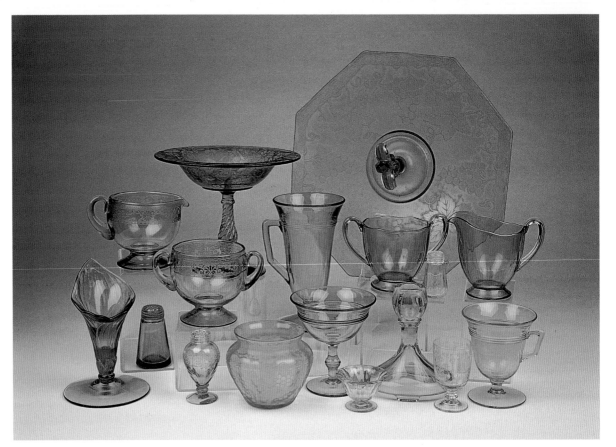

Beautiful colors of Fostoria glassware production circa 1920.

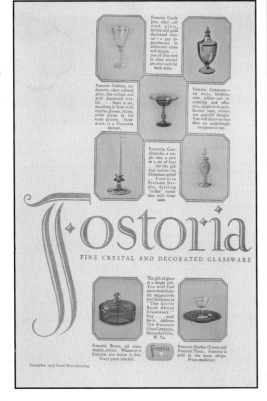

Example of one of the first full color advertisements of Fostoria circa 1924.

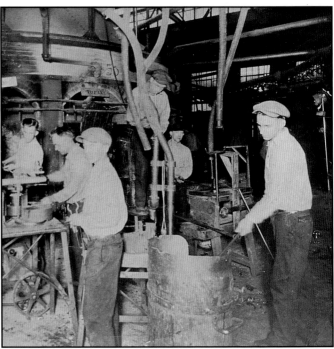

Fostoria factory workers circa 1930. *Photograph courtesy of Paul Myers.*

In 1915 the most popular pattern, the #2056 American line, designed by Phillip Ebeling was introduced. The decorated ware, particularly needle etchings, continued to be popular for Fostoria in the 1920s, but these were expensive to produce, and machine made tableware was starting to rival the quality of these designs. In 1924 Fostoria was the first glass company to introduce complete lines of colored tableware. It was styled to sell, because it conformed to the new trend of the time for beauty in merchandise and was accepted by authorities on table decoration everywhere. In 1928, upon the death of W.A.B. Dalzell, Calvin Roe was elevated to the presidency. Calvin Roe lead the company through the depression.

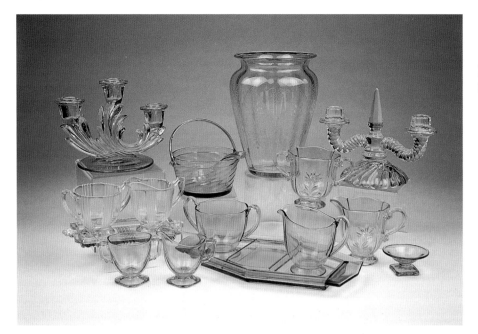

Beautiful samples of colored glassware produced circa 1930s.

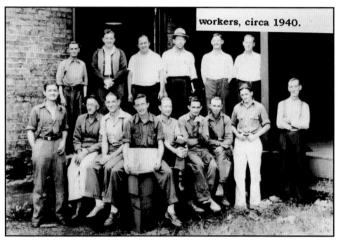

A gathering of workers outside the factory circa 1940s. *Photograph courtesy of Paul Myers.*

The 1930s introduced new dinnerware lines included Baroque, Hermitage, Lafayette, Mayfair, and Sunray; over one hundred decorated and etched patterns were offered in the full line of tableware, as well as many wonderful colors unique to this era. During the depression, production was cut back. Rather than lay off its family of craftsmen, Fostoria put "division of time" into labor contracts to divide up the work so every employee could work at least one or two days a week. The workers who did not have a turn on the day shift often times enjoyed playing basketball outside on a court the factory had installed for them. The dignity and moral of the families was a big concern for the factory, as well as establishing good will and prosperity for the community. Many of the local children, especially boys, enjoyed the opportunity to hang out around the factory and learn some of the glass trade from the older workers, who liked to teach them. Often times this is how the boys would learn and be able to catch turns at the factory when the opportunity came up.

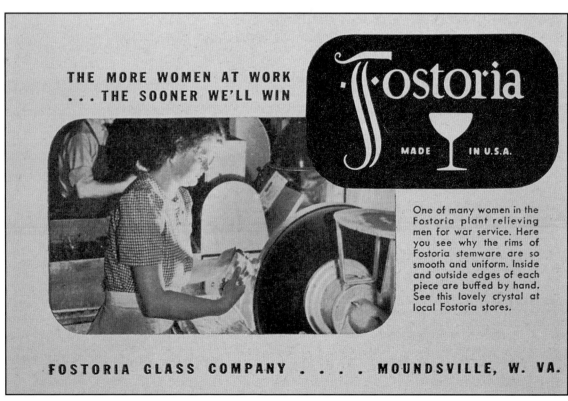

Fostoria employed ladies during WWII, the ad states "The more women at work... the sooner we'll win!"

17

During the war years in the 1940s, many women went to work at Fostoria to fill the men's shoes. They worked in the hot metal departments, pressing and gathering the wares to keep the production going. During this time, Fostoria sacrificed many older moulds as scrap metal. Trends were changing, the decades of color tableware was giving way to the brilliance and clarity of crystal. For comparison, in 1929, only 10% of Fostoria's production was crystal; but by 1939 the reverse was true, only 10% of production was now in color.

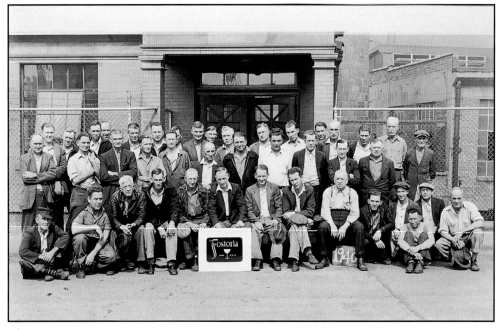

Fostoria craftsmen and shop workers circa 1940. *Photograph courtesy of Paul Myers.*

William F. Dalzell became President of Fostoria in 1945, the second generation of Dalzell family leadership. W.F. Dalzell had been instrumental in negotiating and developing new labor policies, pension plans and life insurance policies for the factory workers. Those whom I interviewed who worked under William Dalzell tell me stories of a distinguished and kind man, with a gentle spirit and great concern for the welfare of his workmen, making them feel like a part of a family at Fostoria. I believe it was his greatest legacy to leave his son, David Beaty Dalzell his gift of imagination and innovation, a touch of humor, and his kindness.

There is romance to be found in the beauty and passion of Fostoria Glass, a romance that was one hundred years in the making. Vernon Etching #277, Green.

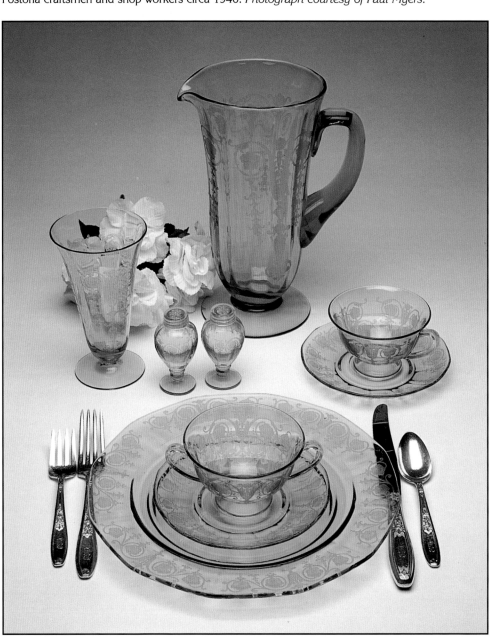

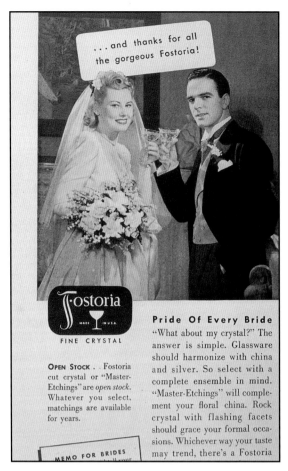

Nothing says romance like Fostoria advertising campaigns for the brides. Fostoria offered elegant patterns for the home; all full lines of dinnerware and accessories were offered "open stock" where you could purchase one item at a time to suit your needs.

During the 1950s there were many changes in trends, as lifestyles changed from formal to informal. Because of the wisdom and ability of Fostoria's leadership to respond to these changes, the company was flexible to new trends, and aware of human needs and the changing marketplace. This flexibility was reflected in their new marketing slogan, "Fostoria, the Glass with Fashion Flair."

Fostoria, the Glass with Fashion Flair, and style of new Melamine.

W.F. Dalzell and the Fostoria factory set many standards that contributed to the prosperity of the community. The Mayor of Moundsville and several councilmen were also employees at Fostoria during this decade. The factory employed about 925 people at this time. In 1958 W.F. Dalzell resigned as President, and Robert F. Hannum took his place. Robert Hannum had come to work at Fostoria in 1928 and through his thirty years held the title of Vice President and General Manager. He remained in office at Fostoria until his death in 1968.

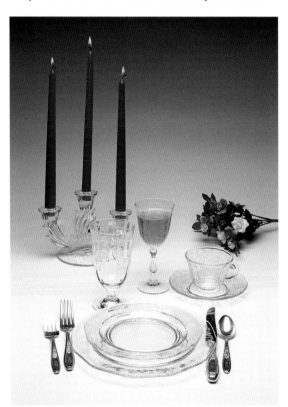

Sample of the romantic pattern Fostoria's Master Etching Navarre #337 produced 1936-1982, one of the beloved etching patterns of Fostoria.

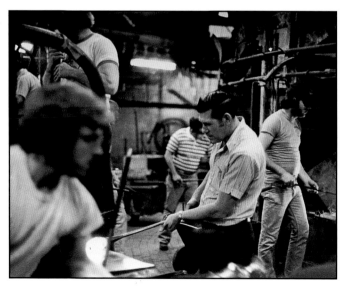

Fostoria's skilled craftsmen creating wares.
Photograph courtesy of Paul Myers.

By the 1960s, the increase in the popularity of Fostoria Glassware, with its innovative marketing techniques, kept pace with the changing times. There were many new products and full lines decorative giftware introduced. During this time period Fostoria began a contractual relationship with Avon to manufacture glass for Avon Products. In 1965 Fostoria purchased the Morgantown Glassware Guild, originally known as Morgantown Glass Works.

In 1968, David Beaty Dalzell became president of Fostoria, the third generation to carry on the heritage with the innovation and determination set by his father and grandfather.

Those whom I have interviewed about working at Fostoria under the leadership of David B. Dalzell tell stories of a humble man with a great heart who knew the industry well. He had a full sense of vision for the direction of the factory and complete understanding of the importance of sharing in the pride of the craftsmen and the products they made. David B. Dalzell often times encouraged his craftsmen to use their imagination and he loved to share in making lunch hour whimsies and paperweights with them. David often times requested special gifts of Fostoria paperweights to be made for visiting dignitaries, his family members, and friends. He was admired by those who worked for him, as well as the competition, for his leadership set Fostoria apart from the other American glasshouses of the era.

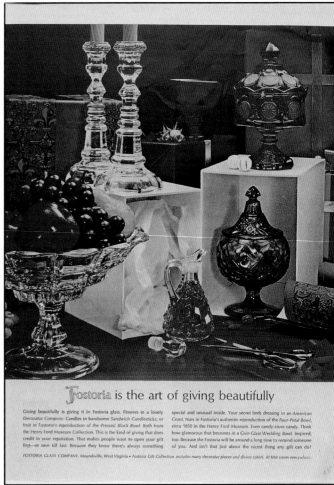

Fostoria the art of giving beautifully, popular patterns circa 1970s.

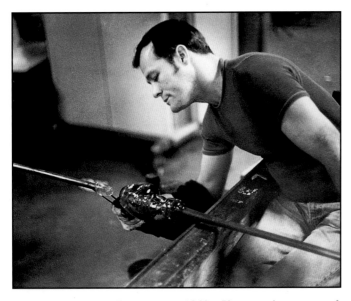

Making glassware at Fostoria circa 1960s. *Photograph courtesy of Paul Myers.*

During the 1970s Fostoria was well known as "The Crystal for America." The Morgantown Glassware Guild shut down in 1971. This same year Fostoria began a joint venture with Pickard China. Together they coordinated glassware lines to match the popular Pickard China patterns of the era. Joint efforts were made in advertising brochures. This decade saw the move toward automation at the factory and the decline of hand blown glassware. The number of people working at the factory was declining as machines slowly replaced the hand shops; the work force in this era was approximately 445 people. David B. Dalzell continued to lead the company with the exacting standards and perspective set by his grandfather. It was reported in a trade journal: *The people at Fostoria have kept their eyes so intently upon the goal of quality products that they are scarcely aware of the craftsmanship in the company they have created. At most they take it for granted as a prerequisite to the quality upon which they insist.*

In 1982, David B. Dalzell, at age sixty-five, decided to retire as president of Fostoria. Succeeding him was his sons, Kenneth Dalzell, the fourth generation to lead as president of Fostoria and David Dalzell, Jr. who served Fostoria as the head of the Sales and Marketing Department. It seems no matter how popular Fostoria was, it was no match for foreign imports; the factory was outdated and production costs were high. In 1982, a decision was made that forced Fostoria to close down all the hand blown shops, and the workforce was reduced to approximately 225 employees. In September 1983, Fostoria was sold to the Lancaster Colony Corporation. It was hoped that Lancaster Colony would be able to provide the necessary capital to save the Fostoria factory.

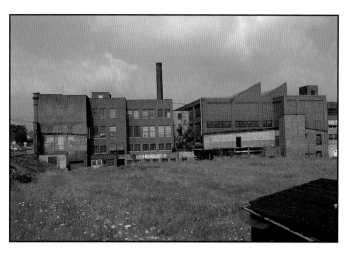
Fostoria factory as seen in a photograph taken 2002.

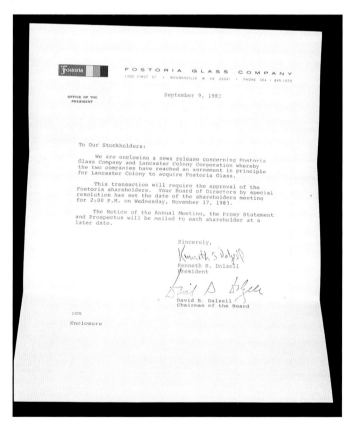
Letter to Fostoria stockholders regarding merger with Lancaster Colony, dated September 9, 1983.

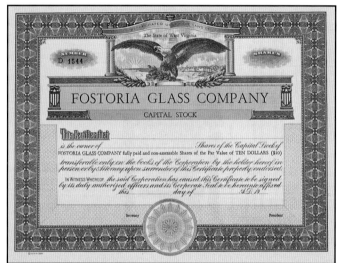
Stock Certificate of Fostoria Glass Company.

One of the main factors contributing to Fostoria's decline was inefficiency; it was outdated. The factory was spread over five acres in the city limits of Moundsville. The Fostoria factory was boxed in. There is a cemetery on one side, and the other sides were lined with city streets. There was no room for expansion. The only solution would have been to level the factory and begin all over again and this was just too costly. In 1986 a decision was made to close the factory. Lancaster Colony moved production of many Fostoria lines to its other factories and kept the Fostoria Factory outlet stores open. Although the Fostoria glass furnaces are cold, the many, many talents of skilled workers is a triumph—the art heritage of handmade Fostoria is second to none in the history of American glassmaking.

Chapter Two
The History of Fostoria's Design and Mould Departments

Design is a unique language expressing one thing in terms of another, insight, impulse, and interpretation, the form evolved out of feeling. Since the creation of Fostoria Glass Company in 1887, the mould and design department was the heartbeat of the company. Fostoria designers were the pulse of the company, the generating and controlling influence in the production of every piece of Fostoria glassware ever produced.

Much of the contributions to the history of Fostoria Glass designers and their important work at the factory is overlooked today. In one published book, the works of Fostoria Designer George Sakier is highlighted. As a result, George Sakier's designs are now well known and numerous. However, Sakier was an artist and outside designer residing in Paris, with an apartment in New York City, submitting drawings to Fostoria for design consideration. It is important for collectors to understand that through his many years of submitting drawings to Fostoria it took the combined efforts of members of the in-house design team, model maker, mould maker, and glassmaker all working together to produce the final product.

It was not the work of one single person that brought fame to this glass company. Fostoria's achievements were the combined efforts of hundreds of men and women, designers, craftsmen, and management alike. All should be given full credit for the impressive history of Fostoria Glass.

It is important to travel back to the beginning of Fostoria Glass production, and present the collector with an introduction to the designers who worked at Fostoria. Taking a look at all designers contributions to the beautiful art of Fostoria that is seen in this book will provide a background for understanding the importance of the role Jon Saffell had in the legacy of this great factory.

From the beginning, the Fostoria mould shop foreman was also the designer of patterns and shapes. Charles E. Beam was one of the original Board Members and the head of the mould shop at Fostoria in 1887. Beam is responsible for the early Fostoria novelty wares. Novelties included paperweights, lamps, cologne bottles, and inkwells. Fostoria's first President, L.B. Martin worked with Beam in the mould department to patent many of the early designs such as Virginia and Sterling patterns in 1888, Late Icicle, the Victoria Pattern, and Frosted Artichoke patterns in 1889 as well as the Cascade and Foster Block patterns in 1890. These designs were made at the original plant in Fostoria Ohio. The design history of Fostoria evolved and the artist-designer was a specialist on a team of many specialists. Working with researchers, lab technicians, mould and model makers, and the glass workers themselves, he would strive to develop designs that were both practical and appealing.

Edgar Bottome came to Fostoria in 1897 from Lenox. Bottome was primarily an artist and a decorator. As such, he not only supervised the decorating department, but he painted and designed decorations. It was a natural step for him to begin to design shapes for his decorations to go on, and so he became the first person at Fostoria to devote the major portion of his time to design. He is responsible for much of the Baroque table service, some Flame items, and many of the beautiful etchings of Vernon, Versailles, June, Trojan, New Garland, and Navarre.

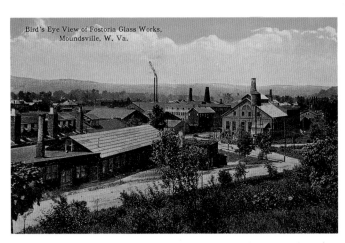

Bird's Eye View of Fostoria Glass Works, Moundsville, W. Va.

Early view of Fostoria Glass Works.

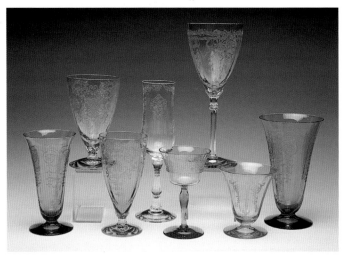

Designs by Edgar Bottome.

Phillip Ebeling came to Fostoria in 1901 to serve as the foreman of the mould-making department. Ebeling designed glassmaking machinery and patented several designs for moulded glass. His moulded lines included #2056 American pattern, moulded intaglio cut wares with floral motifs, glass tops for shakers, and moulded lines of #1913 Flemish, #2106 Vogue, and #2183 Colonial patterns.

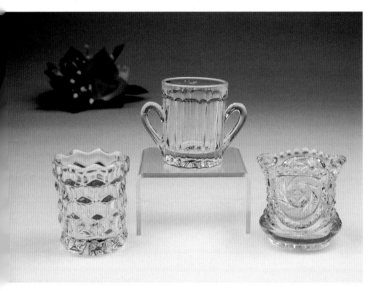

Designs by Phillip Ebeling, Vogue, American, and Colonial.

William H. Magee came to Fostoria in 1925. He designed the #2380 Candy Jar and Cover, #2394 2 inch Candle, #2398 11 inch Bowl, and the line number #5298 Candlestick. Calvin Roe holds the patent design for the Candleholder Bobache that William H. Magee began designing in 1925. Walter Heinze is responsible for the swirl single candlestick patented in 1948 and the combined Candleholder and Epergne patent filed in 1949.

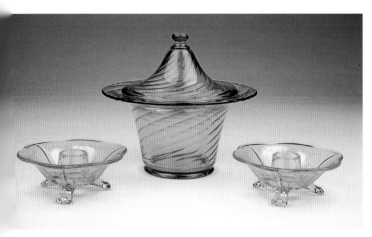

Designs by William H. Magee.

Marvin Yutzey came to Fostoria in 1936 after graduating from Cleveland Institute of Art. Yutzey began as an understudy to Edgar Bottome. Yutzey later became the first Director of Design at Fostoria. Yutzey worked very closely on designs with Sakier through the years. Yutzey's blown stemware designs included #885 Georgian, #6123 Princess, #6097 Sheraton; his pressed designs includes #2630 Century and the #2885 Stratton 24% lead crystal line. In collaboration with Jon Saffell, Yutzey designed the American Milestones Commemorative Plates, the State Plates, and Old Glory series. Yutzey retired in 1977.

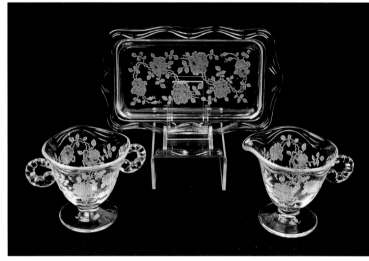

Century design by Marvin Yutzey, Willowmere Etching #333.

Fernando Alvarez came to Fostoria in 1939 and worked closely with design director Yutzey. Alvarez acted as a liaison between the design department, mould shop, and the factory. Alvarez became manager of the design department in the late 1960s and took over more of the technical duties, leaving Yutzey more creative time. Alvarez's designs include the #4186 Mesa pattern, #6125 Distinction, #2882 Moonstone, and the #2821 animal series consisting of Bear, Bird, Cat, Dolphin, Owl, Penguin, and Turtle.

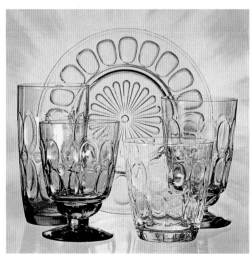

Mesa pattern was a design by Fernando Alvarez.

Robert Cocanhougher worked at Fostoria for a brief period 1939-1943 and devoted his time to development of the sand carvings in crystal during this time period. One of his beautiful sand carvings is the Archer Bowl Carving #24. This is the original sample for the 9 inch bowl that was in the catalogs. One-of-a-kind samples of unique sand carvings on Fostoria vases in production 1940 to 1943 that have not previously been documented are shown in this chapter.

Greg Pettit came to Fostoria in 1971 as a model maker for the design department. Pettit made masters for the mould shop in addition to working with the design team of Yutzey and Saffell. Short time stay and/or part-time designers throughout the history of Fostoria include Robert Grove and Fred Yehl who came to Fostoria to work in the 1950s. Both worked with Marvin Yutzey and Alvarez. In the 1970s through 1980s other designer names included William Hoffer and William Bradford. Outside designers and/or art consultants throughout Fostoria history who contributed to some of the Fostoria studio art design included George Sakier, Raymond Loewy, Russell Wright, Ben Seibel, Helena Tynell, Joy Christov, and James Carpenter.

George Sakier sent his designs drawings to Fostoria from Paris or New York City for nearly fifty years. Known patterns that he designed include #2496 Baroque, Diadem, Flame, Plume, Ivy, #2719 Jamestown, #2832 Sorrento, #2718 Fairmont pressed stemware, #6017 Sceptre, #6113 Versailles stems, and Crown giftware items.

Ben Seibel's design contributions began in 1962, with the #2752 Facet giftware. Later, he designed the #2824 Module drink ware, #2806 Pebble Beach, the lead crystal drink ware #2903 Monarch, and #2934 York.

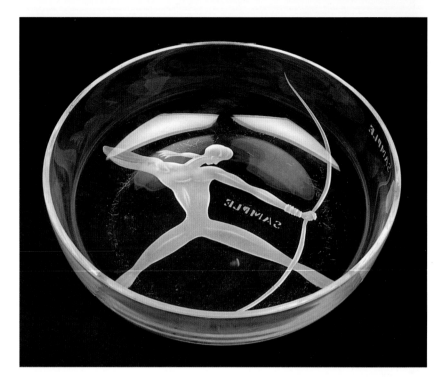

Archer Carving #24 original sample, Robert Cocanhougher.

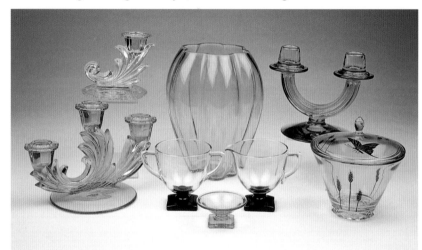

Designs by George Sakier.

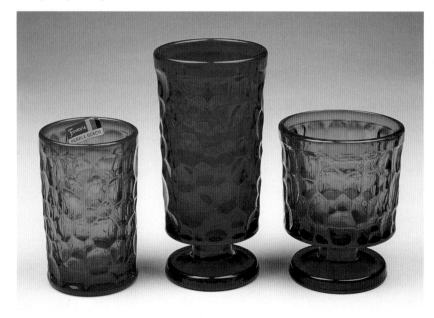

Pebble Beach, design by Ben Seibel.

Jamie Carpenter was a studio glass blower who worked with Jon Saffell in 1977-1978 to develop some "off hand" looking pieces, which became the Designer Collection of Vases. This sample vase made by Jamie Carpenter is an exquisite shape and color, produced by adding neodymium to the test batch. This piece was not produced, only sampled, however it was signed by Jamie Carpenter and presented to Jon Saffell as a gift.

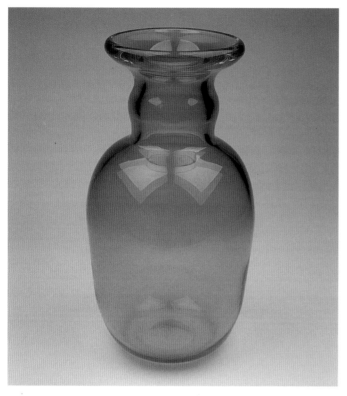

Exquisite Vase, by designer Jamie Carpenter.

Judy Olert was a bridal consultant before being hired by Fostoria in the 1980s for the sales department. Her job was to head up the new product development department where she worked with the design department on suggestions for new lines.

Joy Christov, was a designer discovered by Judy Olert. In 1981, Joy developed a line of items based on basket weave patterns. Basketry is the pattern name Fostoria gave to the designs. There was a short sample run of a Basketry Vase, limited to a few pieces known to exist. This sample Basketry Bowl, 14 inches in diameter is believed to be one of a kind; it never went into production.

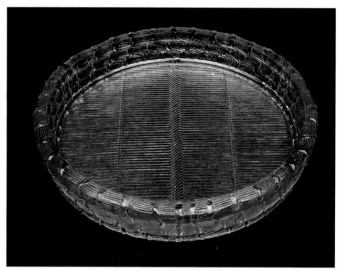

Basketry Bowl design of Joy Christov.

Helena Tynell was a glass designer from Finland who met David Dalzell when he was in Europe. Tynell designed for the Riihimaki glassworks in Finland. She created Fostoria #2825 and #2844 Seashell pattern, #2842 and #2856 Serendipity giftware and #2868 Family Paperweights. All these designs were from the 1970s. Other designs of Helena made it into the production lines of Fostoria, but were difficult to produce and did not sell well.

Serendipity Giftware by designer Helena Tynell.

Luciana Roselli was an Italian designer from New York. Judy Olert had seen some of her work and asked her to develop some designs for Fostoria. Her strong suit was two-dimensional art and she did some beautiful drawings of angels. Fostoria produced an etching plate from one of her drawings and sampled it on this platter. Unique in its 3 dimensional effect, this exquisite platter is etched on both sides.

If you look closely at this design art you can see the artist signature etched in the pattern. A most interesting fact is that there are only two known items of Fostoria that bear artist/designer signature: the first and only production item ever produced by Fostoria bears the signature of Jon Saffell, Designer, that you will see in this chapter. This sample artwork of Luciana Roselli with her signature is the second. This item never went into production; this is only one of two platters known to exist, sampled only.

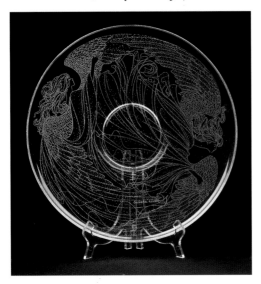

Very unique art Platter, by designer Luciana Roselli.

The Design Department at Fostoria was innovative and stayed with the times; it had resiliency and the creativity to exercise the imagination of the American glass buyer.

From the drawing of the design, to sculpture of the design, to the mould, to sample production of the item, Fostoria craftsmen worked as a team with those who produced the sample product. Sometimes a sample was produced, and for unknown reasons it was never put out, this means never shown in a catalog nor sold to the public. This is referred to as the **"NPO"** file. The Ribbons and Bows Console Set shown here is an **"NPO"** and has never been documented for collectors. The romance of Fostoria and artistry in glass is exemplified in this design of simple Ribbon and Bows; a very romantic pattern. This Ribbon and Bows design sample is believed to be one-of-a-kind, and the work of designer Marvin Yutzey.

There are many beautiful sampled vases of Fostoria never put into production "NPO". Unfortunately, no written documentation among the design records of Fostoria shed light on these one-of-a-kind treasures. My research found documentation that Fostoria did indeed produce these Vase Blanks from 1939 through 1943 in their catalogs. It therefore makes sense that they would have sampled sand carving on one of these blanks. Since Robert Cocanhougher came to work at Fostoria's design department during this period to develop the sand carving process, I have attributed this artwork to him. Perhaps he worked with Marvin Yutzey to produce the beautiful sand carvings on these samples. Who were the designers that created these delightful fantasies in glass? Perhaps it is just as well that much of the stories behind these unique designs are lost in the haze of time. Though the facts are gone, one can marvel in the wonder and romance of these wonderful treasures.

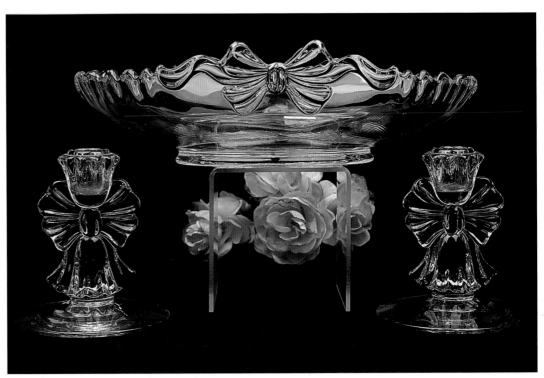

Beautiful Ribbon and Bows Console Set. Sampled, NPO.

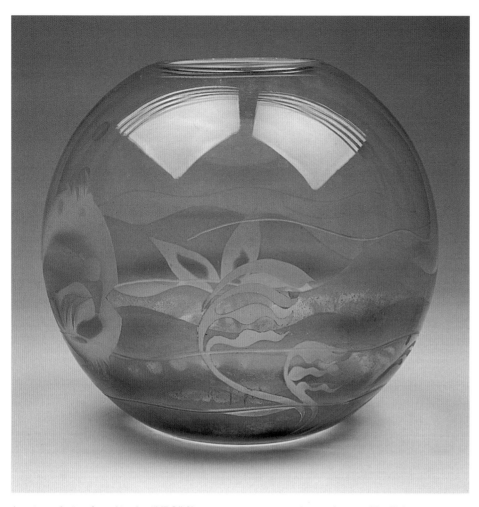

A unique design found in the "NPO" files was an experimental vase designed by Robert Cocanhougher circa 1939. This bubble bowl seascape is very unique, 7" wide and 8.5" tall. **NDV.**

Sampled Vase, Sand Carving Umbrella Boy, sampled on #2612 Tall Vase, circa 1942. **NDV.**

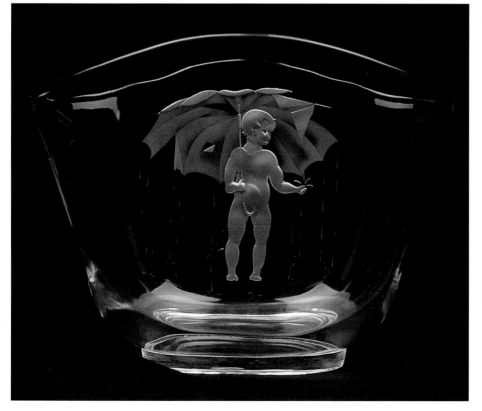

Sampled Vase, Sand Carving Umbrella Boy, circa 1942. **NDV.**

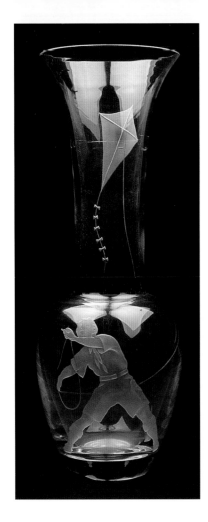

Sampled Vase, Sand Carving Boy Flying Kite, delightful artwork, sand carving is done on both sides of this vase giving it a 3 dimensional effect. Circa 1939. **NDV**.

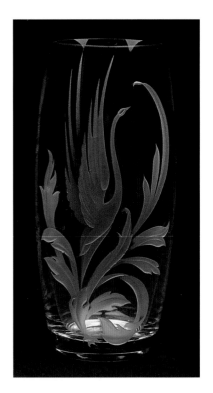

Sampled Vase, Sand Carving Graceful Crane, circa 1940, not in production. **NDV**.

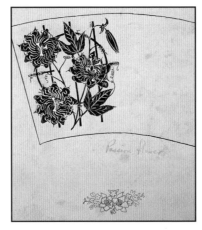

A design sample shown from an unknown artist. Design approved for etching "Passion Flower" artwork. NPO. Believe to be the work of Edgar Bottome.

Sampled Stemware, shown with original pen drawing for this new plate etching. Sampled only, circa 1928, not produced. NPO.

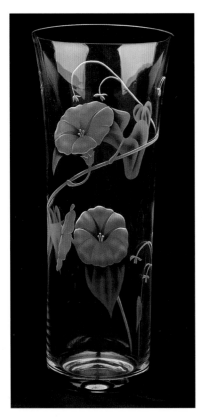

Sampled Vase, Morning Glory Sand Carving, circa 1939. **NDV**.

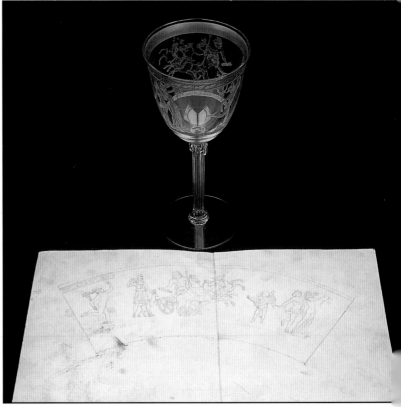

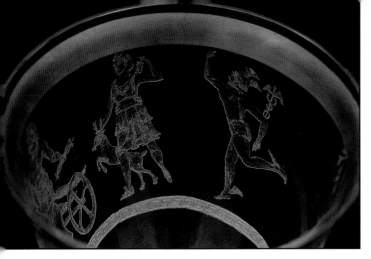

Close up of art work for the beautiful stem etching.

The following is a quote from a newspaper interview with designer Marvin Yutzey dated 1953. When asked the question "Where do you get your ideas for designs?" Yutzey replied: *I get them from people, especially from people likely to buy glassware. There is nothing mysterious about designing products for everyday living. Some persons seem to think that a designer dreams up ideas all by himself. Well, that isn't the way it is done. Of course, suggestions may come from any number of sources- sometimes from nature with its infinite wealth of form and color- sometimes from a centuries-old object of art in a museum, which kindles an idea for a form or detail of contemporary products. Best of all, however, are ideas that grow out of an unending study of people—their needs for everyday living, their tastes, and the furnishing of their homes."*

Yutzey continued: *"Once a basic idea has been approved, it has to be developed into a finished design. This calls for the designer's feeling of what is pleasing proportion, symmetry and balance, with some accent or contrast and an understanding of what glass is capable of doing. I like to think of a designer of handmade glass as a craftsman who lovingly follows an idea through numerous sketches, drawings, three dimensional clay studies, revisions, refinements, plaster models and finally glass in trials. In this way, the designer is so close to his design, that it is almost as if he had made the piece himself, although he may not have handled the actual molten glass".*

It takes talent and training and many times a lot of courage to have an idea and proceed to make that idea a reality. But these are challenges which any creative person enjoys and which a true artist uses in his search for a design that can be sold with pride, knowing you are offering a top value to the Fostoria customers.

Jon Saffell, Designer "The Journey from Fostoria to Fenton"

Jon Saffell worked at Fostoria Glass Company for a total of twenty-nine years. In 1957, he began his Fostoria career as model maker. His role in Fostoria history changed to design assistant, and finally, the title of Director of Design was bestowed upon him. This was the title he held at the closing of the factory in 1986. Jon was an artist who met everyday challenges, and was involved in one way or another with every design produced by Fostoria throughout his twenty-nine years career at the factory. Jon is currently designing and sculpting for the Fenton Art Glass Company.

Jon Saffell was born November 25, 1939 in Glen Dale, West Virginia. He was the son of Robert and Mildred Saffell. Jon expressed a passion for the fine arts at an early age. His father built a chalkboard from a four foot by eight foot sheet of plywood in the basement of their home. Dad supplied the young artist with all the chalk his hands could hold. Jon's creative abilities began to emerge as he spent hours at a time, in the basement, creating drawings on the chalkboard.

Glen Dale, West Virginia is a small town, just outside of Moundsville, the home of Fostoria Glass. Students attended high school in Moundsville, as there was no high school in Glen Dale. Jon had visions of becoming an art educator in high school, and always had a passion for the fine arts. When he graduated in 1957, he was hired at Fostoria Glass. His first job title at Fostoria was that of model maker.

Jon Saffell met his wife Carolyn Nisperly while he was working at Fostoria. They married in 1960. Jon and Carolyn have two daughters, Jill and Julie, and seven

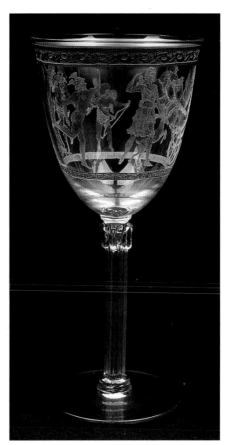

Sampled stem with exquisite design etching and gold trim. NPO.

grandchildren. At least two of Jon's grandchildren seem to have inherited Grandpa's joy of sculpting, so he keeps them supplied with lots of clay!

Jon's first duties in the design department had him working directly with Fostoria's designers Marvin Yutzey and Fernando Alvarez. While working with and learning from these expert designers during the day, Jon attended evening classes at West Liberty State College where he majored in art education. One of the first design moulds Jon Saffell worked on when he came to Fostoria was a unique design in plastics. In 1957, Marvin Yutzey worked with Lathman-Tyler-Jensen, designers from Chicago and Chicago Molded Products to produce the first line of Fostoria Melamine dinnerware.

In keeping up with the trends of the time, Fostoria Melamine was to be introduced as the first "Break-resistant" dinnerware. Fostoria created a line of crystal print glassware to match the patterns of melamine. Jon was responsible for some of the mould designs for this line. This milestone in Fostoria's history, melamine and matching glassware designs of modern times is featured in the dinnerware chapter of this book.

Jon Saffell continued his art classes, taking every art class West Liberty College offered and when he ran out of art classes, he took Art Education classes. As his creative skills began to flourish, his role in the making of Fostoria glass changed. Throughout his early years of working at Fostoria as model maker and drawing, he was inspired by working with known designers Marvin Yutzey, Fernando Alvarez, Ben Seibel, and George Sakier. In later years, as designer and director of design, Jon worked with and led a new generation of designers, Greg Pettit, Jamie Carpenter, Joy Chistov, Helena Tynell, Bill Hoffer, and Luciana Roselli all working together as part of Fostoria's Design Team.

Some of Jon's first design contributions were the simple novelties #420 Frog and #452 Ladybug in 1970. When Greg Pettit was hired as a model maker in 1971, this allowed Saffell more creative time and he designed the first 24% cuttings #916 and #935 Greenfield, and pressed pattern, #2936 Transition.

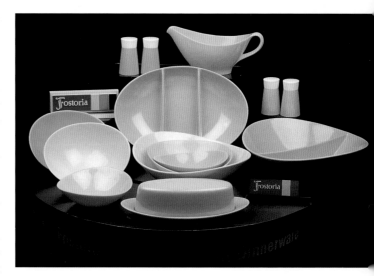

Unique design of Fostoria Melamine in a variety of colors.

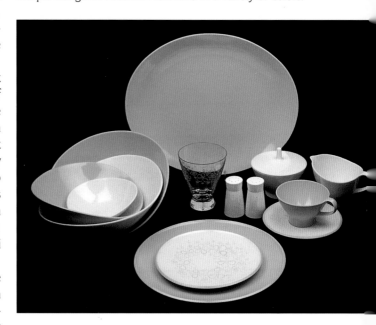

Fostoria's Melamine, Unbreakable Dinnerware.

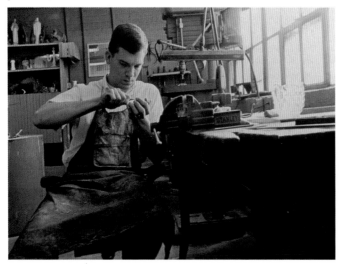

Jon Saffell, Model Maker, at Fostoria office, circa 1957.

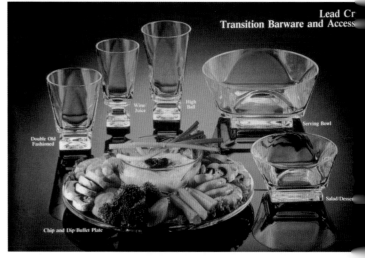

#2936 Transition, design of Jon Saffell.

**Bell
AM01/047**

Jon was responsible for the design of the #2056 American Bell. This bell is a much sought after prize for American collectors. This design was blown into mould and Fostoria shut down all blown ware production in 1982. This Bell was made one year only.

Increasingly, American lifestyles became more casual while Jon was designing at Fostoria, which led to his creation of several new moulded giftware and tableware patterns, the #2977 Virginia line, Transition, and Kimberly lead crystal lines. Fostoria moulded ware was sturdy and well suited to daily use.

#2977 Virginia, designs by Jon Saffell.

When Fernando Alvarez died suddenly in December 1972, Saffell was made design department manager. Pettit, Yutzey, and Saffell worked as a team and produced #555 American Milestones, #2860 Paneled Diamond Point, and several others.

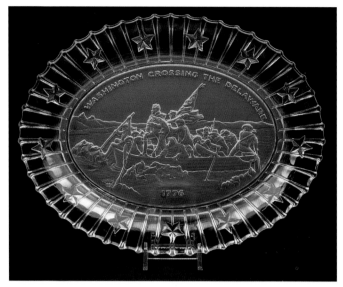

Milestone Plate, Washington Crossing Delaware.

Jon shared his knowledge of sculpture requirements for making the models for these plates. One has to sculpt the plaster master model two times larger than the actual size of the plate to make the mould. You can see from this plaster cast of Washington Crossing the Delaware, the size difference in the sample and the finished product. By creating the large size model, you don't lose design detail in the finished product mould for pressing the glassware.

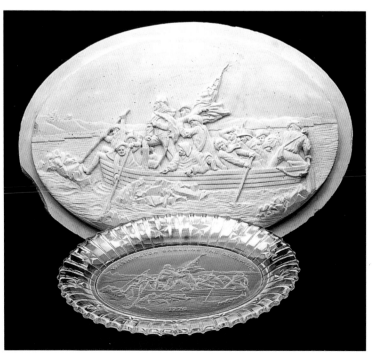

Plate mould and glass plate to show size difference.

With the exception of the two known sampled etching platters that contains the signature of Luciana Roselli previously shown, Fostoria never put its designers name on the mould and/or in finished wares. However, this one production item of Fostoria history contains the signature of Jon Saffell. If you look closely at this plate of Washington Crossing the Delaware, you will see the signature of Jon Saffell in the ice, lower right: "JON". This was one of Jon's first design projects of Fostoria, and he incorporated his signature in the ice, etched in glass as a legacy of his art contribution to Fostoria. This is the only known production item of Fostoria that bears the artists signature.

By 1984, Fostoria blown shops had been closed down, but the decision was made to try to get back into the market by having Fostoria designs made in factories in Europe. The Ming Goblet is an original design of Jon's that was actually sampled. It was to be called the "Ming" pattern, for its oriental look, although around the factory, they called it the "Loop" pattern. Prior to the Fostoria factory closing, the design department was working to try to update the Fostoria image with some contemporary designs. Jon Saffell created a lead crystal #3050 vase, 7.5 inch tall. It was an attempt to do a machine-pressed vase with contemporary cut-look pattern.

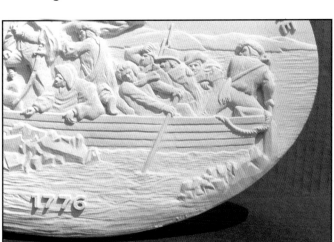

JON signature in the artwork of the ice, lower right.

Jon Saffell became Fostoria's Design Director in 1977 when Marvin Yutzey retired and remained the design director until the factory closed in 1986. Throughout his twenty-nine years of working in design at Fostoria, Jon was responsible for many new stem patterns and experimental designs that were tested against established patterns of Fostoria. The most unique and original design is the Lotus pattern, one of Jon's personal favorites. Jon intentionally modeled the petals at varying heights, for an asymmetrical look, as real petals would be. He intended the design to look like a flower blooming out of a leafy stem. But the sales department was afraid that people would think it was a mistake—that the mould hadn't filled out all the way.

Often times, Jon would be responsible to modify an existing mould. The purpose of this would be to test design a new look to the mould and/or create a custom order product, such as this beautiful stem. This Sakier design stem was re-designed by Jon Saffell by special request of David Dalzell Jr. The original stem is round, and this design was modified to have panels in the stem. This was a special order; two additional sets of twelve were made, one for David Dalzell, Jr. and one for Jon, as he liked the finished product and ordered a set for his wife, Carolyn.

This goblet has an experimental sand-carved rose on it that Jon designed, circa 1960s. The identifying tag on it is marked E-3, which means it was part of a test pattern. (E stands for experimental).

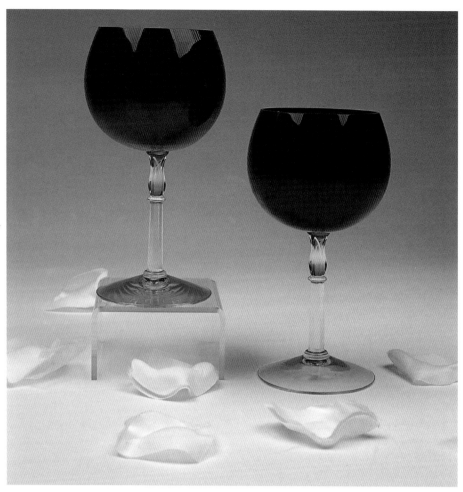

Often times Jon would be responsible to modify an existing mould. This Sakier design stem was re-designed by Jon Saffell by special request of David Dalzell Jr.

The Lotus design stemware is one of Jon's original designs; it was intended to look like a flower blooming out of a leafy stem. These are Jon's favorite, non-produced stems of Lotus with the green stem as he intended them to be.

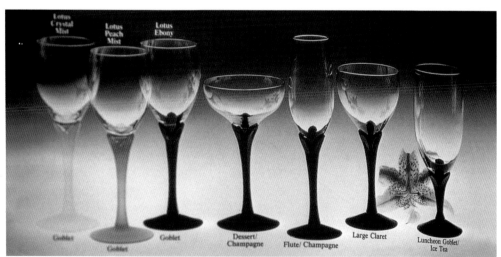

Catalog page of Lotus Stems. Jon revised the stem on this Lotus pattern to suit the sales department needs. The new design shows all of the petals were the same. Fostoria sampled the revised Lotus version in 1979, and introduced this gift line into production in 1980 catalogs.

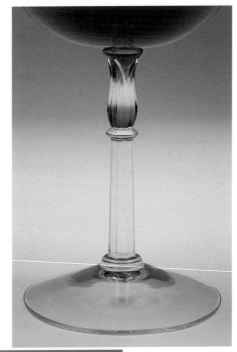

Close up modified stem. The original stem is round, and this design was modified to have panels. This design is extremely scarce, as it was only produced in a limited special order.

Jon utilized his background in model making to return to his passion of sculpture in 1986 when the factory closed. Jon's design skills and entrepreneurship lead him to open a studio at his home office called "Design Prototypes."

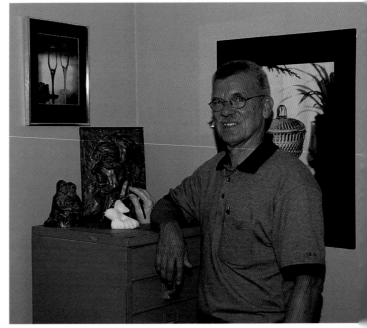

Jon at his home office, Design Prototypes.

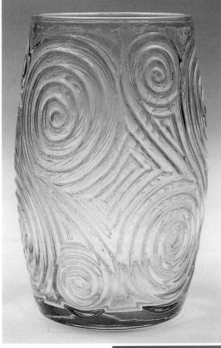

This goblet is an original design of Jon's that was actually sampled. It was to be called the "Ming" pattern, for its oriental look, although around the factory, they called it the "Loop" pattern.

When Fostoria was in the process of closing in 1986, Lancaster Colony Corporation asked Jon to stay on as a designer and consultant for their company. Jon continued consulting work for Lancaster Colony until May 1994. During the time period of 1986 to 1994, Jon did consulting design work with other glass companies that included Indiana Glass Company, Brooke Glass, Pilgrim Glass Company, and Dalzell/Viking Glass. He also did many art sculptures, consulting, mould design. and models for other manufacturing companies.

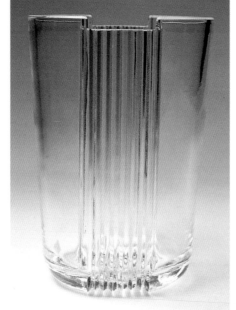

Jon Saffell created this #3050 Vase, lead crystal, 7.5" tall. It was an attempt to do a machine-pressed vase with contemporary cut-look pattern.

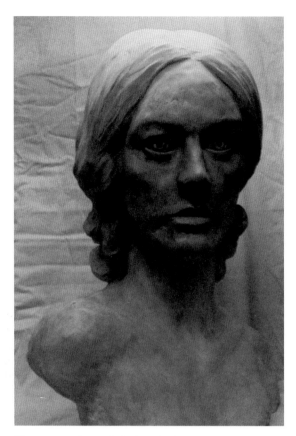

This portrait bust of Jon's wife, Carolyn, was awarded "Best of Show" at the Upper Ohio Valley Art Show many years ago. *Photograph courtesy of Jon Saffell.*

One of Jon's best-known and beloved works of art in his community is "Sammy."

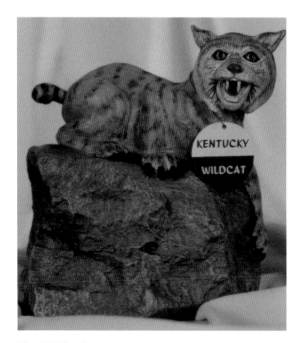

The "Wildcat" was a piece commissioned by a Mr. Hatfield (who claims to be a descendant of the original 'Hatfield and McCoy's'). *Photograph courtesy of Jon Saffell.*

For more than a decade, Jon has shared his knowledge and talents with many Fostoria Glass collectors who desire to know more about the production of Fostoria glass. For those who have researched Fostoria, Jon has provided assistance with Fostoria patent and design records from his personal collection, as well as shared his knowledge for those interested in preserving Fostoria's past. Jon has given seminars and lectures to the National Fostoria Glass Convention on several occasions, providing learning seminars on Fostoria etchings, the design department, and Fostoria's unique products. He provides design and glass history lectures to Fenton Glass Collectors Clubs in the United States. One can say that Jon Saffell has achieved a "Masters Degree in Art Glass" and a lifelong dream of becoming an art educator, as he continues to preserve the art history and education for those of us with a quest for knowledge of the design of glass. We are grateful for the sharing and contributions that he has made to the heritage of Fostoria.

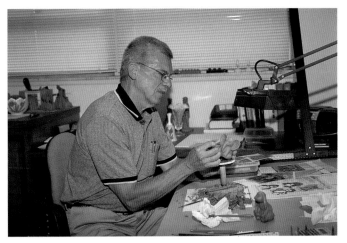

Jon at work in his office at Fenton Art Glass. *Photograph used by permission of Fenton Art Glass.*

In May of 1994 Jon Saffell was offered a job as Product Designer for Fenton Art Glass Company. Since beginning his work at Fenton Art Glass, Jon has designed many new collectible pieces of glass art, figurines, animals, and praying children. Jon often uses his grandchildren for inspiration in his new designs. His grandson and granddaughter were models for the moulds of the Fenton praying children, and another granddaughter modeled for the little girl figurine.

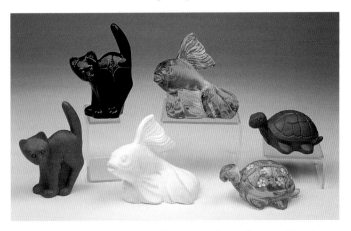

Actual design models of new Fenton products designed by Jon Saffell include: **Left:** Scaredy Cat, new Halloween cat 2002 with its original mould model. **Center:** Goldfish mould model and finished product circa 2002; **Right:** Turtle, circa 2002 with its original mould model.

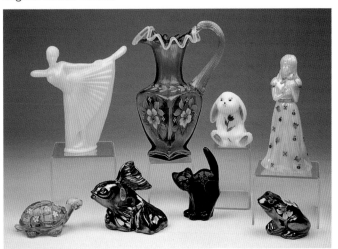

Fenton does a large volume of custom created collectible art glass items for QVC, some of which Jon has been responsible for. This vase is a favorite because of its unique style and 3 dimensional effects created in sculpting the mould. This vase is the first design of Fenton that bears the signature of the designer, Jon Saffell on the bottom.

Jon Saffell, distinguished American sculptor and designer, has earned a place of honor in American art glass history.

This unique three dimensional vase, designed by Jon Saffell, is the first design of Fenton to be produced that bears the artist/designer signature, circa 2002.

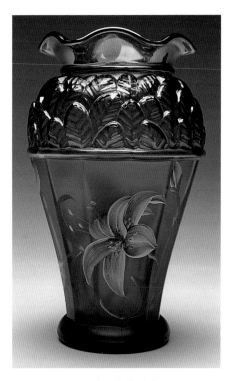

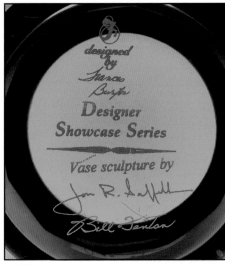

Close up artist signature Jon Saffell and Bill Fenton, circa 2002.

New designs created by Jon Saffell for Fenton. **Top row:** Ballerina, Ewer, Floppy Ear Bunny; and Figurine designed after his granddaughter; **Front row:** Turtle, Goldfish, Scaredy Cat, and Frog.

Crystal or Clear Glass, Passions of a By Gone Era

Early American glass, clear and brilliant in its beauty, has cast its spell over the fortunate few who can collect antiques. It is becoming priceless. Happily enough modern American glass possesses the fine color and crystal brilliance of early ware and follows, in its many patterns, graceful designs of all ages. Yet this wonderful new glass need not be very costly to be lovely. Nothing is more conspicuous in its presence or by its absence than glassware. It is the "necessity" that looks like a "luxury." It is essential to the success of the formal dinner. The glitter of crystal, the glamour of many little sparkling lights reflecting the loveliness of linen, silver, candles and flowers- that is a dinner table to remember. Quoted from *The Little Book About Glassware,* 1925.

The passions of the early years of Fostoria production (1887 to 1920s) bring us fine examples of crystal patterns that reflect beauty and simple elegance. Fostoria Victoria, Frosted Artichoke, Wedding Bells Ware, Hartford, Alexis, I.C., and Lucere are classic examples of timeless treasures. These patterns are heavy glass with unique design features that become easy to recognize once you have been able to study their design. There were several thousand designs in crystal dinnerware, accessories, and giftware produced by Fostoria from 1887 to 1986. The patterns chosen to be included in this chapter represent only a few

of the unique designs of limited production, many of which have never been featured in previously published books on Fostoria.

#183 Victoria, circa 1890

An early pattern, manufactured in Fostoria Ohio was the #183 Victoria line. The patent for this pattern was applied for on May 12, 1890, and Design Patent No. 20, 018 was granted to Lucien B. Martin, President, and assigned to the Fostoria Glass Company on July 15, 1890. This pattern was nearly identical to a design by the French firm of Baccarat, with its unique swirl pattern in the glass. The moulds for this beautiful pattern were packed and delivered to the rail station for shipment to Moundsville, West Virginia when Fostoria moved the plant in 1891. It is said the moulds were on the inventory list and shipped, however, they were never seen again. Some believe the moulds were lost, others think they were used for scrap metal for the war effort. However, it is known this pattern was produced in Fostoria, Ohio only. The lovely pieces in this pressed pattern can be found crystal clear and/or frosted. Some items are stamped on the bottom with the letters 'Pdtd' (which stands for Patent Pending) while other items are found with no significant markings.

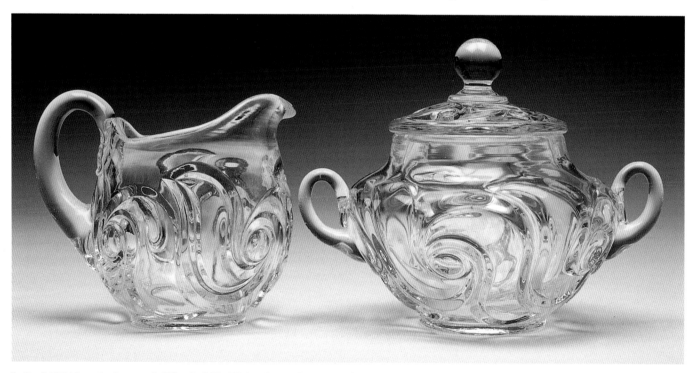

Left: #183 Victoria Cream, 5.25" tall. **$85; Right:** Sugar Bowl and Cover, Crystal 4.75" tall, 7.5" wide. **$95.**

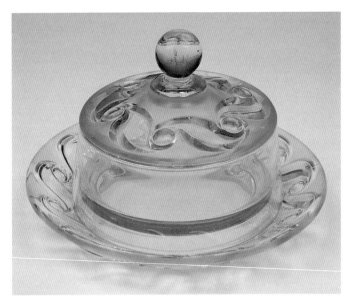

#183 Victoria Butter Dish and Cover. 4" tall, 7" diameter. **$225.**

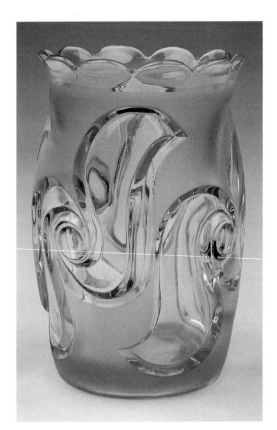

#183 Victoria Spooner, Frosted Crystal 5.25" tall. **$125.**

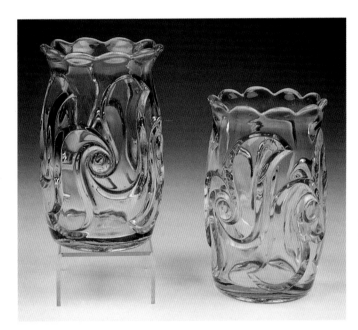

The Victoria Spooner and Celery are both listed in early catalogs with two different measurements that vary less than one-half inch in height. The celery tends to be slightly higher. Both items were offered in Crystal and/or Frosted Finish and there appears to be equal production. **Left:** #183 Victoria Spooner 5.25" tall. **$125; Right:** Celery 5.75" tall. **$115.**

#183 Victoria Flat Sauce Dish, Extremely scarce item. Very shallow dish (less than 1 inch deep) .75" tall, 5.5" diameter. **$155+ each.**

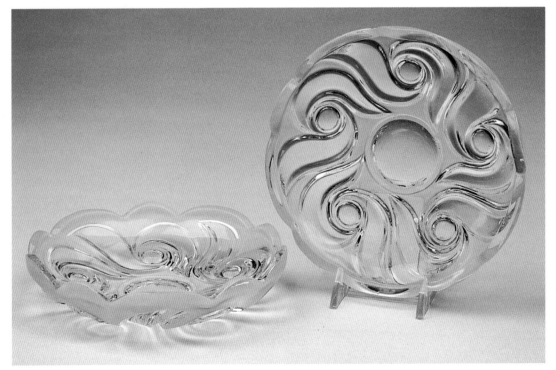

#183 Victoria Individual Frosted Bowl, often referred to as a banana boat. 4.75" diameter. **$115.**

#205 Artichoke, circa 1891

#205 Artichoke pattern produced at the Fostoria, Ohio plant was introduced into catalogs in 1891; this was a short-lived pattern. It was advertised in the October 7, 1891 issue of *China, Glass & Lamps.* This pattern was offered in table service items: Cream and Sugar, Butter and Cover, Spooner, Syrup, Beverage Pitcher and Tumblers, Footed Compote 11" diameter, Footed Compote 7" tall, a Covered Compote, Nappies, Cruets, and Footed Cake Plate. Many collectors call this Frosted Artichoke with the Satin Finish. It was also made in Crystal without finish. Very difficult to find pattern, produced for only three years.

#183 Victoria round Frosted Nappy, 5.5" diameter. **$75.**

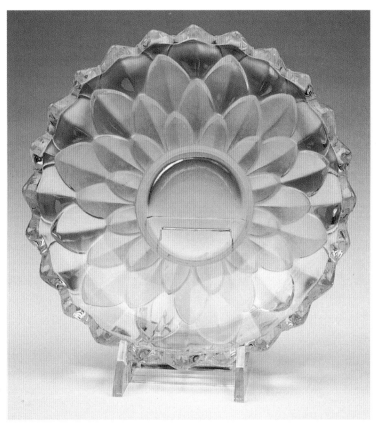

#205 Artichoke Bowl, Frosted, circa 1891, 5" diameter. **$55.**

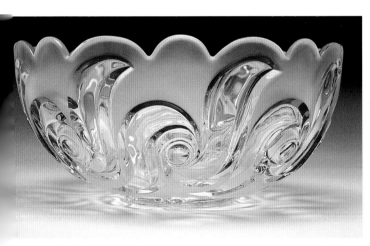

#183 Victoria Frosted Bowl, 9" diameter. **$125.**

Close up Artichoke artistry of design, 6" diameter plate. Circa 1891.

#501 Hartford, 1898-1901

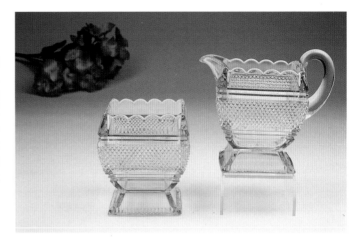

The #501 Hartford pattern, introduced in 1898, was one of the lines designed after the move to Moundsville. This pressed pattern was very popular at the turn of the century. The Hartford pattern was produced in several sizes of tableware, the Cream and Sugar came in a hotel size without lid; the Spooner is about the same size at the Sugar. The larger size Cream and Sugar comes with a lid. The Hartford Toothpick is a unique design that is a favorite prize for toothpick collectors.

Top right:
Left: Sugar, Crystal, 4.25" tall. **$55;**
Right: #501 Hartford Cream, Crystal, 4.25" tall. **$55.**

Right:
#501 Hartford Butter and Cover, 6.5" tall, plate 7" diameter. **$125.**

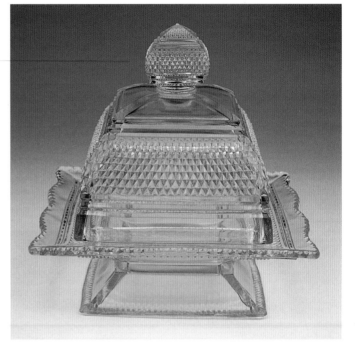

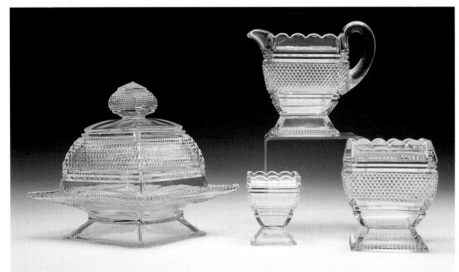

Hartford Grouping. **Left:** Butter and Cover, 6.5" tall, plate 7" diameter. **$125;** **Center Front:** Toothpick Holder, 2.6" tall. **$35; Center Back:** Hotel Cream, 4.25" tall. **$55; Right:** Hotel Sugar open, 4.25" tall. **$55.**

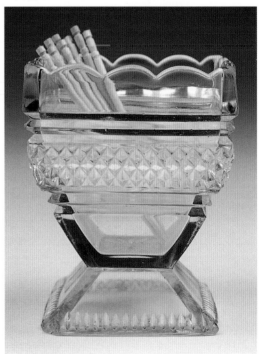

#501 Hartford Toothpick, 2.6" tall. **$35.**

#789 Wedding Bells Ware, 1900-1903

A very beautiful Fostoria Glass pattern #789 Wedding Bells Ware was introduced to the public in 1900 and continued in production until 1903. Although only in the catalogs for a three-year period, this particular pattern was very popular and continues to be highly sought after by collectors today for its elegant style. The Wedding Bells Ware was offered in clear Crystal, Ruby Flashed, or Gold Decorated. Traditionally, table services of this time period offered a large Cream and Covered Sugar, Spooner, and Butter with Cover. It is interesting that Wedding Bells Ware offered two styles of Shakers for this pattern, each with a different top; one was plated and other offered was nickel. The accessories offered for this line include Syrup, Vinegar, Celery, Toothpick, Custard Cups, Punch Bowl and Cups, Water Jugs and Beverage Set with Tumblers, and a variety of Serving Bowls for any need.

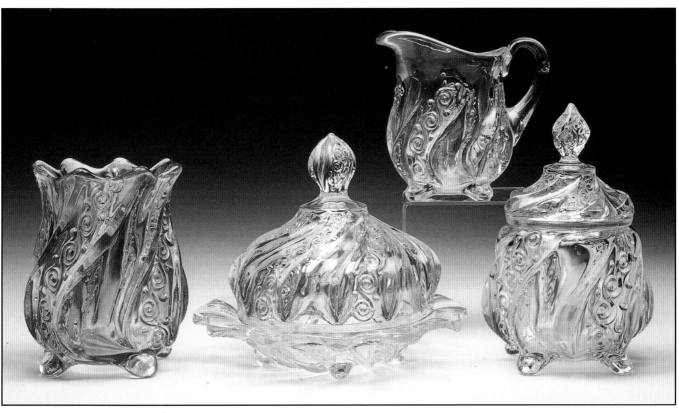

Left: #789 Celery Ruby Flashed, 7" tall. **$125+**; **Center left:** #789 Butter and Cover, 5.6" tall, plate 7.5" diameter. **$155+**; **Center right:** #789 Cream, 7.5" tall. **$65**; **Right:** #789 Sugar and Cover, 7.1" tall. **$75.**

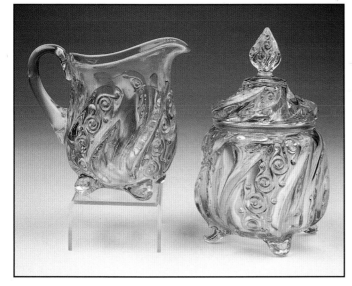

Left: #789 Wedding Bells Ware Cream, 7.75" tall. **$65**; **Right:** #789 Wedding Bells Ware Sugar, 7.1" tall. **$75.**

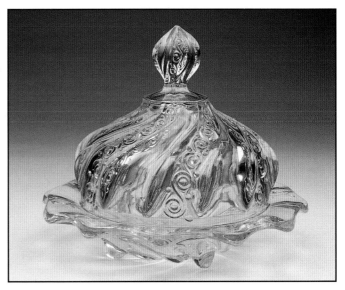

#789 Wedding Bells Ware Butter and Cover 5.6" tall, plate 7.5" diameter **$155+**.

41

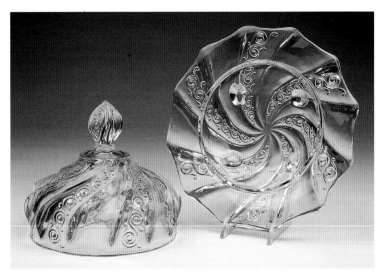

#789 Wedding Bells Ware Butter and Cover open to design artistry.

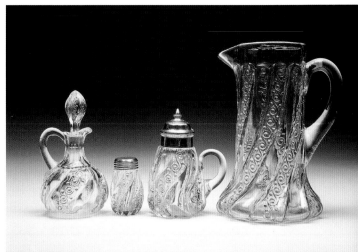

Left: #789 Cruet, 7" tall. **$75+; Center left:** #789 Shaker, 3" tall. **$45; Center right:** #789 Molasses 6" tall . **$85+; Right:** #789 Jug, 9.5" tall. **$125+.**

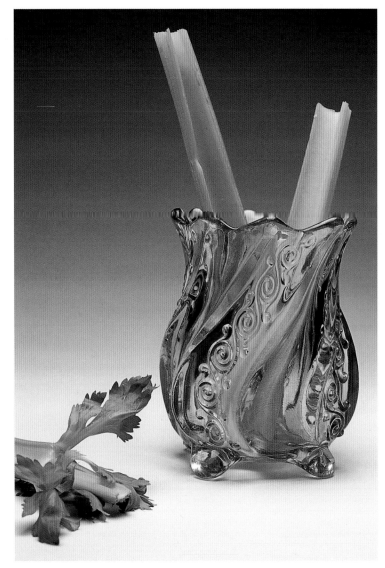

#789 Wedding Bells Ware Celery, Ruby Flash 7" tall. **$125+.**

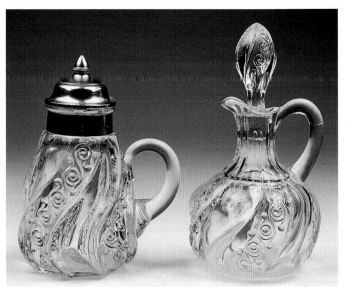

Left: #789 Molasses, 6" tall. **$85+; Right:** #789 Cruet, 7" tall **$75+.**

#1515 Lucere Pattern, 1907-1915

The #1515 Lucere pattern is one of the most elegant crystal lines produced by Fostoria. It was introduced in 1907 as a complete table service offering Cream and Sugar with Cover, Butter with Cover, Comports, Jugs, Individual Sugar and Cream, Shakers, Footed Salt, Spooner, Oil with stopper, Syrup, and Molasses Can. The most elegant in this line is an 8 inch Covered Footed Bowl. Three Vases were offered in the Lucere pattern, an 8 inch, 10 inch, and beautiful 12 inch size. It is interesting to note that the #1515 Lucere was offered in the catalogs decorated with Ruby, Coin Gold, and/or other Colored Bands, and designs applied by hand. I have never seen a decorated piece of Lucere.

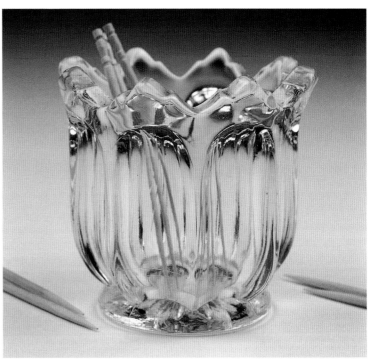

#1515 Lucere Toothpick, 2.25" tall. **$28.**

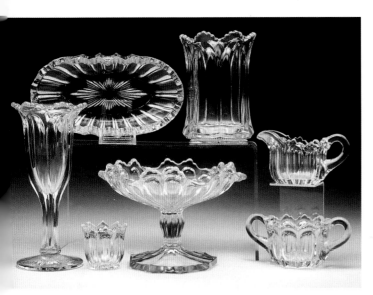

Top row left to right: Relish Dish **$45**; Celery, 7.5" tall. **$35**; Cream, 3.5" tall. **$32.** **Front left to right:** Footed Vase, 8" tall. **$48**; Toothpick 2.25" tall. **$28**; Compote 5.1" tall. **$38**; Sugar bowl. 3.5" tall. **$32.**

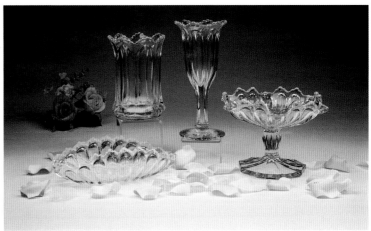

Top row left to right: Celery, 7.5" long. **$35**; Vase, 8" tall. **$48**; **Front row left to right:** #1515 Pickle, 6" long **$24**; #1515 Footed nappy, 5" tall. **$35.**

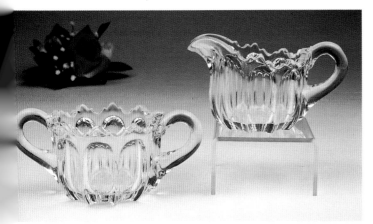

Left: #1515 Lucere Sugar, 3.5" tall. **$32**; **Right:** #1515 Creamer, 3.5" tall. **$32.**

#1819 I.C. Pattern, 1911-1915

The #1819 I.C. pattern of Fostoria is a beautiful and unique pressed pattern, with outstanding design. It appeared in the catalogs from 1911 through 1915. I have seen many items in this line including a fabulous 12 inch Punch Bowl with stand; two sizes of Beverage Jug with Tumblers, Syrup and Molasses Pitcher, Cream, Sugar with Cover, Butter with Cover, Spooner, a Sugar Shaker, Shakers, Salt Dip Footed, Salt Dip Flat; Berry Bowl Set, and several sizes of Serving Bowls. Three sizes were offered in Oil and Stopper including a 2 ounce; 4 ounce and 6 ounce. This pattern was for hotel use; many items are now beginning to surface on the secondary market. I found these fine examples of this early pattern recently at an antique shop in Canada.

An elegant pattern #1819 I.C. Cream, Sugar, and Oil Cruet, circa 1912.

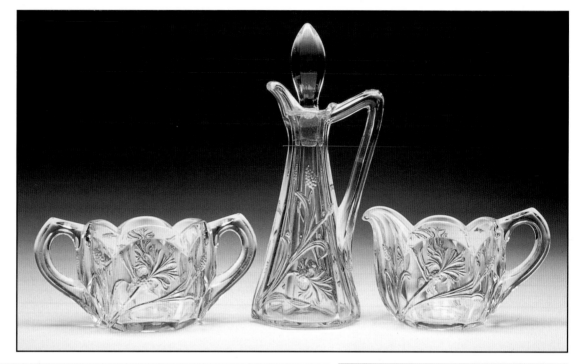

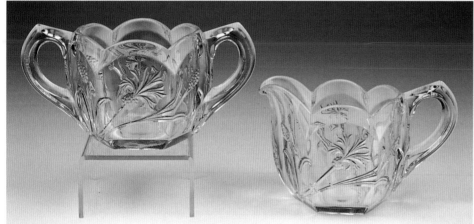

Left: #1819 I.C. Cream 3.25" tall. **$32; Right:** #1819 I.C. Sugar 2.8" tall. **$32.**

#1819 I.C. Oil Cruet, with stopper. 8.5" tall. **$125.**

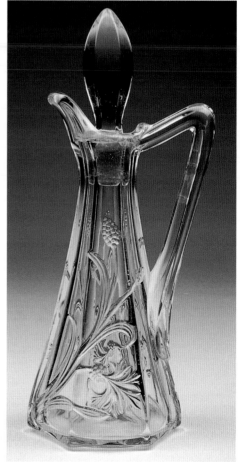

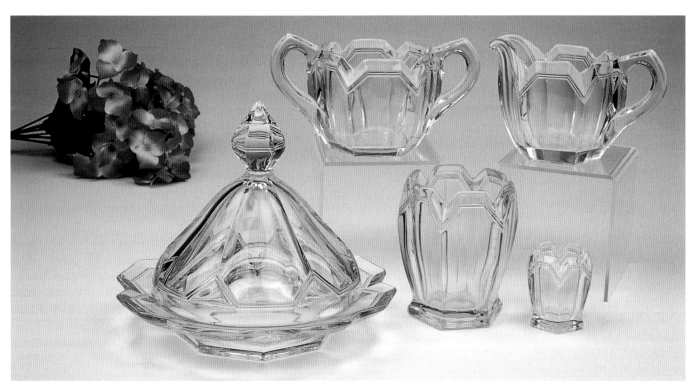

Left: #1630 Alexis Butter and Cover, 6.25" tall, plate 8" diameter. **$145; Center top:** #1630 Alexis Cream and Sugar, 4.25" tall. **$62 pair; Center front:** #1630 Alexis Spooner 6.5" tall **$65; Right:** #1630 Alexis Toothpick. 2.5" tall **$35.**

#1630 Alexis Pattern, 1906-1925

 #1630 Fostoria's Alexis pattern is a favorite among collectors of early Fostoria Crystal. The Alexis pattern was first introduced in the catalogs of 1906 with only two tumblers being offered in this pattern. By 1912 more than fifty items were in production that included a full line of Beverage Sets, Table Service, Salt, Spooner, Cream, Sugar with Cover, Hotel Cream and Sugar, Butter with Cover. The Alexis Salt Dip can be found in three sizes, Individual Salt, Master Salt, and an elegant Footed Salt. The Alexis Toothpick is a popular item; the original is Crystal only and has no marking. The Fostoria Glass Society of America produced the reproduction in 1980 and 1981 as a commemorative piece. The colors produced in 1980 by FGSA were Blue for the founding members and Pink for charter members. In 1981 FGSA made Yellow. All three colors, Blue, Pink, or Yellow, have the FGSA stamped on them. It is interesting to note that the most popular of the Alexis vases include a Sweet Pea Vase and a Nasturtium Vase. Although this pattern was in production for many years, the pattern is highly prized by collectors for its unique design of simple elegance and excellent quality crystal, most often found with very little wear to the crystal, making this outstanding for its ageless beauty.

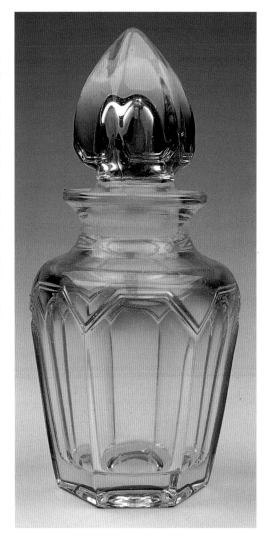

#1630 Alexis Horseradish Jar, 7" tall. **$155+.**

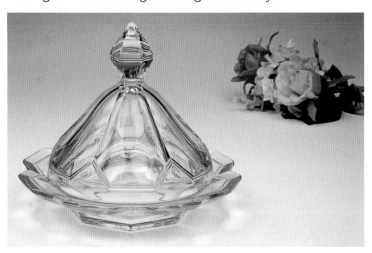

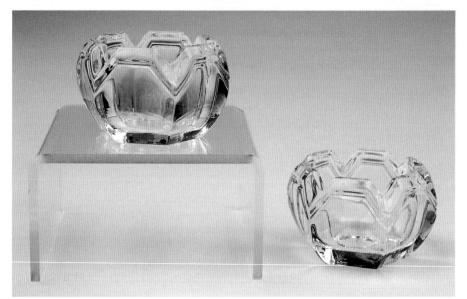

#1630 Alexis Flat Individual Salt, 1.25" tall, 1.75" top diameter. **$24.**

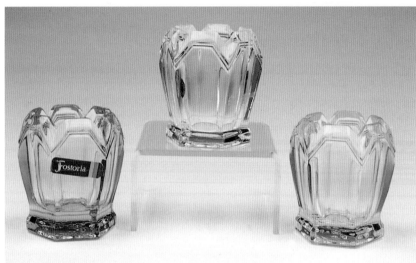

#1630 Alexis Toothpick Holder. **Left:** Pink, circa 1980 marked FGSA, 2.5" tall. **$30; Center:** Crystal, original circa 1925, 2.5" tall. **$35; Right:** Yellow, circa 1981 marked FGSA, 2.5" tall. **$30.**

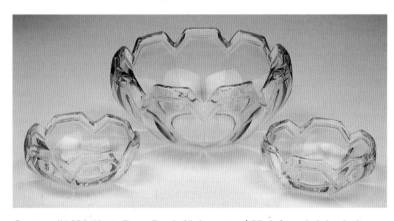

Center: #1630 Alexis Berry Bowl, 8" diameter. **$65; left and right:** Individual berry bowl/nappy, 4" diameter. **$25 each.**

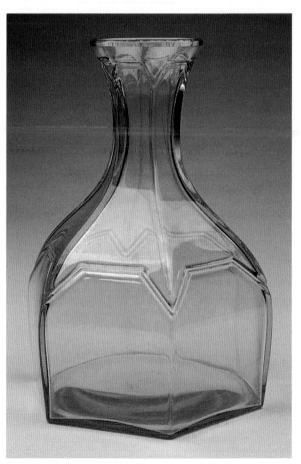

#1630 Alexis, Water Bottle Blown, Capacity 48 ounce, 8.5" tall. **$155+.**

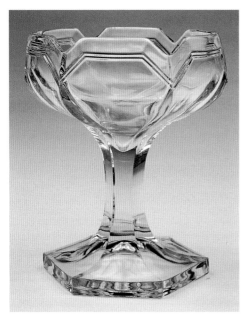

#1630 Alexis, High Foot Bowl,
5.5" tall, 4.5" diameter. **$55.**

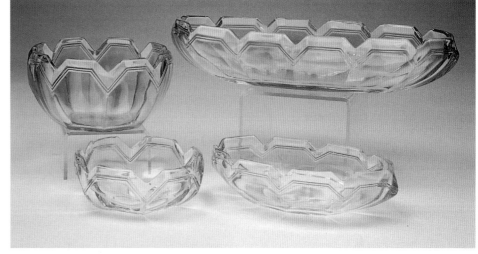

Back left to right: #1630 Alexis Mayonnaise
3" tall. **$48;** #1630 Alexis Celery, 10" long.
$55; Front left to right: #1630 Nappy 4.5"
diameter. **$38;** #1630 Alexis Olive 6" oval.
$45.

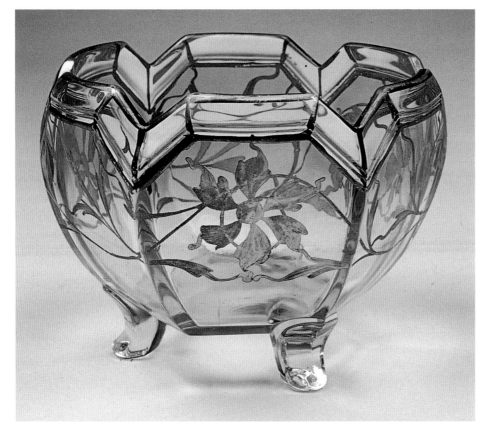

#1630 Alexis, Nut Bowl Hand deco-
rated, 4.75" tall, 5.25" top diameter.
$85.

#2056 American Pattern, 1915–1986

The "AMERICAN" Pattern, our latest production, is original and unique, and must be seen to be fully appreciated. It is the most striking design we have ever produced. It is impossible to produce by illustration the real appearance of this design, which is prismatic in effect; by either artificial or sun light it produces all the prismatic "fire" to a greater extent that any table glassware pattern that we have ever produced. We have applied for patent on this pattern. While this pattern looks massive and heavy, at the same time it is the lightest finished tableware line we have every made. It is as readily kept clean as a colonial design. In the illustrations the "cube" is brought out prominently, but upon examining the glass itself you will see that this cube effect is almost entirely obliterated by the prismatic brilliancy of the pattern. When examined at different angles you see entirely different effects. The novelty of this design will, no doubt, appeal to all up-to-date dealers in high-class tableware. We predict it will be a "repeater", not only in the United States by in foreign countries; in fact, foreign dealers have already cabled us for additional samples, and thus give it the stamp of their approval. Yours truly, Fostoria Glass Company January, 1915.

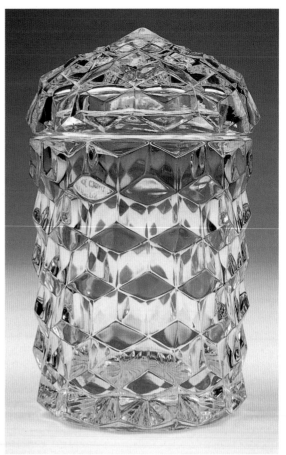

#2056 American Pickle (Jam) Jar and Glass Cover, 1915–1925, Crystal, capacity 12 ounces. Pickle Jar 6" tall, measured without lid. **$550.**

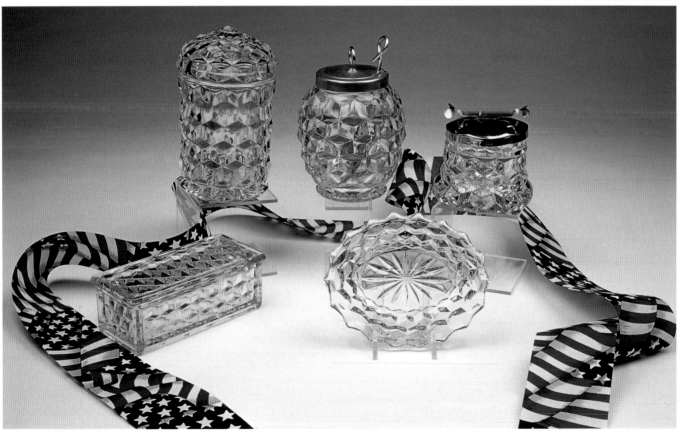

#2056 American Pattern is one of the most beloved of Fostoria Glass patterns produced. The pattern offered more than 350 items in line from 1915 through 1986. Due to limited space and the subject of this book, only a few examples of Fostoria American have been included for their brilliance, clarity, and unique features. These few items had shorter production and tend to be scarce items to find. **Left to right:** American Jewel Box and Cover, American Pickle Jar and Cover, Honey Jar and Lid, Sugar Cuber, Oval Pin Tray.

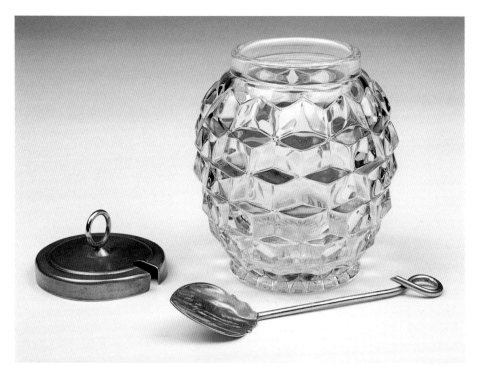

#2056 American Honey Jar with metal cover and spoon, 5.75" tall. **$550.**

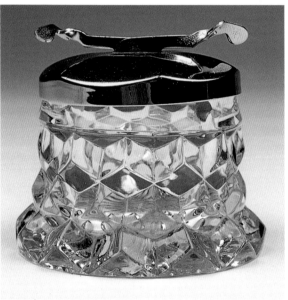

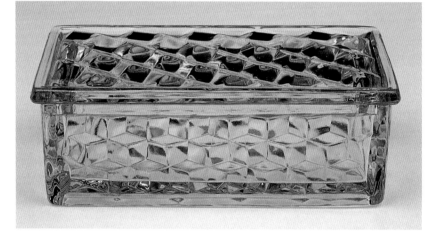

#2056 American Jewel Box and Cover 5.25" long, 2.25" wide, 2" tall. Circa 1915-1928. **$450.**

#2056 American Sugar Cuber and tong in lid. No marking on this one, some say "Made in England" on the bottom. 5.75" tall to top of lid. **$450.**

#2056 American Oval Pin Tray, 5.25" long, 4.25" wide. **$350.**

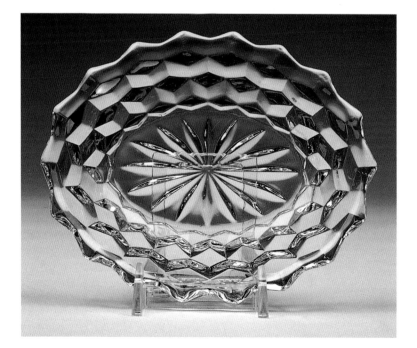

American Sample item, ornate one-of-a-kind Buffet Server. Custom sterling service buffet table centerpiece with four arms holds one large #2056 center bowl and four #2056 Almond Dishes; we believe this piece to be a sample caviar server for a buffet table. Unknown date, believed to be sampled item from Fostoria when experimentation was done to incorporate metal into some of its designs. These American pieces were custom ground to fit perfectly the sterling buffet holder. **$2500+.**

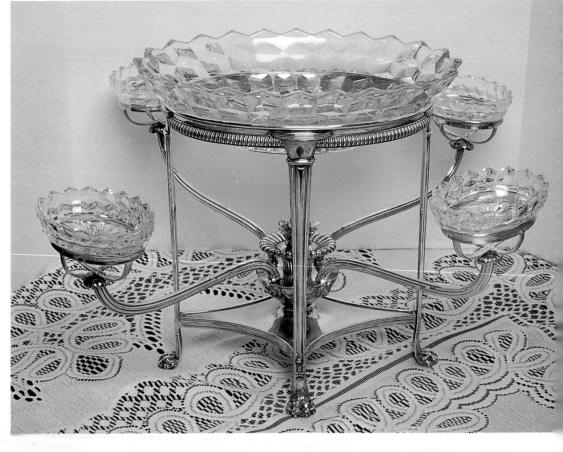

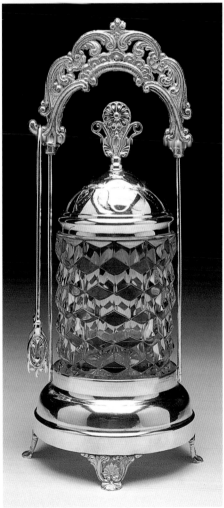

#2056 American Pickle Caster with ornate decorative silver cover in silver holder. 4.75" tall, glass height. **$850+.**

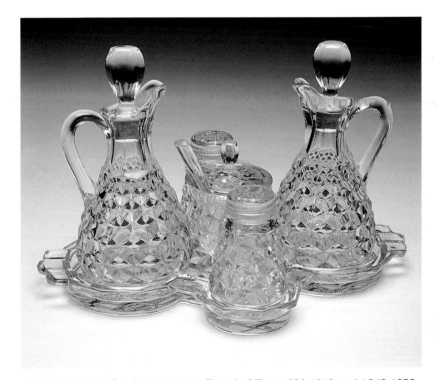

#2056 American Condiment set on Cloverleaf Tray, 1938-1943 and 1942-1958. This set includes 6 items: Cloverleaf Tray, 9 inches in length; two 5 ounce Oil Bottles; two #2 Shakers, and a Covered Mustard with Spoon. **$545+.**

Color, Light, and Glass

Is there a corner that's out-of-keeping in your house? A table that's helpless looking because it needs something? A whole room that's lifeless and somehow wrong because it lacks color? Glass and crystal bring out lights and shadows, "belong" all through the house. A console bowl with candlesticks, crystal gold-encrusted, decorated in blue, on the table in the hall. Colonial glass candlesticks on the mantel in the living room; an amber bowl filled with bright flowers on the library table; a pair of slender iridescent compotes on the buffet in the dining-room. Look at each of your rooms as if you have never seen it before. Then make a mental image of it with a subtle change that gives it new interest, an unexpected bit of beauty, a lovely glass something that will insistently, though not too obviously, accentuate the loveliness of a room. You will know just what to choose for your own room. Great decorators agree on the merit of crystal and glass, but no one can add the precious note of individuality as well as the woman who lives in the room. Quoted from *The Little Book About Glass,* 1925.

Bowls with Matching Candles and Fostoria's Console Sets

In 1924, with national advertising of the full lines of Fostoria dinnerware in full color, Fostoria began to promote the use of the Console Sets, Bowls, and Matching Candles with a choice of styles. The use of Console Sets was most popular from 1926 through 1940, prior to the war years. A look through Fostoria catalogs of the 1930s offers a large variety with more than one hundred patterns to choose from. Every line of Fostoria dinner sets offered two or three different size bowl choices to match your favorite pattern along with a choice of a Single, Duo, or Trindle Candlestick. Early catalogs list the larger bowls of 11 inch to 13 inch size as a Centerpiece Bowl, most often these would include the Flower Holder, (a Flower Holder was a two piece insert, water container with lid that had holes for arranging the fresh flowers) and/or Flower Frog, which was a glass insert for the center with holes for fresh flowers.

The decade of the 1940s saw a decline in colored glassware. Most all Bowls and Candlesticks made during this period were crystal pressed patterns to match a dinner service, or delicate etchings on crystal to match all the Master Etchings of the era. The brilliance and clarity of Fostoria's Crystal patterns continued to be popular throughout the next few decades. Most of the patterns and etchings offered had long running production times, and therefore were not included in this book.

In the 1950s, Fostoria kept in step with its new marketing of "Fostoria, The Fine Giftware with Fashion Flair." The catalogs show the decline of the formal table console sets and new modern, sleek styles began to appear.

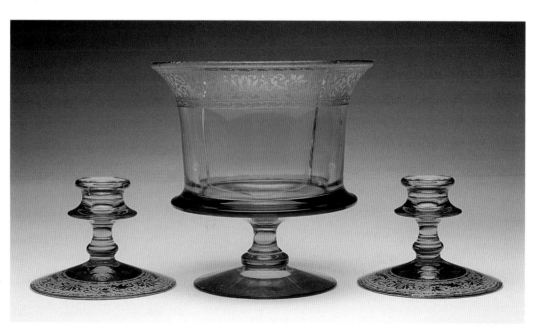

#2324 Small Urn, Royal Etching #273, Green, 1925-1927, 7" top diameter. **$145;** also produced in Amber, Crystal, and Blue. #2324 Candlesticks, Royal Etching #273, Green. 1925-1933. 4" tall. **$60** pair.

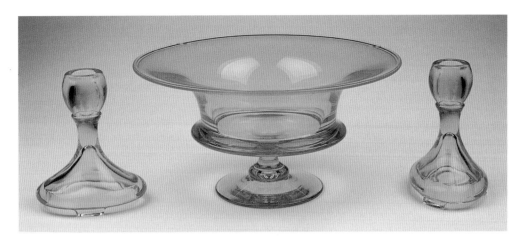

Center: #2324 Console Bowl, Canary, 1925-1926, 10" diameter. **$165; Left and right:** #2299 Candlestick, Canary, 1924-1925, 5" tall. **$38 each.**

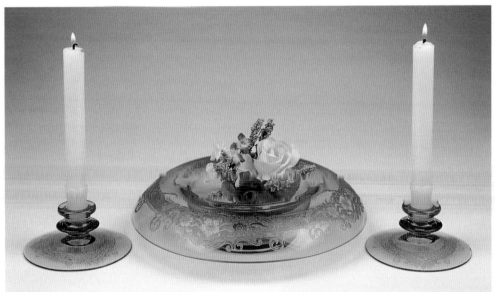

#2329 Centerpiece Bowl, Vesper Etching #275, Amber, 1926-1933. 12" diameter. **$75;** #2324 Candlesticks, Amber, 1926-1927, 2" tall. **$60 pair.**

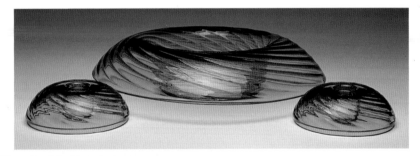

#2329SO Centerpiece Bowl, Amber Swirl, 1927-1930. 12" diameter. **$68;** #2372SO Candlesticks, Amber, 1927-1929, 2" tall. **$55 pair.** Not shown: Also produced in Crystal, Blue, Green, Orchid, and Rose, 1927-1930. Values similar.

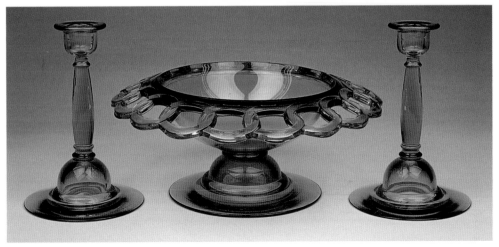

#2333 Footed Console Bowl, Amber, 1925-1927, 11" diameter. **$70;** #2333 Candlesticks, Amber, 11" tall. 1924-1928. **$85 pair.** Not Shown: Also produced in Crystal, Blue, and Green, 1924-1928. Values similar.

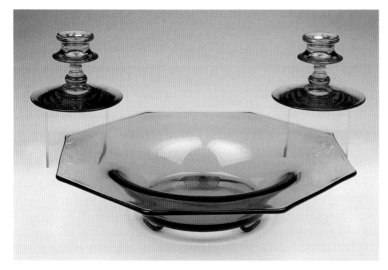

#2342 Octagon Bowl, Orchid, 1927, 12.5" diameter. **$85**; #2324 Candlestick, Orchid, 1927. 4" tall. **$68 pair.** Not shown: Octagon bowl was made 1927-1932 in Crystal, Amber, Green, Rose, Azure. **$65**. Blue, 1927. **$75.**

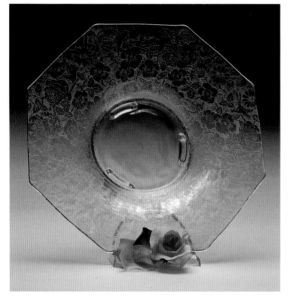

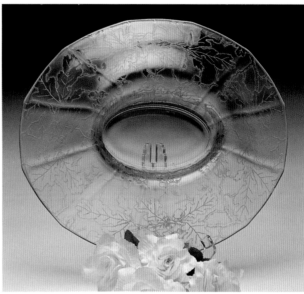

#2342 Centerpiece Bowl, Victoria Decoration 71, Mother of Pearl Iridescence on Paradise Brocade Etching #289, Orchid, 1927-1929, 12" diameter, 3-toed. **$165.**

#2371 Centerpiece Bowl, Oakwood Decoration 72, Mother of Pearl Iridescence and Gold Trim on Oak Leaf Brocade Etching #290, circa 1928. 13" diameter. **$285.**
Not Shown: Also produced in Azure Blue, 1928-1929. **$275.**

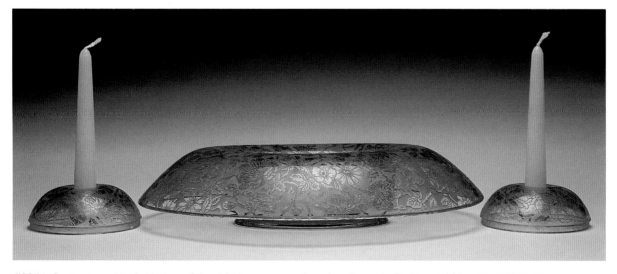

#2371 Centerpiece Bowl, Mother of Pearl Iridescence on Paradise Brocade Etching #289, with #2371 Flower Holder, Orchid, 1927-1928. **$195;** #2372 Candlestick, Paradise Brocade Etching #289. Orchid, 1927-1928. **$110 pair.**

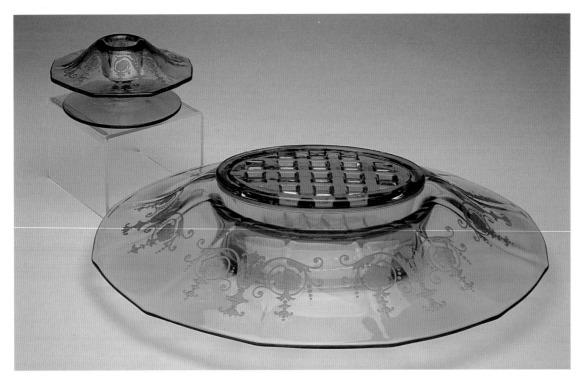

#2375 1/2 Centerpiece Bowl, with #2371 Flower Holder, Vernon Etching #277, Green, 1928-1932, 13" Oval. **$165**; #2375 1/2 Candlestick, Green, 1928-1932, 3" tall. **$110 pair.** Not Shown: Also produced in Crystal, Rose, Azure, Amber, and Orchid.

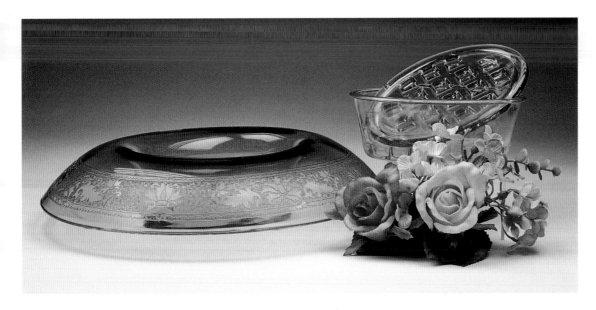

#2375 1/2 Centerpiece Bowl with #2371 Flower Holder, Royal Etching #273, Amber made in 1927, 13" Oval. **$165** Not shown: Produced in Crystal, Green, and Blue, 1927 only. **$165.**

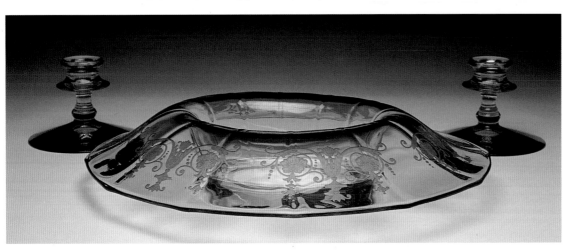

#2375 1/2 Centerpiece Bowl, Vernon Etching #277, Orchid made in1927 only, 13" Oval. **$345**; #2375 1/2 Candlestick, Vernon Etching #277, Orchid, 1927-1928, 3" tall. **$115 pair.** Not shown: Produced in other colors 1927-1932 that include Green, Azure, and Amber, Bowl **$250.** Candlesticks **$95 pair.**

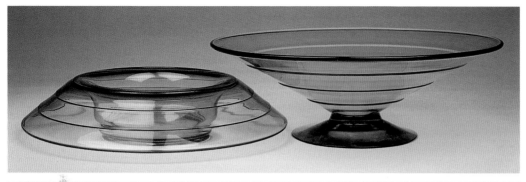

#2390 Bowl, mould was made in two ways, one with the side rolled down became a Centerpiece, 11" diameter; or with sides up and out of mould it was a Bowl 12" diameter. The bowl was produced for one year only 1927-1928, in Amber, Green, and Orchid. Very difficult to find. **Left:** #2390, Orchid Bowl with rim down, 11" diameter, 1927-1928 **$145; Right:** #2390, Green Bowl, 1927-1928, 12" diameter **$145.**

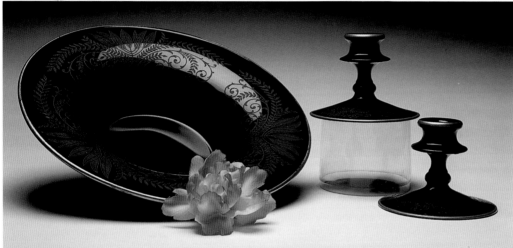

#2394 Centerpiece Bowl, Fern Etching #305, 1929-1932, 12" diameter. **$145;** #2324 1/2 Candlesticks, Fern Decoration #501, Gold edge on Ebony glass. **$120 pair.**

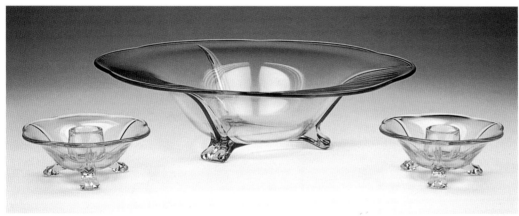

#2394 Bowl 'A,' Azure Blue, 1928-1939, 12" diameter, 3.75" tall, 3-toed bowl. **$65;** #2394 Candlesticks, Azure Blue, 1928-1939, 2" tall. **$55 pair.** Not shown: This was produced in all the colors: Crystal, Amber, Green, Azure, Topaz/Gold Tint, 1928-1939; Orchid 1927. **$65;** Bowls in Ruby, Burgundy, and Empire Green, 1934-1940. **$85.**

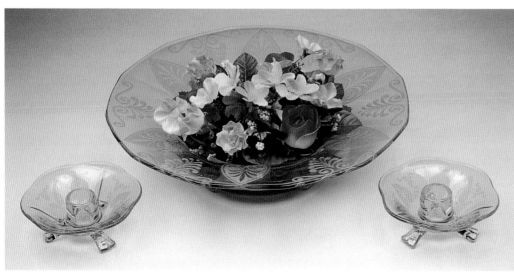

#2394 Bowl 'A,' Trojan Etching #280, Topaz, 1931-1940, 12" diameter. **$125;** #2394 Candlesticks, Trojan #280, 1931-1940, 2" tall. **$65 pair.** Not shown, produced in Rose, 1931-1934, Bowl **$135;** Candlesticks **$75 pair.**

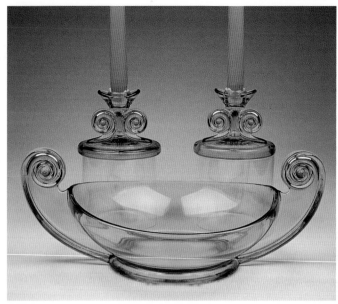

#2395 Bowl, Green, 1928-1938, 10" diameter. $70; #2395 Candlesticks, Green 1930-1932, 3" tall. $60 pair. Not Shown: Produced in Crystal, Amber, Ebony, Rose, Azure, and Topaz. Values similar for these solid colors with no etching or decorations.

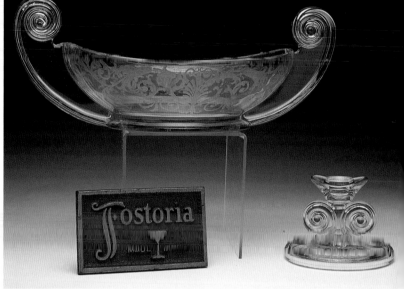

#2395 Bowl, Versailles Etching #278, Azure Blue, 1928-1938. 10" Bowl. $185; #2395 Candlestick, Versailles Etching #278, Azure Blue, 1928-1939, 3" tall. $75 pair.

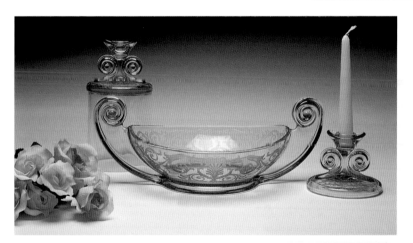

#2395 Bowl, Versailles Etching #278, Rose, 1928-1938, 10" Bowl. $185; #2395 Candlestick, Versailles Etching #278, Rose, 1928-1939, 3" tall. $75 pair.

#2398 Cornucopia Bowl, Azure Blue, 1928-1929, 11" diameter. $155.

56

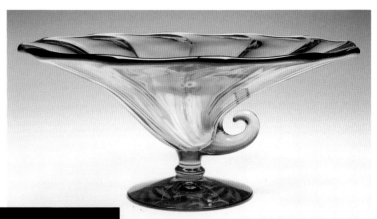

#2398 Cornucopia Bowl, Green, 1928-1930, 11" diameter. **$155;** Not Shown: Also made in Amber, Crystal, Rose, Topaz, Azure, and Ebony. **$155.**

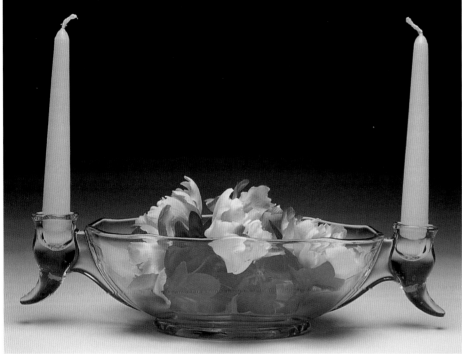

#2415 Combination Bowl, Azure Blue, 1929, 11.5" overall length. **$125;** Not shown: Also produced in Rose, Green, Topaz, and Ebony, bowl made one year only 1929. Values for solid colors, no etchings or decoration. **$125.**

#2415 Combination Bowl, Fern Etching #305, Ebony, 1929. 11.5" overall length. **$235;** Not Shown: This bowl made one year only 1929, produced in Rose, Green, Topaz, and Ebony, with plate etchings popular that year, if found with an etching pattern, value **$235.**

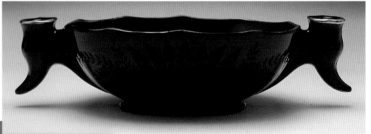

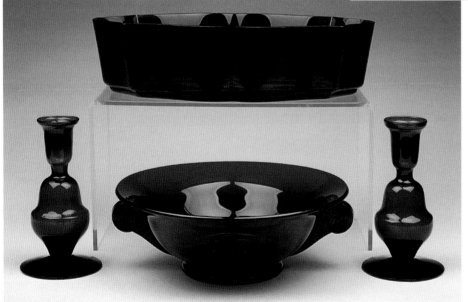

Center top: #2426 Centerpiece Bowl, 12" Oval, Burgundy, 1933-1938. **$145;** Not shown: Made in Regal Blue, 1933-1938. **$145** and Empire Green, 1933-1935. **$165; Center Bottom:** #2536 Handled Bowl, Burgundy, 1935-1939, 9-inch length, 3.25" tall; **$125** Not shown: Made in Crystal, Regal Blue, Empire Green 1935-1939. **$125;** #4113 Candlesticks, Burgundy, 1933-1938, 6" tall. **$125 pair.** Not shown: Candlestick also made in Regal Blue and Empire Green, 1933-1938. **$125 pair.**

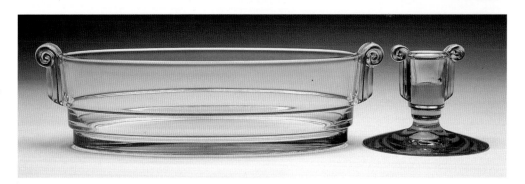

#2443 Oval Bowl, Topaz, 1933-1934, 10" Oval. **$68.** #2443 Candlestick, Rose, 1931-1938, 4" tall. **$32.** Not Shown: Also produced in Crystal, Amber, Green, Ebony, Rose, Azure, and Topaz. Years produced 1931-1938, values similar.

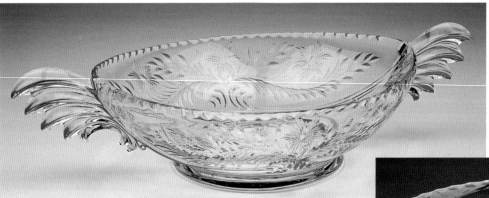

#2484 Handled Bowl, Crystal 1935-1948. Unique in this design is the outstanding cutting that surrounds the bowl sides and bottom, cutting unidentified. Circa 1936. 10". **$165+.**

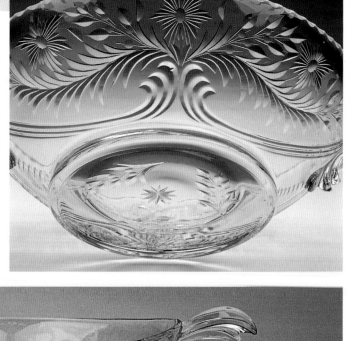

Close up of the unusual design deep cut into #2484 Handled Bowl.

#2484 Baroque Bowl, Versailles Etching #278, Azure Blue, 12" Handled Bowl. #2496 Duo Candlesticks, Versailles Etching #278, Azure Blue, 4.5" tall, 8" spread. Versailles Plate Etching #278 was not produced on this blank. This extraordinary set believed to be one-of-a-kind 3 piece Sample Set of Azure Versailles on Baroque circa 1936. **$1250+.**

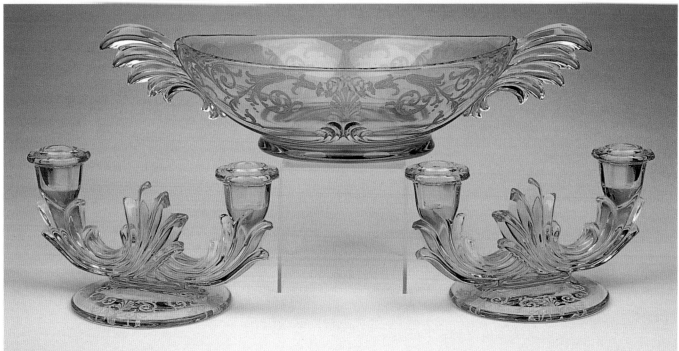

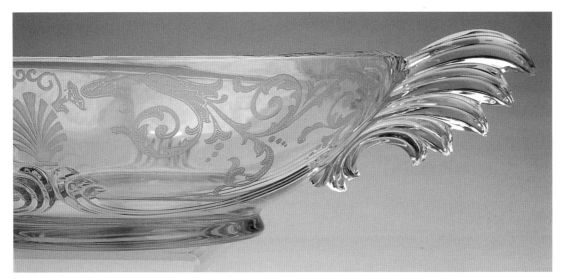

Close up detail of the unique artwork of Versailles #278 on Azure Baroque.

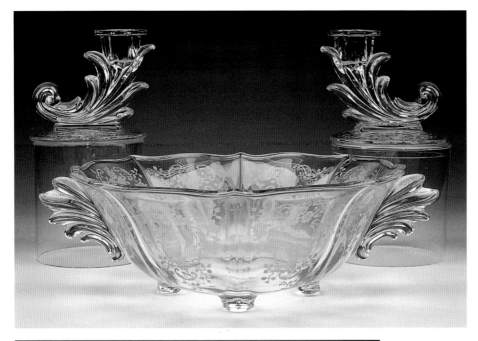

#2496 Centerpiece Bowl, Meadow Rose Etching #328, 1936-1948, 10.5" Handled Bowl, Height 3.38" . **$125**; #2496 Candlestick, Meadow Rose Etching #328, 4" tall. **$75 pair**. Not shown: Also etched Meadow Rose on Azure Blue, 1936-1943, bowl **$175**; candlesticks **$135 pair**.

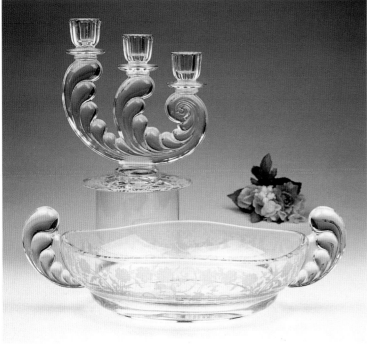

#2594 Handled Bowl, Buttercup Etching #340, 1941-1959. 3" tall, 13.5" overall length. **$135**; #2594 Trindle Candlestick, Buttercup Etching #340, 1942-1959. 8" tall, 6.5" spread. **$155 pair**.

#4024 Victorian Bowl, Empire Green, 1934-1935, 10" diameter, crystal foot. **$145**.
Not shown: Produced in Regal Blue 1934-1942 **$145**; Burgundy 1934-1943 **$135**.

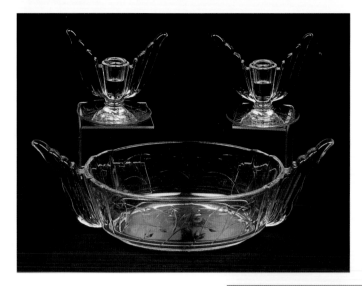

#2563 Viking Handled Bowl, Crystal, 1939-1943. This unique design pattern is not seen very often. 9.5" long, 7.25 "wide. **$165;** #2563 Viking Candlesticks, 1939-1943, 4.5" tall. **$88 pair.**

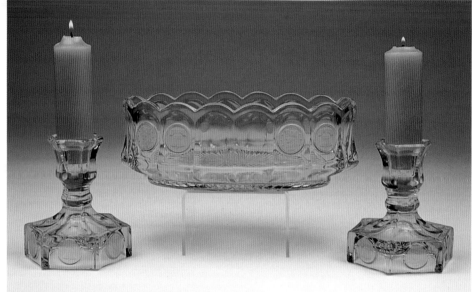

#1372 Coin Oval Bowl, Azure Blue, 1960-1966, 1975-1982, 9" long. **$135;** #1372 Coin Candlesticks, Azure Blue, 1960-1966, 1975-1982, 4.5" tall. **$55 pair.**

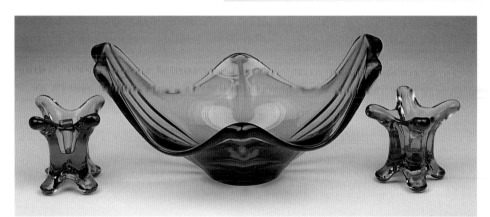

#2741/266 Centerpiece Bowl, Sculpture, Grey Mist 1961-1971, 14" length. **$55;** #2742/311 Candlesticks, Grey Mist 1961-1971, 3" tall. **$32 pair.**

#1515 Heirloom Centerpiece Oval Bowl, Blue 1960-1961 **$135.** Not shown: Also produced in Yellow, Blue, Pink, Green, Opal, and Bittersweet Orange 1960-1961, **$135.** #2726/311 Heirloom Candles, Blue 1959-1970, 3.5" tall. **$65 pair.** Not shown: Candles in Pink, Green, Opal 1959-1970. **$65 pair;** Candles in Yellow or Bittersweet Orange, 1960-1962. **$85 pair;** Candles in Ruby, 1961-1970. **$75 pair.**

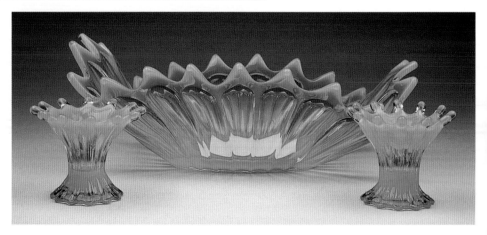

Candelabra, Candlesticks, Lustres, and Candle Lamps

The romance of Fostoria by candlelight dates back to the beginning of the factory in Fostoria Ohio in 1887. Candelabras were produced in various sizes from the small single Candlestick to a large 30 inch tall, 7 arm Candelabra complete with shade and candle. This early production of a wide assortment of Candelabras ranging in height from 15 inches to a grand total of 35 inches tall, offered customers many choices through the early part of the century.

The 1920s introduction of full lines of dinnerware service, many varieties of Candlesticks were available for all patterns of glassware, in every color, design style, and complete variety of etchings. All lines of tableware offered matching Candles in two or more sizes, and Fostoria continued to corner the market with Decorator Candlesticks that were perfect for gifts for any occasion. There were Candlesticks for Dresser Sets, and Candlesticks with Perfume Sets, Candlesticks to brighten up any little corner of the home, as well as Candlesticks for formal and informal dinner table settings. In the 1930s Fostoria began to produce various Art Deco and Duo Candlestick Sets that could easily be purchased as gifts. Deep colors of Burgundy, Regal Blue, Empire Green, and Ruby were popular decorator items.

By the 1940s the colors were loosing their appeal and Crystal Candlesticks with etchings and pressed designs were popular for their clarity and brilliance. Few Candle Lamps were available in the American pattern, with hurricane shade and a three-piece candle lamp with candle insert. The 1950 through the 1980s brought designs informal candle lighting and gift items in Milk Glass, Heirloom pattern with modern flair, and several other casual design candlesticks. Coin Candlesticks, Oil Lamps, and Patio Lamps were popular, and produced for several years. A beautiful new design, Duo Coin Candlestick, and a unique Heritage Crystal and Gold Candlestick, designed by Jon Saffell, were never produced because of the factory closing in 1986, and are among the last two unique Candlesticks shown here.

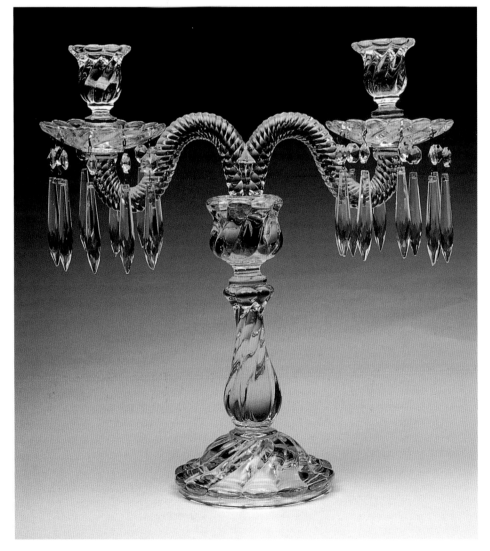

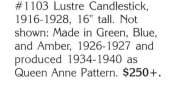

#1103 Lustre Candlestick, 1916-1928, 16" tall. Not shown: Made in Green, Blue, and Amber, 1926-1927 and produced 1934-1940 as Queen Anne Pattern. **$250+.**

#15 2-Light Candelabra with U Drop Prisms, 1889-1925 in crystal. Also appeared in catalogs 1934-1942. 13" height, 14" spread with 7" base diameter. **$375+.**

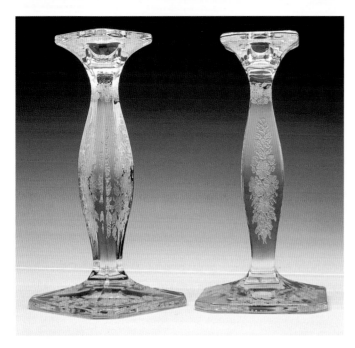

#1490 Deep Etched, 1909-1928, produced in Crystal only, 8" tall. **$125 pair.**

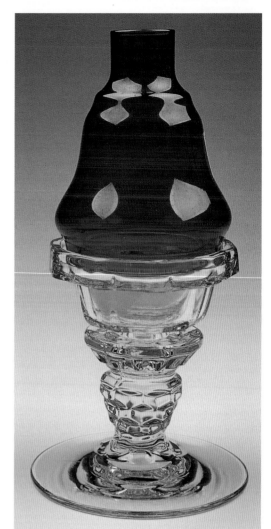

#2056 American Candle Lamp complete, Crystal 1939-1943. Consist of three pieces; 3" tall candlestick, candle shade, and wax pot. Shown with Oriental Ruby Shade, circa 1939. This shade is an excellent deep Ruby glass, reflection spots are from camera flash. **$285.**

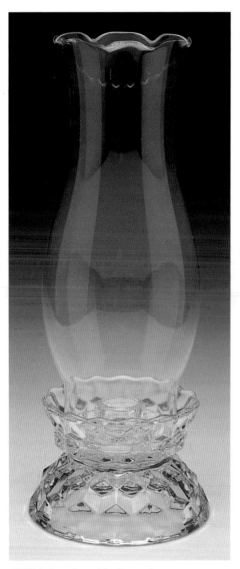

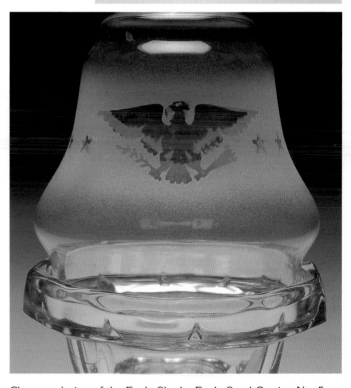

#2056 American Hurricane Lamp complete, Crystal 1939-1943 and 1953-1959. Consists of hurricane lamp base and chimney. American designer Phillip Ebeling. 12" tall. **$455+.**

Close up design of the Eagle Shade, Eagle Sand Carving No. 5, design of Robert Cocanhougher, produced 1939-1943. (A complete #2056 Candle Lamp consists of a 3" tall Candlestick, a shade, and a wax pot). Price for complete set, #2056 American Candle Lamp with Eagle shade. **$245.**

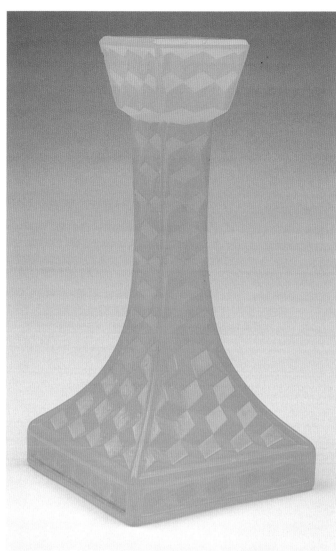

Experimental, #2056 American Eiffel Tower Candlestick, Canary with Silver Mist satin finish, circa 1926. Extraordinary, very scarce (only a few known to exist). 7.5" tall. **$1285+.**

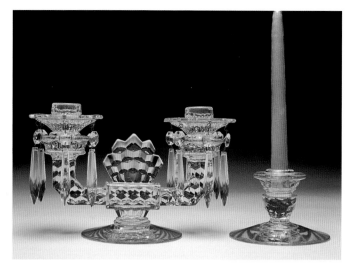

Left: #2056 1/2 American Twin Candle, Crystal Flat Foot Candlestick with Bobache 1927-1982. 4.75" tall, 8.5" spread. **$175; Right:** #2056 American Single Candle, Crystal, 1937-1982, 3" tall. **$20 each.**

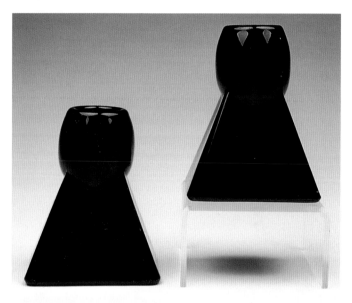

#2298 Candlestick, Ebony, 1925-1927 (most often used with dresser clock set).3.5" tall. **$62 pair.** Not Shown: Produced in Crystal, Amber, Green, Canary, and Blue. **$58 pair.**

#2324 Candlestick, Amber with Decoration 55, Blue Enamel tinted bands on Amber, 9" tall. **$145+ pair.** Not shown decoration on Blue, Green, or Crystal, 1925-1929 and Canary, 1926. 9" tall. **$155+pair.**

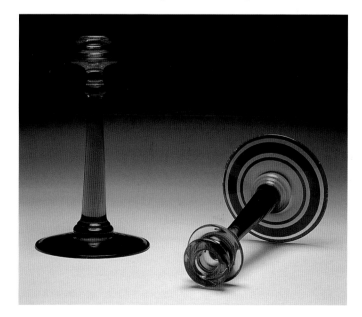

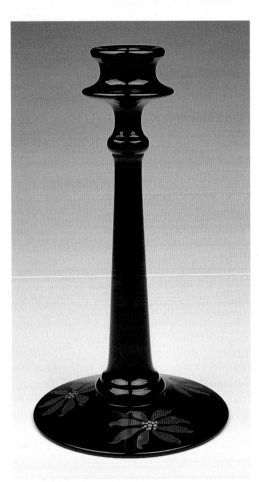

#2324 Ebony Candlestick, with Poinsettia Decoration #67, produced for one year only 1926. Beautiful, elegant design, 9" tall. **$165+ pair.**

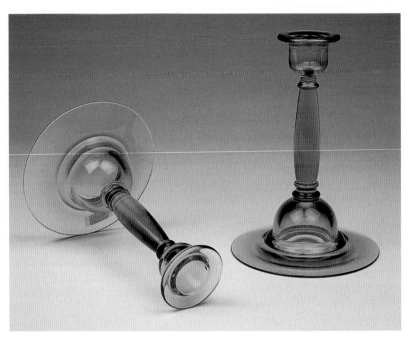

#2333 Candlestick, Amber, 1924-1926, 11" tall. **$145+pair.**

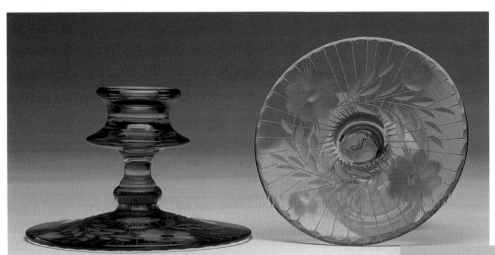

#2375 Candlestick, decorated with unknown cutting, Fostoria Blue circa 1927. Extremely unique is the Fostoria 'F' signature in the bottom of these candles. 3" tall. **NDV.**

Close up Fostoria Blue sample cutting on Candlestick #2375 circa 1927, shows detail of the "F" center bottom. This is the only pair known to be marked in this fashion. Believed to be patent pending and/or salesman sample.

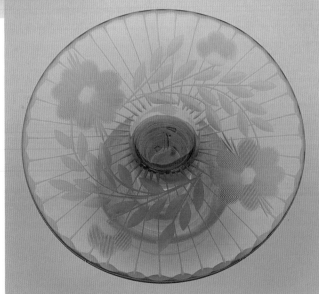

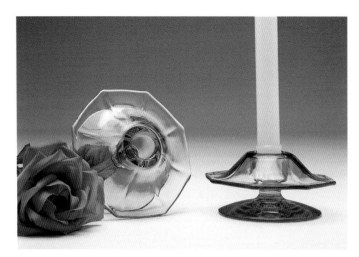

#2375 1/2 Candlesticks, Mushroom, Amber, 1929-1932, 2.5"
tall. **$45 pair.**

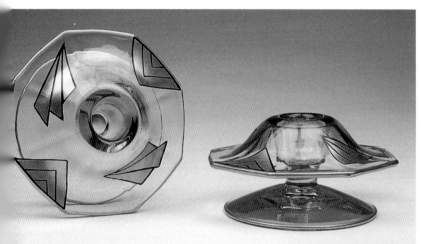

#2375 1/2 Candlesticks, Rose, Gold Enamel
Fan Decoration, 1928-1932. **$115 pair.**

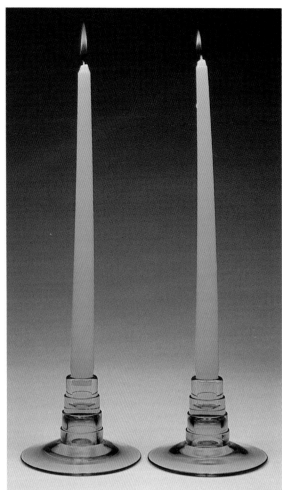

#2390 Candlesticks, Green, 1927-1929, 3" tall. **$65
pair.** Not shown: Produced in Amber, Azure, Rose,
Crystal, and Ebony. **$65 pair.**

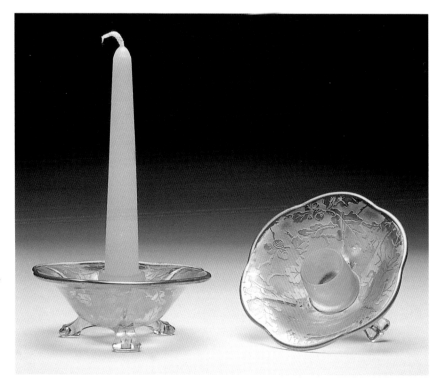

#2394 Oakwood 3-toed Candleholder, Azure,
1928-1929. Oakwood is Fostoria Decoration 72,
Mother of Pearl Iridescence and Gold Trim on
Brocade Etching #290, Oak Leaf. 2" tall. **$165
pair.**

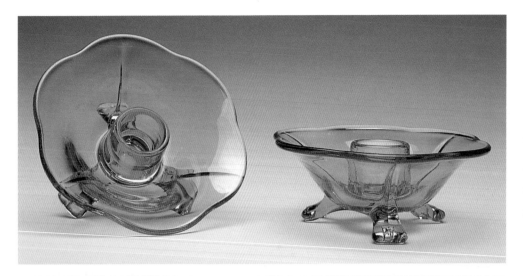

#2394, 3-toed Candleholder, Wisteria, 1931-1936. 2" tall. **$115 pair.** Not shown: made in Crystal, Orchid, Azure, Green, Rose, Topaz/Gold Tint. **$85 pair.** Not shown: Regal Blue, Burgundy, and Empire Green, 1934-1939. **$115 pair.**

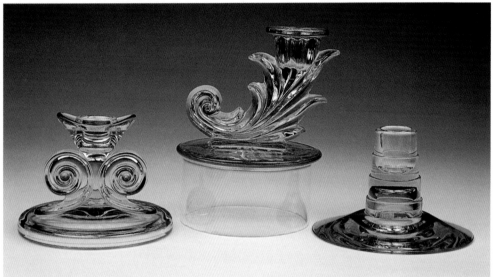

Left: #2395 Candle, Azure Blue, 1930, 3" tall. **$55 pair; Center:** #2496 Baroque Candlestick, Azure, 1936-1943, 4" tall. **$75 pair; Right:** #2390 Candlestick, Azure, 1929 only, 3" tall. **$65 each.**

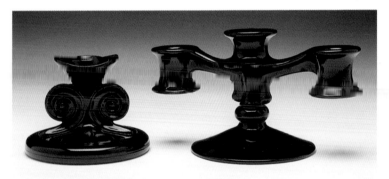

Left: #2395 Candle, Ebony Scroll, 1930-1932, 3" tall. **$75+pair.** Not shown: Also made in Crystal, Amber, Green, Rose, and Azure. 3" tall. **$75+pair; Right:** #2383 Trindle Candlestick, Ebony. **$125+ pair.**

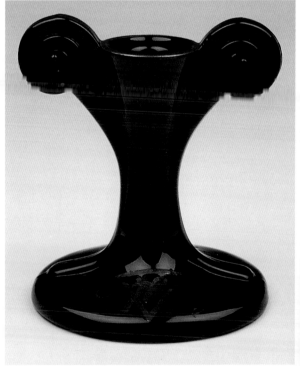

#2395 1/2 Candlestick, Ebony 1929-1939, 5.5" tall. **$85 pair.** Not Shown: Produced in Crystal, Amber, Green, Rose, and Topaz/Gold Tint, 1929-1939. **$85 pair.** Azure blue, 1929-1934. **$115+ pair.**

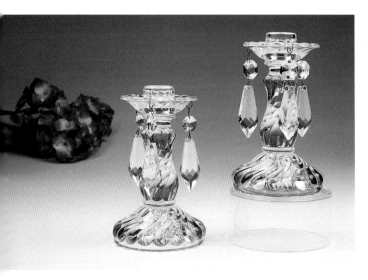

#2412 1/2 Colony 6" Lustre Candlestick, using 3 B Prisms, 1938-1942. **$125 pair.**

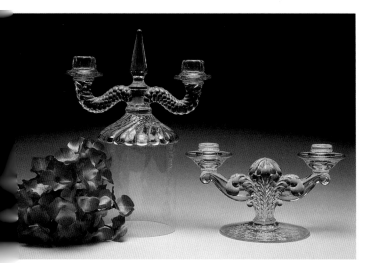

In the beautiful nothingness of crystal is hidden magic; its secret art is reflection of dancing lights and mysterious colors. **Top:** #2419 Colony Duo Candlestick, Crystal, 1938-1965, designer George Sakier. 6.25" center height, 8.5" spread. **$155 pair; Bottom:** #2560 Coronet Duo Candlestick, Crystal, 1958-1959. 5.15" tall, 9" spread. **$110 pair.**

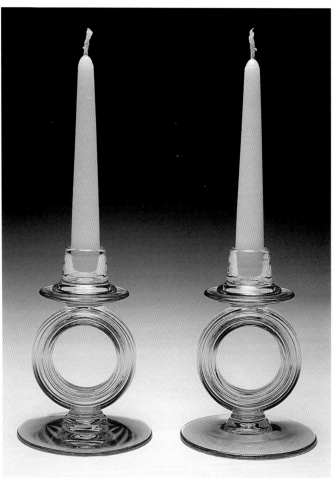

#2446 Candlestick, Topaz, 1931-1935. 6" tall. **$76 pair.** Not shown: This candlestick can be found in Ebony, Amber, Green, Azure, Rose, and Crystal. **$76 pair.**

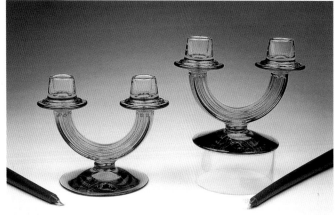

#2447 Duo Candlestick, Green, 1931-1938. 5" tall, 6.5" spread. **$95 pair.** Not shown: This candlestick can be found in Ebony, Amber, Rose, Azure, and Crystal. **$95 pair.**

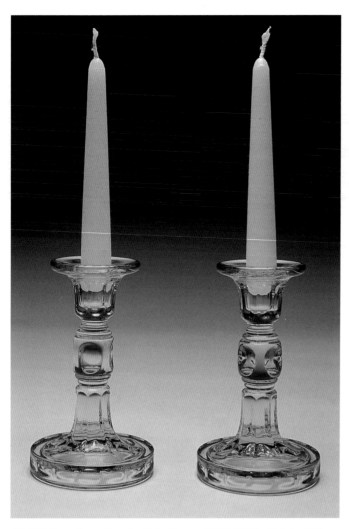

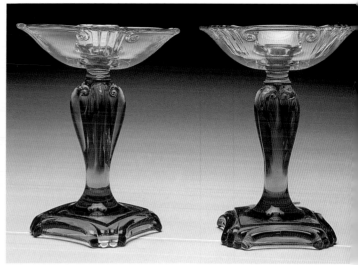

#2470 Candlestick, Crystal Bowl, Amber Stem. This candlestick was produced one year only with color bases 1933-1934. **$110 pair.**

#2449 Hermitage Candlestick, Topaz, 1932-1935, 6" tall. **$95 pair**. Not shown: Produced in Green, Amber, Crystal, Azure, 1932-1935. **$95 pair**; Wisteria. **$150 pair.**

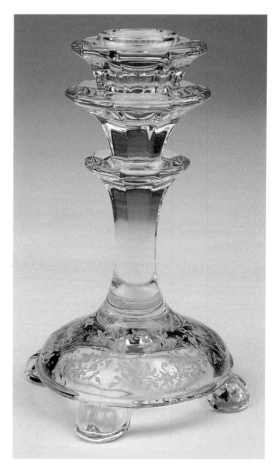

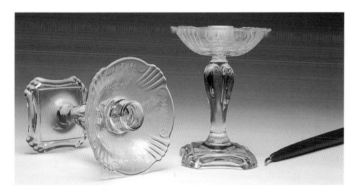

#2470 Candlestick, Crystal, Florentine Etching #311, 1933-1943, 5.5" tall. **$135 pair.**

#2470 1/2 Candlestick, Crystal, Springtime Plate Etching #318, 1934-1943. 5.5" tall. **$115 pair.**

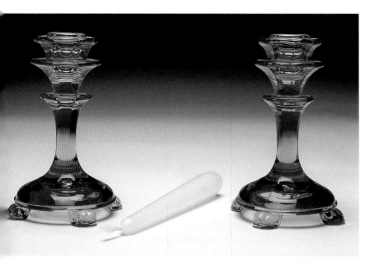

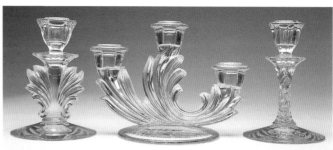

Left: #2496 Baroque Single Candle, Crystal, 1936-1958. 5.5" tall. **$65 pair; Center:** #2496 Baroque Trindle Candle 6" tall, 8.5" spread. **$95 pair; Right:** #2496 Baroque Single Candle, Side View. 5.5" tall. **$65 pair.**

#2470 1/2 Candlestick, Amber, 1933-1940. **$95 pair.** Not shown: produced in Green, Rose, Topaz, and Wisteria. **$95 pair.** Not shown: made one year only, 1935 in Regal Blue, Burgundy, Ruby, and Empire Green. **$125 pair.**

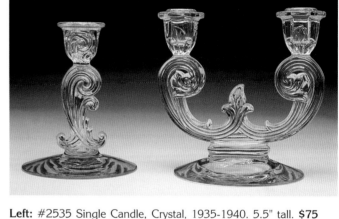

Left: #2535 Single Candle, Crystal, 1935-1940. 5.5" tall. **$75 pair; Right:** #2533 Duo Candlestick, 1935-1940, 6.5" tall, 6.5" spread **$125 pair.**

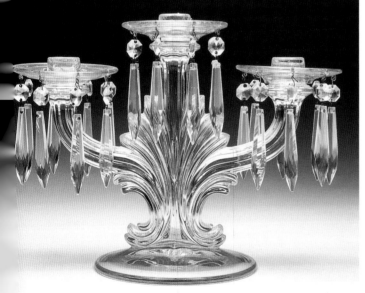

Original Candelabra for Christmas ad reads: *Candelabra are lighting the smartest tables these days. And nothing adds so much to candlelight as these crystal candelabra; made by Fostoria's famous craftsmen.* #2484/337 Candelabra, Crystal 1936-1982, using #2482 Bobache, 9.5" tall, 12.75" spread. **$155 each.**

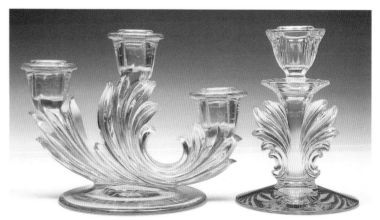

Left: #2496 Baroque Trindle Candle, Topaz/Gold Tint, 1936-1940. 6" tall, 8.5" spread. **$95 pair; Right:** #2496 Baroque Single Candle, Gold Tint, 1937-1943, 5.5" tall. **$80 pair.**

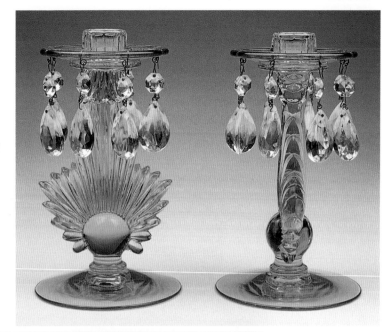

#2545 Flame Lustre, designer George Sakier. Gold Tint 1937-1942. *To celebrate its Golden Jubilee and to introduce the lovely new Gold Tint; a color which has fire, the sparkle and the brilliance of jewel topaz.* Quote from 1937 Ad for this Flame Lustre. Not shown: Pair was introduced in Azure and Crystal. The Flame Lustre consists of 8 U Drop Prisms, 7.5" tall. **$115 each.**

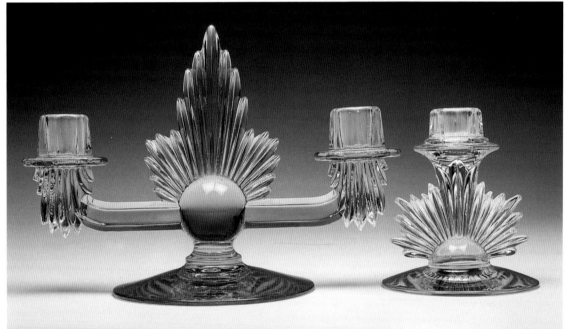

Left: #2535 Flame Duo Candlestick, Gold Tint, 1937-1943, 6.75" tall, 10.5" spread. **$150 each; Right:** #2545 Flame Candlestick, Crystal, 1937-1958, 4" tall. **$72 pair.**

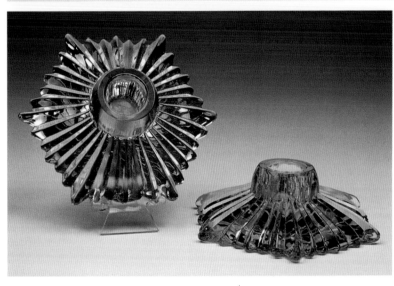

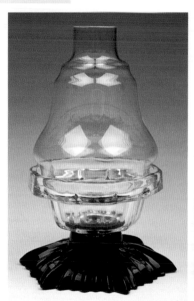

#2545 Candle Lamp, Ebony base, consisting of #26 Candle Lamp Base with peg and #26 Candle Lamp. 1953-1958. **$65 each.**

#2545 Flame Candlestick, Azure Blue, 1937-1940, 2" tall. **$52 pair.** Not shown: Also produced in Crystal and Gold Tint. 2" tall. **$52 pair.**

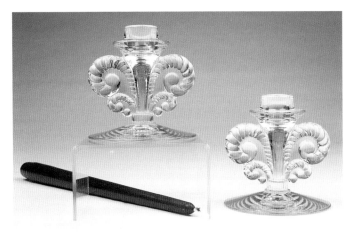

#2560 Coronet Single Candlestick, Crystal, 1938-1959. 4.5" tall. **$48 pair.**

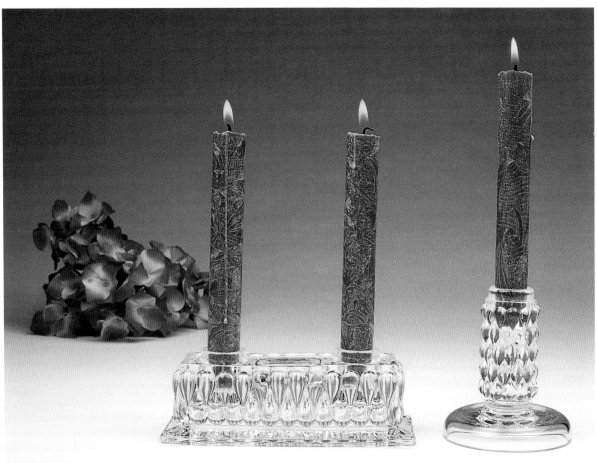

Original ad reads: *When tall slender candles are hushing the night, Myriad crystal is as exquisitely beautiful as rippling waters reflecting the sunset.* **Left:** #2592 Myriad Duo Candlestick, Crystal, 1942-1944, 7.25" length. **$95 pair; Right:** #2592 Myriad Single Candlestick, Crystal, 1941-1944, 4" tall. **$55 pair.**

#2592 Myriad Single Candlestick, Crystal, 1941-1944 designed by George Sakier, 4" tall. **$55 pair.**

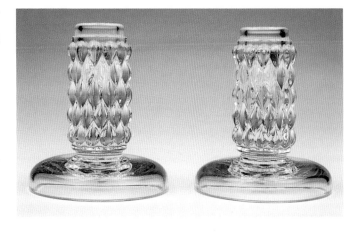

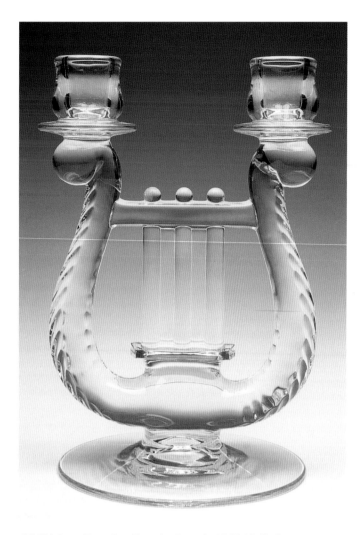

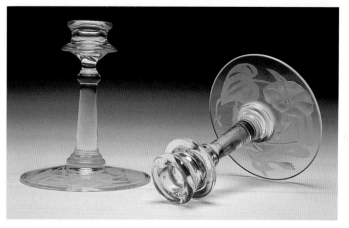

Morning Glory Giftware #319, Crystal, 1982. Originally produced 1939-1943 and 1953-1957; Morning Glory Carving #12, designer Robert Cocanhougher. Candlesticks 6" tall. **$125 pair.**

#2601 Lyre Duo Candlestick, Crystal, 1942-1948 designer George Sakier, 8" tall, 5.75" spread. **$155+ pair.**

#6023 Duo Candlestick, Morning Glory Carving #12, Crystal, 1939-1943 and 1953-1957, designer Robert Cocanhougher. 5.5" tall, 6" spread. **$155 pair.**

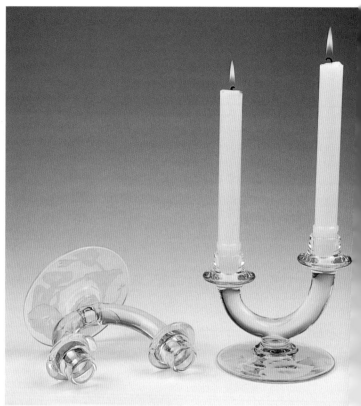

#2630 Century Trindle Candle, Crystal, 1950-1978. 7.75" tall, 7.5" spread. **$135 pair.**

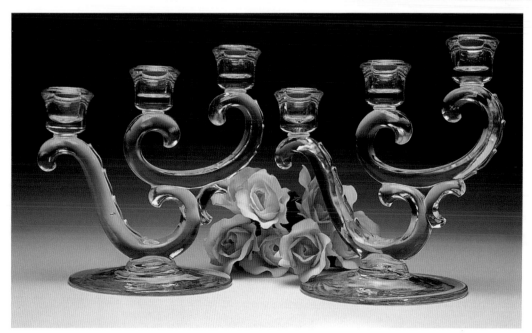

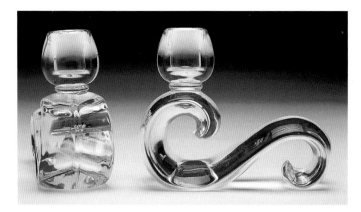

#2638 Contour Candle, 1949-1965. Made in Crystal and Ebony. 4.5" tall, 7" spread. **$110 pair.** Not shown: Ebony 1954-1958. **$135 pair.**

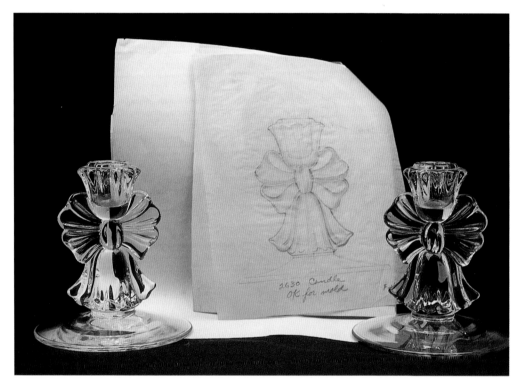

One of the most elegant and romantic patterns found in the design morgue at the close of the factory in 1986. Original drawing for these beautiful bow candlesticks was approved for production. Three-piece set, candlesticks and exquisite centerpiece bowl were sampled, and never put out into production. It is believed these beautiful bow candlesticks are the design art of Marvin Yutzey, and the only pair known to exist. Candlesticks 4.5" tall. **NDV**

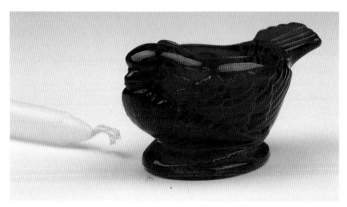

#2521/327 Bird Candleholder from the Centennial II Collection 1974-1978, and re-introduced as the Holly and Ruby Giftware Line, #312 Ruby Bird Candleholder, 1981-1982, small bird 2" length. Not shown: Bird Candleholders in Crystal and Crystal with Satin Finish. **$35 pair.**

#1372 Coin Candlestick, Ruby, 1967- 1982, 4.5" tall. **$68 pair.** Not shown: Produced in Crystal, Amber, Olive Green, Ruby, and Blue. **$68 pair;** Empire Green, 1963-1964. **$155+ pair.**

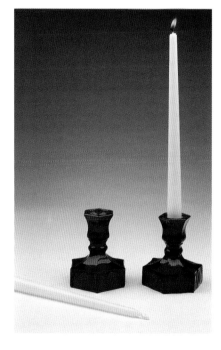

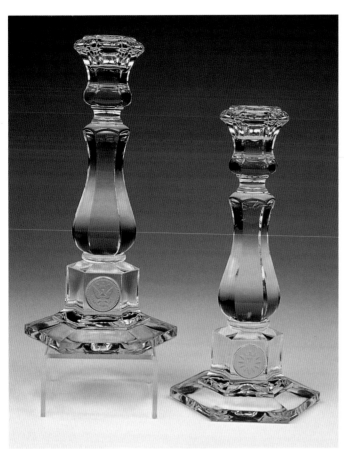

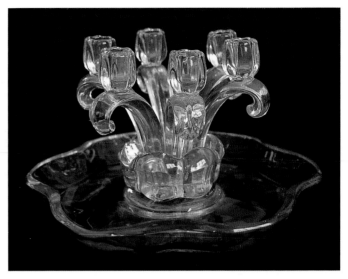

#2640 Garden Center, 8-piece set, Crystal, 1949-1963. Consisting of Lily pond, Flower Block, and six Candleholders. 7.5" tall, Lily pond 14" diameter, 2" tall. **$245.**

#1372 Coin Candlestick, Crystal, 1968-1982, 8" tall. **$125 pair.** Not Shown: Amber, Olive Green, Ruby. **$115 pair.**

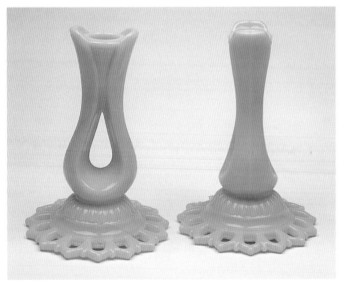

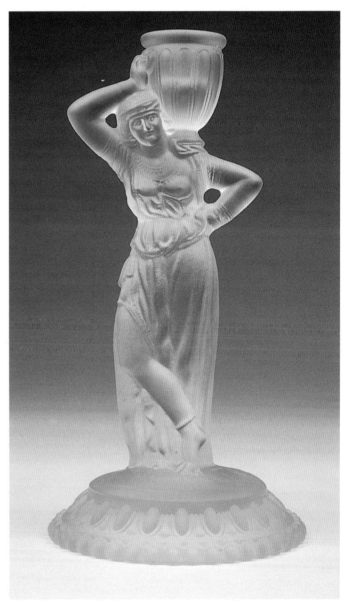

#2675 Randolph Pattern, Aqua Milk Glass, 1957-1959. 6" Candles. **$65 pair.** Not shown: Peach Milk Glass 1957-1959 **$65 pair;** Milk Glass 1955-1965. **$48 pair.**

Rebecca at the Well Candlestick, Crystal Mist, Henry Ford Museum Collection, 1965-1970, 9" tall. Crystal Mist. **$225 pair.** Not shown: Olive Green Mist. **$175 pair,** Copper Blue Mist. **$255 pair.**

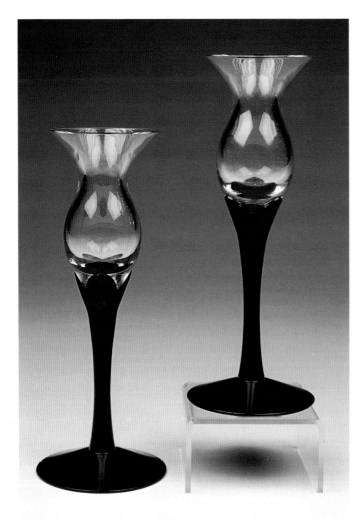

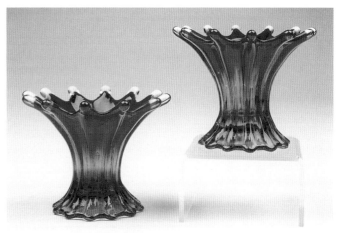

#2726/311 Heirloom Candleholder, Bittersweet Orange, 1960-1962. 3.5" tall. **$65 pair.** Not shown: Made in Blue, Pink, Green, Opal, Yellow, and Ruby. **$55 pair.**

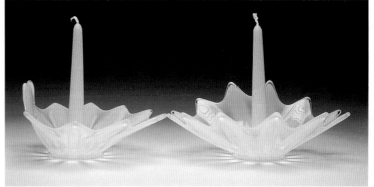

#323 Lotus Candlesticks, Ebony Base, designer Jon Saffell, 1981-1982. **$155 pair.** Not shown: produced with Peach Mist and/or Crystal Mist base. 7.5" tall. **$155 pair.**

#2183/311 Heirloom Flora Candles, Opal, 1959-1962. 3.75" tall. **$45 each.**

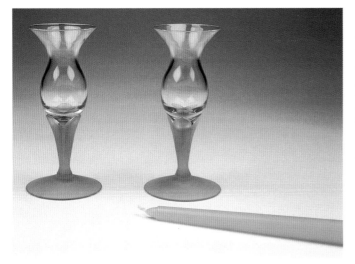

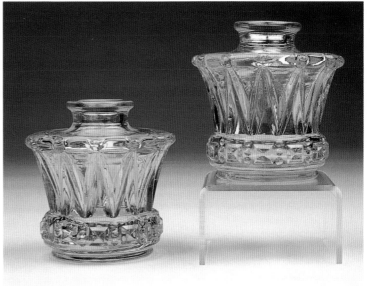

#318 Lotus Candlesticks, Peach Mist candlesticks, designer Jon Saffell, 1981-1982. Not shown: produced in Crystal Mist and/or Ebony base. 5.5" tall. **$125 pair.**

#2749/314 Windsor Crown Gold, 1962-1965. Fostoria Crown collection is fashioned after famous crown designs of old world. Candleholder 3" tall. **$115 pair.**

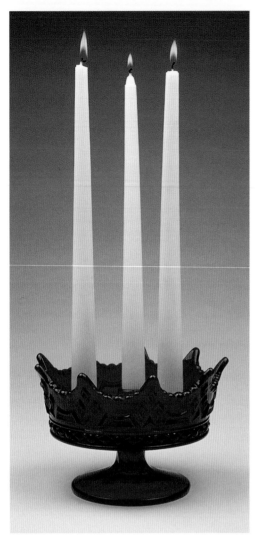

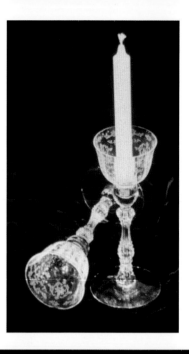

Extraordinary experimental design of Navarre Etching #327, sampled on a modification of stem #6016 creating the elegant footed Navarre candleholder. This is one-of-a-kind pair known to exist. Photograph courtesy of Jon Saffell, Designer. **NDV.**

#2766/311 Luxemburg Crown is fashioned after the famous crown designs of the Old World. Ruby Trindle Candle, 1963-1965, 7.25" Diameter. **$155.** Not Shown: Made in Crystal, Gold and Royal Blue. **$145.**

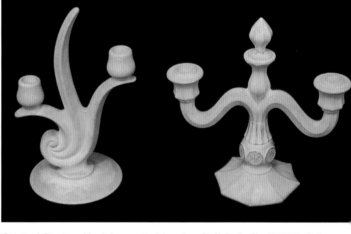

Original Design Models created by Jon Saffell. **Left:** #1372 Coin Pattern, Duo Candlestick designed by Jon Saffell; **Right:** Duo Candlestick, original drawing by George Sakier, working model created by Jon Saffell. The designs never got a chance to be tested before the factory closed in 1986. **NDV.**

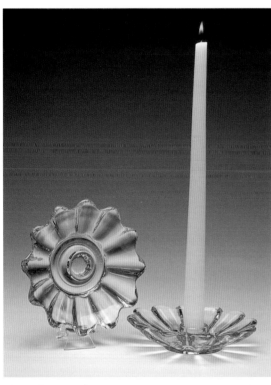

Celestial Pattern #318, Sun Gold, 1985. One of the last designs produced by Fostoria in 1985. 5.5" diameter. **$25 pair.** Not Shown: Crystal and Blue with Iridescent Finish. 5" diameter. **$25 pair.**

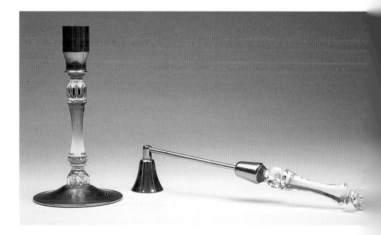

Left: Sample Candlestick designed by Jon Saffell, made of 24% lead crystal with 24K gold plated foot and candleholder top. This candleholder was created from the lead crystal handle of the flame snuffer, by adding a 24K gold plated metal foot and candleholder top. The candleholder was to be part of the Heritage Giftware line to be introduced in new catalog that never went into production because of the factory closing. **Right:** #H004/304 Flame Snuffer, 24K Gold Metal. This Sample Candlestick is believed to be the only sample produced. **NDV**

Chapter Five
Fostoria Dinnerware

Fostoria has an astonishing power to give gaiety, color, sparkle to the simplest meal. No longer is it surprising to have the soup course, the salad, or dessert, the after dinner coffee appeared in Fostoria dishes. Today the vogue is distinctly for glass for table settings. At first a complete dinner service of glass sounded like a fairy tale or a glittering dream from Arabian Nights. But Fostoria is absolutely practicable for serving hot as well a cold foods. Fostoria platters and dinner plates, cups and saucers, vegetable dishes, soup plates, cereal dishes are as serviceable as the stemware, the flower owls, the candlesticks and compotes. The complete dinner service of Fostoria is made in amber, green, azure, dawn, crystal and orchid. Quote from *The New Little Book About Glassware,* 1926.

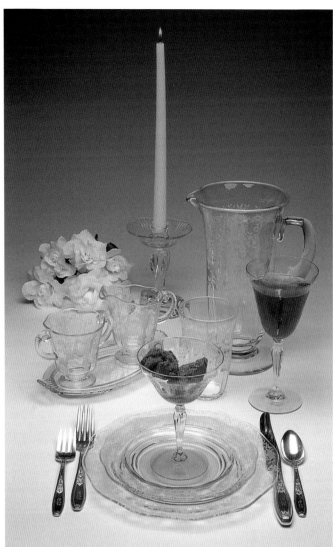

Formal Dinnerware, Master Etching Navarre #327.

Popular Dinnerware. Master Etching Lido #329.

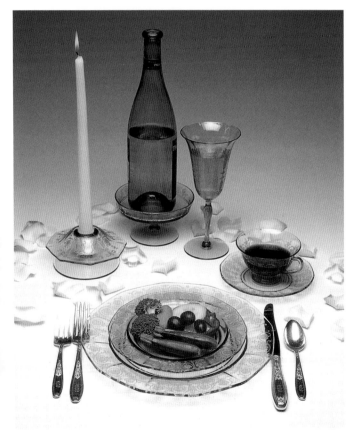

For Formal Dinner, Vernon Plate Etching #277, Orchid, circa 1927.

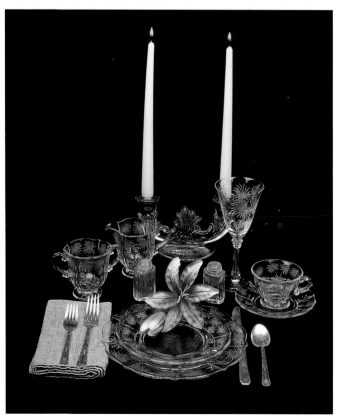

Fostoria produced thirteen major pattern lines of complete dinnerware patterns that included more than fifty items in the line. These popular patterns included American, Pioneer, Fairfax, Baroque, Hermitage, Mayfair, Lafayette, Sunray, Colony, Century, Contour, Coronet, and Raleigh. Many of these patterns were blanks used for the elegant and master etchings of Fostoria. When a blank, such as Fairfax, was utilized to decorate with an etching, i.e. June, the blank then took on the name of the etching pattern and was listed in the catalog by the plate etching name and number.

#2056 American Line entered the market in 1915, and remained very popular in the catalogs until 1982. This beloved pattern was one of the longest running patterns offering more than three hundred fifty items in line throughout its long Fostoria history. There are millions of pieces of American to be found. The hunt for elusive pieces would include limited production and colored American, the American Dinner Bell, and a sampling of short run items that could include: 6 inch Ice Tea Plate, 24 inch Torte Plate, 4 inch Oval Tray, 5.25 inch Pin Tray, 12 inch by 4 inch high Nappy, 8 inch by 2 inch Shallow Flared Nappy, 9 inch Cupped Bowl, Hotel Cracked Ice, 8.5 inch Three Handled Bowl, Large Wedding Bowl, Oblong Dresser Bowl, Sugar Cuber with Tongs in lid, Crushed Fruit with Lid, Honey Jar with lid, and Biscuit Jar with Lid and Bail are just a few of the difficult pieces to find in this pattern.

#2350 Pioneer Line was the first complete line of dinnerware introduced by Fostoria in full color in 1924. William Dalzell was responsible for the introduction of the complete dinnerware lines in full color of glass, and responsible for creating the color standards of excellent in Fostoria glassware. The Pioneer full line of dinnerware offered five sizes of Plates, Flat or Footed Cup and Saucer, After Dinner Cup and Saucer, Flat or Footed Cream Soup and Saucer, Flat or Footed Bouillon and Saucer, Egg Cup, three sizes of Bowls, Round Butter with Cover, and Grapefruit with Liner and Ashtray. Pioneer was produced in Crystal, Amber, Green, Blue, Ebony, Regal Blue, Burgundy, Empire Green, and Ruby. Pioneer blank was used for a few of the cuttings and early etchings. Although catalogs of the era did not show Pioneer as being made in Canary, a remarkable Royal Etching #273 has been found on #2350 8 inch Plates, 12 inch Platter, and a 15 inch Platter circa 1926.

#2375 Fairfax Line was introduced into the catalogs in 1927 and remained popular until 1944. The Fairfax line of colored glassware was one of the most popular and the blank used most often for plate etchings of Vernon, Versailles, June, and Trojan to name only a few. Fairfax colors included Crystal, Amber, Green, Orchid, Rose, Azure, and Topaz/Gold Tint. Some Crystal items continued to be popular in line, and used as etching blanks until 1960. A few items were produced in limited quantity in Ebony and Ruby. Most outstanding and difficult to find are the Fairfax Orchid color items being made one year only 1927-1928. The Cream and Sugar Set on #2429 Service Tray with Lemon Insert was produced for two years only, 1930-1932 in Crystal, Rose, Azure, Green, and Topaz. Imagine this: if you could pick any one item of Fairfax, say a Sugar Bowl, and start to collect this one item in every color, every pattern, every cutting and every etching ever produced on this one sugar bowl blank, you could have a beautiful collection of more than 1119 Fairfax Sugar Bowls—no two exactly alike! Now that's Unique!

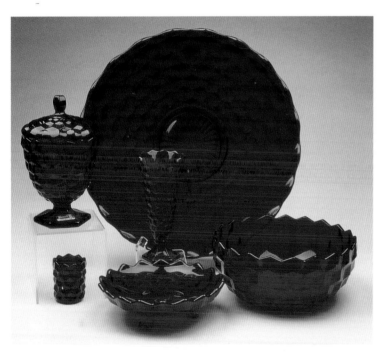

American Ruby, Candy and Cover, Platter Bowl, Vase, and Toothpick.

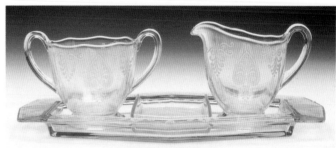

#2429 Service Tray with Lemon Insert, Trojan Etching #280, Topaz 1929-1932. **$295+**; #2375 1/2 Cream and Sugar, Trojan Etching #280, Topaz 1929-1932 **$145**; 4-piece set, Cream and Sugar, Lemon Insert, Service Tray, complete **$435+**.

#2412 Colony Line features simple elegance in swirls of glass. Following in the footsteps of Fostoria's early Cascade and short lived Queen Anne Pattern, Colony proved to be the most successful and remained a long running pattern offering a complete line of dinnerware products and accessories for all occasions, giftware, and smoking accessories. With the exception of a few early pieces of Colony, most in line items were in catalogs for many years, 1939 through the 1970s. A few items known to be produced for less than five years include a 7.25 inch Ice Bowl, Cigarette Box and Cover, 12 inch Salver, Sweetmeat, Three-toed Tid Bit, Urn and Cover, and Vases in a 12 inch and 14 inch height.

#2419 Mayfair Line, a very art deco design with its square corners and stylish handles was introduced into the catalogs in 1931. Mayfair offered a variety of colors including Crystal, Rose, Green, Amber, Topaz/Gold Tint, Wisteria, Regal Blue, Burgundy, Empire Green, and Ruby. Ebony Mayfair and several items such as the Sauce Bowl and Stand, Condiment Tray, Syrup, and Cover and Saucer were in line catalogs for less than five years and are harder to find. Very few pieces were produced four years only in the Wisteria color from 1931 to 1936. These include: Handled Bonbon, Handled Lemon tray, a 6 inch Plate, 7 inch Plate, and a tea size Cream and Sugar.

#2440 Lafayette Line was introduced into the catalogs in 1932 and most items disappeared from catalogs by 1940. Lafayette offered a complete line of products including Plates in five sizes, Cup and Saucer, After Dinner Cup and Saucer, Individual Almond, Cream Soup and Liner, Fruit Bowl, and Cereal Bowls to name a few. The variety of colors offered in the Lafayette line was outstanding and this was one of the most elegant of dinnerware blanks. Unique to this pattern is the deep colors of Regal Blue, Burgundy, Ruby, and Empire Green with their elegant Handled Bowls, Oval Mayonnaise, and Handled Divided Relish dishes. Interesting to note is the bold colors were offered in complimentary accessory items in line only such as Serving Bowls and Plates, Divided Relish Dishes, and Cream and Sugar.

#2449 Hermitage Line was a beautiful pressed pattern first introduced into the catalogs in 1932 in brilliant colors of Crystal, Green, Amber, Azure, Topaz/Gold Tint, Ebony, and Wisteria. The Wisteria was color offered for a few years only, 1932-1936. Hermitage offered a full line of dinnerware products and serving accessories. Most items offered in line catalogs from 1932 through 1938 only, with a few pieces in catalog until 1940. The Ice Dish and Liner seems to be the most difficult to find item. The Bar Bottle and Cocktail Shaker in this pattern was produced for one year only, 1932-1933 making these items hard to find. Hermitage was most widely advertised as being the glass of fashion, in vogue for its quaint design and six fashion colors!

#2496 Baroque Line was designed by George Sakier, and first introduced into the catalogs in 1936. Produced in Crystal, Azure, and Topaz/Gold Tint from 1936 through 1942, it offered a complete line of dinnerware and unique gift items. Candlesticks, Vases, some serving items were produced in colors of Ruby, Empire Green, Regal Blue, Amber, and Ebony from 1935-1937. Baroque Crystal blank was one of the blanks used for the master etchings, and many beautiful designs can be found in Gold Overlay and Silver Overlay on Baroque.

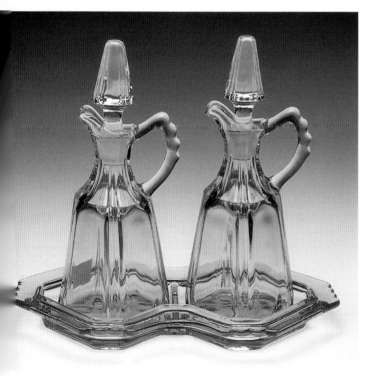

#2419 Mayfair, Oil on Condiment Tray, Rose, two 6-ounce Oil, and Tray 8.75" long. Rose 1931-1934. **$345.**

#2496 Baroque , Azure 1936-1938. **Left:** #2496 Two Part Relish, 1936-1943. 6" square **$42**; **Right:** #2496 3-Toe Bonbon, Azure, 1937-1943. 7.75" diameter **$45**; **Center:** #2496 Sauce, Plate and Ladle, Azure 1936-1940. **$85.**

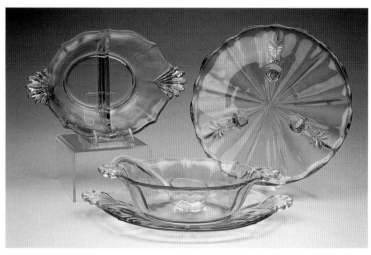

#2510 Sunray/Glacier Line offered a beautiful line for the hostess. Sunray plain was elegant with its ribbed lines in Crystal. Glacier was the name given to this line with Silver Mist ribbed lines on Crystal with a Satin Finish. Golden Glow is the name given this pattern with Amber stained colored ribbed lines on Crystal. All lines were created from the same moulds, just different finishes offered a unique variety for the hostess to choose from. Most items offered in line catalogs from 1935 to 1943, with the majority of items being made for less than five years.

#2560 Coronet Line was a unique line of dinnerware with its graceful wavy lines on the edges of all items and fancy handles. Coronet was introduced with a limited line of products into catalogs in 1938, the full line was in catalogs by 1940 while many of the accessory and serving items were discontinued out of catalogs by 1943. The Coronet blank was used for some etching patterns and their crystal dinnerware remained in matching service until 1959. Those items produced for less than five years include the four-part and five-part Relish, 6 inch Comport, 5 inch Fruit Bowl, and 6 inch Cereal Bowl, two-part Mayonnaise with two ladles, two-part Salad Bowl, 3.5 inch Pansy Vase, and the Footed Shakers.

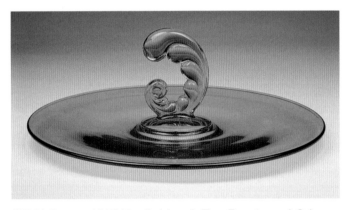

#2364 Sonata, 11.5" Handled Lunch Tray, Experimental Color Amber and Iridescent treatment, circa 1942. Believed to be one-of-a-kind test sample found in the design morgue at close of factory. $275+.

#2574 Raleigh was a popular line first introduced into the catalogs in 1939. Although it was introduced as a dinnerware line, the number of items offered in the catalogs for this pattern through 1965 is limited. While most other full dinnerware lines offered more than fifty products, Raleigh has less than forty. It is interesting note also that Raleigh had no matching stemware lines, but coordinated well with the Georgian and Dolly Madison patterns. Raleigh is the blank used for the Master Etchings of Willow, Colonial Mirror, Sampler, and Plymouth, most popular in the catalogs from 1940-1943 only. The items offered for less than five years include

the Bonbon, 5 inch Comport, Lemon Dish, 9 inch Plate, Sweetmeat and the Whip Cream, making these items scarce and harder to find.

#2630 Century Line, was a wonderful pattern for Fostoria with its diamond dew drops swirling into carefree harmony around the magic of purest crystal. Century was introduced into the catalogs in 1949 offering the Three-toe Bonbon, Salad Sets, Cream and Sugar, Lily Pond, and limited dinnerware items. By 1950, a full line of more than fifty items was featured in the catalogs. Ladies of the era were tired of the colored and decorated glassware; the magic and harmony of the purest crystal and unique modern styling of Century made this a popular pattern. There was a 3 pint Jug, 9.5 inches tall produced for two years only 1950-1952, and three items of limited production 1950 to 1958 that include a Party Plate Set, 7.5 inch Handled Vase, and 8.5 inch Oval Vase that are scarce to find. Century blank was used for some Master Etching patterns and Crystal Prints.

#2638/2666 Contour was introduced into the catalogs in two different line numbers. The first to appear in the #2638 Contour line, introduced in 1949 with a limited number of accessories and serving pieces. These items remained in line as decorator and smoking accessories designed in heavy crystal. While the #2638 Contour was in production, Fostoria introduced #2666 Contour into the catalogs in 1952. This included glassware with a Fashion Flair. Therefore, this pattern name was in the catalogs under two different line numbers at the same time, offering a limited number of items in casual dining. Most elegant is Contour items found in Ebony produced at Fostoria 1953-1962 include #2638 Candlesticks, #2666 Mayonnaise, Plate and Ladle, 9 inch Salad Bowl, 11 inch Salad Bowl, a Four-piece Salad Set and the Flora Candles. The Oil and Stopper, and Shakers were produced in 1955 only; they are on the seldom seem list for collectors. Contour moulds were used in #2685 Seascape pattern produced 1954 to 1957 in Caribee Blue and Coral Sand. They used the same moulds but were given a different name and line number in the catalog for marketing purposes.

Naturally, it was impossible to include full lines of dinnerware in this chapter. Instead, showcased are a few examples of Fostoria's dinnerware, from various patterns, chosen for their artistic style and contribution to the heritage of this factory. These are known to be produced for less than five years. Included are the seldom seen, lesser known, and the never before documented patterns of Abstraction, Canary with Royal etching, and Fostoria's Melamine, a remarkable milestone of unbreakable dinnerware.

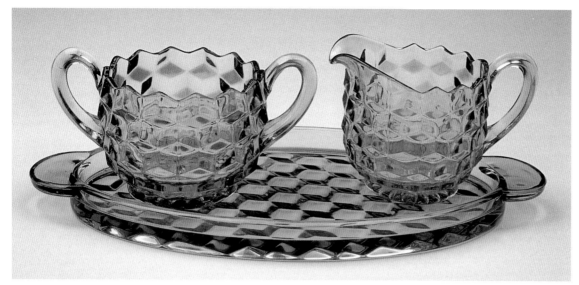

#2056 American Pattern, Cream and Sugar on Service Tray, Green. Cream 4.25" tall, Sugar 5.25" tall, Cream and Sugar Tray 6.75" long. **$295+.**

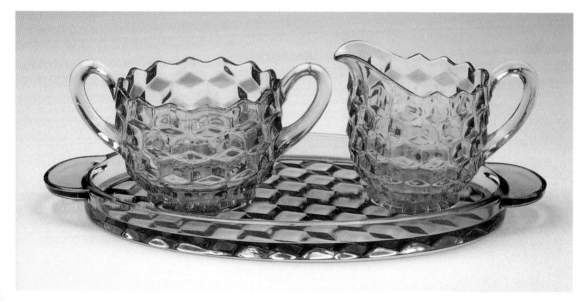

#2056 America Pattern, Cream and Sugar on Service Tray, Rose. Cream 4.25" tall, Sugar 5.25" tall, Cream and Sugar Tray 6.75" long. **$365+.**

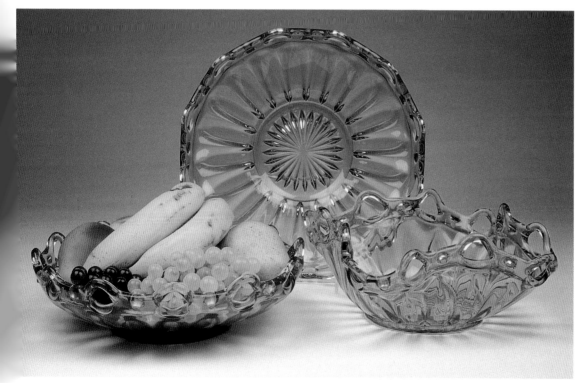

Left: #2183 Colonial Prism Cabarette Bowl, Amber 1925-1934, 12" diameter. **$55; Center:** #2183 Colonial Prism Cabarette Bowl, Orchid 1927. **$75; Right:** #2183 Orange Bowl, Green 1927-1930, 8.25" square. **$45.**

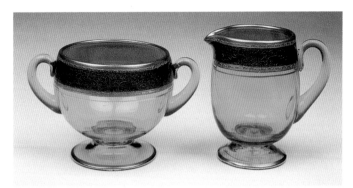

#2315 Cream and Sugar, Blue 1925-1927, beautifully decorated Coronada Blue Decoration #49, White and Yellow Gold Encrusted Royal Etching, extremely scarce. **$125 set.**

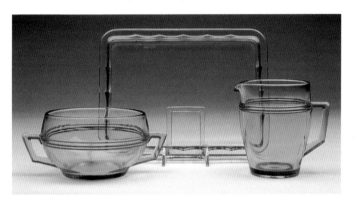

#2321 Priscilla Pattern, Cream and Sugar on 2000 Condiment Tray, Blue 1929-1931. **Left:** Sugar 2.5" tall, 4" diameter; **Center:** Tray 7.5" long, 5.5" wide; **Right:** Cream 4" tall. **$65 set.**

Close up design art on #2321 Priscilla handle.

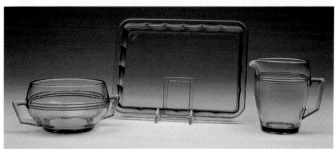

#2321 Priscilla Pattern, Cream and Sugar on #2000 Condiment Tray, Green 1929-1931. **Left:** Sugar 2.5" tall, 4" diameter; **Center:** Condiment Tray 7.5" long, 5.5" wide. **Right:** Cream 4" tall. **$65 set.**

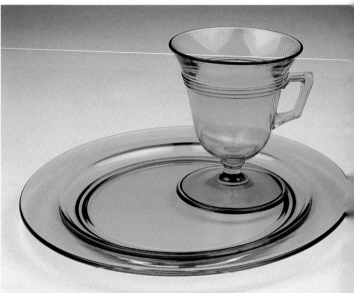

#2321 Pricilla Mah Jongg Set, Luncheon Plate with Handled Custard Cup, Green 1925-1927. Catalogs offered this plate in two versions as Mah Jongg set with Sherbet and/or Bridge Set with the Custard Cup as shown. Collectors often refer to it under both names. Custard Cup 4" tall, Plate 8" diameter. **$35.**

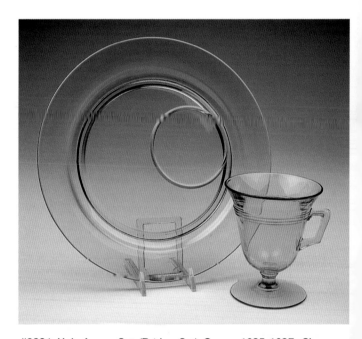

#2321 Mah Jongg Set (Bridge Set) Green, 1925-1927. Shown plate up to see design details. **$35.**

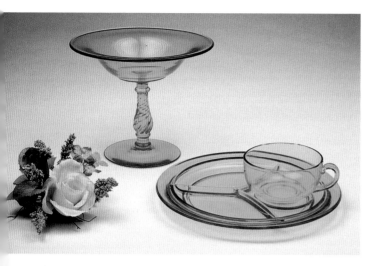

Left: #2327 Comport, 1924-1928, 7" tall. **$45;** Right: #2350 Pioneer Snack Set, Blue, 1926-1927. Not listed in catalog. Pioneer Cup and Snack Plate 9.5" diameter. **$65.**

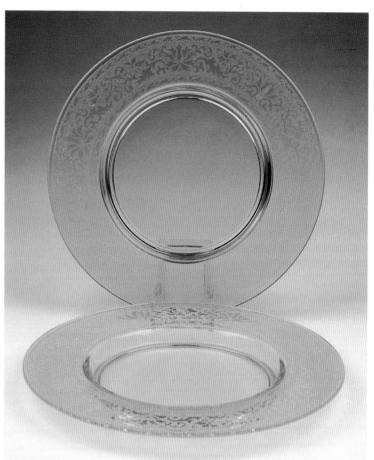

#2350 Plate, Royal Etching #273, Canary. This item not shown in any catalog listings. Canary was produced 1925-1926 only. Royal was produced on Pioneer blank colors 1925-1927. This exquisite find never before documented. 8.5" diameter. **$60 each.**

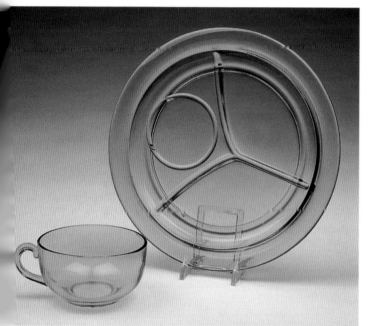

#2350 Pioneer Snack Set, Blue, 1926-1927. Showing ribbed divider sections on plate. Not listed in catalog. 9.5" diameter. **$65 set.**

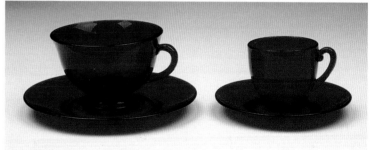

Left: #2350 1/2 Pioneer Tea Cup/Saucer, 1934-1936. **$35;** Right: #2350 Pioneer After Dinner Cup and Saucer, 1934-1936. **$48.**

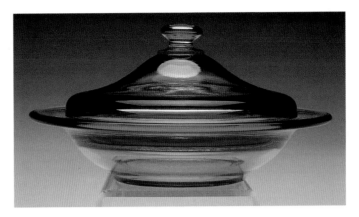

#2350 Pioneer Butter and Cover, Amber, 1926-1934. **$115.**

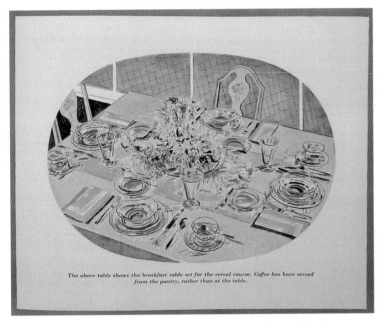

Breakfast Table Set in Green, from Fostoria Glass of Fashion.

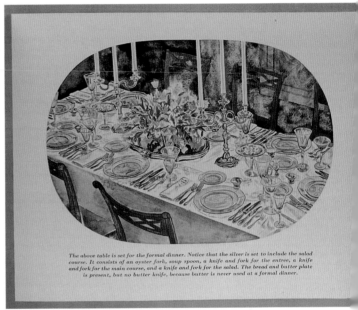

Formal Dinner Set in Topaz from Fostoria Glass of Fashion.

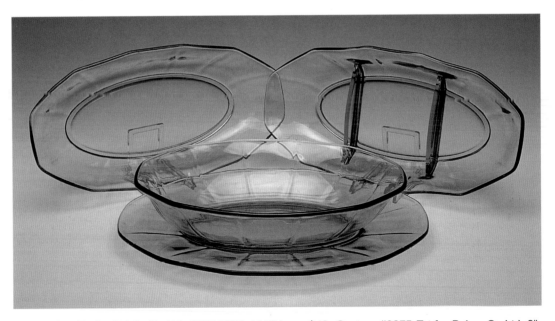

Left: #2375 Fairfax Relish, Orchid, 1927-1928, 11.5" long. **$48; Center:** #2375 Fairfax Baker, Orchid, 9" Oval, 1927-1928. **$85** and 12" Plate circa 1927. **$75;_Right:** #2375 Fairfax, Three-part Divided Relish, Orchid, 1927-1928, 11.5" long. **$52.**

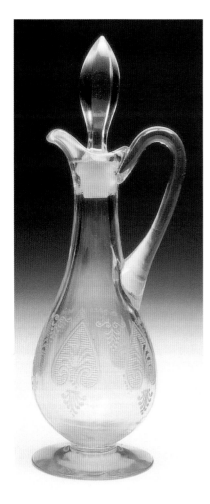

Trojan Plate Etching
#280, #2375 Footed
Oil, Topaz, 1929-1934,
9.75" tall. **$395.**

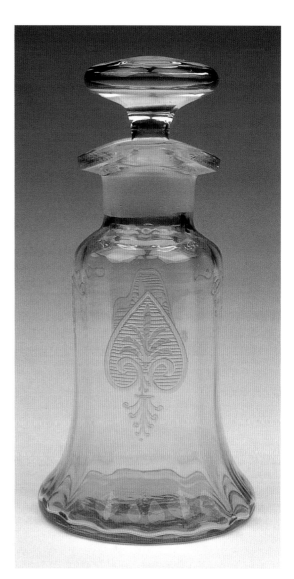

#2375 Salad Dressing Bottle,
Trojan Etching #280, Topaz,
circa 1933, not listed in
catalogs. **$785+.**

#2375 Fairfax Footed Oil, Green, 1929-1938.
9.75" tall. **$185+.** Not shown: Produced in Amber,
Topaz/Gold Tint, Rose, and Crystal 1929-1938
$185+. Azure 1929-1934. **$225+.**

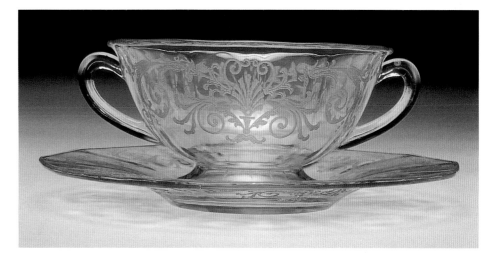

#2375 Cream Soup and Plate, Versailles Etching #278, Topaz/Gold Tint, 1929-1943. **$95.**

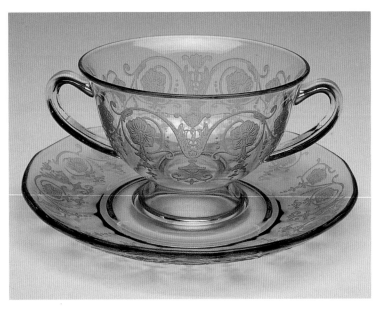

#2375 Cream Soup Bowl and Plate, Vernon Etching #277, Orchid, 1927-1928. **$75.**

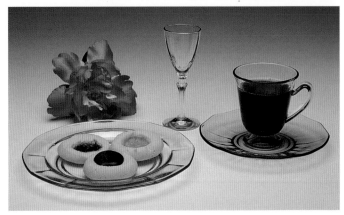

Mix of colors shown here as Fostoria suggested to mix the colors for informal gatherings. **Center:** #2375 Fairfax, Rose 7" diameter plate. **$14; Right:** #2375 Fairfax After Dinner Cup and Saucer, Orchid, 1927-1928. **$28; Center Rear:** #5098 Cordial, Rose, 1928-1940. 3.75" tall. **$18.**

Abstraction, a unique pattern of Fostoria that appeared in catalog 1929 for one year only. All items in line were produced on #2375 Fairfax blank. This pattern was very art deco and modern style for its time. A sampling of #2375 Handled Lunch Trays, 11" diameter. Azure, Green, and Rose, **$135 each**.

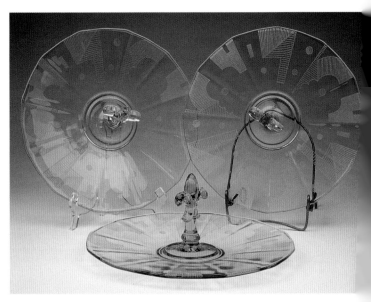

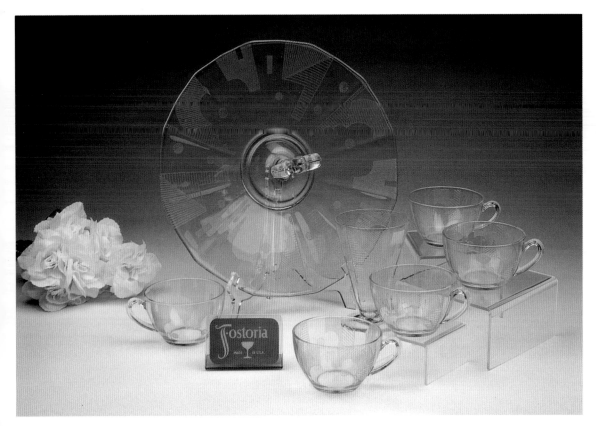

#2375 Abstraction plate Etching #304, Azure Blue 1929. Shown several pieces in the line, Center Handled 11" Lunch Tray **$135**; Tumbler **$18**; and cascading Tea Cups (featuring different unique Abstraction designs), **$22 each.**

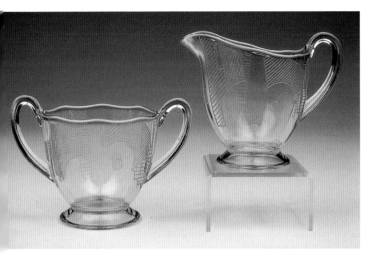

#2375 Abstraction Plate Etching
#304, Footed Cream 3.75" tall and
Footed Sugar 3.5" tall, Azure Blue,
1929. **$68+.**

Formal Lafayette Wisteria Table Setting
from Fostoria's Glass of Fashion.

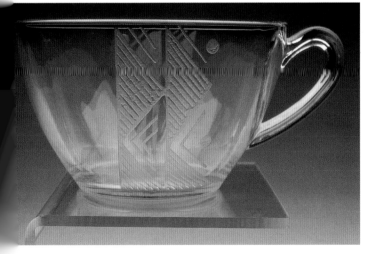

Close up design detail of Abstraction #304 on
cup. This unique design features two styles of
etchings on the cups. The abstract swirl
geometric design shown on the large platters
and plates, and this art deco design with its
square lines.

#2375 Abstraction Etching #304, Footed
Cream 3.75" tall and Footed Sugar 3.5" tall,
Green, 1929. **$68+.**

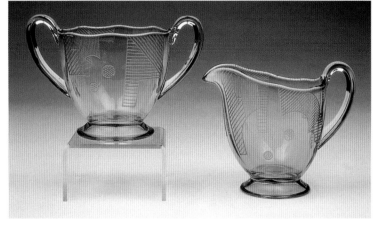

Center rear: #2375 Abstraction Luncheon Tray, Green, circa1929. **$135; Center front:** #2375 Abstraction #304 Luncheon Plate, Green 9" diameter. **$22; Left:** Abstraction #304, Green, 1929, Footed Cream 3.75" tall and Footed Sugar 3.5" tall. **$68+; Right:** #2375 Abstraction #304 Footed Cup and Saucer, Green, 1929. **$32.**

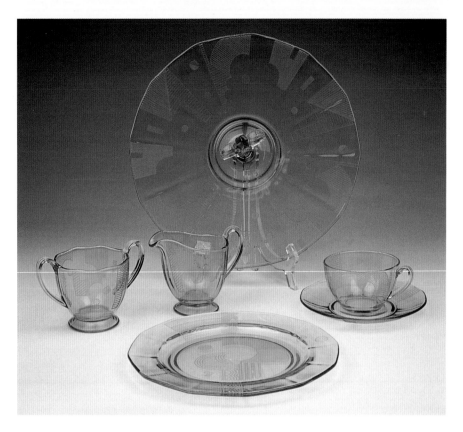

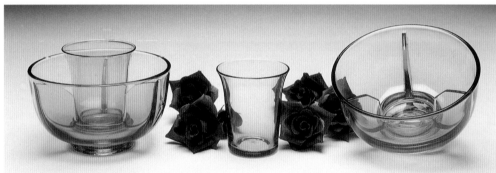

Left: Pictured as shown in catalog. Fairfax Ice Bowl with Tomato Juice liner. **$35; Center:** #2451 Tomato Juice Liner **$18; Right:** Tomato juice ice dish to show inside 3 prongs that hold Tomato Juice liner and/or crab meat cocktail. **$15.**

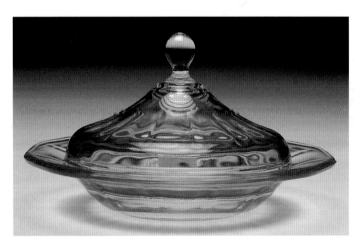

#2375 Fairfax Butter and Cover, Topaz/Gold Tint, 1929-1943. 6" diameter plate. **$125.**

#877 Grapefruit and #945 1/2 Grapefruit Liner, Exquisite Vernon Etching #277, Orchid, 1927-1928. **$110.**

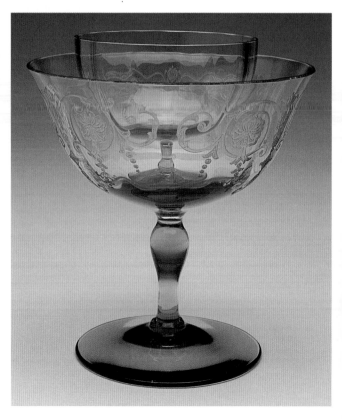

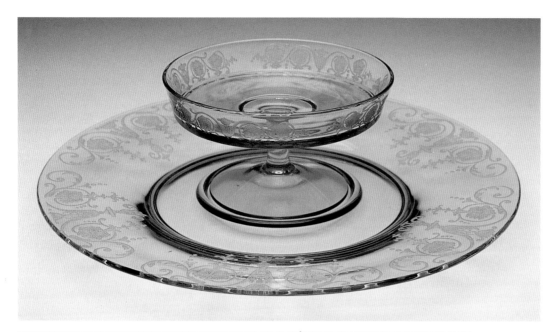

#2368 Footed Cheese and Cracker Plate, Vernon Etching #277, Orchid, circa1927, not listed in catalogs. 11.5" plate. **$185+.**

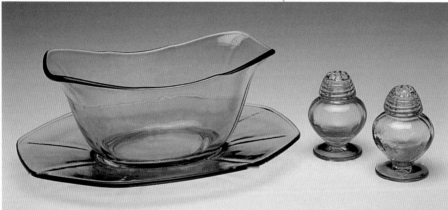

Left: #2375 Sauce Boat and Plate, Orchid, circa 1927. Scarce, not listed in catalogs. **$165+; Right:** #2375 Shakers, Vernon Etching #277, Orchid, circa 1927-1928. Scarce. **$125+.**

Below:
#2342 Handled Lunch Tray, Thelma Cutting No. 186, Amber, 12" diameter. Extremely scarce pattern to find, Thelma Cutting produced one year only 1928, discontinued in 1929. Not Shown: Also produced in Green, Rose, and Orchid. **$145.**

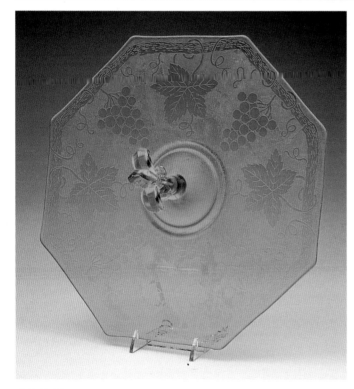

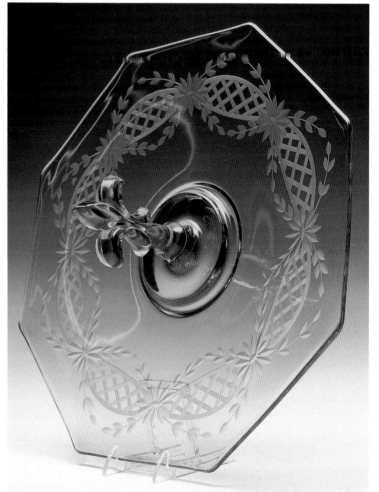

#2342 Handled Lunch Tray, Grape Brocade Etching #287, 1927-1929. 11" diameter. **$165+.** Not shown: Also produced in Green, 1927-1930; and Orchid, 1927-1928, **$165+** .

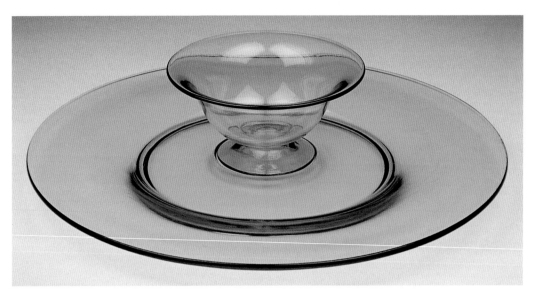

#2315 Lettuce Plate and Mayonnaise, Green, extremely scarce set to find, produced for two years only in catalogs 1928-1930. Lettuce plate is 13" diameter. **$95+.** Not shown: this unique service set was produced in Crystal, Amber, and Rose 1928-1930. **$95 set.** Orchid and Azure Blue one year only 1928. **$125+.**

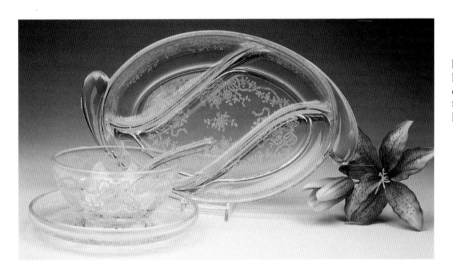

Left: #2364 Mayonnaise, Plate and Ladle, Romance Etching #341, Mayonnaise 2" tall 5" diameter, Plate 6.25" diameter. 1942-1970 **$72; Right:** #2364 3-Part Relish, Romance Etching #341, 1.5" tall, 10" long, 7.25" wide. 1942-1970. **$78.**

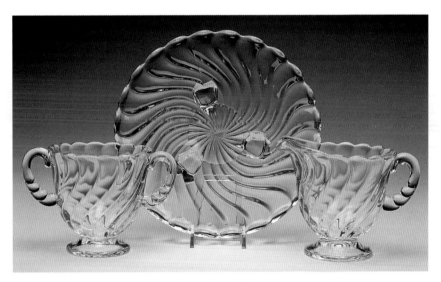

#2412 Colony Cream and Sugar, Crystal 1940-1970. Sugar 2.8" tall, Cream 3.25" tall. **$25/set. Rear:** Colony Tid Bit, 3-toed, showing art of Colony Design, Crystal, limited production, 1940-1944. **$56.**

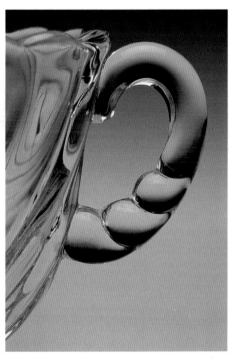

Close up of Colony handle for design pattern.

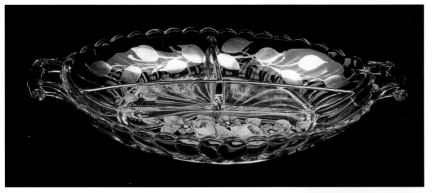

#2412 Colony 3-part Relish, Charleston Decorated, circa 1940. 10.25" long, 2.4" tall, 6.25" wide. **$75.**

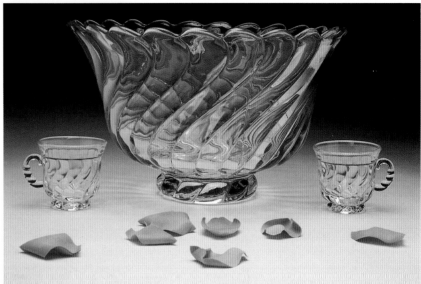

#2412 Colony Punch Bowl, Crystal, 1952-1973, 2-quart capacity. 9.8" tall, 13.25" top diameter. **$600+.**
#2412 Colony Punch Cups, Crystal. **$12 each.**

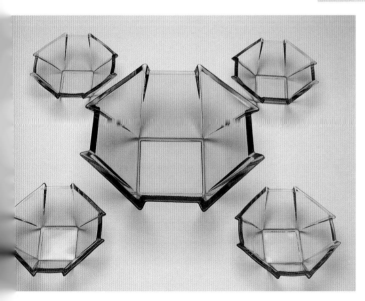

#2402 Geometric Bowl set designed by George Sakier, Amber, Center Bowl 10" diameter, 3" tall. **$45;** Small Bowls 4" wide. **$18 each.**

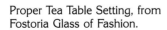

Proper Tea Table Setting, from Fostoria Glass of Fashion.

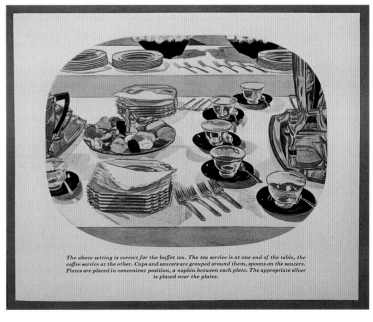

The above setting is correct for the buffet tea. The tea service is at one end of the table, the coffee service at the other. Cups and saucers are grouped around them, spoons on the saucers. Plates are placed in convenient position, a napkin between each plate. The appropriate silver is placed near the plates.

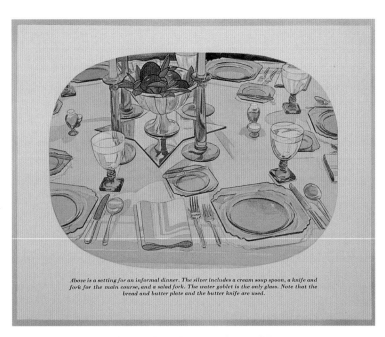

Above is a setting for an informal dinner. The silver includes a cream soup spoon, a knife and fork for the main course, and a salad fork. The water goblet is the only glass. Note that the bread and butter plate and the butter knife are used.

Mayfair Table Setting from Fostoria Glass of Fashion.

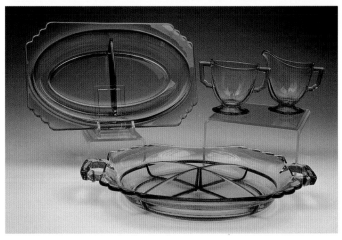

Left: #2419 Mayfair 2-part Relish, Amber, 1931-1938, 8.5" long. **$26; Center:** #2419 Mayfair 4-part Handled Relish, Amber, 1921-1938, 8.5" square. **$28; Right:** #2419 1/2 Mayfair Footed Cream, 3.75" tall and Footed Sugar, 3.25" tall. **$45.**

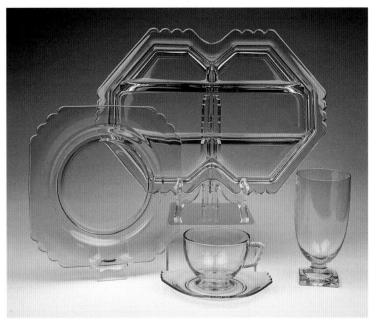

Rear. #2419 Mayfair 5-Part Relish, Topaz/Gold Tint, 1931-1943, 13.75" long. **$38; Left:** #2419 Mayfair Plate 9" square. **$18; Center:** #2319 Mayfair Cup and Saucer **$22; Right:** #4020 Footed Tumbler, Topaz/Gold Tint, 1929-1943, 10 ounce, 5.5" tall. **$22.**

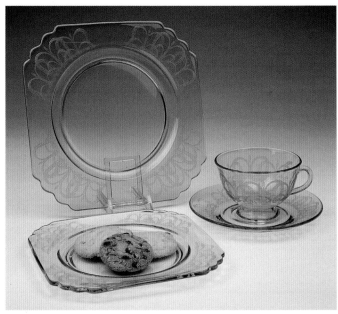

Left and Center: #2419 Plate, Fountain Etching #307, Green, 8" square. **$25; Right:** #2419 Cup and Saucer, Fountain Etching #307, Green, 1929-1930. **$28.**

Left: #2419 Mayfair Pattern, Oil, 6 oz., Green, 1931-1938 **$75; Center:** #2574 Oil, 4.5 oz., Willow Etching #335, 1939-1943, **$95; Right:** #2496 Baroque, Oil and Stopper, 3.5 oz., Gold Tint, 1937-1943, 5.5" tall. **$355.**

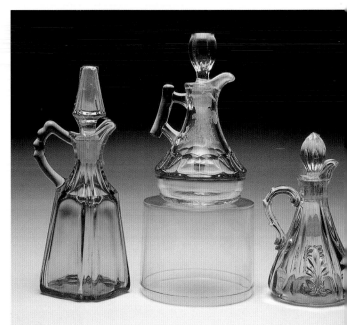

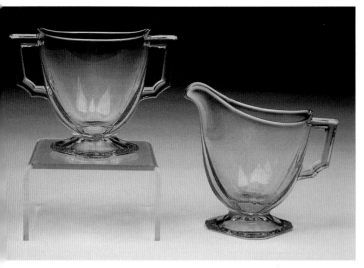

#2419 Mayfair, Wisteria, 1931-1936, tea size Cream 2.75" tall and Sugar 2.5" tall. **$75.**

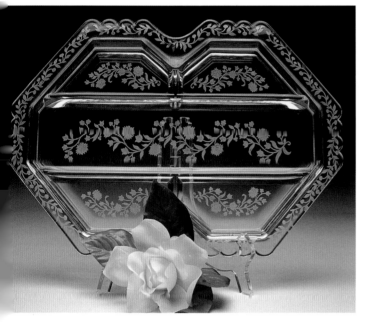

#2414 5-part Relish, Rambler Etching #323, 1935-1943. 13.25" long. **$75.**

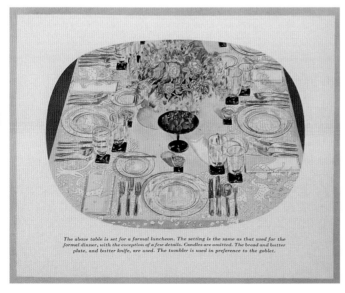

Formal Dinner Table, from Glass of Fashion.

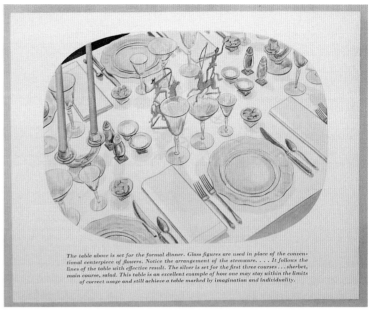

Formal Lafayette Wisteria Table Setting from Fostoria's Glass of Fashion.

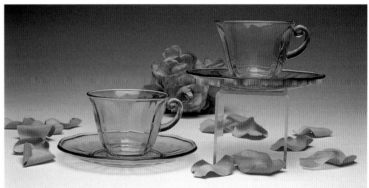

#2440 Lafayette, Cup and Saucers, Wisteria, 1931-1938. **$32 set.**

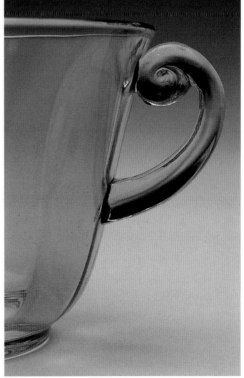

Close up design art of #2440 Lafayette Wisteria handle.

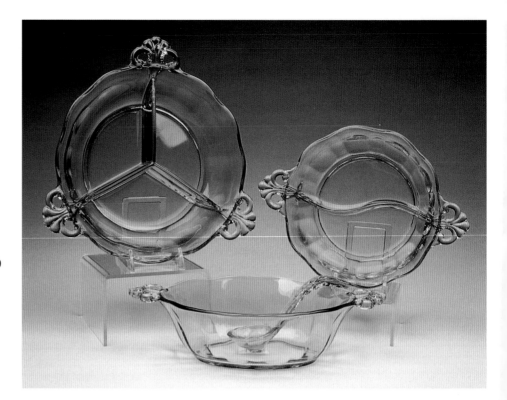

Left: #2440 Lafayette 3-part Relish, Topaz/Gold Tint. **$48; Center:** #2440 Mayonnaise, Liner, and Ladle, complete. **$68; Right:** #2440 Lafayette 2-part Relish, Topaz/Gold Tint. **$34.**

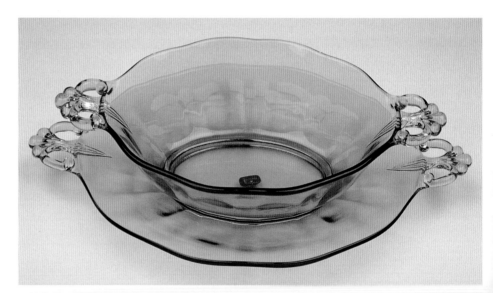

#2440 Lafayette Sauce Dish and Plate, Amber, 1933-1940. Dish 6.5" Oval, Plate 8.5" long. **$98.**

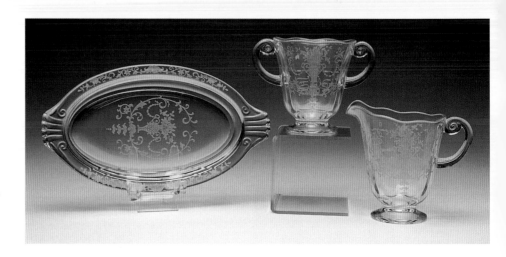

Left: #2470 Tray, Sugar and Cream, Florentine Etching #311, Crystal, 1933-1943. Tray 7.25" long. **$52; Right:** #2440 Cream and Sugar, Florentine Etching #311, Crystal, 1933-1943. Sugar Footed, 3.75" tall. Cream Footed 4.25" tall. **$85.**

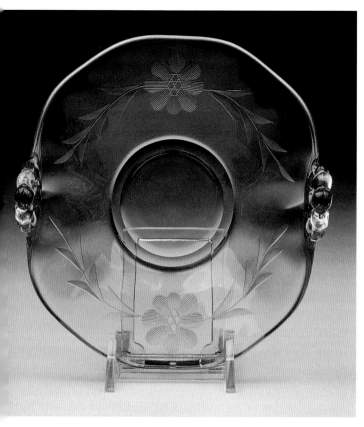

#2440 Lafayette Bon Bon (unknown cutting) Rose, 1933-1937. 5" Handled. **$38.**

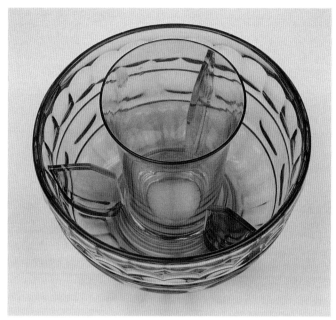

#2451 Hermitage Liner, with Blown Tomato Juice (also used for crab meat and fruit cocktail) Wisteria, 1932-1935. **$65 set.**

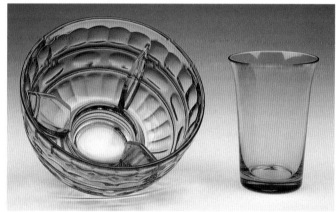

Left: #2451 Ice Liner Hermitage, Wisteria, 1932-1935; **Right:** Blown Tomato Juice Tumbler, Wisteria, 1932-1935. **$65 set.**

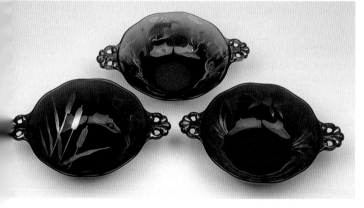

#2440 Lafayette Bon Bon, circa 1935-1939, with Decorations applied in Gold, 5" Handled. **Left to right:** Burgundy with Decoration Gold Cattail. **$42;** Empire Green with Decoration Whimsical Fish. **$42;** Regal Blue with Decoration Hummingbird. **$42.**

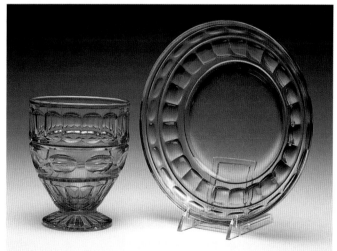

Left: #2449 Hermitage 9 ounce Goblet, Wisteria, 1932-1938, 5.5" tall. **$24; Right:** #2449 Hermitage Plate, Wisteria, 1931-1936, 8" diameter. **$28.**

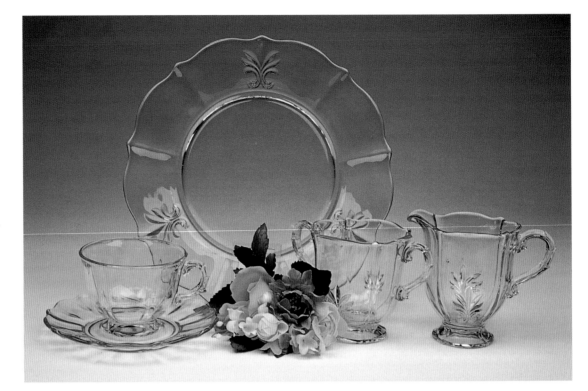

Left to right: #2496 Baroque Cup and Saucer, Azure, 1936-1943. **$38;** #2496 Baroque Plate, Azure, 1936-1943, 9" diameter. **$65;** #2496 Baroque Footed Cream 3.5" tall and Footed Sugar 3.25" tall, Azure, 1936-1943. **$95.**

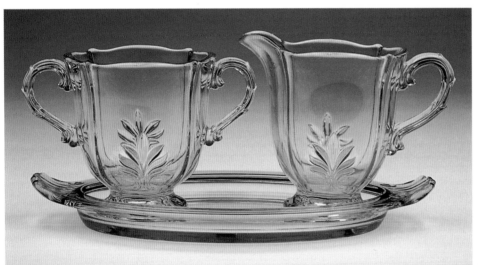

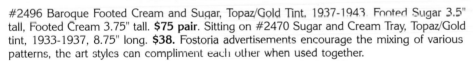

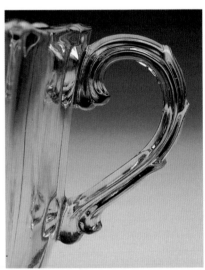

#2496 Baroque Footed Cream and Sugar, Topaz/Gold Tint, 1937-1943. Footed Sugar 3.5" tall, Footed Cream 3.75" tall. **$75 pair.** Sitting on #2470 Sugar and Cream Tray, Topaz/Gold tint, 1933-1937, 8.75" long. **$38.** Fostoria advertisements encourage the mixing of various patterns, the art styles can compliment each other when used together.

Close up Baroque handle to show elegant design details.

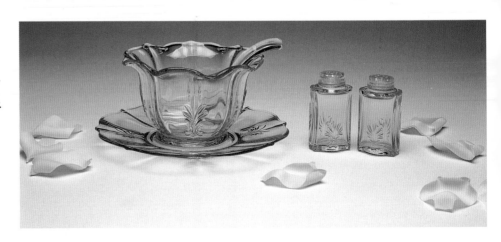

Left: #2496 Baroque Mayonnaise, Plate and Ladle, Gold Tint, 1937-1942, 3.5" tall, Plate 6.5" diameter. **$85; Right:** #2496 Baroque Shakers, Gold Tint, 1937-1942, 2.75" tall. **$210+ pair.**

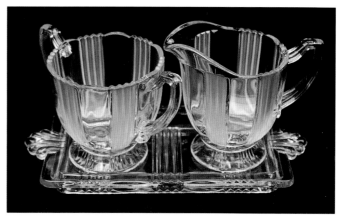

Left: #2510 Sunray/Glacier Sherbet, 3.5" tall. $14; Center: #2510 Sunray/Glacier Plate, 1936-1943. 9" diameter. $23; Right: #2510 Sunray/Glacier 9 ounce Footed Tumbler, 4.75" tall. $16.

#2510 Sunray, Glacier Footed Cream and Sugar, 1936-1943. Footed Sugar 3.75" tall, Footed Cream 4" tall. $48 set.

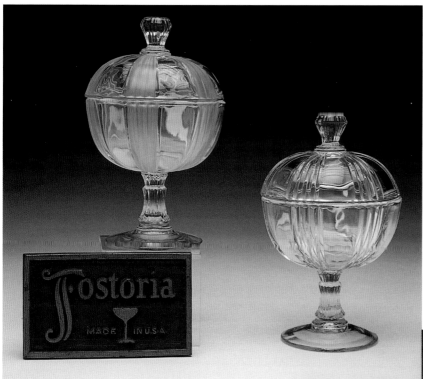

Left: #2510 Sunray/Glacier Footed Jelly and Cover, 1935-1938. 7.75" tall. $85. Right: #2510 Sunray Footed Jelly and Cover, 1935-1939. 7.75" tall. $78.

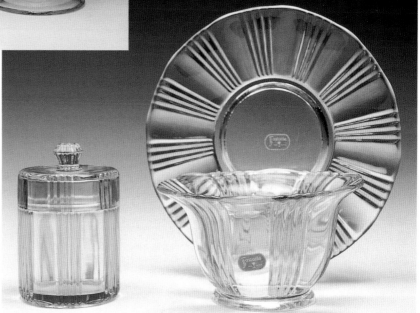

Left: #2510 Sunray Golden Glow Decoration 513, Cigarette and Cover, 1935-1937. $95; Right: #2510 Mayonnaise and Plate, Golden Glow Decoration 513, 1935-1937. Mayonnaise 3" tall, Plate 6" diameter. $85.

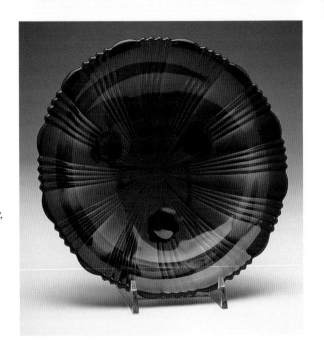

#2510 Sunray Bon Bon 3-toed, Ruby, 1936-1940. 7" diameter. **$54.**

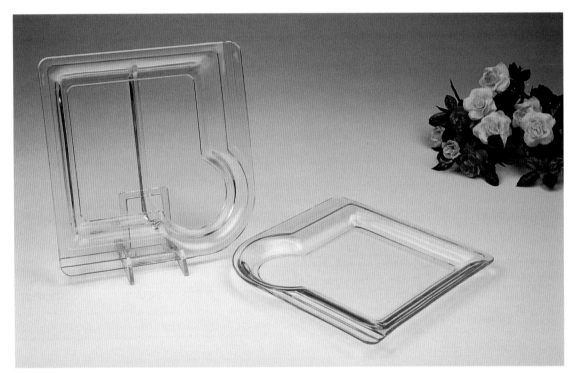

#2541 Snack Plate, Crystal, 1935-1943. This Fostoria snack plate is 6.75 inches square. The divided plate was called an Appetizer Plate. Only the Snack Plate was sold in Fostoria catalogs. The Appetizer Plate and Snack Plate were made by Fostoria for Toastmaster, designed to fit the perfect slice of toast. These were marketed through Toastmaster Advertisements from this time period, advertised for hospitality parties as individual snack plates for bread and spreads. **$15 each.**

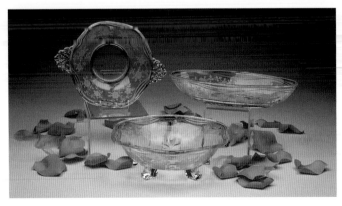

#2560 Coronet blank, Willowmere Etching #333. **Left:** #2560 Bon Bon, 6" diameter. 1938-1958. **$40; Center:** #2560 3-toe Bon Bon, 1938-1968. **$44; Right:** #2560 Olive, 1938-1958, 6.25" long. **$35.**

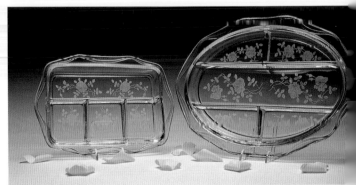

Left: #2560 4-part Rectangle Relish, Willowmere Etching #333, 1938-1943. 10" long, 6.75" wide. **$85; Right:** #2560 5-part Oval Relish, Willowmere Etching #333 1938-1943, 13" long. **$110.**

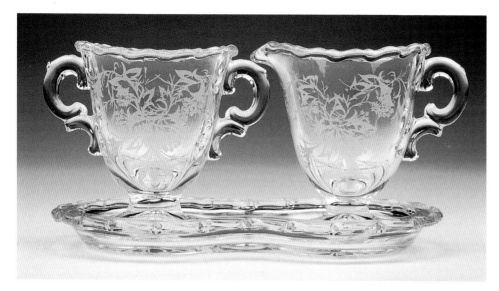

#2630 Cream and Sugar on Tray, Heather Etching #343. Cream, 4.25" tall and Sugar, 4" tall. **$38.** Cream and Sugar Tray, 7.25" long. **$32.**

#2560 Century Bowl, Blue, Experimental color, sampled only. Circa 1957. **NDV.**

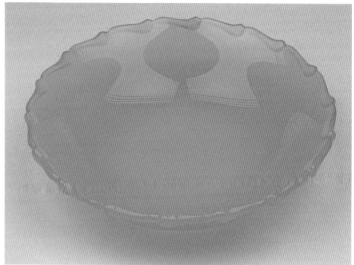

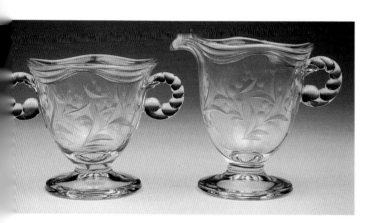

#2560 Cream and Sugar, Cynthia Cutting #785. Cynthia design is a gray cutting. The soft harmonious effect is achieved by leaving the cut pattern unpolished. My cousin, Walton Hepe was an excellent glasscutter of this pattern at Fostoria. Cream 4.25" tall, Sugar 4" tall. **$62.**

Rear: #2364 Torte Plate, Romance Etching #341, 1942-1968, 16" diameter. **$78;** **Front:** #2595 10" Handled Bowl, Romance Etching #341, 1942-1957, 13.5" long overall. **$135.**

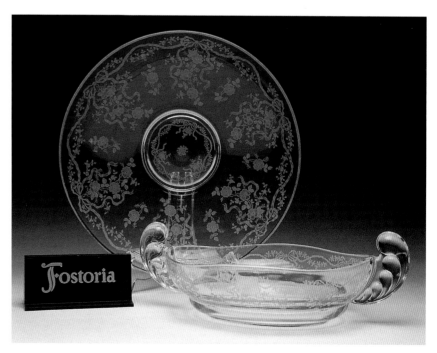

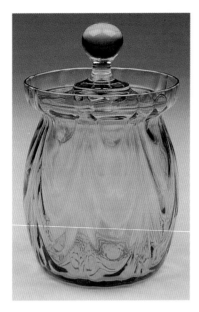

#4087 Marmalade and Cover, Green Loop Optic, circa 1934, 5" tall. **$115+.**

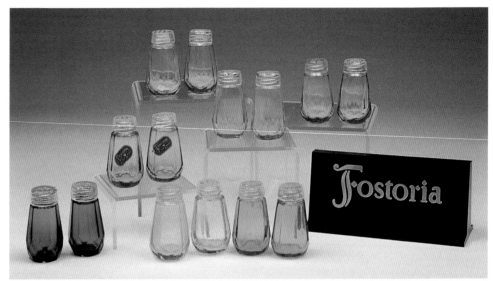

#2111 Shaker, FGT. Listed in catalogs as Shakers, FGT for Fostoria Glass Tops. Crystal tops on the Fostoria shakers are most difficult to find in mint condition. All shakers are priced as a pair. **Upper left:** Azure Blue, 1928-1939, **$78**; **Center row:** Amber, 1924-1940, **$68**; Canary, 1924-1926, **$110**; Rose, 1928-1939, **$78**; **Front row:** Empire Green, 1934-1939 (not listed in catalog) **$95**; Topaz/Gold Tint, 1930-1939. **$78**; Blue 1924-1927, **$95**.

#2513 Grape-Leaf Pattern Individual Almond Dish, Empire Green, 1935-1942. Pictured with the original box of one dozen. This Grape-Leaf pattern was produced in Burgundy, Regal Blue, and Crystal. Shown Empire Green, 2.5" diameter. **$22 each.**

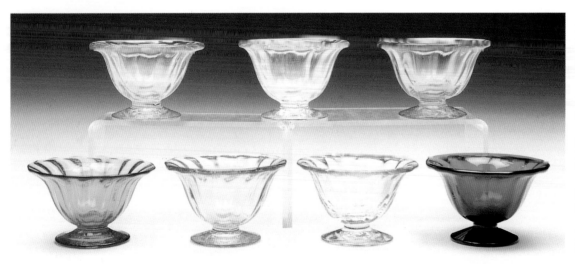

#2374 Individual Nut Dish, 1.5" tall, 2.25" diameter. **Top row left to right:** Topaz/Gold Tint, 1929-1940, **$28**; Crystal, 1928-1943, **$25**; Green, 1928-1932, **$28**; **Front row left to right:** Blue, 1928-1929, **$35**: Amber, 1928-1932, **$28**: Azure Blue, 1928-1932, **$28**: Emerald Green, 1934-1937, **$32**. Not shown: Regal Blue and Burgundy 1934-1937, **$32**.

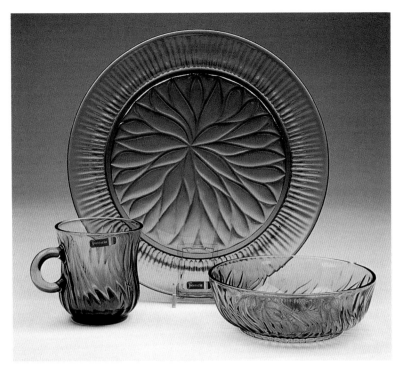

#GO05/666 Gourmet Service Snack Set. For today, whether an intimate dinner or a brunch with friends, Gourmet Service will highlight any occasion. Produced for one year only 1977-1978, the Gourmet Service was available in Crystal, Brown, or Green. The Snack Set consisted of a Plate, Soup, and a Cup. Soup/Salad Bowl 6.25" diameter, Plate 10.5" diameter, Cup, Handled 5" tall. Priced as three piece set $36.

Close up Gourmet Handle to show art design.

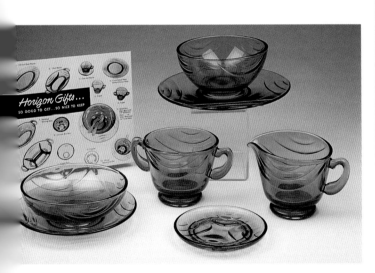

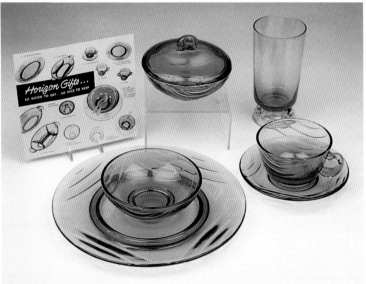

#2650 Horizon pattern was produced 1951-1954 only in two colors of Cinnamon (shown) and Spruce. This was a unique design for the era, a shot lived pattern. **Left:** Cereal Bowl 5" diameter, **$14** and Plate 7" diameter, **$10; Center front:** Coaster, Cinnamon color, **$12; Center:** Cream and Sugar, Cinnamon, Sugar 3.25" tall, Cream 3.5" tall, **$35; Center rear:** Mayonnaise Bowl and Plate, **$34.**

#2650 Horizon, Cinnamon, 1951-1954. **Back from left:** Nappy and Cover, 3.25" tall, 5" diameter. **$25;** #5650 Ice Tea Tumbler, 1951-1958. **$12; Front from left:** Plate 7" diameter. **$10;** Finger Bowl, 3.5" diameter. **$12;** Cup and Saucer, 8 ounce capacity. **$22.**

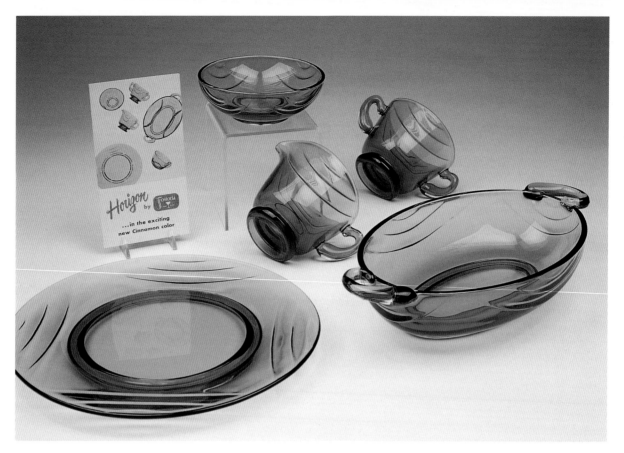

#2650 Horizon, Cinnamon, 1951-1954. Photographed as original advertisement to show the art of Fostoria. Note in catalogs the Fruit Bowl and the Cereal Bowl are the same size bowl. **Back:** Fruit Bowl, 5" diameter. **$12; Center:** Cream and Sugar, laying on side. **$35; Left:** #2650 Sandwich Plate, 11" diameter. **$25; Right:** Handled Serving Dish, 2.5" high 11.5" long. **$35.**

Fostoria's Melamine, Break Resistant Dinnerware with Fashion Flair

Fostoria collectors may be surprised to find that the company produced a full line of "Break-Resistant Dinnerware with Fashion Flair" called Melamine. Yes, Melamine, a plastic design for modern times! It was the post war years of the 1950s and young American families were on limited incomes and wanted more casual living, modern fashion with brighter colors, informal dining and entertaining. The 1950s introduced new products in plastic dinnerware that seemed to fit the budget and lifestyle needs. The major glassware companies of the era were challenged to find ways to market casual designs when the new trends were to turn away from formal crystal dinnerware. Fostoria's design director Marvin Yutzey began working with Lathman-Tyler-Jensen designers from Chicago Molded Products to produce Fostoria Melamine. This was introduced and nationally advertised to be "Break Resistant Dinnerware with a Fashion Flair."

Original Advertisement *Break Resistant Fostoria with a Fashion Flair.*

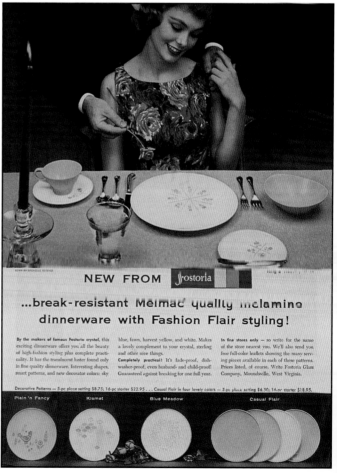

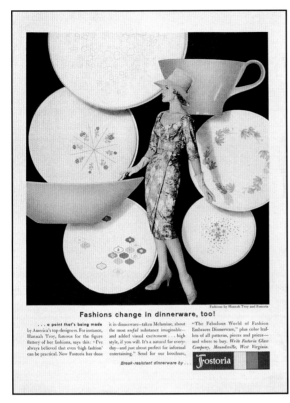

Fostoria Melamine advertisement of January 1959 featuring one of America's top fashion designers, Hannah Troy, as the designer of the dresses the model is wearing in the Fostoria Advertisements.

This was an innovative and bold step for Fostoria, known for its exclusive glassware products. It was a step that kept Fostoria in the forefront of the glass industry when other glass manufactures struggled to compete with the trends of the era. I believe Fostoria's Melamine, although trendy and short lived, deserves a place in the Fostoria history books for its unique innovative design and contribution to the legacy of the factory.

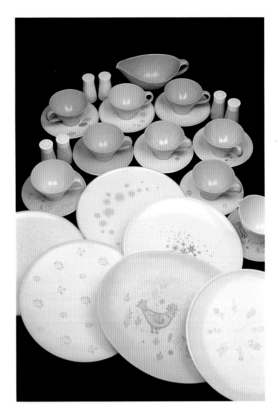

An array of Fostoria's Melamine designs, Shakers, Accessories, and Serving Platters.

The production of Fostoria designs in moulded plastic, called Melamine was done in the Chicago area by contracts with Chicago Molded Products. The Melamine patterns met all the government standards set for the plastic industry in the 1950s. These standards were set by the U.S. Bureau of Standards and the Society of the Plastics Industry. The standards were guidelines for the manufactures regarding the size, weight, sanitation, density, and durability of the plastic dinnerware. Fostoria glassware was designed with etchings to match the Melamine designs and production of these, called "Crystal Prints" were made in Moundsville at the Fostoria Plant.

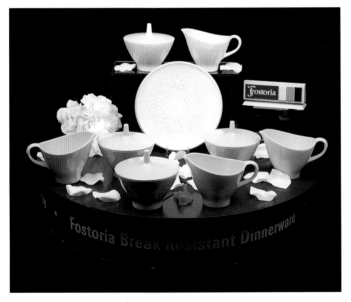

Fostoria Melamine in White, Fawn, Sky Blue and Harvest Yellow offer sleek modern styles, Cream and Sugar Bowls with Covers.

Christmas Advertisement for Fostoria Melamine showing combinations of "Open Stock," Cup and Saucer patterns available.

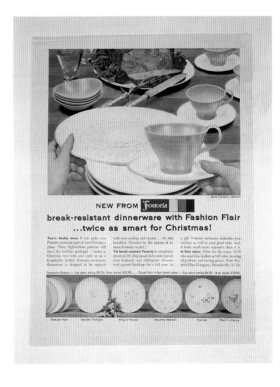

Fostoria produced the Decorated Melamine in a total of eight different patterns. The patterns are listed by Decoration Number as shown in the Fostoria January 1959 Catalog. The decorated pattern names were: (1) Blue Meadow, (2) Kismit, (3) Plain N' Fancy, (4) Ring of Roses, (5) Golden Twilight, (6) Country Garden, (7) Greenbriar and (8) Sun Valley.

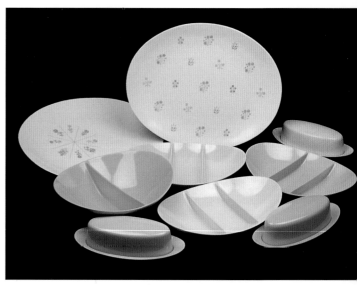

A large variety of patterns was available "Open Stock." Original open stock on all colors and patterns by the piece were individually priced from **$1.35** for a Cup and/or Saucer, up to the largest item offered, a 15-inch Banquet Platter for **$5.75**.

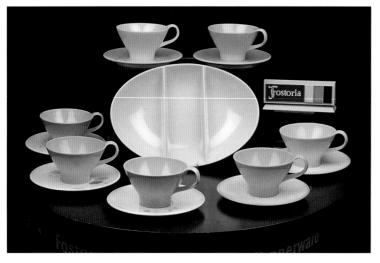

Fostoria's Melamine Break Resistance Cup and Saucers display a variety of available colors.

Fostoria produced Melamine in five solid colors: Sky Blue, Harvest Yellow, White, Fawn (beige), and a Mint Green. The solid colors were offered by open stock. Open stock refers to the items being sold one piece at a time. Fostoria's national advertising for Melamine encouraged the purchase of open stock solid colors to coordinate with the decorated patterns and list the Pattern Name with suggested solid color to coordinate with it:

Pattern	*Coordinating Solid Color*
Blue Meadow	Sky Blue
Kismit	Sky Blue
Plain N' Fancy	Harvest Yellow
Ring of Roses	Fawn
Golden Twilight	Fawn
Country Garden	Sky Blue
Greenbriar	Mint Green
Sun Valley	Harvest Yellow

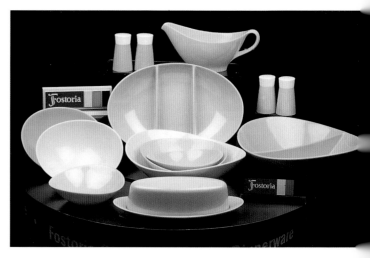

A variety of Fostoria Melamine including Gravy Boat, Covered Butter Dish, and Bowls in various sizes. These feature a sleek beveled edge design.

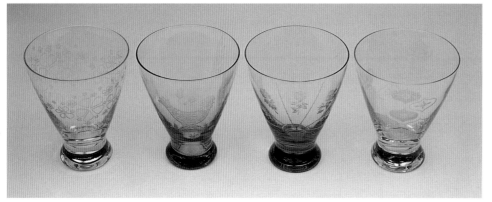

Fostoria designed Crystal Prints glassware to match the design and color patterns of the Melamine.

The January 1, 1959 Melamine Dinnerware Catalog offered the following:

Sixteen Piece Starter Set (four dinner plates, four cups, four saucers, four fruit/dessert bowls); *Five Piece Place Setting* (dinner plate, cup, saucer, soup/salad, bread and butter plate); *Twenty-nine Piece Service for six* (six dinner plates, six cups, six saucers, six soup/salad, one sugar and cover, one cream, one oval platter and one open vegetable).

The "Fostoria" logo name is moulded on the bottom of EACH PIECE of Fostoria Melamine. A collector will have to become familiar with the various design patterns and colors offered to be able to recognize the Fostoria glassware patterns that go with these lines.

Although the modern trend was to have unbreakable dinnerware with a casual flair, the offerings of the Melamine dinnerware by other manufactures of the time period seemed to quickly lose its appeal. The once shiny and bright table setting began to get dull and stained, repeated washings and scrubbings tended to fade the designs, knife cuttings and food stains stayed on the plates. The coffee and tea stains remained in the cups. The plastics claim to be "break-resistant" could not hold true as customers found that the dinnerware lines could chip, crack and/or break.

Unfortunately, Fostoria's Melamine introduction to the market place was in 1959 at a time when trends were quickly changing. In the early 1960s, the American public gave up its interest in unbreakable 1950s plastic dinnerware as Asian and European imports began to flood the marketplace with casual china at affordable prices. The modern lines of Fostoria Melamine were listed in catalogs for only two years, 1959 and 1960. The matching glassware disappeared from the catalogs in 1962. This remarkable milestone in Fostoria history of making "break-resistant" dinnerware quickly ended.

Pictured here are Fostoria's melamine decorated patterns.

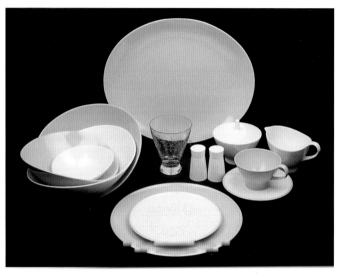

Blue Meadow Decoration #1 shown with Casual Flair Sky Blue accessories and White. Pictured with Sky Blue Goblet.

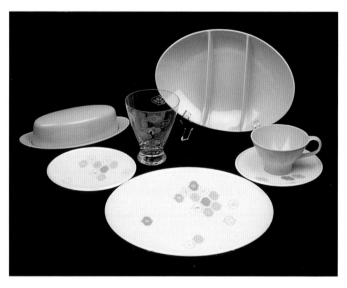

Kismet Decoration #2 is reminiscent of space age comets, popular in 1950s era modern decorating. Printed on White. Kismet was designed to mix with Casual Flair Sky Blue or White. Shown with matching glassware, Kismet Crystal Print Goblet.

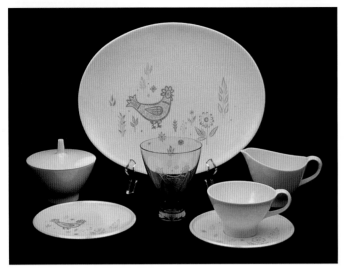

Plain n' Fancy Decoration #3, was produced in Harvest Yellow. The large chicken design is featured on the serving platters and plates. Serving bowls and accessories are used with Casual Flair in Harvest Yellow. Shown with matching Plain n' Fancy Crystal Print Goblet.

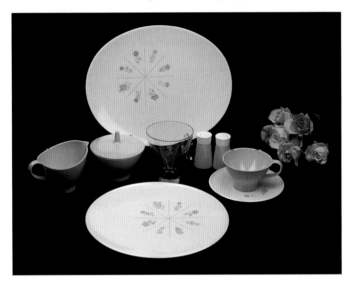

Ring of Roses Decoration #4 is one of my favorites done on the soft beige color called Fawn. Ring of Roses was designed on approximately 1/4 of the entire surface of the plates, not decorated on the bowls. Coordinate with Fawn color Casual Flair or White. Crystal Print Ring of Roses Goblet, Fawn color.

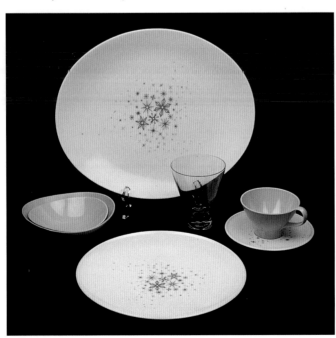

Country Garden Decoration #6 was one of the popular patterns with its sprinkling of flower motif all over the plate. Coordinates with Sky Blue or White Casual Flair. Sky Blue Goblet used here.

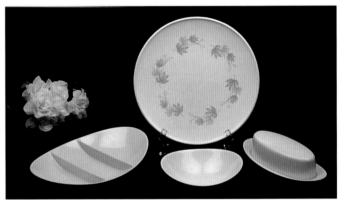

Greenbriar Decoration #7, a beautiful soft leaf design in the form of a wreath on this plate. Coordinates with Mint Green Casual Flair, or White. Both this design and the Mint Green colors are extremely hard to find, because of very limited production, it was introduced just shortly before the entire production line was stopped.

Golden Twilight Decoration #5, with a modern rendition of flickering stars, used with the Fawn or White Casual Flair, depending on your color scheme in the home. Matching Fawn Goblet.

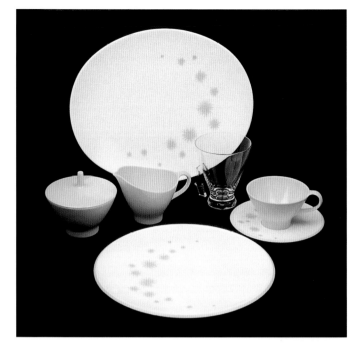

Sun Valley Decoration #8 was designed with sunny yellow dainty to coordinate with Harvest Yellow Casual Flair. This design is very limited. Sun Valley and Greenbriar are two patterns listed in the 1959 catalog, but not advertised previously in printed advertisements for Fostoria Melamine. It is believe these two were scheduled for release when the line was dropped suddenly from production and the catalogs, therefore these two decorations, #7 and #8, will be the hardest for collectors to find.

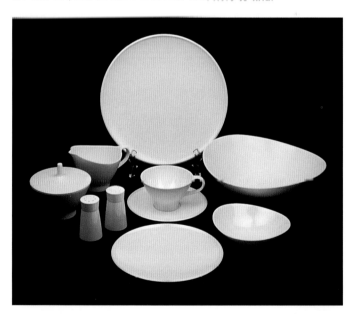

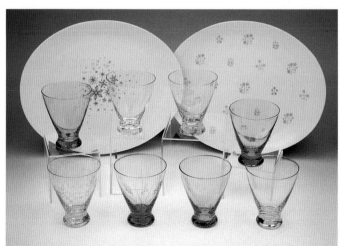

Value Guide for Fostoria Melamine

For the purpose of a value guide for Fostoria Melamine items on today's current market I have listed each item by the original catalog number with current value. Most difficult pieces to find are the shakers, sauce boat, sugar with cover, butter and cover. Values given are for **MINT** condition, solid colors no cracks, chips, food stains, coffee or tea stains, knife marks, or damage to the melamine. Fostoria original catalogs offered the Solid Colors "Casual Flair" for sale at less money than the Decorated items. For Decorated items in **MINT** Condition, add 25% to the value.

Values were derived from many sources, including dealers actual sales and prices collectors have paid, and on line Internet auctions. Collectors of 1950s plastic dinnerware will find Fostoria Melamine is very scarce on the market, having been produced for only two years. Very limited information has been documented for this Fostoria collectible until this publication.

Item #	Item	Value
1/554	10.5" Dinner Plate	$8
1/540	7.5" Salad Plate	$8
1/540	6" Bread & Butter Plate	$4
1/396	Cup	$5
1/397	Saucer	$5
1/421	Fruit/dessert bowl	$8
1/392	Soup/salad bowl	$9
1/676	Sugar & Cover	$15
1/680	Creamer	$9
1/836	Open Vegetable	$13
1/837	Divided Vegetable	$16
1/238	Salad Bowl	$13
1/622	3 part relish	$15
1/364	15" Buffet Platter	$16
1/541	13" Oval Platter	$14
1/300	Butter & Cover	$16
1/661	Sauce Boat	$15
1/661	Shaker with top	$8

This book is intended only to be a guide when determining what an item is worth. The collector will ultimately decide what to pay for a specific item.

Center left:
White Casual Flair produced to coordinate with all eight patterns of Melamine. These were not listed in the advertising of Casual Flair, but packed in with the boxed sets of Melamine as accessory items. All items were available Open Stock and coordinated with any pattern.

Casual Flair plain matching glassware were Sky Blue, Fawn, and Harvest Yellow. The Crystal Print etching designs include eight patterns named the same as the Melamine; Blue Meadow, Kismet, Plain n' Fancy, Ring of Roses, Golden Twilight, Country Meadow, Greenbriar, and Sun Valley.

Chapter Six
Fostoria Elusive Fruit, Animals, and Figurals

Romance and fruit go hand in hand, bunches of grapes, delicious apples… tastes so tempting, the designers of Fostoria must have had these thoughts in mind when they designed glass fruit, first introduced in 1934, in rich, luscious, colors.

A remarkable Versailles Etching #278 Bowl filled with #2512 Fostoria's Fruit.

The #2512 line of glass fruit consisted of a total of six fruit designs: Grapes, Apple, Orange, Banana, Pear, and Peach. They appeared in bold colors and silver lined in the July 1934 catalog supplement. They were nationally advertised in magazines for Christmas sales. The original 1934 ad featured the fruit in a Baroque bowl. The advertisement is recreated here with a complete set of #2512 Glass Fruit as shown in the original ad, utilizing a very scarce Azure Bowl with Versailles etching #278, elusive indeed!

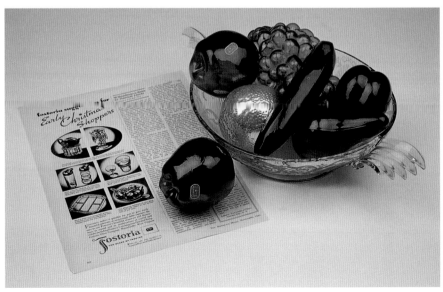

Fostoria's elusive #2512 Glass Fruit circa 1934.

There were six glass fruit items produced in the bold colors of Regal Blue, Burgundy, Empire Green, and Silver Decoration. The Silver decorated glass fruit required additional steps in production to apply the silver lining inside the crystal glass, therefore, at the time of introduction in July 1934 the price of the Silver decorated was higher than the colored fruit. Each type of Glass Fruit has one value according to size, regardless of color or design, based on known recent sales, Internet auctions, and dealer input. Each piece of Glass Fruit would have had a Fostoria brown label on them. All Glass Fruit items are hollow inside, blown into a mould. The Fostoria Fruits were designed and sized as real fruit; they are very difficult to display as they roll. Perhaps this design flaw contributed to the short run of these items.

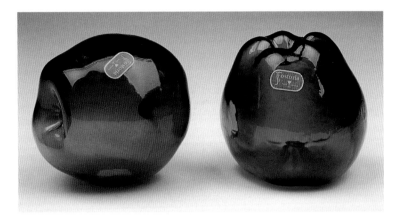

#2512 Apple is shaped the size of a Red Delicious apple, approximately 3.25" diameter, hollow center with small opening near the stem. **Left:** Burgundy Apple **$250+**; **Right:** Empire Green Apple. **$250+**.

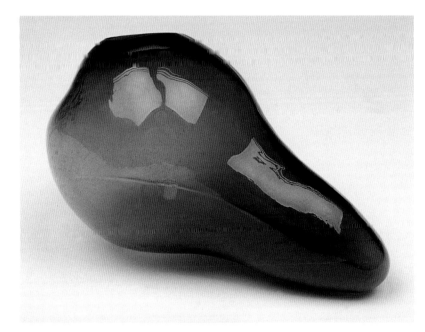

#2512 Burgundy Pear is shaped the size of a large pear, 5.25" length, hollow center with small opening at the stem point. **$250+**.

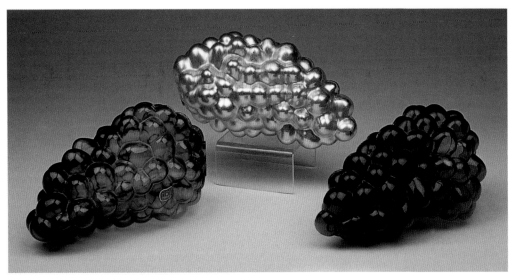

#2512 Grapes are very large size, hollow bunch. In handling these grapes, they appear to be the most delicate of the glass fruit due to the size and shape, and would have been easily shattered. **Left to Right:** Emerald Green, Silver Decorated, Burgundy cluster of grapes 7.25" length. **$275+ each.**

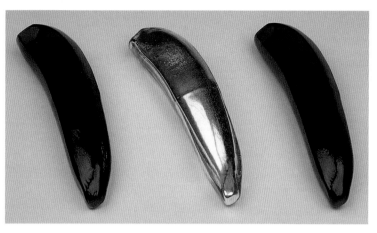

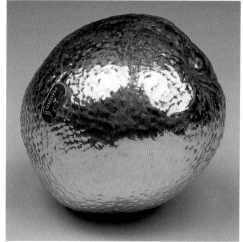

#2512 Banana the actual size and shape of a Chiquita banana, elongated blown glass with hollow center, and opening in top at stem. The silver deposit is applied to the inside the crystal fruit. **Left to Right:** Burgundy, Silver Decorated, Regal Blue. 7.5" length. **$265+ each.**

#2512 Orange is a perfect example of the wonderful design work of Fostoria to capture the texture of orange peel on this perfectly sized orange. This example is with the Silver Decoration, hollow center. 3.75" diameter. **$265+.**

#2512 Peach, Burgundy, the luscious deep color temps you to take a bite. The peach is smaller in size proportion than the other glass fruit, more like a perfect plum. Very light weight, approximately 2.75" diameter. **$250+.**

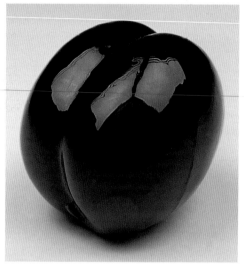

Delight in the color of glass, the brilliance of crystal, its transparency, the play of light flickering through it, the glamorous reflections, is a joy multiplied because it is inherited from countless generations of beauty-lovers. Today American glass is designed in a variety of lovely shapes and exquisite color. The experience of the ages is at the disposal of the people who make, from the special snow-white sand mined in the mountains of West Virginia, the finest modern American glass – Fostoria. Quote from Fostoria Advertisement, 1934.

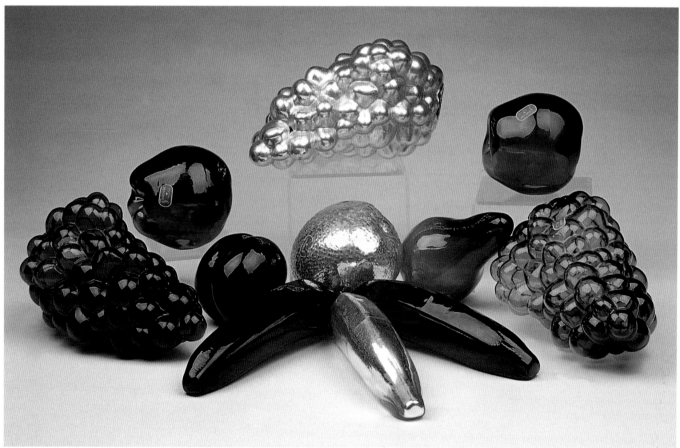

110

Fostoria Animals and Figurals

The unique designs of Fostoria figurals and animals first introduced in the 1930s continue to appeal to collectors today. The first to appear, in the 1934 catalogs, were the Fish Seafood Cocktail and Fish Cream and Sugar produced in the same bold colors as the Fostoria Glass Fruit: Burgundy, Regal Blue, Empire Green, and Ruby, Crystal and Silver Mist were also offered in the catalogs.

In 1935, Fostoria introduced four wonderful animals as "Table Charms" new decorative pieces of high good humor. These were the Penguin, Pelican, Seal, and Polar Bear. In these modern designed innovations for your table, console, or buffet, Fostoria master craftsmen have created birds and animals of glass and have given them all a sly touch of humor that makes them seem to join in your enjoyment. A 1935 Fostoria advertisement for these Table Charms reads, *"In every home there is a need for these unusual decorative pieces. They add just that proper tone of smartness and interest to an otherwise barren spot. As a gift, bridge or door prize they are always acceptable."* The four original "Table Charms" were produced in Crystal, Silver Mist, and Topaz color. The Fostoria Glass Society of America purchased the Pelican mould from Lancaster Colony in 1987. The FGSA has produced the Pelican as a commemorative item limited edition color each year thereafter; these are clearly marked FGSA, and the date produced. The one exception is the Amber Pelican, first produced for FGSA; it bears no marking or date. The 2003 commemorative Pelican was made in Yellow Burmese by the Wilkerson Glass Company, Moundsville, West Virginia. The Wilkerson Glass family had three generations of family members work at Fostoria 1939-1986.

The Fostoria Horse, Eagle, and Elephant Bookends were made in Crystal and Silver Mist and were shown in catalogs from 1939 through 1943. In 1980 these were produced in Ebony, as a short run experimental item sold only through the Fostoria Factory Outlet stores. In 1943 Fostoria made a set of Owl Bookends in Crystal and Silver Mist. Production was limited to one year only on these items. Between 1940 to 1943, Fostoria catalogs offered the Reclining and Sitting Colt and Deer in Crystal and Silver Mist. The Colt and Deer moulds were produced in Milk Glass in the 1954 to 1958 catalogs. The Standing Colt and Deer was produced in Blue glass, by special order and limited number for Blue Colt Collectibles in 1980.

The 1950s saw the introduction to many new animals and figurines. William Dalzell con-

tracted with the Ann Donahue Studios of New York to design animals and figurals that included the Chanticleer, Sea Horse, Mermaid, Lute, Lotus, Buddha, Madonna, and St. Francis. The Chanticleer was produced in Crystal and Ebony and in Milk Glass (also a limited test run with a modified design on the tail in Milk Glass). Both Madonna and St. Francis were produced in Crystal and Silver Mist and offered with or without a lighted base. The crystal Duckling family, Squirrels, and a playful pair of Goldfish were offered in catalogs from 1950 through 1957. The #4165 Santa Claus Cookie Jar was produced for a six-month period only in July 1955. It is believe there were design flaws that resulted in too many breaking during production; therefore, production was stopped on this item. The Hen and Nest Covered Box was produced from 1957 to 1959 in White, Aqua, and Peach Colored Milk Glass.

In the 1960s, the Ducking Family and Squirrels were produced in variety of colors. These colors include Amber, Cobalt, Olive Green, Amber Mist, and Olive Green Mist. In 1965, a variation of the original Seafood Cocktail Fish had been introduced as "Flying Fish" produced in beautiful colors of Teal Green, Ruby, and Lavender. As these items were handmade and swung out to form a vase, each item varies in height; no two flying fish are exactly alike.

During the last two decades of Fostoria's production in the 1970s to 1980s, we saw the introduction of animal designs by Fernando Alvarez that included a Cat, Bird, and small Whale. Contributions from art students at the Philadelphia School of Art designed a Stork and Small Rabbit for Fostoria. Jon Saffell contributed to designs in 1979 of a Lady Bug and Frog, and a three-piece Nativity sculpture that was a limited edition. In 1980 Jon Saffell designs included his Lion, Ram, and Dog Animal Head Ashtrays. Fostoria figurals are whimsical and fun to collect.

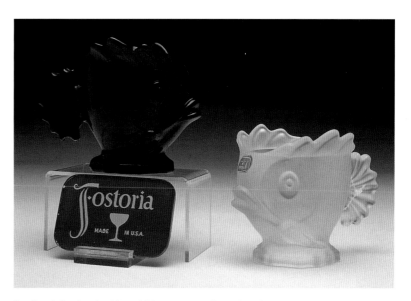

Seafood Cocktail 1934-1938 was one of the first figural items issued by Fostoria. **Left:** #2497 Seafood Cocktail, Regal Blue 3.25" tall, 5" long. **$35**; **Right:** #2497 Seafood Cocktail, Silver Mist 3.25" tall 5" long. **$32.**

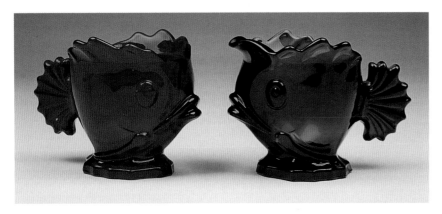

Left: #2497 1/2 Fish Sugar Bowl, Ruby, 1934-1936, 3.25" tall, 5" long. **$35; Right:** #2497 1/4 Fish Creamer, Emerald Green, 1934-1936, 3.25" tall, 5" long. **$35.**

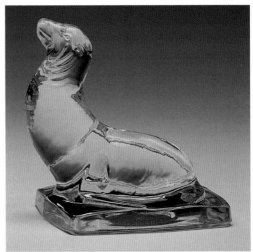

#2531 Penguin, Topaz/Gold Tint, 1936-1939, 4.6" tall, 1.8" wide. **$95.**

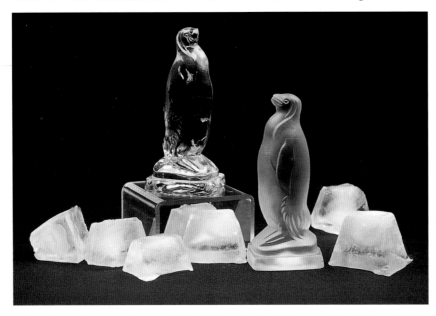

Left: #2531 Penguin, Crystal, 1935-1943. 4.6" tall, 1.8" wide. **$75; Right:** #2531 Penguin, Silver Mist 1936-1943, 4.6" tall, 1.8" wide. **$65.**

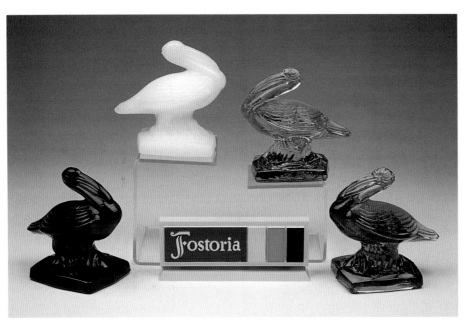

#2531 Seal, Crystal, 1936-1943, 3.75" tall, 3.75" wide. **$75.**

#2531 Pelican, all shown are FGSA issued after 1987. **Left to right top:** Milk Glass and Blue; **Bottom row:** Cobalt and Amber. Amber one not marked, all others marked FGSA. These measure 3.9" tall, 4.25" wide. **$55+.**

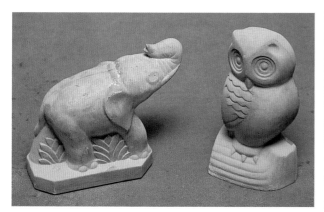

Original design models produced by Ann Donahue Studios in New York for the Elephant and Owl Bookends, circa 1942. These were used as master models from which the iron moulds were made. **NDV.**

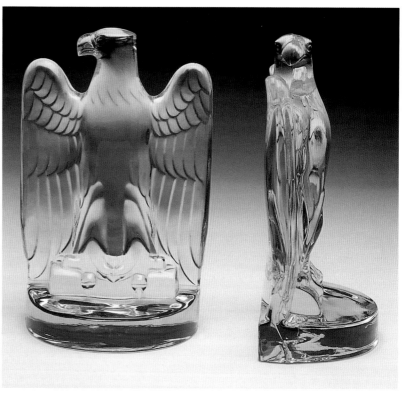

#2585 Eagle Bookends, Crystal, 1940-1943, 7.5" tall, 4.5" wide. **$195 pair.**

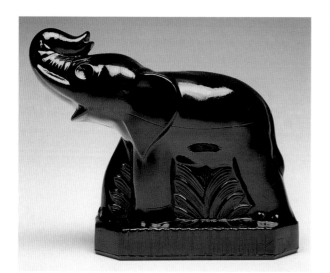

#2500 Elephant Bookend, Ebony, circa 1980. 6.25" tall, 7.5" long. **$175 each.**

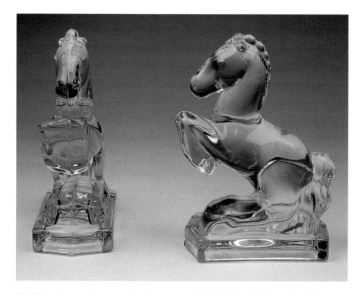

#2564 Horse Bookends, Crystal, 1939-1942. 5.75" tall, 7.6" long. **$125 each.**

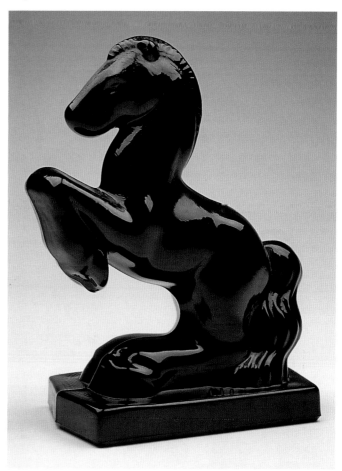

#2564 Horse Bookend, Ebony, circa 1980. 5.75" tall, 7.6" long. **$155+ each.**

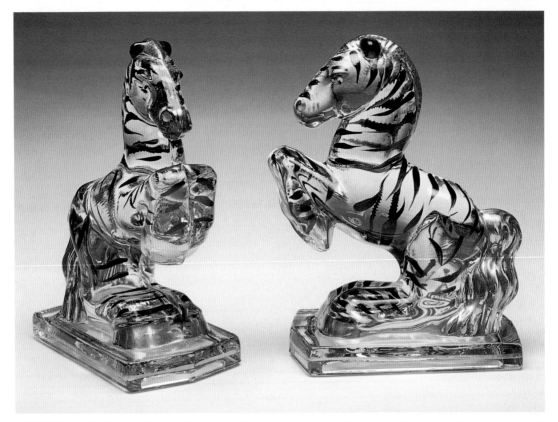

#2464 Horse Bookends, Crystal, Charleston Decorated to resemble a pair of Zebra, gold decoration and enamel painting, outstanding set. 5.75" tall, 7.6" long, circa 1942. **$195 each.**

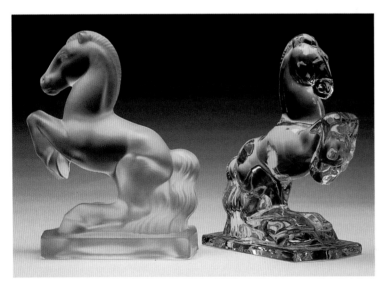

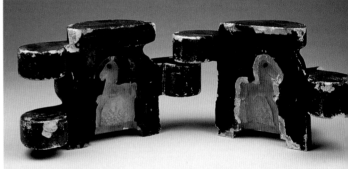

This is the original mould for pressing the #2589 1/2 Colt reclining. *Courtesy of a private collector of Fostoria animals and memorabilia.*

#2464 Horse Bookend, Silver Mist. Comparison of similar mould by New Martinsville Glass, Crystal. **Left:** Fostoria Horse in Silver Mist, detail to note is the mane is combed and the base of the Fostoria horse is much thicker and hollow inside. **Right:** New Martinsville horse is similar in size and mane design, however the base of this is much thinner and partially hollow. Fostoria Horse Bookend in Crystal or Silver Mist, circa 1940-1943. **$125 each.**

#2589 1/2 Colt, reclining, Silver Mist 1940-1943, 2.4" tall, 2.75" long. **$30.**

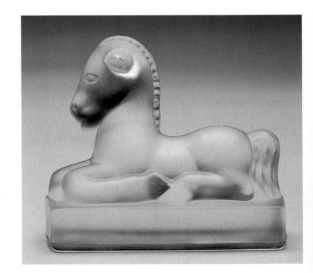

114

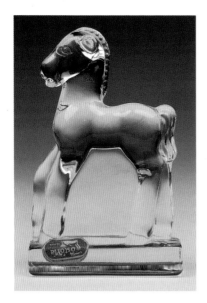

#2589 Colt, standing, Crystal, 1940-1943 with original Fostoria brown label. 4" tall, 4.25" long. **$35.**

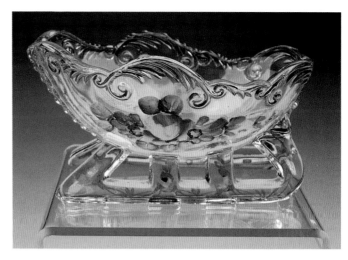

#2595 Sleigh, Charleston Decorated, Crystal, circa 1940. 2" tall, 4.25" long. **$68.**

Left: #2589 1/2 Deer, reclining, Milk Glass, 1954-1958, 2.4" tall, 2" long. **$30; Right:** #2589 Deer, standing, Milk Glass, 1954-1958, 4.25" tall, 2.1" long. **$40,**

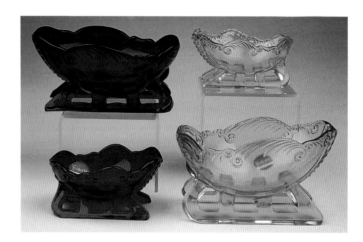

#2595 Sleigh, Circa 1980-1982. **Rear left to right:** Ruby, 3" tall, 6.1" long. **$52;** Light Blue, 2" tall, 4.25" long. **$35; Front left to right:** Ruby, 2" tall, 4.25" long. **$38;** Light Blue, 3" tall, 6.1" long. **$45.**

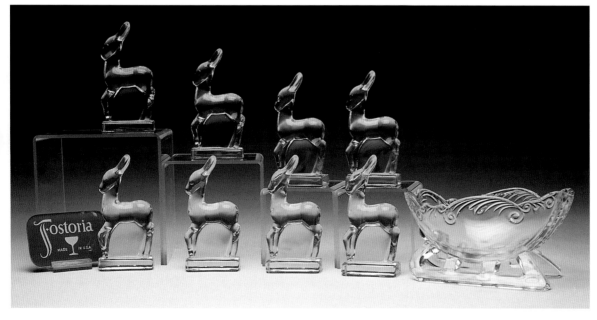

Deer with Sleigh; you could decorate with your Fostoria for holiday fun! Eight #2589 Deer, standing, Crystal, 1940-1943, 4.25" tall, 2.1" long. **$35 each.** Shown with Fostoria #2595 Crystal Sleigh, 1980-1982, 3" tall, 6.1" long. **$45.**

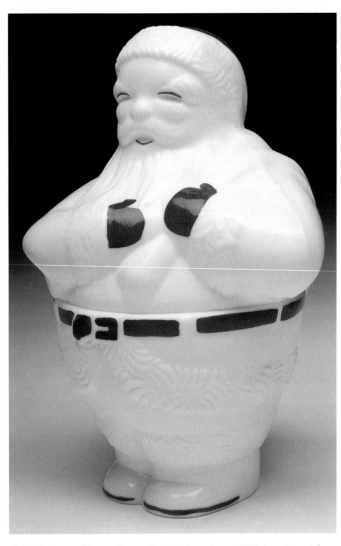

#4165 Santa Claus, Santa Cookie Jar, circa 1955 (produced for six months only). This one made of Milk Glass, with hand painted red trim. 9" tall, 7" wide. **$350+.**

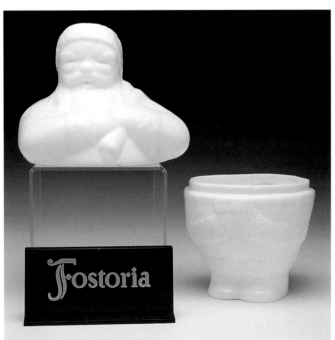

#4165 Santa Cookie Jar, Milk Glass, 9" tall, 7" wide, shown here in two parts. There was believed to have been a design flaw in the body size and shape of this mould. Santa was easily broken getting the body parts out of the mould. Circa 1955 (produced for six months only). **$350+**

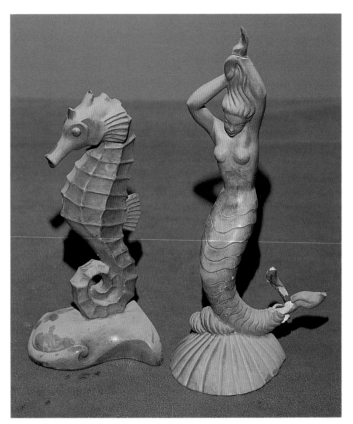

Seahorse and Mermaid, Original design models produced by Ann Donahue Studios in New York. These were used as master models from which the iron moulds were made. Circa 1950. **NDV**

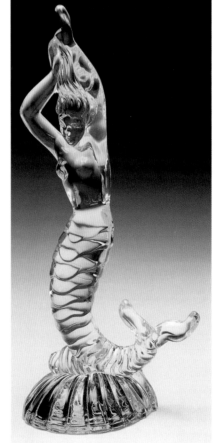

#2634 Mermaid, Crystal 1950-1958. Front view shown here, 10.25" tall, 5" long. **$175.** Not pictured the #2634 Floating Garden Bowl, 13" diameter, offered in catalogs as a center-piece base for the Mermaid. The value of 13" bowl **$85.**

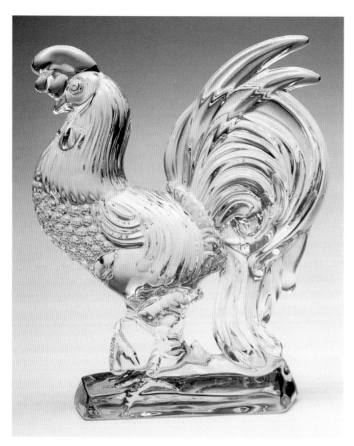

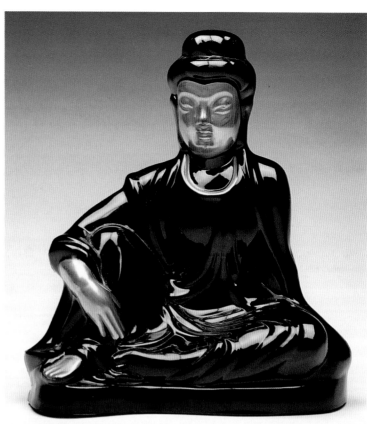

#2629 Chanticleer Rooster, Crystal 1950-1958, 10.75" tall, 8.25" long. $275. Not pictured. Ebony Chanticleer, circa 1953-1957. $500; Ebony with Gold Decoration, circa 1954-1957. $600+.

#2626 Chinese Bookend, Buddha, Ebony with Gold Decoration, circa 1957. 7.25" tall, 6.75" wide. $375.

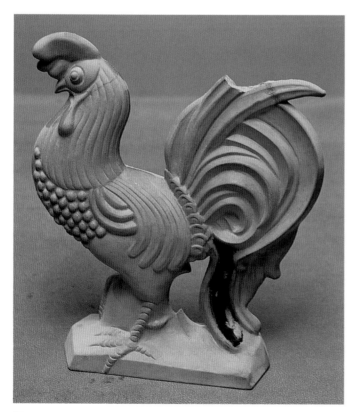

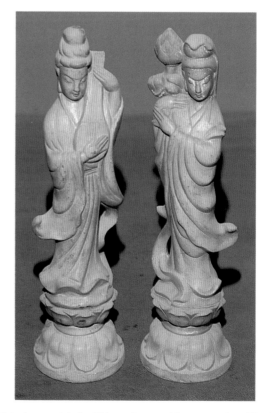

Chanticleer Rooster original design model produced by Ann Donahue Studios in New York, circa 1950. In Milk Glass production the tail would break off when removing the glass from the mould. This original mould was modified circa 1957 (tail appears to be broken off this model) however, the modification to the mould didn't improve the production problem, therefore, any Milk Glass Chanticleer is scarce. $700+.

Original design models for Chinese Lute and Lotus, produced by Ann Donahue Studios in New York. These were used as master models from which the iron moulds were made. The Chinese Lotus stood 12.25" tall, had a plain horizontal hair effect and carried a vessel. The Chinese Lute stood 12.25" tall had a more ornate hair design and is playing a lute. NDV. Not Shown: The Chinese Lute and Lotus are 12.25" tall, produced in Silver Mist circa 1956-1963. $175 each. They were produced in Ebony with Gold Decoration circa 1957. $450+ each.

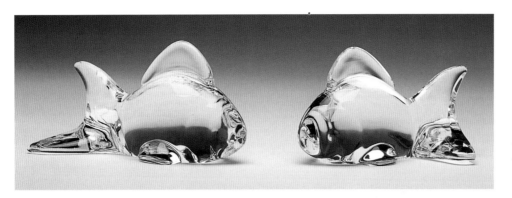

#2633A Gold Fish, (horizontal) Crystal, 1950-1957, 1.25" tall, 4.1" long. **$165 each.**

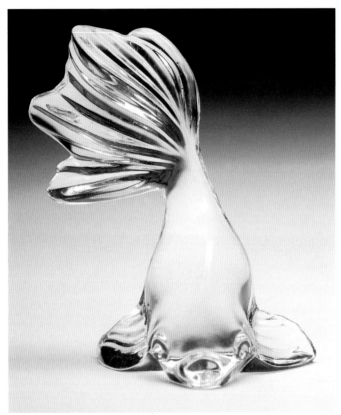

Left: #2821/420 Frog, Olive Green, 1971-1973, 1.75" tall, 3.5" long. **$45; Right:** #2821/410 Whale, Blue, 1971-1973, 3.25" tall, 2.75" wide. **$40.**

#2633B Gold Fish, (vertical) with tail up, Crystal, 1950-1957, 3.5" tall, 2.5" long. **$175.**

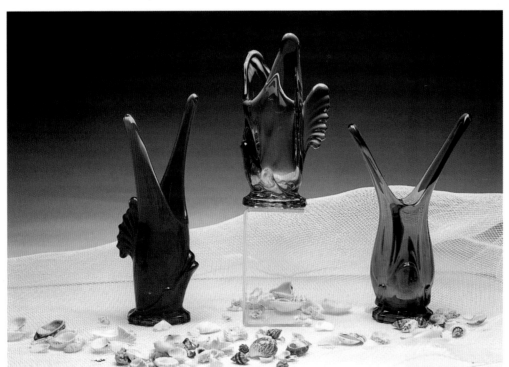

#2497/787 Flying Fish Vase, these were produced circa 1965 from the original 1934 seafood cocktail mould swung out to create a vase. **Left to right:** Ruby Flying Fish, 7" tall, 3.25" long. **$55;** Lavender Flying Fish 5.75" tall, 3.25" long. **$45;** Teal Green Flying Fish, 6" tall, 3.25" long **$45.**

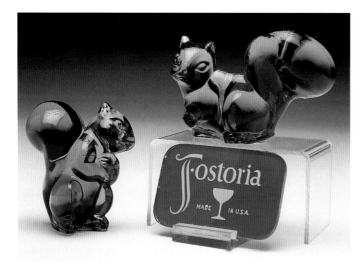

Squirrels, (two pieces in the set) Olive Green, 1964-1973. **Left:** #2631/702A Squirrel, sitting, 3.25" tall, 2.5" long. **$35;** **Right:** #2631/702B Squirrel, running, 2.5" tall, 4" long. **$35.**

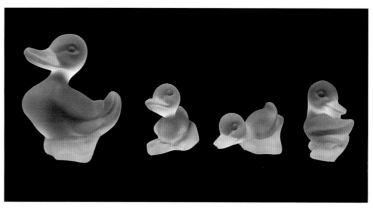

#2632 Duckling Set, Silver Mist, circa 1950-1957. **Left to right:** #2632/404 Mama Duck 4.25" tall **$45;** #2632/406 Duckling "B" heads up walking, 2.4" tall. **$28;** #2831/407 Duckling "C" head down, 1.5" tall. **$28;** #2631/405 Duckling "A" head back, 2.5" tall. **$28.**

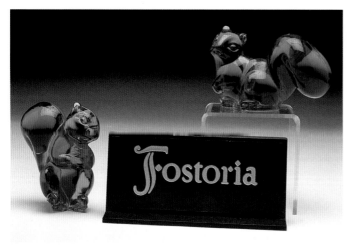

Squirrels, (two pieces in the set) Cobalt Blue, 1965-1973. **Left:** #2631/702A Squirrel, sitting, 3.25" tall, 2.5" long, **$55;** **Right:** #2631/702B Squirrel, running, 2.5" tall, 4" long. **$55.**

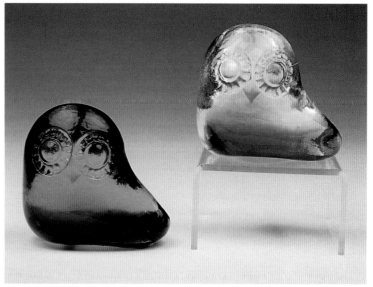

Left to right: #2821/527 Owl, Lemon, 1971-1973, signed Fostoria on the bottom. 2.75" tall, 3.25" wide. **$40;** #2821/527 Owl, Crystal, 1971-1973, 2.75" tall, 3.25" wide. No signature on bottom. **$35.**

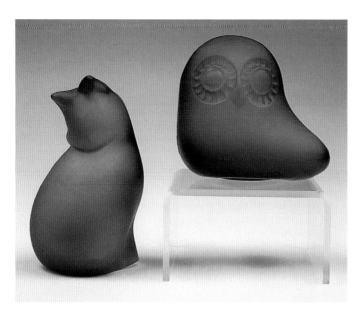

Left: #2821/357 Cat, Olive Green Mist, 1971-1973, 3.25" tall. **$40; Right:** #2821/527 Owl, Olive Green Mist, 1971-1973, 2.75" tall, 3.25" wide. **$40.**

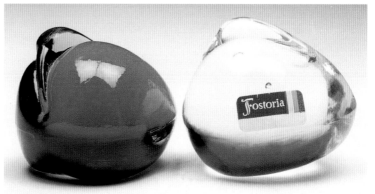

#2821/304 Stork, circa 1971-1973. Design contributions from the art students at the Philadelphia School of Art. **Left to right:** Stork, Olive Green, Fostoria signature on bottom, 2.35" tall 2.75" long. **$35.** Stork, Crystal, Fostoria signature on bottom, 2.35" tall, 2.75" long. **$38.**

119

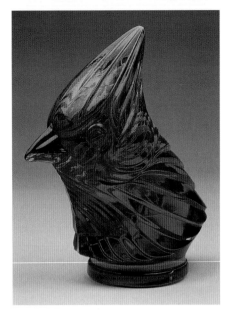

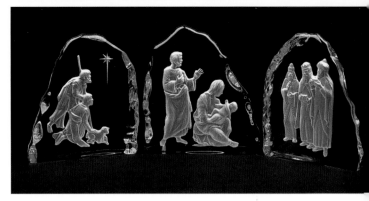

Nativity Sculpture, Limited Edition Series, designed by Jon Saffell. Each item came with a limited edition series card, numbered and in a velvet box, original issue price of these was $125.00 each. **Left to right:** The Shepherds was the last of the series issued 1981. **$250**; The Holy Family was the first issued in series, 1979. **$250**; The Magi was the second issue in series 1980. **$250**.

Cardinal Head, Ruby. Fostoria designer Jon Saffell worked with Bill Bradford to create the model for the mould for this cardinal head. This item was produced by Fostoria as a special order for the Frederick Crawford Museum, Western Reserve Historical Society, circa 1980s. Special orders produced in Silver Mist and Ruby. This Ruby is not a true deep ruby red, appears to be transparent like cranberry. **$65**. It is believe the original color run of this custom order was not true ruby and rejected. These original transparent like Cranberry Cardinal Heads were ordered liquidated at the Factory Outlet Store in the early 1980s.

Saint Francis, Silver Mist, 1957-1973, 13.24" tall, 3.6" wide. **$325**.

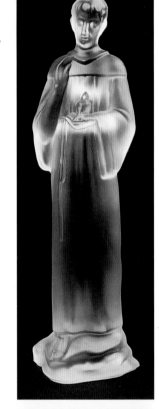

Unique design sculptures/ash trays by Jon Saffell, production limited to eighteen months only, 1980-1981. The frosted crystal design has a dual function – standing up, these are intended to be used as animal sculpture decorative items while laying down they are designed to be used as ashtrays. **Left to Right:** #FU01/116 Lion **$45**; #FU02/116 Ram, **$45**; and #FU03/116 Hound, **$45**.

Madonna #2635, Silver Mist, 1967-1973 was produced in three sizes. **Left to right:** Madonna #2635, 1967-1973, 10" tall. **$85**; Small Madonna, Silver Mist, sold through Fostoria outlet stores circa 1970, 6.75" tall, 1 1/2" wide at base. **$24**; Tiny Madonna, Silver Mist, sold at Fostoria outlet stores circa 1970, 4.1" tall, 1" wide at base. **$18**. Not pictured: Crystal or Silver Mist Madonna with lighted ebony base, 11.6" tall, **$150**.

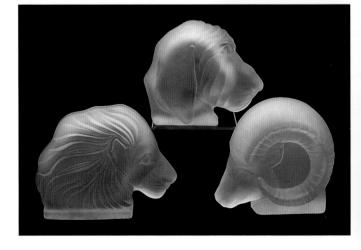

Fostoria as Gifts

Consider the Gift of Fostoria and think of these things: Footed tumblers, Cocktail Glasses, Goblets, Ice-tea glasses, Teacups; A pair of Compotes for candies and nuts; A Candy Jar or a Candy Box; Cigarette Boxes and Ash Trays; A Cake Plate; Salad Plates and a Salad Bowl; A Sandwich Tray; Rose Bowls and Vases; Ice Tub; Salt and Pepper Shakers; A Complete Dinner Service; A Refreshment Set, a Luncheon Service or a Breakfast Set!!! Look for the Fostoria label, the little-brown-and-white label guarantees genuine Fostoria. Every piece of glassware leaves the factory carrying this label. Quote from *Fostoria, New Little Book About Glassware,* 1926.

If you could only imagine and have a total count of the enormous number of gift items that were handmade daily for nearly one hundred years of Fostoria Glass production one would venture to say there would be more than several million pieces of beautiful glass. For this chapter of gifts I have chosen to include a sampling of some of the items that were target marketed specifically as "Gift Items" for the bride and for the housewife for Special Occasions and Holidays.

Fostoria Bells "Let Freedom Ring"

Fostoria Glass Bells are unique treasures, for each design was produced for a short time period, limited edition holiday, and special occasions. You may find scarce Fostoria bells in etched patterns from early years, such as the Orchid Vernon bell shown in this chapter, however, early pattern bells were never listed in any catalog. Often, when the stem or foot of a goblet was damaged, the stem would be cut and ground so that it was smooth. Then a clapper would be added to make the goblet into a bell. Some early bells were experimental items and never put out. Others were created on lunch hours and traveled home with the worker for a special gift.

It is interesting to note that the Avon holiday bells made by Fostoria had porcelain clappers in Christmas shapes of a snowflake, dove, tree, or angel. It is thought the clapper inventory was sold in bulk at the close of the factory. Several boxes of these clappers of mixed designs have been sold to Fostoria collectors to use as miniature Christmas ornaments. Another interesting note is that several of the Navarre Crystal and Azure Bells have been seen with a Ruby glass clapper. It is assumed this was done for Christmas or as a Valentine's Day special order.

Collectors may notice that bells with an etching such as Navarre, Heather, and Vernon appear to have the etching upside down. This is because leaving the foot off the standard production goblet created the bells and finishing the stem for the handle, the clapper was added and when used as a bell, the pattern design is upside down. There are two exceptions to this design process discovered in my research: The Navarre etching #327 Bell produced in Crystal for Avon was made using the #6026 Greenbrier Blank; collectors can notice the design difference in the stem and handle of the bell, and the height varies by one inch. The Fostoria Chintz Etching #338 was produced on #6049 Blank, making the handle of this bell a different style than the standard goblet. The Chintz Bell was commissioned in the 1970s by the Willamette Valley National Bank in Portland, Oregon, and given as a gift for opening an account with the bank. The Chintz Bell was made only for this bank promotion and not sold through department stores or featured in the catalogs.

Fostoria first introduced Dinner Bells in matching patterns of Navarre, Richmond, Serenity, and Sheffield in catalogs in the 1970s. Fostoria made Bells for special occasions, Valentine's Day, Mother's Day, and Christmas, as well as Commemorative Wedding Bells for custom orders. In 1979 Fostoria introduced "The Wedding Bell" a figural bell that depicts a Bride. The top handle (head) is finished in a frosted silver mist, with the bottom bell being of clear crystal.

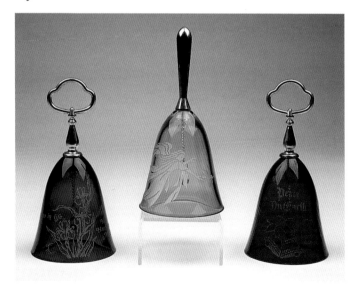

Left to Right: Mother's Day, Cobalt Bell. **$95;** Holiday Bell, Green Angel. **$95;** Peace on Earth, Ruby Bell, 1986. **$110.**

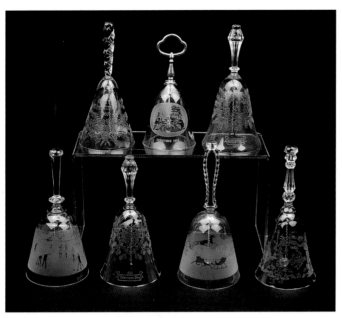

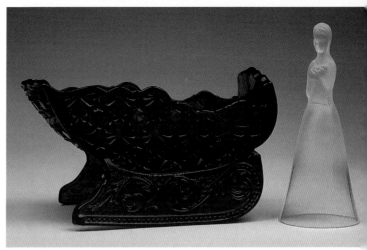

Fostoria Special Collection of Bells.
Top row left to right: 1980 Merry Christmas Bell. **$95;** 1972 Coca Cola Christmas, Brass Handled Bell. **$85;** 1979 Christmas Holly Bell. **$95; Front row left to right:** 1978 Ice Skater Bell. **$95;** 1979 Valentines Day Bell. **$95;** 1977 Sled Ride Bell. **$95;** 1980 Navarre Avon Team Leader Bell (notice the #6029 Greenbrier stem handle). **$145.**

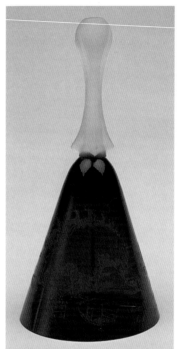

Daisy and Button Sleigh, Ruby. This was contract work; Fostoria pressed this sleigh for L.G. Wright Company, who owned the mould. Sleigh 4.5" tall, 11" long. **$200;** The Wedding Bell, produced 1979-1982. The Wedding Bell features a figural bride produced in Crystal with Silver Mist finish on upper half of the body. 7.25" tall. **$135.**

Holiday Bell, 1981. Night Before Christmas, beautiful Ruby with Silver Mist handle. According to production data from Jon Saffell, this was to be the first of a series of four holiday bells designed in hand blown Ruby. In 1982, Fostoria stopped production on hand blown ware, therefore, this was the only one released from the planned series. **$155.**

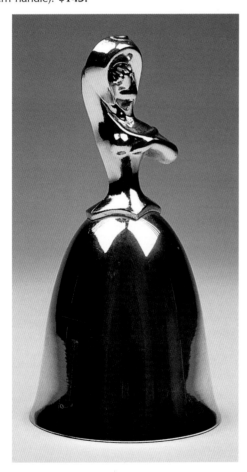

This elegant figural Lady Bell was a new mould sample discovered in the design morgue at the close of the factory in 1986. This bell was created using silver metal chrome overlay on the glass figurine. Believed to be one of a kind. **$185+.**

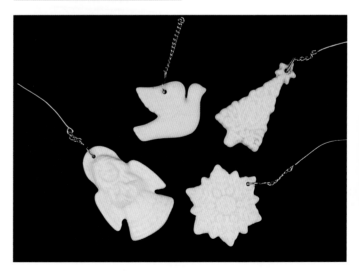

Featured here are the porcelain clappers that Fostoria put into the series of holiday bells produced by special order of the Avon Company. **Left to right:** Angel 1.75"; Dove 1.25"; Tree 1.25"; Snowflake 1.45"; all in white porcelain. Leftover inventory of these were sold in bulk when the factory closed in 1986. In 1992 these clappers were sold (by the dozen, four of each design) at $20 dozen to collectors as miniature Christmas ornaments. 2003 values, $3 each. **$36+ dozen.**

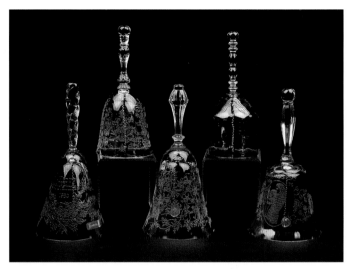

Top row Left to right: Crystal Navarre Etching #327 Bell with Ruby Clapper circa 1977 (notice the Wilma stem handle). **$165;** A special order Bell produced on #6127 Festive stem, circa 1970 Yellow Bowl with Ruby Clapper. **$110; Front row left to right:** Merry Christmas 1980 Etched Holly Bell. **$110;** Chintz Etching #338 Bell, special commission circa 1970. **$185;** Mother's Day 1979 Bell, etched mother and child inside an oval frame with delicate floral decoration. **$110.**

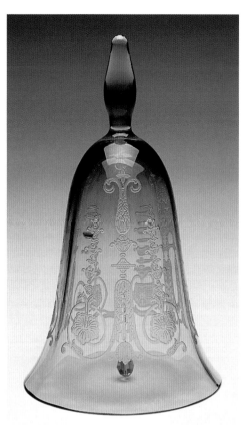

Scarce Vernon Etching #277 Bell, Orchid, 1927. This outstanding bell was created from a Orchid Vernon Goblet, with foot ground off and polished, clapper added to make this one-of-a-kind bell. (Perhaps a lunch hour whimsy). **NDV.**

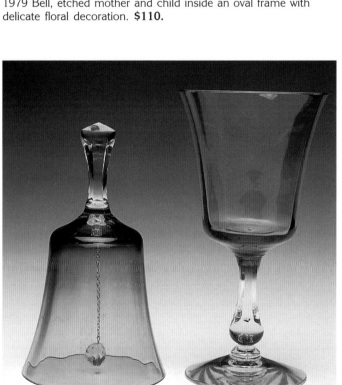

#6071 Harvest Bell. This one-of-a-kind bell was created from a #6071 Harvest Goblet with a broken foot on the stem, foot was ground off and polished, the clapper added to make the bell, circa 1980. (Perhaps a lunch hour whimsy). **NDV.**

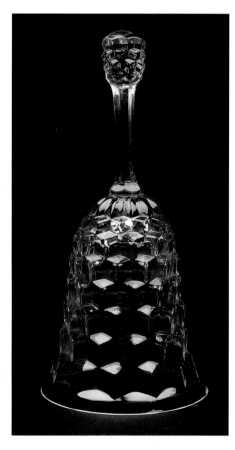

A grand prize for the Fostoria collector is the #2056 American Bell designed by Jon Saffell, and introduced into the catalogs July 1981. Unlike the heavy pressed American Pattern, Jon Saffell designed this #2056 American Bell to be hand blown. Unfortunately, Fostoria ended the production of hand blown ware early in 1982 as the company was struggling with the high cost of production at that time. This ended of an era of handmade glassware at Fostoria. This delicate, lightweight beauty is scarce with production less than one year, and sought after for its historical significance. **$550+.**

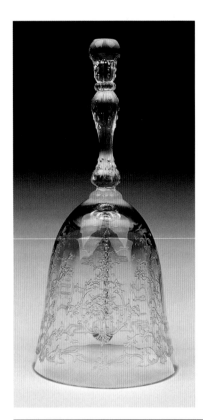

Navarre #327 Bell, Azure Blue, 1976-1982. 6.25" tall. **$135;** Not shown: Navarre #327 Bell, Pink, 1976-1978. 6.25" tall. **$125.**

Fostoria Commemorative Bell, with metal handle, was produced by the Moundsville Chamber of Commerce commemorating the date the Fostoria factory was closed. The bell is etched featuring the Fostoria Brown Label, est. 1887, Moundsville, W. Va. Feb. 28, 1986. **$85.**

Special commemorative Centennial Liberty Bell, Crystal, etched 1886-1986 Statue of Liberty. 7" tall. **$95.**

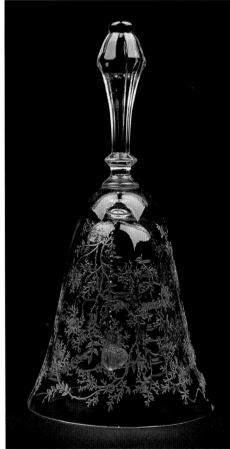

Chintz #338 Dinner Bell was a special commission by the Willamette Valley National Bank in Portland, Oregon circa 1970 and given as a gift to customers who opened a bank account with the bank. This bell was produced on #6049 stem blank. This was not a catalog item and not sold through department stores. 7.25" tall. **$185+.**

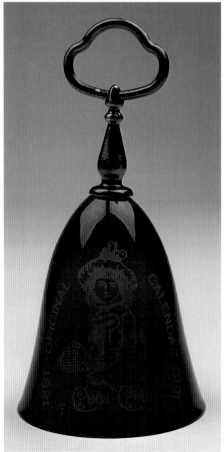

Ruby Flashed Bell produced by special commission for the Centennial of the Coca Cola Company. This lovely bell features the calendar girl from 1891 Coca Cola Calendar etched in the glass. **$125.**

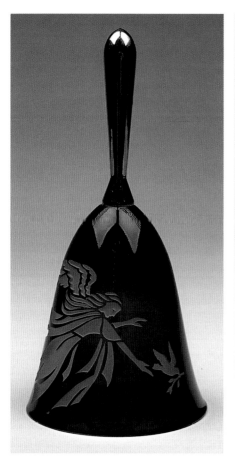

Cobalt Christmas Bell designed by Jon Saffell circa 1981. Sampled only. The lead crystal glass bell was stained with a cobalt blue dye and the Christmas Angel design was sand cut into the glass through the blue stain, creating this elegant cut to clear, Cobalt Christmas Bell. This sample item believed to be one of a kind. **$155+.**

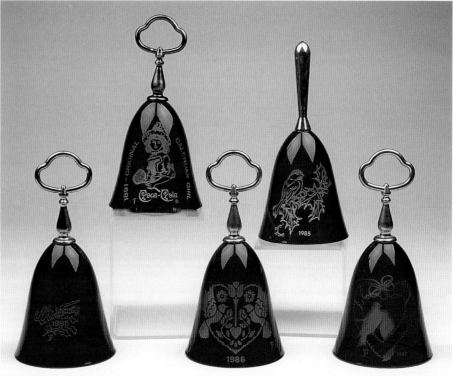

Fostoria Ruby Bells with metal handles. **Top row left to right:** 1891 Coca Cola Commemorative Bell. **$125;** 1985 Holiday Ruby Flash Bell. **$125; Front row left to right:** 1985 Christmas Holly Bell. **$110;** 1986 Love Bell, Ruby Flash. **$110;** 1987 Love Birds, Ruby Flashed, gold metal handle. **$110.**

Glassware for the Bathroom and Bedroom

Once upon a time perfume bottles and tear bottles and little glass jars were treasures for princesses. They were cunningly wrought and precious as jewels. Today powder jars and perfume bottles, jewel boxes and trays of glittering glass can belong to every woman who loves to have pretty things on her dressing table. Fostoria makes all these; Vanity sets (candlesticks with a combination perfume bottle and powder jar), little clocks, water bottle and glass sets. Delightful, they are in glass! Quote from *Fostoria Little Book About Glassware,* 1925.

The boudoir has always been a place of mystery and romance where 19th century women took pleasure in the art of looking beautiful. Can you remember Mother's Dressing table? As children, we dabbed on her perfume and sampled her lipsticks. As a young girl blossoms, she regards her mother's dressing table with new fascination. She dreams of the proms to come, she no longer views the powder puff as a plaything, but the accessory that beautifully smoothes mother's powder. In romantic days of old, crystal perfume bottles were the dazzling treasures of princesses. Today these fine Fostoria treasures can hold a variety of perfumes, shampoos, or even antiseptics, to decorate your home and add beautiful things to your daily joy.

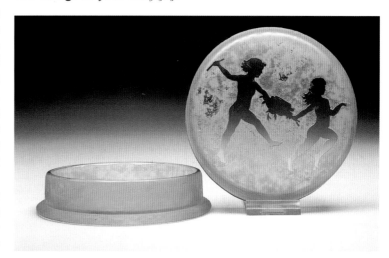

#2359 1/2 Puff Box and Cover, Cupid Brocade Etching #288, Green, 1927-1928, 4.5" diameter. **$450+.** Not shown: also made in Blue and Ebony. A very scarce item. **$450+.**

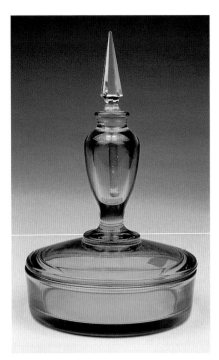

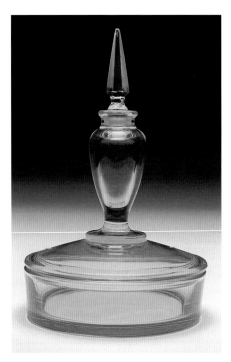

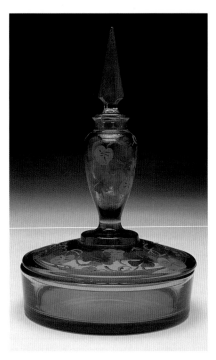

#2276 Vanity Set, Green, 1924-1927. Harry G. Dalzell filed patent on this Vanity set January 10, 1923. 7.5" overall height, 4.25" box diameter, 1.75" box height. **$155.**

#2276 Vanity Set, Amber, 1924-1927. 7.5" overall height, 4.25" box diameter, 1.75" box height. **$145.**

#2276 Vanity Set, Canary, 1924-1926. 7.5" overall height, 4.25" box diameter, 1.75" box height. **$255.**

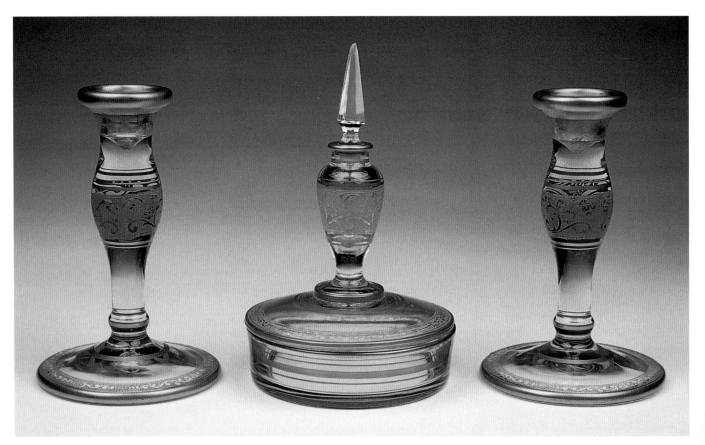

#2276 Vanity Dresser Set with Candles. #2276 Vanity Set, Blue Design and Encrusted Gold Decoration. Patent by Harry G. Dalzell. 7.5" overall height, 4.25" box diameter, 1.75" box height. #2269 Candlesticks, Blue Design and Encrusted Gold. 1924-1926. Set Vanity and Candlesticks **$455+.**

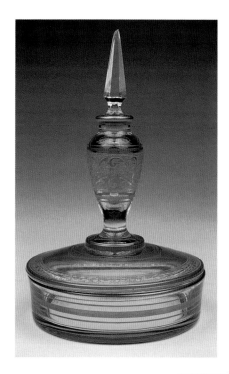

#2276 Vanity Set, Blue Design and Encrusted Gold Decoration. 7.5" overall height, 4.25" box diameter, 1.75" box height. **$255.**

#2347 1/2 Puff Box and Cover, Blue, 1926-1927 with label. 7" diameter. **$75.**

#2322 Cologne with stopper (dauber), Cupid Brocade Etching #288, Blue, 1927. 6" high. **$675+.** Not shown: Also made in Green and Ebony. **$675+**

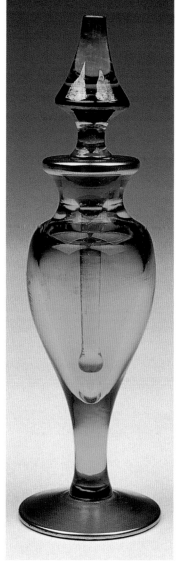

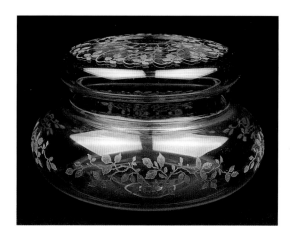

#1904 Bon Bon and Cover, Etching #221, circa 1910. 5.5" diameter. Also used on vanity as powder jar. **$85.**

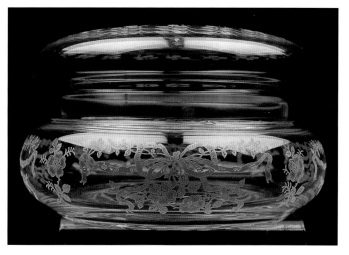

Sampled: #1904 Bon Bon and Cover, experimental with Romance Etching #341, circa 1942, not a production item. Could be used on vanity as a powder jar. 5.5"diameter. **$155.**

#2276 Vanity Set, Crystal, 1924-1928. Cutting unknown. This one shown without the stopper (dauber). 6" overall height, 4.25" diameter, 1.75" height of box. **$85.**

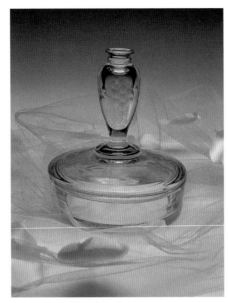

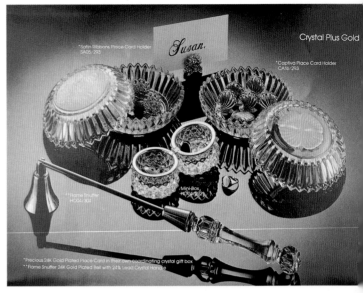

The Original Satin Ribbon Box shown in advertisement SA05/293.

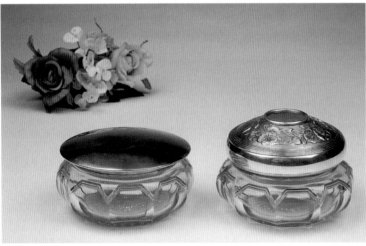

Left: #1630 Alexis Pattern Puff Box with sterling silver lid, 3.75" diameter. **$75. Right:** #1630 Alexis Pattern Hair Receiver, sterling silver lid. 3.75" diameter. **$85.**

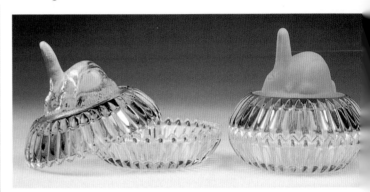

Modified Bunny Satin Ribbon Jewel Box circa 1981. Limited edition run. Notice how the mould is two parts and the lid fits the box. **Left:** Bunny Box, Crystal. **$45; Right:** Bunny Box, Satin Finish. **$55.**

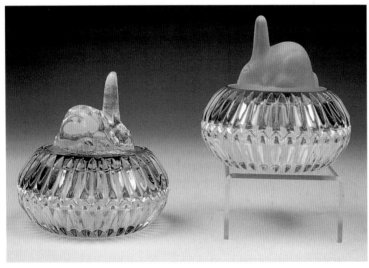

Unique production variation of the Satin Ribbon Jewel Box. SA05/293. The jewel box was produced 1981-1982 only. The mould was modified to incorporate this bunny finial on the lid. Production was limited to a trial run, one-day only; approximately one hundred items were produced and most went home with the workers. **Left:** Bunny, Satin Ribbon Jewel Box, Crystal, 4" diameter, 4" tall. **$45. Right:** Bunny, Satin Ribbon Jewel Box, Satin Finish, 4" diameter, 4" tall. **$55.**

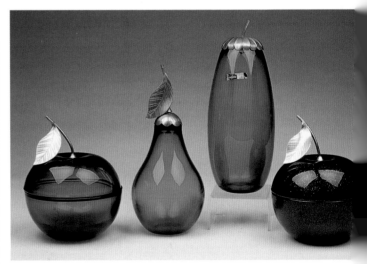

#2699 Unique Dresser Set was produced one year only 1956-1957. This design features a metal leaf/stem on the Apple and Pear that are removable. This set was produced in a color called Marine and Avocado shown here. Not shown: also produced in Pink, Clover, Amethyst, and Bark. **Left to right:** #2699 Apple and Cover, Marine color. **$95;** #2699 Pear, Marine color. **$95;** #2699 Melon, Marine color. **$115;** #2699 Apple and Cover, Avocado color. **$95.**

#2056 American, Blue, produced one year only, 1925-1926. **Back:** #2056 Dresser Tray, 7.5" x 10.5" **$475+**; **Front row left to right:** #2056 3-toed Bon Bon, 7" diameter. **$160**; #2056 Cologne and Stopper, 5.5" tall. **$400+**; #2056 Jewel Box and Cover, 2.25" wide, 5.25" long, 2" tall. **$450+**.

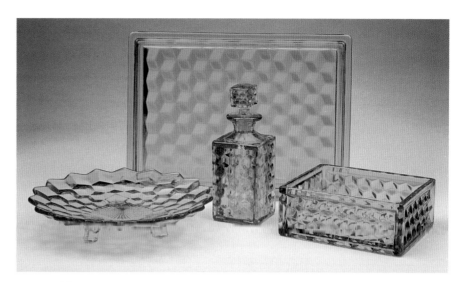

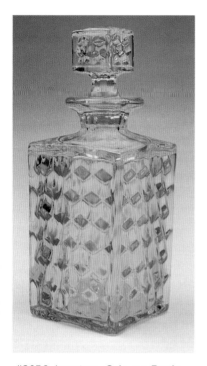

#2056 American Cologne Bottle and Stopper, Canary, 1925-1926, 5.5" tall. **$375+**

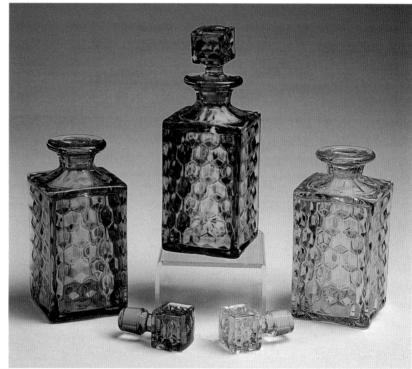

#2056 American Cologne Bottle and Stopper. **Left to right:** Amber, 1925-1926, 5.5" tall. **$275+**; Blue, 1925-1926, 5.5" tall. **$400+**; Canary, 1925-1926, 5.5" tall. **$375+**.

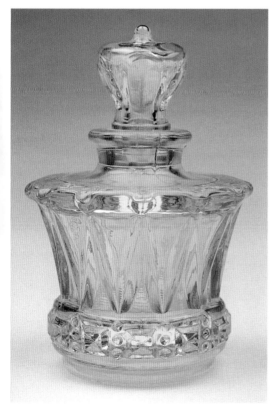

Windsor Crown #133 Bottle and Stopper, Gold, 1962-1965, 4.25" tall. **$125.**

#2056 American
Colored Treasures

Fostoria American is the most beloved of all Crystal patterns produced by Fostoria. The popularity of American pattern in crystal remained constant from 1915 though 1982, with many items coming in and out of the production line at different time intervals. The American Colored items are hard to find. Production years for Fostoria American colors run from 1925 through 1927, with some items being made in Blue, Canary, Green, Amber, Orchid, Azure, Topaz, and Ruby. The Orchid, produced only in 1927 and Canary, produced only 1926 are going to be the most difficult to find. Some items were made one year only in colors, with no accurate factory record to show the quantities produced. A few pieces in Jadite color were made in the 1930s and White, Aqua, and Peach Milk Glass items were produced from 1957 through 1959. Shown are a few experimental and lustre colors and a few favorite choices for colored American that were sold as giftware items.

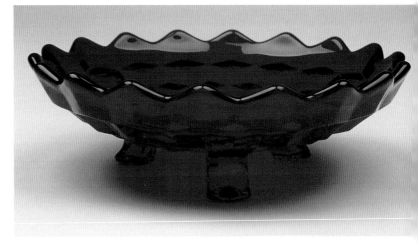

#2056 American 3-toed Bon Bon, Ruby, produced one year only, circa 1982, 7" diameter. **$95.**

#2056 American Bitters Bottle with Tube. This is scarce color referred to as Autumn Glow Luster. The color was applied like an iridescent glaze over crystal and fire polished to get the iridized autumn glow, stunning honey-gold color, circa 1920. 4.5 ounce, 5.75" tall. **$450+.**

#2056 American 3-toed Bon Bon. In Crystal, this Bon Bon was popular and remained in the catalogs 1924 to 1982. However, it was produced one year only 1925-1926 in the colors shown here, making the 3-toed Bon Bon in color a highly prized item for collectors. **Left to right:** #2056 3-toed Bon Bon, Amber, 7" diameter. **$125;** #2056 3-toed Bon Bon, Blue, 7" diameter. **$160+;** #2056 3-toed Bon Bon, Canary, 7" diameter. **$185+.**

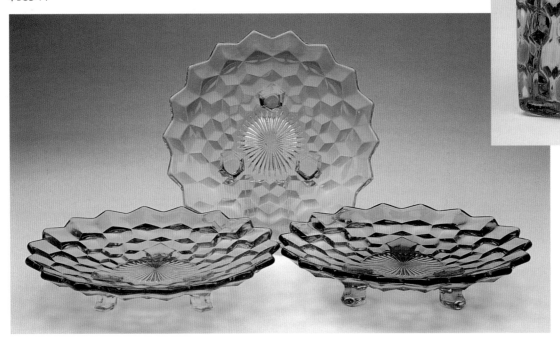

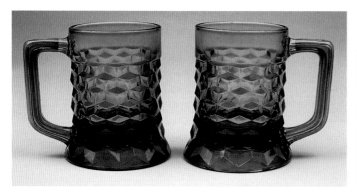

#2056 American Beer Mug, Smoke Brown, 1933-1943, 12 ounce, 4.5" tall. **$125.**

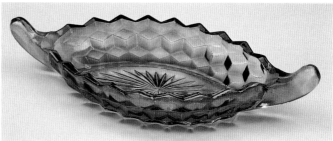

#2056 American Small Relish Boat, Ruby Flash, sampled circa 1928. Extremely scarce. Catalog measurement on this states 9". My measurement 8.5" long. **$275+.**

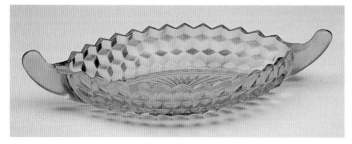

#2056 American Small Relish Boat, Green, 1925-1926, 8.5" long. **$175+.**

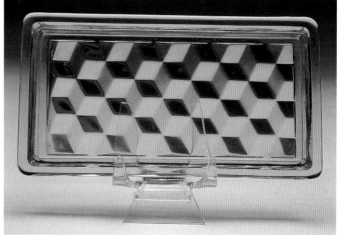

#2056 1/2 American Oblong Tray, Canary, 1925-1926, 5" long, 2.5" wide. **$225+.**

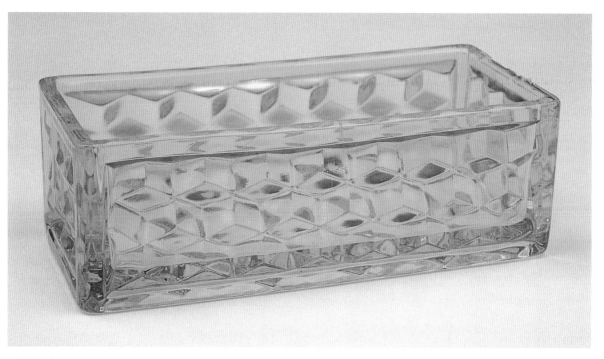

#2056 American Jewel Box and Cover, Canary, 1925-1926, 5.25" long, 2.25" wide, 2" tall. **$450+.**

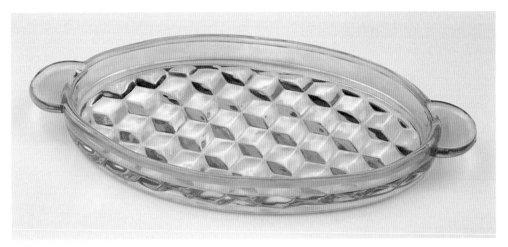

#2056 American 6" Oval Tray, Autumn Glow Luster. This was a flashed on color over crystal, extremely scarce. 6.75" long, 3" wide. **$165+.**

#2056 American Almond, Blue, made from the Argus Blue glass circa 1976, produced one year only, 4.5" oval. **$55.**

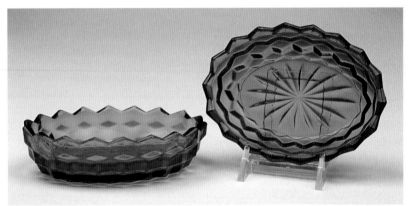

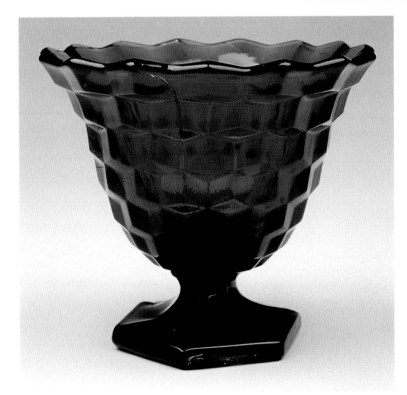

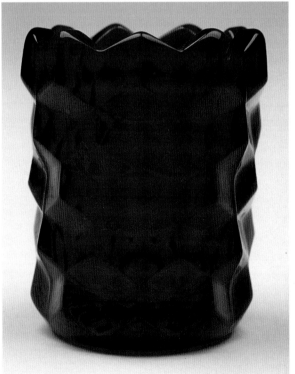

#2056 American Mayonnaise Dish, experimental color, Brown, affectionately referred to as a shade of root beer, sampled circa 1948. Official factory experimental pieces will be marked on the bottom. A diamond tipped stylus was used to engrave a number on the bottom representing an identification of the special color. *Close up sample of this type of experimental engraving is shown in the stemware and whimsies chapter of this book.* Footed Mayonnaise, 4.75" tall. **$265+.**

#2056 American Toothpick, Ruby, was made for Fostoria Glass Society of America, clearly marked and dated FGSA 1983. A total of 500 Toothpicks were made. 2.25" tall. **$65.**

Candy Jars and Candy Boxes

Fostoria Candy Jars and Candy Boxes were the most popular gift items for any season of the year. Early catalogs feature an assortment of shapes in Round and Square Nappies, Sweetmeat Dishes with and/or without dividers, Bon bons, and Mint Trays. Most all patterns offered matching accessory items for the sweet tooth. The Footed Compotes in early colors were considered for use on the formal dining table for sweets. With the full color lines of dinnerware introduced in 1924 and 1929, came an assortment of Footed and Covered Candy Jars, offering the hostess her choice in one-quarter pound, one-half pound, and one full pound size. There was a three-part divided Covered Candy, Confection and Cover, Square and Oval Candy Box, and Jars offered in all patterns, etchings, and colors 1929 and 1934. Candy jars can be found in all colors of Fostoria, Spiral Optic, Loop Optic, Regular Optic, Enamel Decorated, Etched, and with Cuttings.

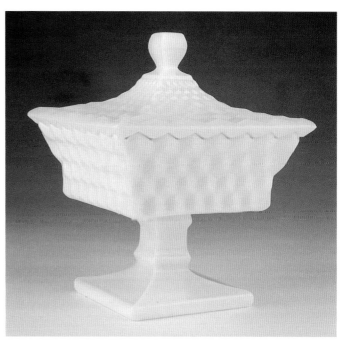

#2056 American Wedding Bowl and Cover, Milk Glass, 1953-1965. 8" tall. **$145.**

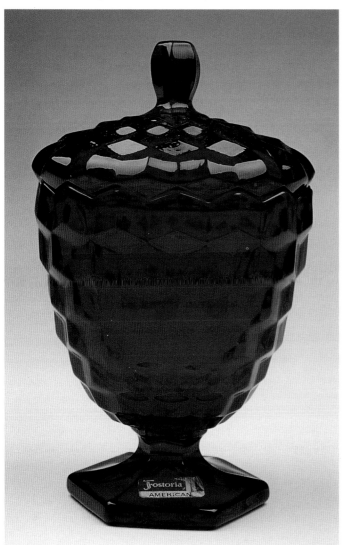

#2056 American Hexagon Footed Candy and Cover, Ruby, circa 1982. 7" tall. **$155.**

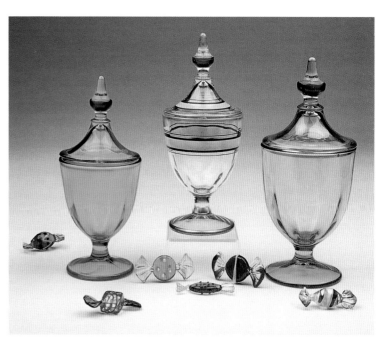

Left to right: #2328 Candy and Cover, Blue, 1925, 7" tall. **$65;** #2328 Candy and Cover, Decorated, circa 1925, 7" tall. **$60;** #2328 Amber Candy and Cover, 1925, 7" tall. **$55.**

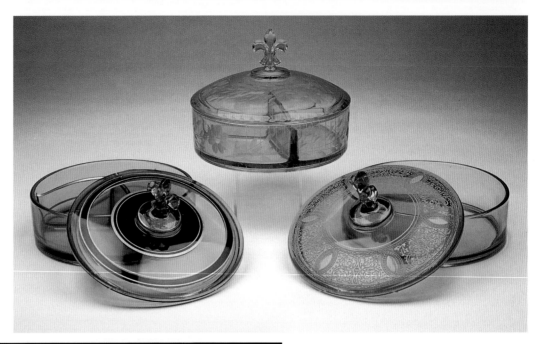

#2331 Three-part Candy and Cover, three compartments inside. 7" diameter. **Left to right:** Amber with Decoration 55, circa 1926. **$75;** Canary with cutting number unknown, 1924-1926. **$95;** Amber with gold and enamel decoration circa 1926. **$75.**

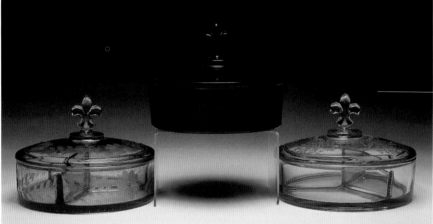

#2331 Three-part Candy and Cover, three compartments inside. 7" diameter. **Left to right:** Green, cutting decoration unknown, 1924-1926. **$75;** Ebony, 1925-1928. **$85;** June Etching #279, Rose, 1928-1935. **$255+.**

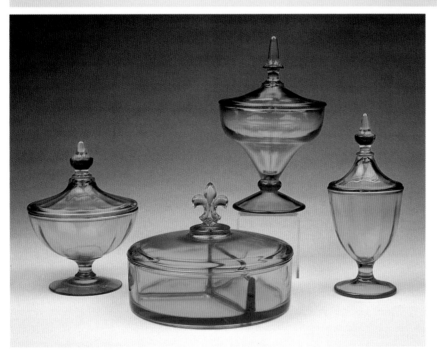

Fostoria Blue Candy Box and Cover circa 1925-1927. **Left to right:** #2250 Candy and Cover, 1925-1927. **$85;** #2331 Three-part Candy Box and Cover, 1925-1927. **$95;** Experimental one pound Candy Jar and Cover, circa 1927. **$85;** #2328 Candy and Cover 7" height. **$65.**

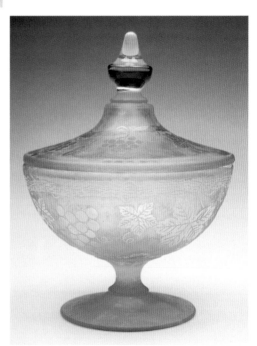

#2250 Candy Box and Cover, Half Pound, Grape Brocade Etching #287, 1927-1929, 6.5" tall, 5" diameter. **$110.**

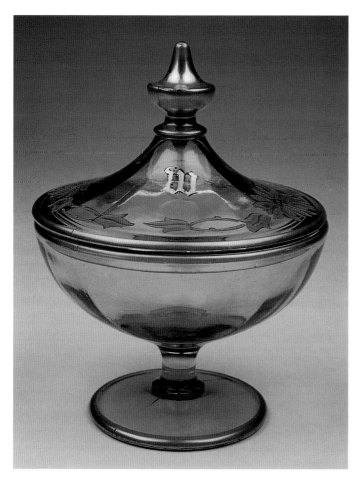

#2250 Candy Box and Cover, Rivera Decoration 44, Cutting with Encrusted Gold on Amber, made 1924 only. Personalized with initial "W" in gold makes this one especially unique. 5.4" tall. **$110.**

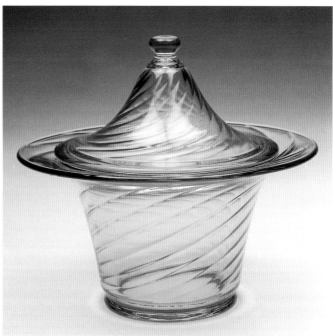

#2380 Confection and Cover, Spiral Optic Green, 1928-1930. 6" tall. **$58.**

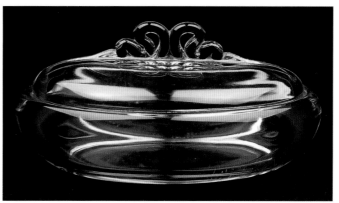

#2616 Oval Candy and Cover, Crystal, 1942-1943 half pound capacity. 4.5" tall 6.5" long. **$95.**

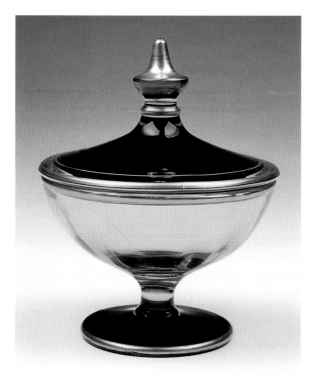

#2250 Candy Jar and Cover, Canary, decorated with enamel painted foot and lid, 1924-1926. 6.5" tall, 5" diameter. **$85.**

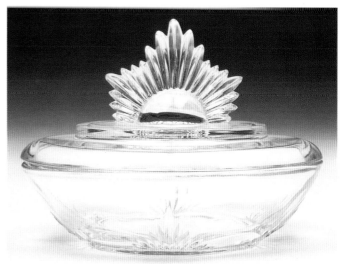

#2545 Flame, Oval Candy Box and Cover, Crystal, 1937-1938, half-pound capacity. 4.25" tall 6.5" long. **$95.** Not Shown: also made in Azure and Gold Tint. **$110.**

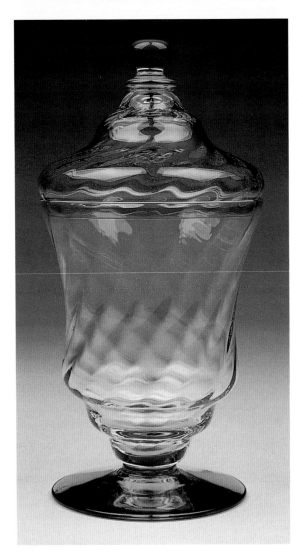

#5084 Candy Jar and Cover, Spiral Optic Crystal with Green Foot, produced one year only, 1926-1927, 9" height. **$155.**

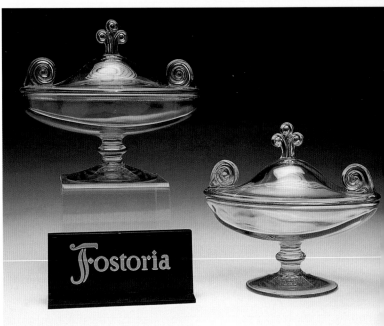

Left to right: #2413 Footed Urn and Cover, Green, 1929-1930, 6.25" tall, 7" long. **$95;** #2413 Footed Urn and Cover, Rose, 1929-1930, 6.25" tall, 7" long. **$95.**

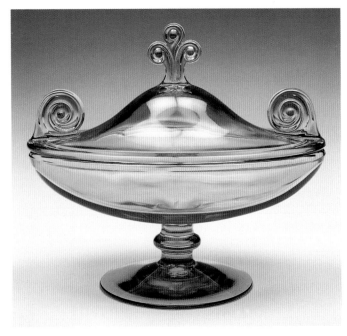

#2413 Footed Urn and Cover, Amber, 1929-1930, half-pound capacity, 6.25" tall, 7" long. **$95.**

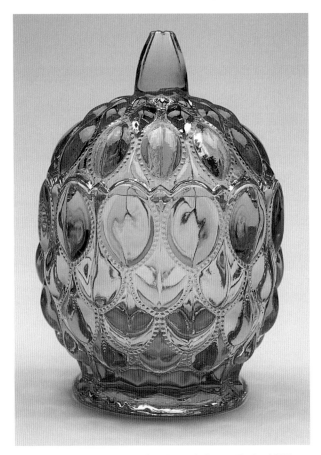

#1229/676 Centennial II Candy and Cover, Pink, 1970-1981. In January 1970 Fostoria introduced a new giftware line made up of sixteen hand-moulded items they originally made about fifty years prior. The name Centennial II was selected because of the closeness of our Country's two-hundredth anniversary. It represents the American Renaissance. This beautiful candy dish was created using the Frisco Pattern Candy Jar and Cover #1229, from 1903. 6.5" tall. **$45.**

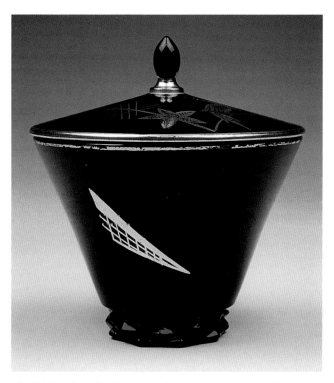

#2430 Diadem Candy Jar and Cover, designed by George Sakier, Ebony, 1930-1934 with decoration. 5.5" tall, 5" diameter. **$85.**

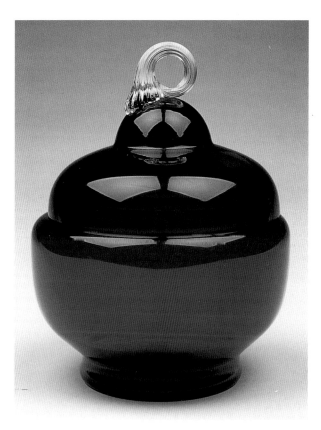

#4099 Candy and Cover, Regal Blue, 1934-1942, 6" tall. **$165+.**

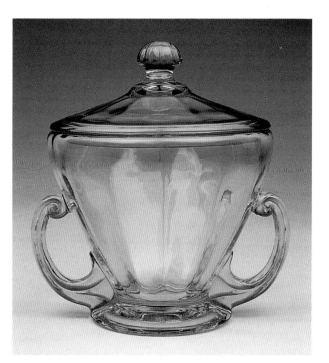

#2456 Candy and Cover, Topaz, 1933-1934, 5" diameter, 5.5" tall. **$120.**

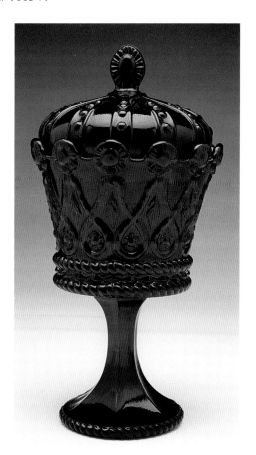

Hapsburg Crown Footed Chalice and Cover, Regal Blue, 1961-1965, 9.5" tall. **$135+.**

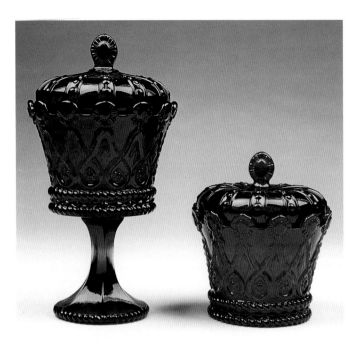

Left: Hapsburg Crown Footed Chalice, Ruby, 1961-1965, 9.5" tall. **$165**; **Right:** Hapsburg Crown, Candy and Cover, Royal Blue, 1961-1965, 5.5" tall. **$95**.

Afternoon Tea Treasures

Because afternoon tea is the one meal of intimate conversation, its popularity is unquestioned. There are really no definite requirements governing either the size or the covering of the tea table. The cloth should always be dainty and fresh, and table adequate to hold the tea things and food. With this setting there is a glass tea warmer heated by a generous sized candle, and what could be more practical or unique! Quote from a Fostoria advertisement from 1930 on how to set a proper tea table.

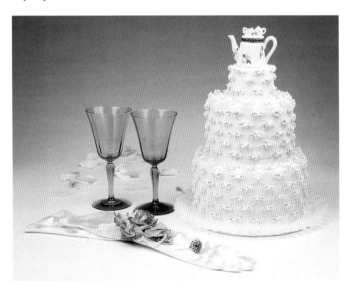

Fostoria Tea Party for the Bride! Always in Fashion!

Fostoria Glass Company long promoted the idea of afternoon tea with its advertising circa 1920-1930. Advertising brochures and booklets promoted the idea of setting the proper table for afternoon tea and bridal tea parties. Fostoria introduced the custom designed "Tea Warmer" in the catalog in the year 1934. This was produced in Crystal and Topaz. The tea warmer was designed with an insert that held the warming candle, and metal plate on top that the teapot would sit on. This item was promoted as a gift item for Christmas 1934 along with the introduction of the elusive Fostoria glass fruit.

#2491 Tea Warmer with original box, Crystal, 1934-1943. For coffee, for tea, for toddies, for chocolate. Priced complete as shown. **$150+**.

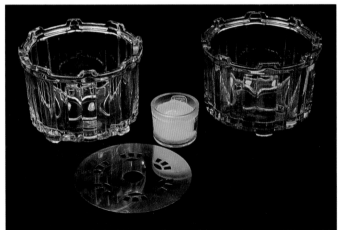

#2491 Tea Warmer, Crystal and Topaz/Gold Tint, introduced in 1934. Complete set includes glass tea warmer, metal top plate, insert glass, and warming candle as shown. Crystal, 1934-1943 **$150+**. Topaz/Gold Tint, 1934-1939 **$175+**.

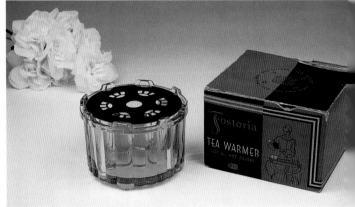

#2491 Tea Warmer with original box, Topaz/Gold Tint, 1934-1939. Priced complete as shown. **$175+**.

Hawaiian Pattern

This art glass design of Fostoria was made from 1961 to 1963. It's called Hawaiian, and was produced in two-tone colors: Amber with Peacock Blue accent color and/or Amber with Brown accent color. This pattern is often overlooked on the secondary market, but may become one of the more sought after by true collectors of Fostoria's art glass. Each and every piece of the Hawaiian pattern is unique and has color variation due to the amount of gather pressed into the mould, as well as the amount of hand-shaping by the glass artist who created the final product. This was an extremely difficult pattern to execute. The accent color, either Peacock Blue and/or Brown was first gathered and dropped into the mould, then a gather of Amber glass was dropped into the mould, when pressed together the glass would fuse to the accent color to create the design. Once free from the mould, the glass was hand shaped into the desired piece. It is believed that this pattern will appreciate in value for its unique hand crafted design, limited production, and contribution to the legacy of Fostoria's art glass.

Collectors will find that the Hawaiian pattern offers a variety of fourteen different serving and decorator items in the catalogs that include a Appetizer Set, Cheese and Cracker set, Torte Plate, Basket, Candy Dish, Two Vases, and several Bowls that vary in size from 8 inches to 15 inches, for Flower Float and Serving Dishes. Don't overlook the opportunity to add at least one of these unique Hawaiian pattern items into your Fostoria collection.

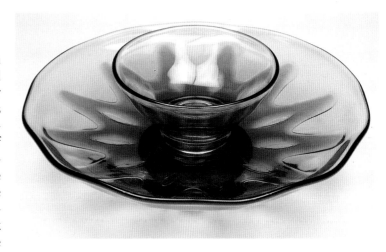

#2737 Hawaiian Appetizer Set, Amber and Brown accents, 1961-1963. Shown together. **$98 complete.**

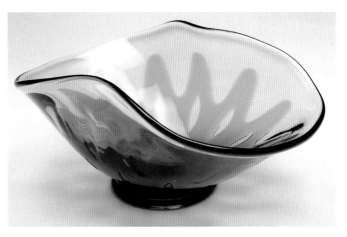

#2737 Hawaiian #126 Basket Bowl, Amber and Peacock Blue, 1961-1963. They called this a basket and it has no handle. Basket bowl is 3.6" tall, 8" long and 5.5" wide at the widest part. **$54.**

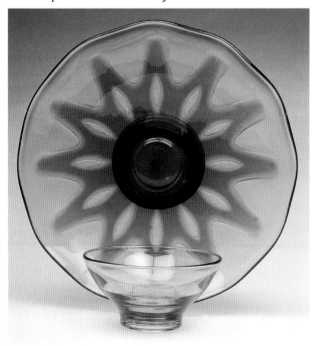

#2737 Hawaiian Appetizer Set, Amber and Brown accents 1961-1963. The large bowl, 11" wide and 2.5" tall, has a raised round center part, which holds the small bowl, 2.5" tall and 5.25" wide, in place. Note there is a two-tone pattern only on the large bowl and the small one is plain. This set is very hard to find complete. **$98 complete.**

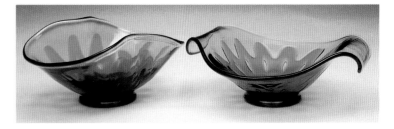

Left: #2737/126 Hawaiian Basket Bowl, Amber and Peacock. 3.6" tall, 8" long, 5.5" wide. **$54; Right:** #2737/188 Hawaiian Bowl, 9" handled. **$54.**

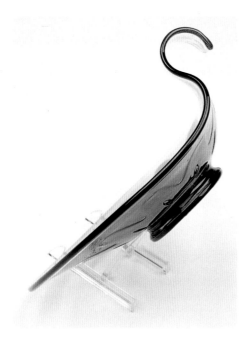

#2737 Hawaiian side view to show the design thickness and style.

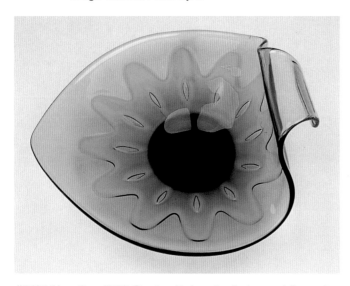

#2737 Hawaiian #500 Candy with handle, Amber and Peacock Blue, 1961-1963. 8" long **$48**

Fostoria's Heirloom, Fine Giftware with Fashion Flair

The Heirloom pattern of Fostoria was introduced in 1959. It fell into the category of "Fine Giftware with Fashion Flair," part of Fostoria's new marketing program.

Heirloom was marketed as being made like handmade antique glass. Thus the name, Heirloom, for this group of "Free-form" shapes. Heirloom's delicate beauty begins with a gather of molten glass by hand from the furnace. After moulding, the glass, while still pliable, is swung by the craftsmen to stretch it out and form the shape, thus each piece is truly unique. You will find beau-

tiful pieces of Heirloom in colors of Pink, Green, Blue, and Opal all produced between 1959 through 1970. The Ruby color was offered in the catalogs 1961 through 1970, however, not all items were available in Ruby. Yellow was in the catalogs 1959 through 1962. Bittersweet Orange was made for two years only 1960-1962.

Many of the items in the Heirloom line were shaped from the same moulds. The vases and bowls would be swung out of the mould and hand shaped to form the desired product. Several of the older workers who had jobs at the factory as pressers and/or gathering for this time period, tell stories about the difficulty in producing this product. For some, the challenge was fun and they delighted in creating the Heirloom pattern, for each piece that came out of the mould was loving hand shaped and each design a unique treasure. For others, their stories tell the most difficult task was to watch out and protect yourself when the vases were swung. Many a time the vase would go flying off the pontil and fly across the room with such force, workers didn't want to be on the receiving end of these stray vases. Here is just a sampling of the Heirloom pattern, presented for its unique design contribution to the Fostoria art glass legacy.

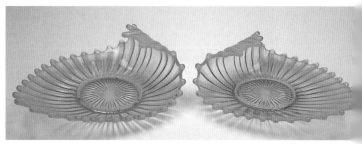

#2729 Heirloom Bon Bon, Blue, 1960-1970. 7" long, 5.5" wide. **$38.**

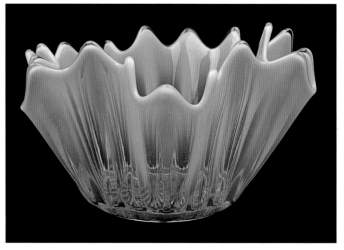

#1515/208 Heirloom Bowl, Blue, 1959-1970, 10". **$65.**

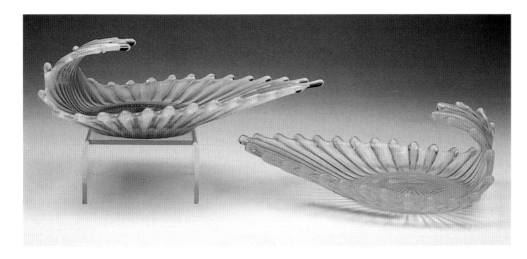

Left to right: #2729 Heirloom Bon Bon, Pink, 1960-1970, 7" long, 5.5" wide. **$38;** #2729 Heirloom Bon Bon, Blue, 1960-1970, 7" long, 5.5" wide. **$38.**

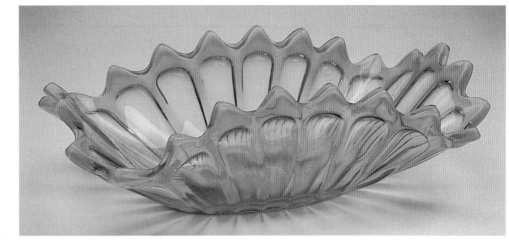

#1515 Heirloom Oblong Bowl, Green, 1959-1970, 15" length. **$75.**

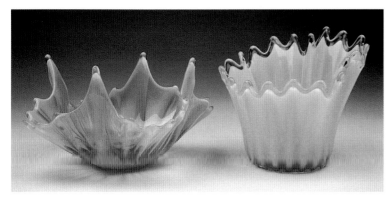

Left: #2720 Heirloom Crinkled Bowl, Pink, 1959-1962, 6.5" width. **$45.** **Right:** #1515 Heirloom Bowl, Pink, 1959-1970, 10". **$65.**

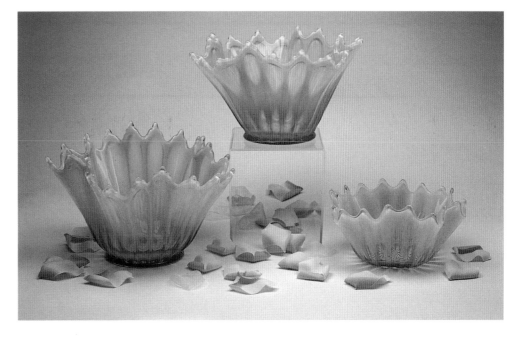

Left to right: #1515 Heirloom Bowl, Pink, 1959-1970, 10". **$55;** #1515 Heirloom Bowl, Pink, 1959-1970, 10". **$55;** #2727 Hanky Bowl, Pink, 1960-1970, 5.5". **$45.**

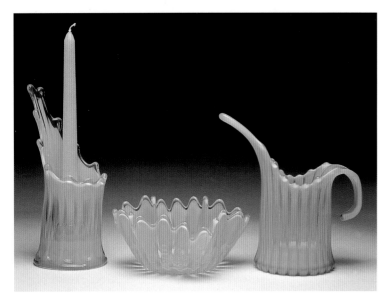

Left to right: #1515/311 Candle Vase, Blue, 1959-1961, 10" tall.
$95; #2720 Heirloom Bowl, Blue, 1960-1970, 8.5" bowl. $55;
#2728/807 Pitcher Vase, Blue, 1960, 9" tall. $125.

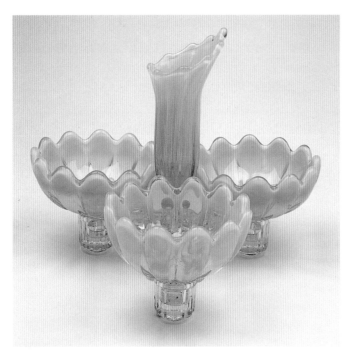

#2727/364 Table Charms, consisting of a 3-lite Candle Arm
(clear), 1-Peg Vase and 3 Flora Candle Bowls. Heirloom Yellow,
1959-1962. 10" . $165.

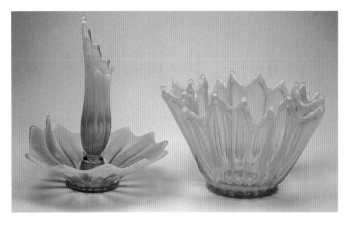

#2685 Seascape

Fostoria's pressed line #2685 Seascape is another
one of the unique lines that appeared in the catalogs
1954 through 1957. The colors offered were called
Caribee Blue and Coral Sand. The Coral Sand color
appears to be a pink opalescent color. The moulds for
the #2666 Contour line in production at this time were
used for the #2685 Seascape line. Because this line
was not as popular as it was hoped and the production
cost were high, the line was discontinued by 1958.

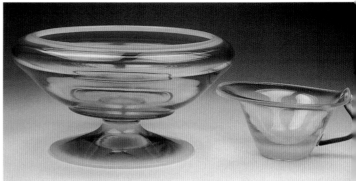

Left: #2685 Seascape Footed Bowl, Coral Sand, 4.75" tall 8.75"
diameter. $95. Right: #2685 Seascape Handled Preserve, Coral
Sand, 6.5" long. $45.

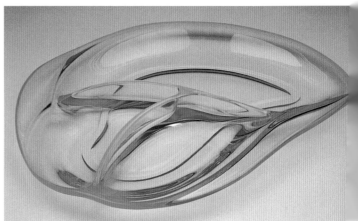

#2685 Seascape 3-part Relish, Caribee Blue, 11.75" long 8.25"
wide. $65.

#2183/311 Heirloom Flora Candle Bowl, 8" diameter and 1-Peg
Vase, 9.5" tall, creating floral holder. Heirloom Yellow, 1959-
1962. $125.

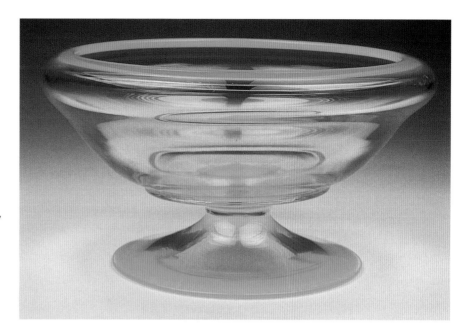

#2685 Seascape Footed Bowl, Caribee Blue, 4.75" tall 8.75" diameter. **$95.**

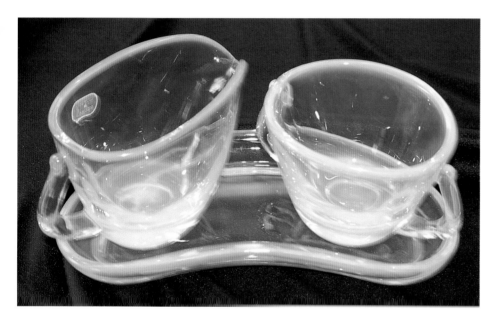

#2685 Seascape Cream and Sugar on Tray, Caribee Blue. Sugar 2.75" tall; Cream 3.25" tall; Tray 7.5" long. 3-piece set as shown. **$110.**

#2685 Seascape Mayonnaise, Plate, and Ladle, Caribee Blue. Plate 6.25" diameter, Mayonnaise 2.75" tall. 3-piece set as shown. **$75.**

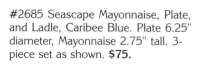
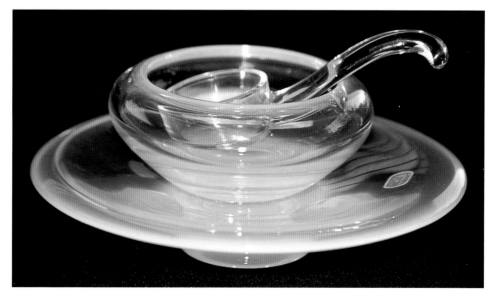

Chapter Eight
Fostoria Glass Paperweights

There is a little magic and mystery found in owning a genuine Fostoria paperweight, hand made by the glass artist on his off hours at the Fostoria factory. Genuine Fostoria paperweights are made from high quality Fostoria crystal. The paperweight artist works his magic with the molten glass, capturing different feelings with designs of flowers, birds, spiders, special interest, and whimsical motifs portrayed under the glass. Some paperweights were made to celebrate holidays, birthdays, and romance with personalized special occasions memorialized in the various forms of color and crystal.

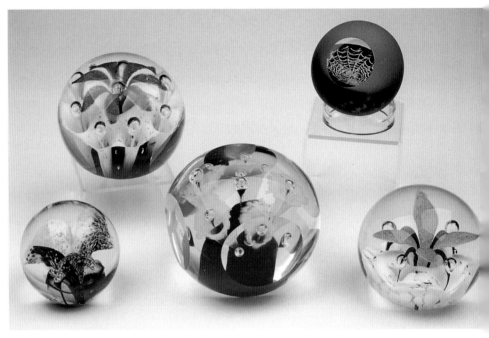

Collection of wonderful Fostoria Paperweights.

The first to begin experimenting and making glass paperweights on his lunch hour and off hours at Fostoria was glassworker John Murphy. My mother, Alta Miller, had taken a trip back home in 1970 to visit relatives in Moundsville. Mom was the first to hear stories of Murphy making ruby apples and beautiful floral paperweights at the factory. Mom was invited to John Murphy's home to see some of the paperweights he had made at Fostoria. It was there she purchased her first Ruby Apple, and one of his amazing Orange Trumpet Flower weights. She asked Murphy to make ruby apples for each of her four children. In 1971 Murphy made my mother a paperweight with an incredible flower inside, each pedal inscribed with the name of one of her four children: Gene, Juanita, Alan, and Hara; this one was stunning and beautiful to behold. I was amazed at this weight, and fascinated with the design, the clarity, and detail captured in the glass; when I held it in my hand I was hooked!

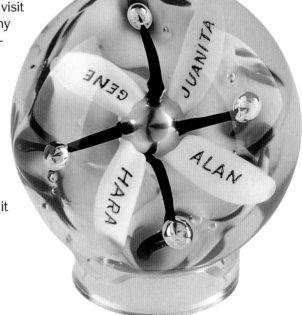

Personalized Floral by John Murphy, 1971, reads Gene, Juanita, Alan, Hara.

The first paperweights in my Fostoria collection were Murphy's signature ruby apple and a grand paperweight with a ruby base and five-yellow flowers. In 1972, when my first child was born, Murphy created a personalized weight that bears her name: Jennifer Maureen 2-25-72 inscribed on an opaque white glass plate that was inserted into the center of a perfect floral design. This began my passion for collecting these fantasies in glass.

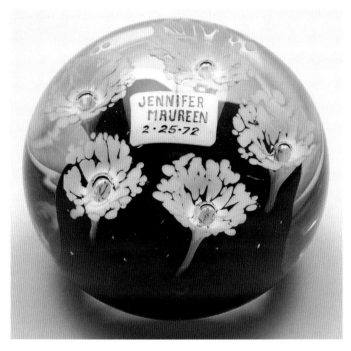

John Murphy paperweight, personalized, Jennifer Maureen 2-25-72.

The second artist to create Fostoria paperweights with a passion was Fred W. Wilkerson, with his unique design spider web that seems to be marching to infinity. This has become Wilkerson's signature paperweight and well sought after by Fostoria collectors. Through the years, I have added many Wilkerson weights to my collection that include his Birds In Flight, Butterfly, Bananas, and several whimsical designed personalized weights for my three sons commemorating their birth dates. I am intrigued by his artwork incased in the glass; the personalized weights capture a moment in time that evoke fond memories.

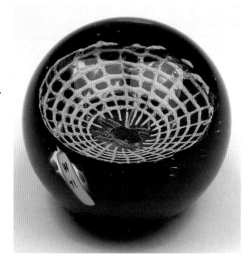

Unique Spider Paperweight by Fred W. Wilkerson.

A new collector cannot get the feel and appreciation for the quality of the Fostoria paperweight from one photograph of the glass. It is impossible to capture the romance of the motif with only one angle view. There are many layers to the designs and style techniques such as air bubbles, ribbons, various colors, personalization, and many facets that cannot be captured in one picture. The passion comes from holding the paperweight in your hands and viewing it from all angles. When you can clearly see the beautiful jewel colors and magnification of the design and explore the fantasy encased inside the glass, you can feel the art and this becomes the charm.

Outstanding among Fostoria's off-hour paperweight makers were John Murphy and Fred W. Wilkerson. Murphy and Wilkerson created their own signature design pieces. They made their own moulds for the design motifs; Murphy created his moulds at his home, Wilkerson at the mould shop at Fostoria.

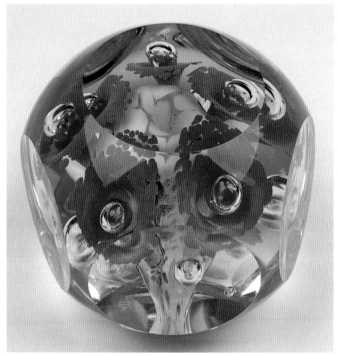

Magnum Paperweight, five Trumpet Flowers and five windows cut in this perfect weight, created for my mother, Alta Miller, in 1973, by artist John Murphy.

Murphy and Wilkerson had an audience among the factory workers. They were watched and admired from top management starting with President David Dalzell, the board of directors, union members, foreman, and other factory workers in the shops. Soon co-workers Paul Myers, Kenny Robinson, Jack Wayne, and others joined in making paperweights at the factory. They persuaded top cutters such as Bill Suter and Wilford Baker to cut some of the facets in the paperweights for them. As my passion for collecting these grew, I added to my collection with some paperweights of Paul Myers, Kenny Robinson, and glasscutter Bill Suter.

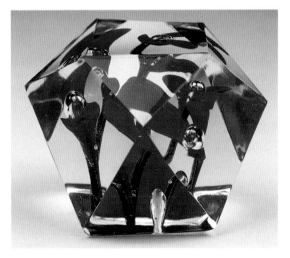

This miniature weight has outstanding design cutting of 16 facets cut by excellent glasscutter, Bill Suter. Signed BN Suter. Miniature 1.5" tall. **$385+.**

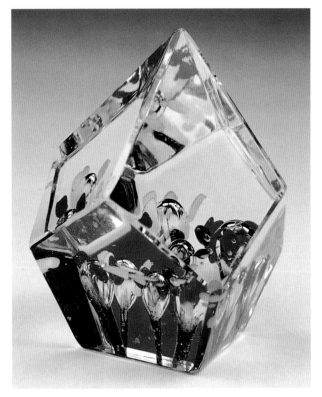

This outstanding multi-faceted miniature paperweight contains 18 facets in all and showcases the incredible art of Bill Suter, signed BN Suter. Miniature 1.75" tall. **$425+.**

The paperweight artist all had a common bond. The men shared their passion for creating the paperweights and shared their skills as they discovered new techniques and methods of working the glass. They were respectful of each other and did not copy their co-workers designs.

The paperweight is an art form. Each man developed his own unique style of weight design. Murphy weights are exceptionally done in an old world style of weight making. Murphy is noted for his Trumpet Flowers, Multi- Floral with Ribbon, Black Eyed Susan Flowers, Mallard and Cattail, and his signature Ruby Apple. Wilkerson weights include his incredible Spider Web, Birds in Flight (single and multiple birds), Dainty Butterfly, and personalized one-of-a-kind whimsical designs. Myers' signature weights include his Long Stem Flowers, Daisy and Butterfly, Snowflake, Pheasants, Circus Clown and Big Top. Several workers such as Kenny Robinson, Jack Wayne, and Sam Lennox are known to have made a few paperweights; these are believed to have been floral design in various colors of glass and experimental apples.

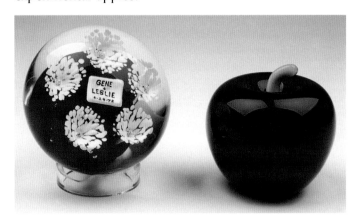

John Murphy personalized paperweight made for my brother, Gene Miller's wedding: Gene & Leslie, 1972 and John's signature Ruby Apple, both are family treasures!

The Fostoria paperweight artists would do their design layout in the moulds that they created at home, and bring their design in early mornings, lunch hours and/or dinner hours to make their paperweights at Fostoria. It was not uncommon for each of them to create six weights at a time and put these on the lehr for cooling down and return later in the day to pick up their works of art only to discover that some of them were missing.

Since Fostoria never sold these paperweights to the public, there was no quality control or anyone watching to insure that what goes on the lehr comes off in the same quantity. As with many of the lunch hour whimsies, they were made for the fun of creating them and many workers helped themselves to take home a treasure of the day. These items often times went home from the factory in a lunch box of one of the workers. In

some cases, a factory worker would simply take a weight and sandblast the Fostoria logo on the bottom, or sign his name and take it home and give to a family member or friend. These lost treasures will be showing up at a yard sale, flea market, estate sale, antique mall or Internet auction.

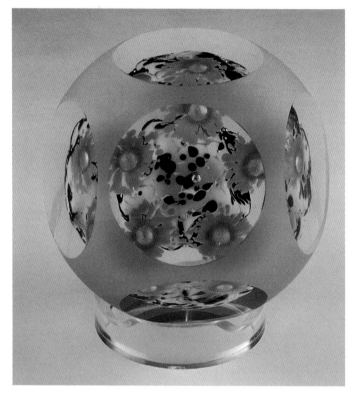

A unique paperweight created with Jamestown Pink, design features five pink flowers, ebony and milk glass base and five windows cut in. Signed J Murphy.

I've collected and studied the artistry of Murphy and Wilkerson for more than thirty years; I recognize their artwork designs in the paperweights. A few times at a yard sale or Internet auction I have purchased paper weights that are the creation of one of these fine artists, only to find another person's signature, Fostoria logo etched on bottom, or no signature on the bottom. I believe this to be one of the "treasures" missing from the lehr at the end of the day. There is no shame in purchasing one of these treasures to add to ones collection of Fostoria for these artists are well sought after. My goal is to educate the dealers and collectors of these treasures to be sure to attribute the article to the rightful artist.

I recommend the dealer or the new collector of Fostoria paperweights become familiar with the artists featured in this chapter; study their designs and look for that artist signature on the finished paperweight. Fostoria artists featured in this book were proud of the designs they created; they made the moulds themselves, and did not share their moulds. The artist worked long hours to create and

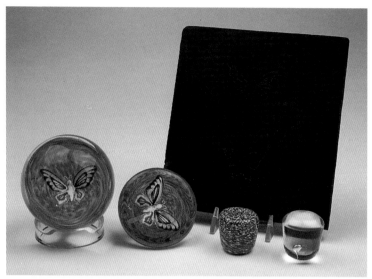

Wilkerson Butterfly Design mould plate shown with the frit glass and progressive set for the Butterfly Paperweight.

layout his design and utilized his talents to make the paperweight; it's unfortunate that so many disappeared off the lehr without their signatures. It will be important when one begins to market or collect genuine Fostoria glass paperweights to attribute the design to the proper artist. The values attributed to the Fostoria paperweight reflect finished works that have been signed by artist.

It is important to note that the artist of these paperweights rarely repeated themselves. Even though they had a mould for design pattern, the butterfly, spider, birds, flowers, each new creation was hand made and had its own unique style. Resemblances may be noted between similarities the artist is known for; however, each weight may feature different treatments of the design, a different color in the glass used for the motif, or a different finish with a different number of facets. In each paperweight there is always an individuality, and that is the beauty found in collecting. It would seem these Fostoria glass artists set out to produce an item about which he could say, "In all the world there is no other weight like this."

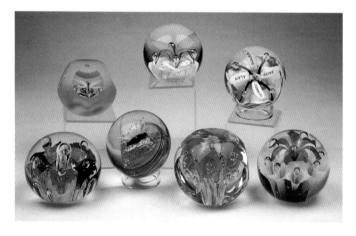

John Murphy signature paperweight classics.

Value Guide for Fostoria Paperweights

The author decided to give one value in this book instead of a price range. Dealer input, designer input, antique show prices, known auction and internet sales, have all been evaluated when putting the values on the Fostoria paperweights.

Values given are for items in MINT condition with known artist signature. Items with any damage, such as nicks, chips, or cracks are worth less than the given price, depending on the severity.

To determine the price distinguished between ordinary and a truly scarce or unique Fostoria paperweight, the author has set some criteria:

• The types of colors and combinations of colors used.

• Some colors used in Fostoria paperweights created at lunch hours were colors of limited run items in production color at the time period. (For example Jamestown Blue and Pink; Coin Emerald or Ruby.)

• The number of colors used in the paperweight (the more disparate and numerous the colors, the more difficult the paperweight is to anneal without cracking).

• Use of Fostoria Yellow color in the design. (Scarce, Fostoria Yellow was tempered at a different rate than the other colors and many fractured)

• The clarity (quality) of the crystal.

• The number of production steps required making the weight (number of gathers, designs, color overlap, facets are more costly).

• The types of subjects depicted in the work (the more detail, more time involved in making the weight.)

• The placement of the artwork arrangement within the height of the weight, the artist difficulty of the subject.

• The manner is which the paperweight is faceted, if at all.

• The number of facets (windows) in the weight.

• Frosted, acid etched, or sandblasted finish.

• The existence of any signature and date.

Each paperweight shown has been given a starting price base rate market value of **$215** based on known production, limited quantity of genuine Fostoria glass paperweights. Values added for each facet, $25; frosted or sandblasted finish, $25; extra gathers, $15; personalization, $45; scarce color, $55; unique subject, $85. Since all Fostoria paperweights by same artist may vary with finished product, this formula of added value to base price was calculated individually for each paperweight shown in this book.

Ultimately this comes down to supply in demand, what YOU the collector is willing to pay for an item and what a dealer is willing to sell it for. These values are only a guide they are not intended to set prices for the Fostoria marketplace. Neither the author nor publisher assumes any responsibility for transactions that may occur because of this book.

John D. Murphy, Glass Artist

John David Murphy was born March 7, 1938, a son of John Edward and Gay Lively Murphy. He attended public school of Cameron, West Virginia but dropped out of high school and began work in the construction field before coming to work at Fostoria. John entered the work trade at Fostoria in August 1963; his job title was a presser. He worked at Fostoria for a total of twenty-one years, leaving when the factory closed in 1984. John was an amateur artist. His subjects included landscapes and objects from nature.

John and Sandy Murphy, circa 2002.

John and his wife, Sandy share a common interest in art. They worked together side by side on the design layouts for the beautiful paperweights he created. He did the artwork and created his moulds at home by carving out his design patterns in squares of black carbon. He would choose the colorants he wanted to utilize for the inside of his paperweights. Usually these would be pieces of colored cullet he found around the waste piles of broken glass at the factory. He would break up the glass and shift it through rags to get it very fine. These fine grain-like sand colorants would be laid out in the black carbon design mould. Sandy would work on the layout in the evenings, filling in the variety of colorant into the moulds John had created. He then took the design plates in to work and warmed them in and created his paperweights in an old world art style that he taught himself.

John was the first man to create Fostoria paperweights; it is amazing that he made these beautiful works of art without benefit of teachers, formal training, or research on the subject.

In the late 1960s Fostoria had acquired Morgantown Glassworks and the truck drivers would take glass loads back and forth from Fostoria to Morgantown. One day when the truck driver came to drop off a load, John noticed a perfectly round and intriguing glass paperweight on the dashboard of the truck. He had never seen a paperweight in his life before this day and he immediately became interested in it. John asked the truck driver where he had gotten it and if he could get another one for him? The next trip back from Morgantown, the truck driver brought two glass paperweights for Murphy that he purchased for $2 each.

John was intrigued with the idea of making one himself. With his background as an artist and his impulse to want to put his art inside a glass paperweight, he couldn't wait to begin to explore with the glass. He started to come to work in the pre-dawn hours and worked as time permitted to experiment with the pots of glass. Because of his desire and interest in art, and a strong will to achieve set goals, he was able to teach himself to make paperweights. Fostoria had the clearest and best crystal of all the glasshouses of the era, affording the artist the most outstanding crystal gather to work with. John soon began to set the standards of paperweight making at Fostoria; the others enjoyed watching him and followed in the joy of creating these wonderful treasures.

It was in July 1969 John took a box of the Fostoria paperweights he had made and went down to Star City to confer with John Gentile. John Gentile was a second-generation paperweight maker at the small glass factory owned by his family in Star City, West Virginia. John wanted to show Gentile his style of paperweights and discuss the techniques he developed. A local author, Jean S. Melvin was at the Gentile factory researching a book on glass paperweights at that time. Jean was delighted to meet John Murphy there and see the paperweights he had created at Fostoria. Jean contacted Fostoria Glass and got permission from David Dalzell, Sr. to come to Fostoria and go out on the factory floor to observe and photograph John Murphy making his paperweights. Fostoria Glass paperweights and John Murphy are documented and published in her book titled *American Glass Paperweights and Their Makers*, revised edition, second printing 1970.

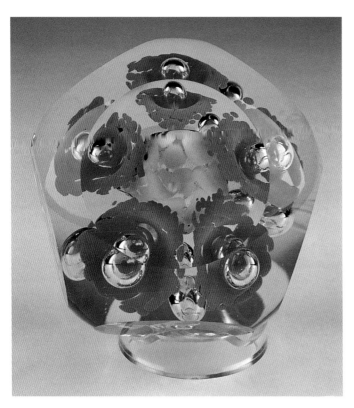

J. Murphy popular paperweight design, Orange Trumpet Flowers.

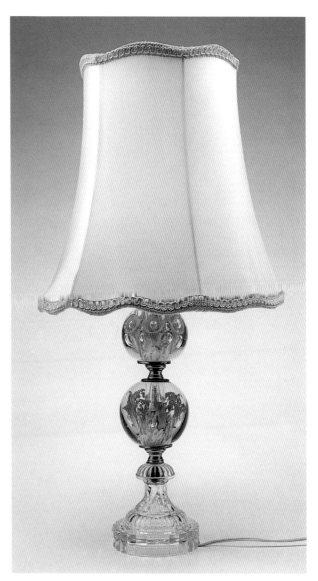

Orange Trumpet Flower Lamp created by John Murphy.

In addition to the beautiful paperweights that John made, he produced a total of eighteen Fostoria Paperweight Lamps for family members and close friends. The paperweight lamp was created from combining several paperweights of like designs, using the same colorants and style, but making each weight of a varying size. As lamps needed to have electrical wiring, John worked to develop a technique where he could make the center opening of the paperweight for the wiring while actually rotating the molten glass gather, amazingly equal and perfectly formed each time.

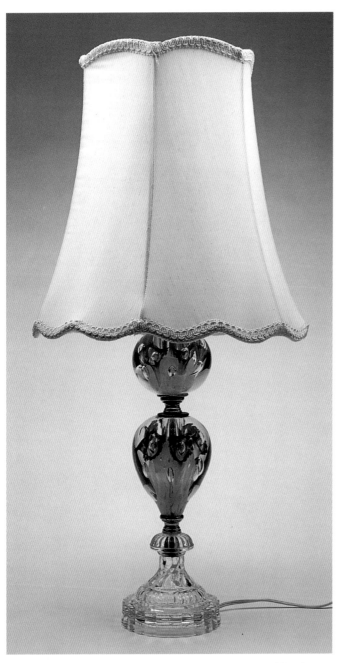

Blue Floral Lamp, with Colony Base, created by John Murphy.

His paperweight lamps maintain the exact balance and brilliance of the crystal, when assembled they are most stunning designs. He even created a miniature matching paperweight finial for the tops of each lampshade!

For the finishing touch in some of the paperweights that John created, he did his own cutting on the wheels for each window he put on his design. Although I refer to the cuts in the finished paperweights as "facets," John prefers to call the cutting of the finished paperweight, "windows" in which to view the intricate designs incased in the glass.

In 1991, John Murphy had a large paperweight auction in Moundsville that liquidated most of the paperweights that he had produced at Fostoria. Among these sought after treasures were a few pair of the extraordinary paperweight lamps. Murphy's paperweights can be found today at local estate sales, glass shows, antique malls, and on line Internet sales.

The Murphy Fostoria paperweights have been consistently rising in value over the past decade since this large auction in 1991. Part of the rise in price is reflected in the fact that his Fostoria paperweights were previously documented and published for collectors of American glass paperweights. Collectors seek out his artwork for his old world style and the incredible detail and colorants used in his designs.

Values given for Murphy paperweights reflect known recent sales of his artwork, with a base value rate of $265. All added value for treatments and finishes reflect the same values in the standard value guide for genuine Fostoria crystal paperweights.

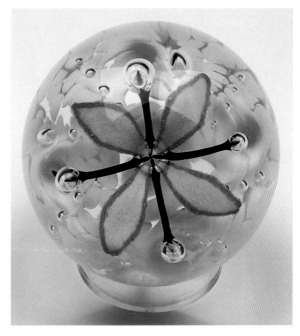

This weight features a feathered white base with romantic blue and pink flower with four petals and black ribbon pulled through. Signed J Murphy, 3.5" tall 3" diameter **$355.**

150

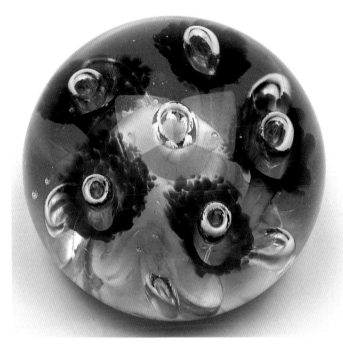

This large, beautiful crystal weight has an interior design of five cobalt blue flowers with controlled air bubble centers. Signed J Murphy, 2" tall, 4" diameter. **$355.**

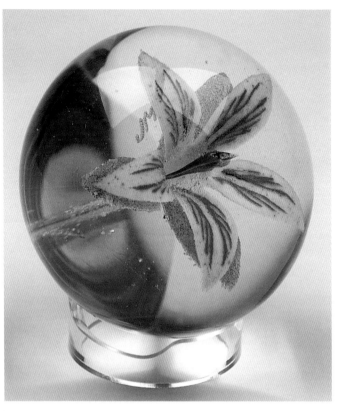

Simple elegance can be found in this romantic paperweight with white base, red and white frit petal flower with green frit stems. Signed JM inside the glass, and J. Murphy on bottom, 3" tall, 3.5" wide. **$355.**

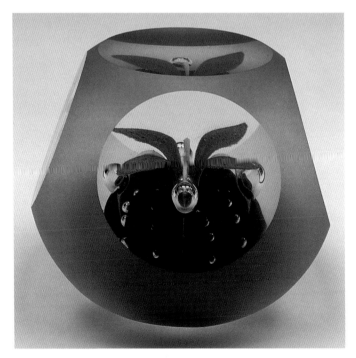

This exceptional weight, with ruby base, has an interior design of four petal blue flowers and elegant pulled white ribbon with air bubbles. There are five windows total, one top and four sides frosted with satin finish. 3.25" tall, 3.25" diameter **$535.**

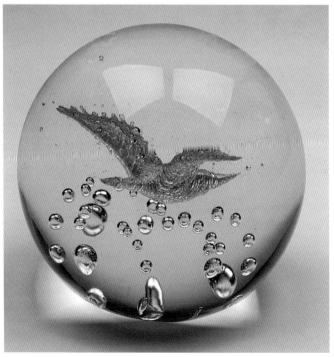

Here is an example of Murphy's Blue Goose (Custom design named after the Blue Goose) Puffed goose in flight, with Murphy's unique swell up process with rising air bubbles. Signed J. Murphy, 3" tall, 3.5" diameter. **$355.**

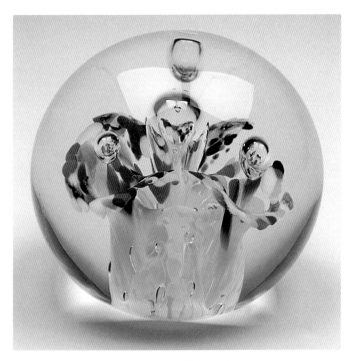

The interior decorations are incredible in this experimentation with three brilliant multi-color flowers, utilizing a variegated color and base. Signed J. Murphy, 3" tall, 3" diameter, perfect round. **$395.**

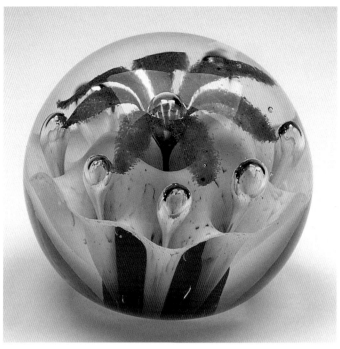

Side view to show the layers and process of making the patriotic design. No blocking tools are used, created by gravity flow; an ice pick is used to punch down molten glass layers on this incredible paperweight.

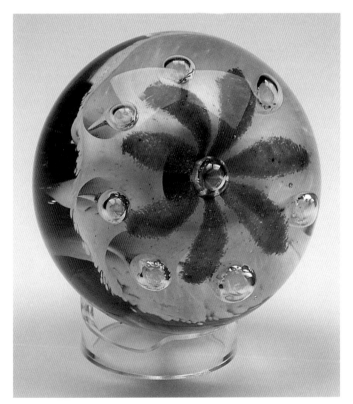

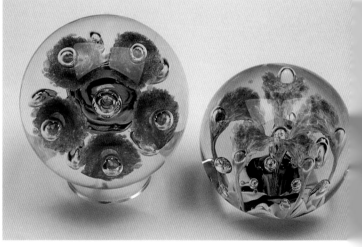

Amazing color in this seldom seen pair made with paint dye on petals, very difficult to produce and extremely scarce. Each weight features an ebony black and white swirl base, signed J. Murphy. **Left to right:** A five-trumpet flower weight with paint dye on pedals, 3" tall, 3" diameter. **$475+**; This features one flower with five petals, 3" tall, 4" diameter. **$465+.**

A patriotic favorite with fantastic detail, you have to hold this one to view the design of this red, white, and blue punch down weight. It is extremely difficult to make a punch down weight. A total of seven gathers was required to produced this seven petal blue flower, encased milk glass punch down layer with seven air bubbles, and ruby base with center air bubble. Exceptional. 3" tall, 3" diameter. **$560+.**

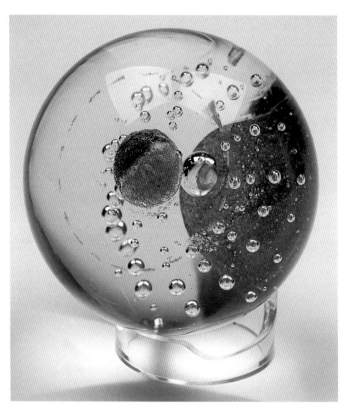

Inspired by America exploring space, this moon weight has details that cannot be captured on one photograph. Outstanding interior artwork is an elegant moon in the center and small space ship traveling around the moon, with the earth below. Extra gathers required to make this design. Signed J. Murphy 3.25" tall, 3.5" diameter **$625+.**

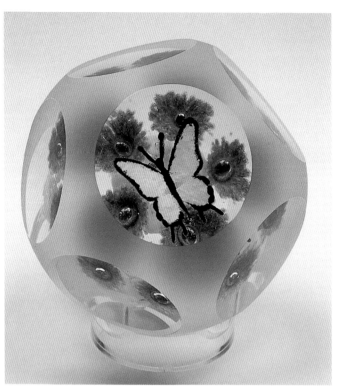

Extremely scarce, use of yellow and blue dye painted over glass for flowers. This is one of Murphy's incredible Butterfly Paperweights, featuring five blue flowers and five windows, one top and four sides. Signed. 3.5" tall, 4" diameter. **$545+.**

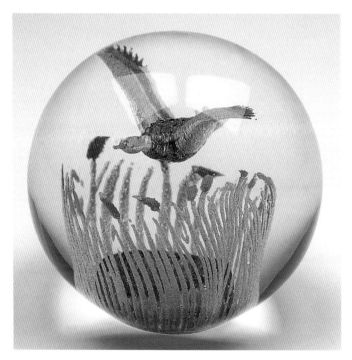

One of Murphy's the most popular designs is the Mallard in Flight and Cattails. His signature inside the glass is in the green grass. Blue base, orange cattails, multi color mallard in flight. 3.5" tall, 3" diameter. **$355.**

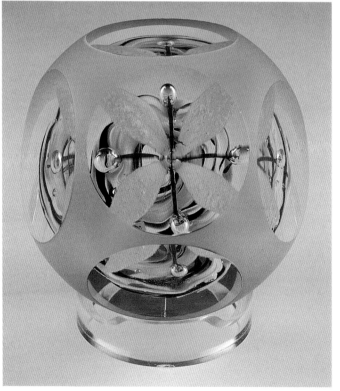

Extremely scarce yellow floral, with red ribbon pulled over ebony and white base. Finished with five windows and frosted. A unique treasure! Signed J Murphy, 3.5" tall, 3.5" diameter. **$515.**

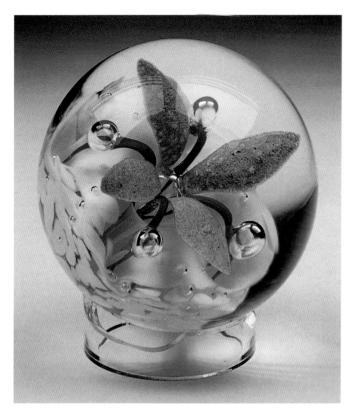

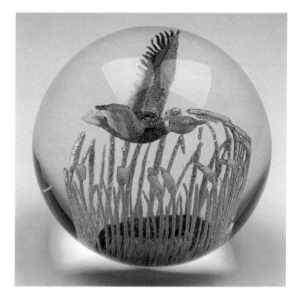

Mallard in Flight and Cattails, with the use of a blue base and white cattails, multi color mallard duck swell up design. Signed. J. Murphy, 3" tall, 3.5" diameter. **$395.**

A bold and beautiful floral design. Base of milk glass, with use of Argus Green glass for the four petal flower and five controlled air bubble center with a beautiful ruby ribbon pulled through, amazingly even. Signed. 3" tall, 3" diameter. **$345.**

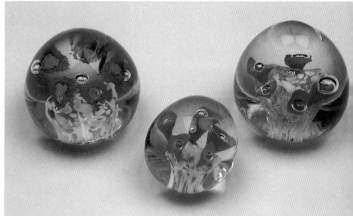

Extraordinary art work in miniature. These are the finials off the paperweight lamps Murphy created. They measure between 1" diameter and 1.25" diameter. John also made and faceted one-half inch paperweight earrings for his wife, Sandy.

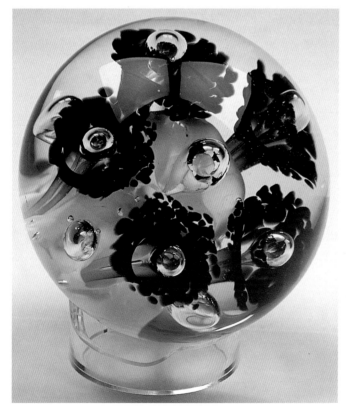

This beautiful weight offers simple elegance with an interior of five brilliant ebony flowers with controlled air bubble centers over an elegant white milk glass. Signed. 3" tall, 3.5" diameter. **$385.**

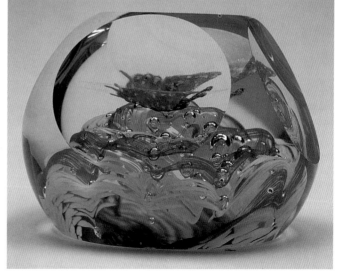

Here's a beautiful example of the Butterfly weight with use of patriotic colors; three dimensional red and white swirl base, blue and white butterfly. Blue painted dye over white glass. Five windows cut in. Signed, 3.5" tall, 3" diameter. **$425.**

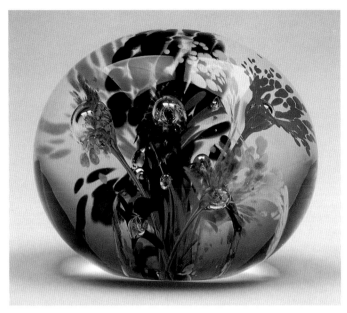

This magnum weight is one of the largest known. Blue, black, orange, and green are used to create this unique multi flower and air bubble weight. 4" tall, 4" diameter. **$365+.**

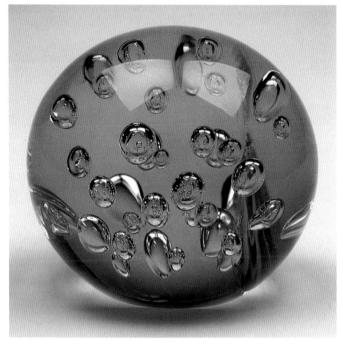

This magnum weight is soothing to touch and hold. It is transparent, radiating light beautifully through its Jamestown Pink color with multi air bubbles encased inside. Solid and heavy. 3" tall, 4" diameter. Signed. **$365.**

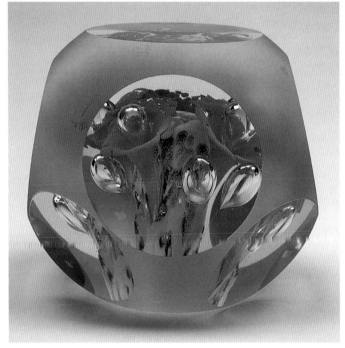

This extraordinary magnum weight is very detailed, with a total of nine facets to view the incredible five orange flowers frosted inside this beauty. Signed J. Murphy, 3" tall, 3.5" diameter. **$660+.**

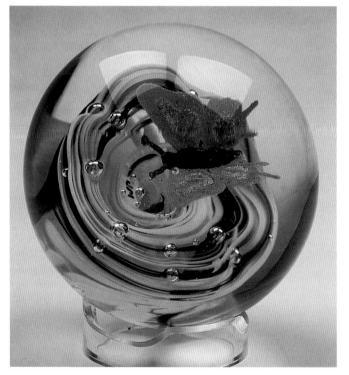

Another wonderful example of the Butterfly weight featuring an interior design of ebony and milk glass base swirl with a butterfly of cobalt blue body, orange and green wings. Signed JM inside the glass and J. Murphy on the bottom. **$365+.**

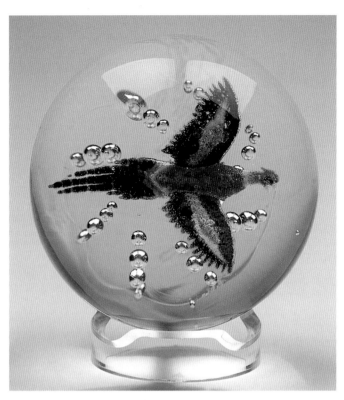

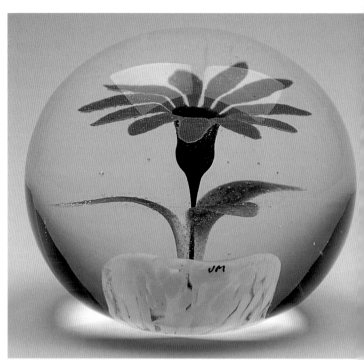

Flowers blooming in the home garden is the inspiration for this wonderful Black Eye Susan design weight. Orange flower with perfect individual petals, green stem, and white base, signed J. Murphy. Several of these were made. 3" tall, 3.5" diameter. **$345.**

A great example swell up of Ring Neck Pheasant in Flight. This elegant Ring Neck Pheasant was one of the most requested designs, the artwork extraordinary use of multi-colored frit. It was a bestseller among the workers. Signed J. Murphy on bottom. **$345.**

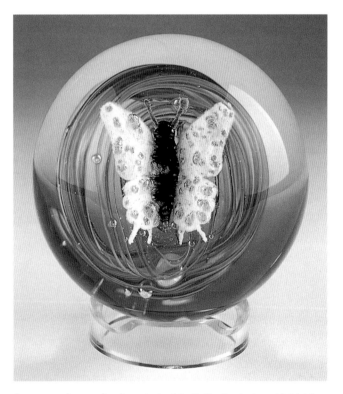

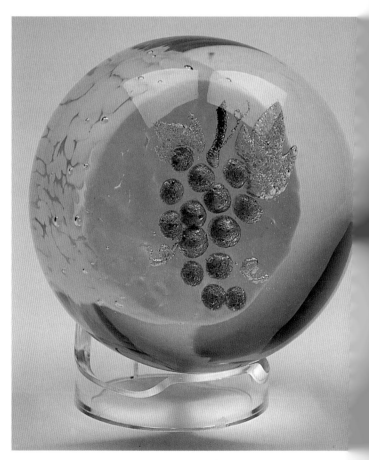

An unusual use of colorants in this Butterfly design. Light blue base, Argus Blue butterfly body with swell up wings of opal and honey yellow, black antlers. Signed J. Murphy. 2.5" tall, 3" diameter. **$355.**

White base, puffed up grape cluster of light blue grapes inside glass, artist signature inside the glass in the little curly stems by the leaves. John made several of this design with dark blue glass grape clusters. Unique design process to create, scarce to find. Signed J Murphy, 3" tall, 3" diameter. **$425+.**

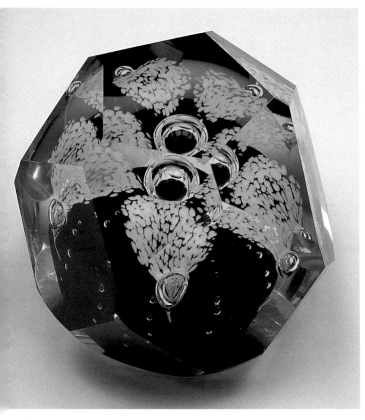

Extraordinary magnum weight. The interior is cobalt blue base, white flower controlled air bubbles and a total of sixteen window facets. 3.5" tall, 3.5" diameter. **$745+.**

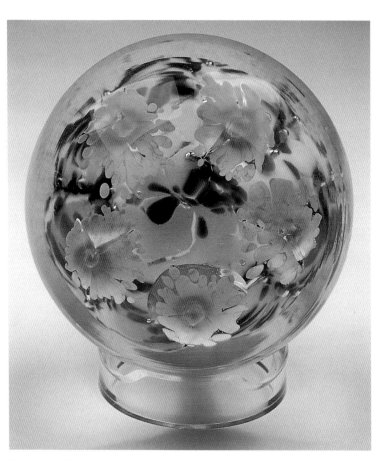

The use of Fostoria Yellow is hard to find in a paperweight, as it was tempered at a different rate and most often cracked. This is a beautiful example of five yellow flowers with blue base, limited edition, signed J Murphy, 3" tall, 3.25" diameter. **$425+.**

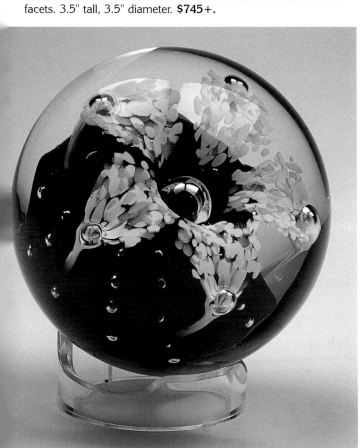

A perfect Calla Lily encased in glass. This beauty features a ruby base with five green and white calla lily flowers, perfectly shaped center air bubbles. Amazing even, wonderful craftsmanship. **$395.**

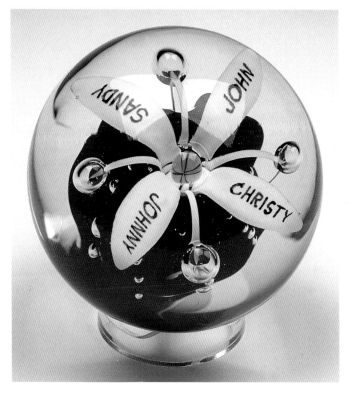

Personalized Murphy Family floral paperweight. **NDV.**

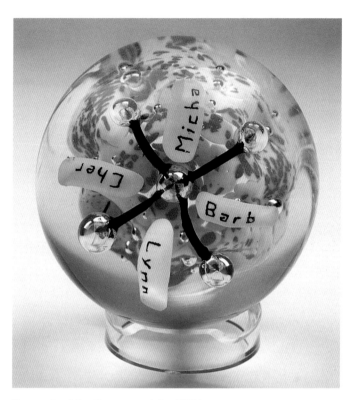

Personalized family paperweight. **NDV.**

This is an example of the stunning blue floral paperweight lamp produced to sit on a Colony lamp base. The beautiful 27" tall lamp features two magnum weights, the lower elongated weight is 5.5" diameter, extremely difficult to create with a total of five blue flowers and controlled air bubble centers surrounding the white base. The upper magnum weight is 3.5" diameter, with similar design of blue floral and controlled air bubbles with matching milk glass base. One of two double blue paperweight lamps known to be created by John Murphy. **$1450+.**

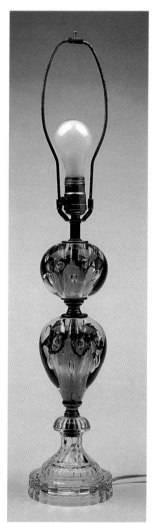

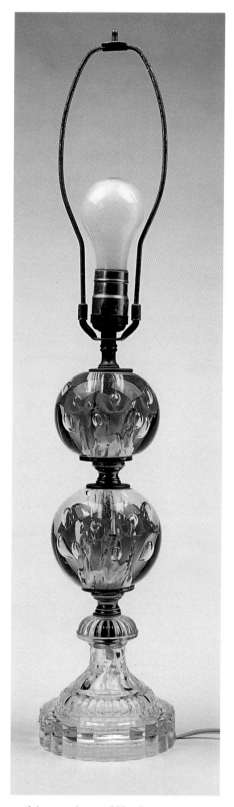

This is a beautiful example is a 27" tall orange trumpet flower double weight lamp. This one produced to sit on a Colony lamp base. The orange trumpet flowers are some of the most sought after among collectors of Murphy weights. This lamp features two magnum weights, the lower weight is 5.4" diameter and had a total of five trumpet flowers with controlled air bubble centers. The upper magnum weight is 3.5" diameter with a perfectly centered arrangement of similar orange trumpet flowers. One of four similar double orange paperweight lamps known to be created by John Murphy. **$1450+.**

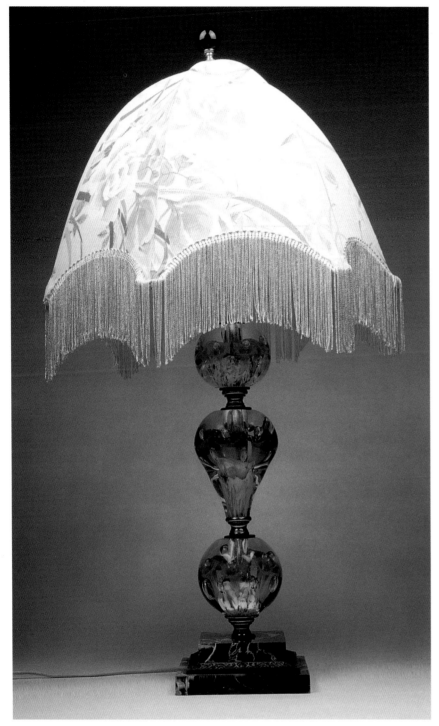

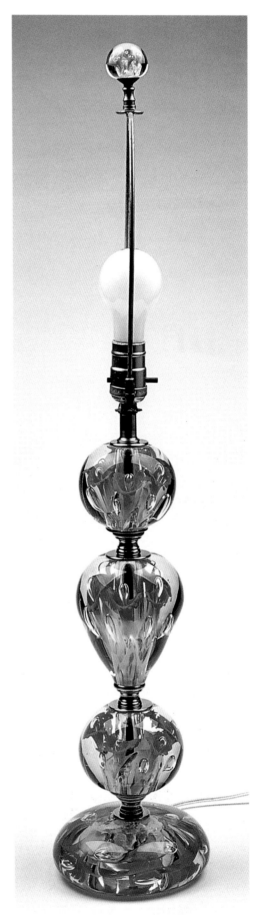

Exquisite one of a kind, 31" tall custom created orange trumpet flower triple weight lamp on a custom designed marble base. These three beautiful weights contain a total of five trumpet flowers each with controlled air bubble centers on a base of variegated milk glass and green swirls. Magnum bottom weight is 4" diameter, beautiful and extremely difficult to create; the elongated magnum center weight is 6" long; the 3.5" top weight 3.5" diameter; Finial 1.5" diameter. **$1850+.**

Outstanding and most difficult to produce this fantastic 30" tall, five paperweight lamp. The bottom base weight is extremely difficult to produce and this is one of three known to survive with the base weight attached. This is a popular orange trumpet flower design, with the five orange trumpet flowers in each weight, each with perfect controlled air bubbles and base color of milk glass and green. Measurements of weights from bottom up to the top: Base weight flattened orange trumpet flower magnum size 2.5" tall and 6.5" diameter; first weight magnum 4" diameter; second weight elongated magnum center 5" long; third weight 3" diameter; beautiful miniature matching final, 1" diameter. One of only three lamps know to exist with five weights. **$2350+.**

Paul Myers, Glass Artist

Paul Myers was an outstanding glass worker, as well as the union representative for American Flint Glassworkers Union Local #10 for seventeen years. Myers enjoyed watching Murphy and Wilkerson create paperweights and soon was the third man to join in this creative off hours work.

Paul Myers was born August 28, 1927 in Moundsville, West Virginia. Paul quit high school in the tenth grade; he would have graduated from Moundsville High in 1945. He did several odd jobs around Moundsville until he decided to enter the glass trade at Fostoria. Paul was hired at Fostoria Glass in November 1948. Paul Myers made a good career at Fostoria Glass and worked there a total of thirty-one years.

25th Anniversary Award for 25 years working at Fostoria. **Left to Right:** Jack Anderson, Starkie Haught, Otis Church, and Paul Myers. *Photograph courtesy of Paul Myers.*

Paul Myers acquired much of his early skills from his two uncles who worked at Fostoria, Okey Myers and Fountain Myers. As a young boy growing up in Moundsville, most days the boys would hang out around the factory and visit the older men who worked there on their lunch hours and dinner hours. Playing outside the factory as he often did, Paul said he knew all the workers. The boys would learn the glass trade and how to gather from the older men who worked at the factory. Some of the workers would come outside on lunch hours and get a bunch of tar, get the tar really hot in a bucket and get a stick to represent a gathering rod and teach the boys to gather the hot tar from the bucket. This gave the boys a chance to learn to handle the hot tar and gather it up, to eventually be able to catch a turn inside the factory when the were old enough to work.

Back in those days, the only way a boy would get a factory job at Fostoria was to catch a turn on one of the shifts. In order to be able to catch a turn, you must first be able to handle the hot molten glass, therefore, the old worker teaching the young boys how to gather the hot melted tar gave them the advantage they needed to make a career in glassmaking at Fostoria.

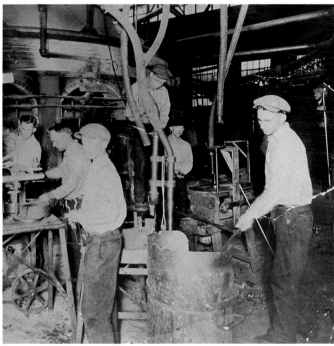

A look inside one of Fostoria's shops of yesteryear. *Photograph courtesy of Paul Myers.*

It was most interesting to note that the older glassworkers did the hiring of the new workers for the shops. If you had family relations working at the factory or if the shop workers liked you and your personality, they would tell the foreman to put you on their shop and you were hired.

However, if they didn't like you, and you were not doing a good job for them in the shop, they would tell the foreman to take you off the shop. If you didn't catch a turn in another shop that day, the foreman would simply put you out the door and that ended your job at Fostoria. The old workers themselves in the shop had the authority to have the young boy stay or go, and they would regulate who would work at Fostoria and who would not.

Myers created his own designs of the Daisies and Butterfly, whimsical Circus Clown and Big Top, his Pheasant in Flight, and enjoyed making long stem flowers. Myers enjoyed coming to work early at 5 o'clock in the morning to allow time to create his paperweights before the start of work.

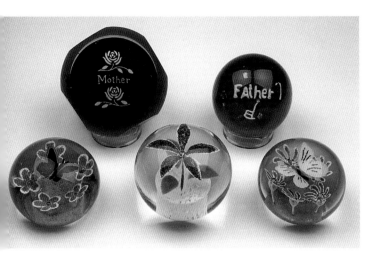

Collection of Paul Myers paperweights designs.

the weight may be found, but these styles are signatures of Paul Myers creations.

Myers was good friends with Bill Suter, a great cutter at Fostoria, and they began to make some paperweights together. Paul would make the weight and Bill would do the cuttings, sometime single facets, often times multiple facets. These weights would bear the signature of both Myers and Suter, and often times the weight would be dated. Suter signed most of his weights with his initials and last name: B.N. Suter.

Fostoria President David B. Dalzell enjoyed watching Myers and Suter create weights. David asked them to make paperweights for the Fostoria Executive Board of Directors. They came to work early to create these for David, and all the Executive Board weights made bear the signatures of Paul Myers and B.N. Suter on the bottom. John Murphy was also involved with the production of these twelve weights.

Myers made special weights for union representatives, the Fostoria board of directors, and factory workers. These weights shown vary in designs, as some may have additional facets to them and different colors used in the production of a special order weight. Many of the weights have extra gathers in the glass. The design treatments and technique made in production can only be determined by holding and viewing the paperweight from all angles, look closely in the designs for signature of "PM" in the inner design, such as in the tall grass with pheasant paperweight. Check the bottom of a paperweight for the inscribed signature "Paul Myers" and/or that additional signature of "B.N. Suter" when looking at a Myers paperweight that has facets.

Some of the first paperweights Paul made were gifts for his mother and father. Like the other workers, Paul would have put his signature on the weights he made when they were finished. Many were made for other factory workers to give to family members and friends. Daisy and Butterfly, the Pheasant and his signature Circus Clown and Big Top are a few of his most popular designs among the workers. Familiarize yourself to the art style of the maker. Variations in colors made inside

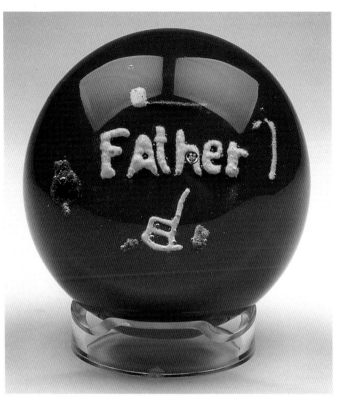

Paul's first gift weight, a ruby glass base personalized "Father" designed in grains of milk glass, encased in a final gather of crystal. Signed Paul Myers 71. 3" tall, 2.5" diameter. **$235.**

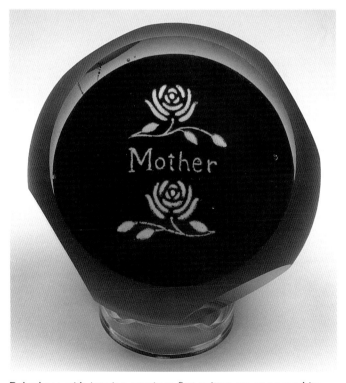

Ruby base with interior greetings first written on opaque white glass plate in cold technique and the plate is inserted in the glass. This weight has five facets, one top and four sides. Facets done by Bill Suter, signed Paul Myers 71. 2" tall, 2.8" diameter. **$345+.**

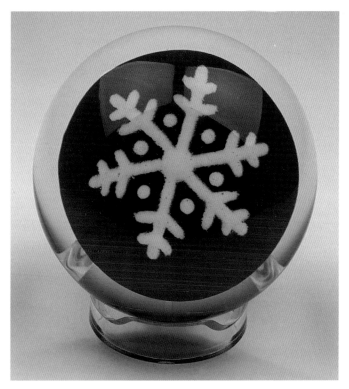

Snowflake paperweight features a red ruby base with a milk glass snowflake. Signed Paul Myers. 2.5" tall, 3.5" diameter. **$245.**

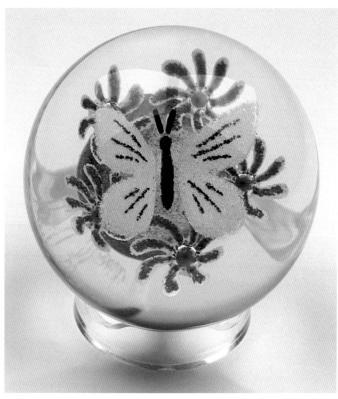

Scarce yellow Butterfly and Daisy, base weight green, five blue daisy flowers with stem, yellow butterfly, and ebony body. Signed Paul Myers, 2.5" tall, 3.5" diameter. **$345.**

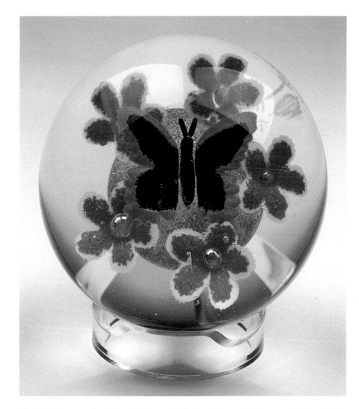

Paul is known for his designs of Butterfly and Daisy weights. This example has a green base with five orange and opaque white daisy flowers, with ebony butterfly trimmed in green. Signed Paul Myers 71. 2.5" tall, 3.5" diameter. **$295.**

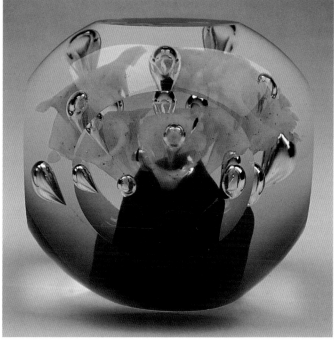

This design has a ruby base with five yellow flowers and air bubbles. Finished with five facets cut by Bill Suter. Made for Fostoria Board of Directors at the request of David B. Dalzell, then President of Fostoria, circa 1971. Signed PM only on the bottom. Magnum weight, 3" tall, 4" diameter. **$365+.**

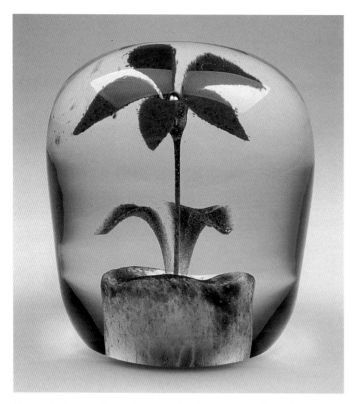

Unusual elongated weight, contains long stem ruby red flower with five petals and with three green leaves. Signed Paul Myers 71. 3.5" tall, 2.5" diameter. **$245.**

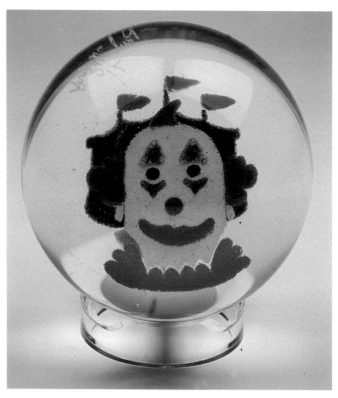

Circus design Clown and the Big Top. Bottom base is the circus tent, clown center, multi colors used green, orange, ruby, blue; these are Jamestown and Argus colors. This was a popular design. Signed Paul Myers 71. Measures 3" tall, 2.5" diameter. **$285.**

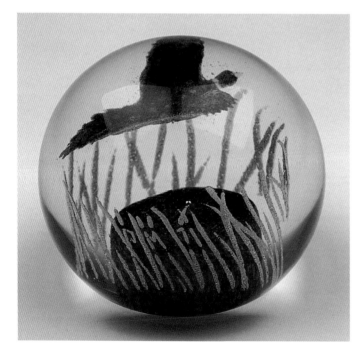

Sample of Myers design Pheasant in Flight. This is three-dimensional with swell up pheasant and Myers signature is inscribed inside the glass "PM71" that can be seen in the tall grass. Myers made many of these with various colors of pheasants and different finishes to the weight, for many of the workers. 3.5" tall, 2.75" diameter. **$285+.**

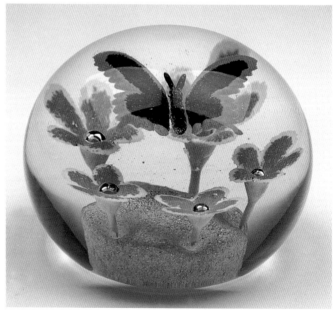

Butterfly and Daisy pattern, this combination of colors popular among the workers, features a green base, orange and white frit flowers and a swell up orange and black butterfly. 2.75" tall, 3.5" diameter. **$285.**

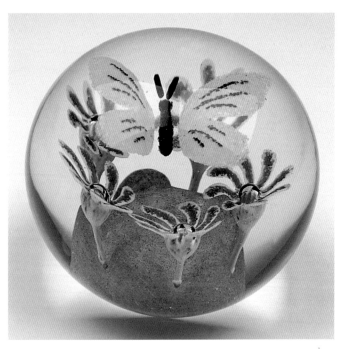

Daisy and Butterfly featuring Jamestown Blue daisy flowers in whimsical design with yellow frit butterfly. Signed Paul Myers on bottom. 2.75" tall, 3" diameter. **$345+.**

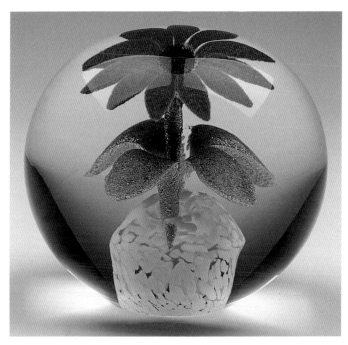

Paul liked to make floral daisy paperweights, one of his favorite flowers. This is an orange daisy with four leaves of green, white opal base. 3" tall, 3.5" diameter. **$275.**

Kenneth Robinson, Glass Artist

Kenneth Robinson's family played a large part in the history of Fostoria Glass Company. Four generations of the Robinson family worked there, from 1910 to 1984. The first to enter the glass trade at Fostoria was his grandfather, George Bennett who started work in 1910 and continued until his death in the late 1940s. Kenny's father, William Thurman Robinson began work at Fostoria in the late 1920s and continued there for fifty years until his retirement in 1970s. He was an excellent foot setter at the factory. The blown stemware was made in three parts; a foot setter is the man who puts the foot on the blown stemware. Kenny's dad had a total of 12 brothers and sisters who all worked at the factory in various jobs. They all married and had children who grew up to take jobs at Fostoria completing the four generations working from 1910 to 1984.

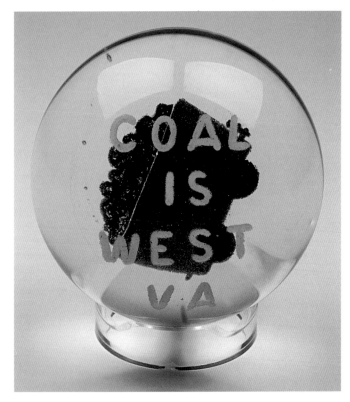

This is one of the last paperweights made at Fostoria factory by Myers and Suter in 1973. They decided to put a lump of coal into the paperweight and slogan "Coal is West Virginia.". This unusual magnum weight has seven gathers and faceted, difficult to see in the photograph. Myers made the weight and Suter did the cutting. Signed by Paul Myers and B. Suter, 3.5" tall, 3.75" diameter. **$325+.**

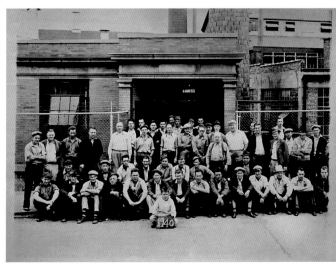

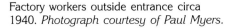

Factory workers outside entrance circa 1940. *Photograph courtesy of Paul Myers.*

Kenny's mother, Juanita Robinson-Yoho entered the work trade at Fostoria during the war years, she worked in the hot metal department doing the men's jobs during the war. After time off to raise her children, she went back to work at Fostoria and stayed there until her retirement in 1978.

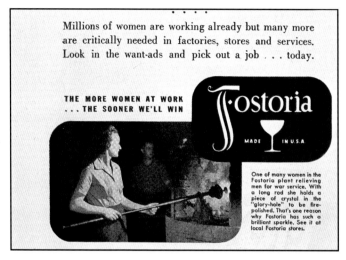

Millions of women are working already but many more are critically needed in factories, stores and services. Look in the want-ads and pick out a job . . . today.

THE MORE WOMEN AT WORK ... THE SOONER WE'LL WIN

Fostoria
MADE IN U.S.A

One of many women in the Fostoria plant relieving men for war service. With a long rod she holds a piece of crystal in the "glory-hole" to be fire-polished. That's one reason why Fostoria has such a brilliant sparkle. See it at local Fostoria stores.

WWII War Years – Women working in the Hot Metal Department at Fostoria.

Kenny Robinson went to work at Fostoria in 1960 right after he got out of the service. There were about 850 employees at that time. Kenny started out catching turns at the factory for workers who became ill and were sent home. He worked on the labor gang, which included anything from unloading boxcars, painting, cleaning, and working any department that needed him. In 1971 he was offered a job as Foreman in the mould-cleaning department. Robinson family tradition of working at Fostoria continued when Kenny's wife Clara took a job at the Fostoria Glass Factory Outlet store in Moundsville in 1971. Three of Kenny and Clara's five children, Patty, Cindy, and Robby entered the glass trade at Fostoria when they were old enough to work· Patty and Robby did various factory work; and Cindy worked on the Avon products, sandblasting the George and Martha Washington goblets. All lost their jobs when the factory closed.

Kenny Robinson was not a glassworker at the factory, however he liked to experiment with the pots of glass and make whimsies during lunch hours. Kenny enjoyed working with the glassworkers and particularly enjoyed watching Murphy and Wilkerson creating from the pots of glass. Kenny made a lot of weights called "Free Flow" block mould, created from a free flow of molten glass into a mould from a regular line. Some of these are featured in the whimsies section of this book.

Kenny soon joined in weight making with his friends Paul Myers and Jack Wayne. Kenny called his first paperweights "Crystal Balls" that were three layers of gathers from the pots of crystal with no design inside. He referred to these as his "Fortune Teller" weights. He just liked making them to practice the gathering of three layers of glass to try to get the feel for making weights.

With the help of Wilkerson, Murphy, or Wayne he created other designs as well. Several paperweights were gifts for his family members. He also made night-lights for his wife and mother from the weights as well as other types of lunch hour whimsies shown in the whimsies chapter of this book.

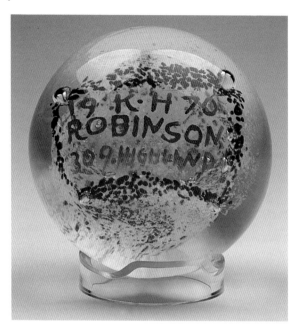

This large ruby base weight was one of the first created as a gift for his wife, Clara in 1970. Signed Robinson 70, 3.5" tall, 3" diameter. **NDV.**

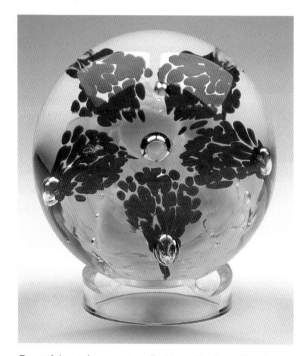

Beautiful weight, core is rolled in milk glass. This has five ruby flowers and center air bubble. Signed Robinson and Fostoria Logo. 5" tall, 3" diameter. **$245.**

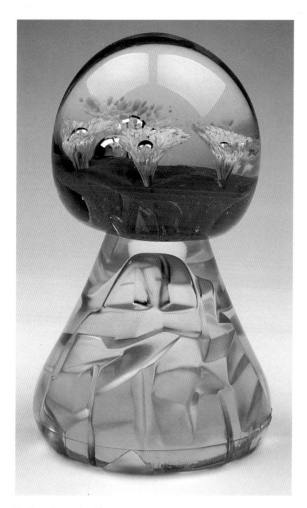

Pedestal weight. Bottom is an experimental pressed vase from 1970 that was never put out, vase was turned upside down. A round paperweight was glued on top to make a night light. Shown here the side view to see the experimental vase clarity. 6.5" tall, 3.5" diameter. **$295+.**

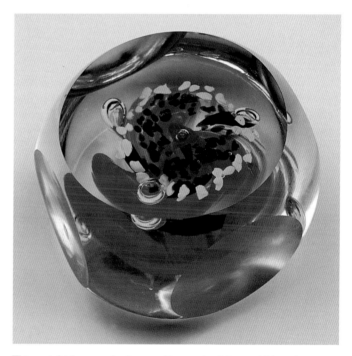

Ruby red base paperweight with three blue and three white flowers encased in the glass. Not signed, circa 1970. Magnum weight 3.75" tall, 4" diameter. **$255.**

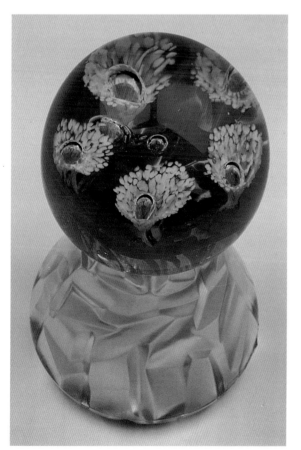

This weight has a ruby base, with a red, white, and blue abstract design. Five facets cut, one on top and four side facets. Signed Kenny Robinson 1970. 2" tall, 3" diameter. **$345.**

Pedestal weight showing details from above.

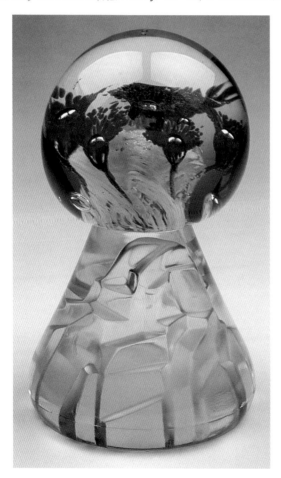

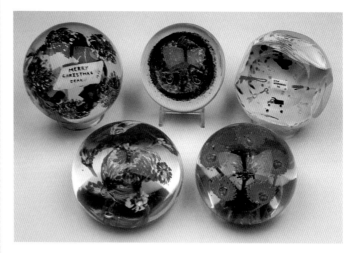

Don Wilkerson designed paperweights.

Big apple, personalized Kenneth & Clara 1971, 4 gathers in this apple, ruby core with crystal overlay, 4.5" tall, 3" diameter. **$215.**

Don Wilkerson was born in 1916; he entered the work trade at Fostoria in 1939. Don left the factory to serve in the Navy during WWII. He returned to work at Fostoria in 1944 and continued working there until his retirement at the age 62 in 1983. Throughout his many years of working at the factory, he worked a variety of job titles such as working on the labor gang, the boilers, truck driver, and in the maintenance department. Don particularly enjoyed watching his son Fred Wilkerson and the other glassworkers making paperweights. Don became interested and thought he would enjoy making a few designs of his own. Since he never handled the molten glass or gathered glass at the factory, he asked his son to gather and make the finished paperweights from designs he created and laid out at home. Fred would come home at dinnertime and/or go to work in the early morning and make the paperweights for his dad. Wilford Baker was an excellent glass cutter, and helped finish some of the weights with his excellent cutting skills. In some cases, these paperweights bear the signature of Don Wilkerson on the bottom; others bear the signatures of Fred Wilkerson and/or Wilford Baker. All of the paperweights of Don Wilkerson are gathered and made by his son, Fred; Wilford Baker cut the finishing facets.

A multi-color floral wreath with greeting written on white opaque glass, personalized, "Merry Christmas Dear" inserted inside. A design Wilkerson made for his wife for Christmas 1970. Signed Don Wilkerson 1970. 3" tall, 4" diameter. **$285.**

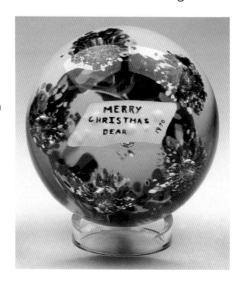

Pedestal weight night light created as a gift for Kenny's mother, Juanita Robinson-Yoho, circa 1971. 6.5" tall, 3.5" diameter. **$295+.**

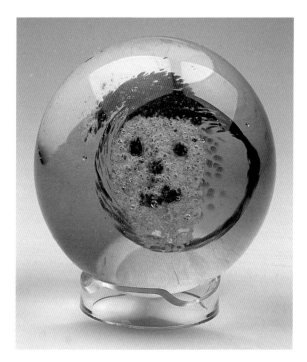

A very whimsical Santa paperweight, in red, white, and blue. Dated 1970. This weight is very large and heavy. 3" tall 4" diameter. **$215.**

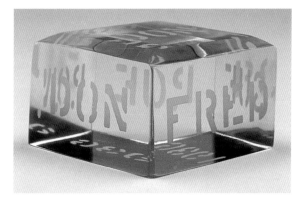

A very unusual personalized paperweight made for an anniversary gift. This weight was hand cut by Wilford Baker with a total of nine facets, giving look of square and beveled edges. This is inscribed with the wedding date on back, each side has a family member name. 1.75" tall, 2.25" square. **NDV.**

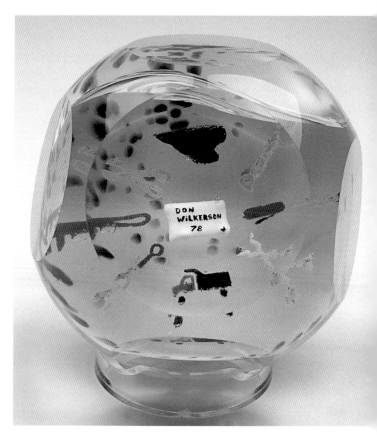

This exceptional weight includes five facets, one top and four side facets by Wilford Baker. Items inside the weight depict items found in the maintenance shop at Fostoria, truck, and tools. Opaque glass center plate is personalized Don Wilkerson 78. 2.5" tall, 4" diameter. **$365+.**

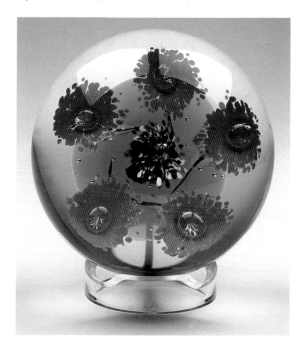

This unique weight features unusual mix of colorants, five orange flowers, ebony black base, green gather, with air bubbles in center of each flower. Signed Don Wilkerson 1972. 2.5" tall, 3.5" diameter. **$265+.**

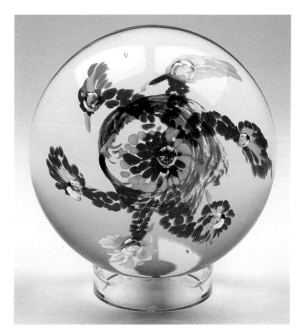

A unique abstract design, red, white, and blue swirls of glass, pinwheel flower shape. Seven air bubbles. Signed Don Wilkerson 2.5" tall, 4.3" diameter. **$245.**

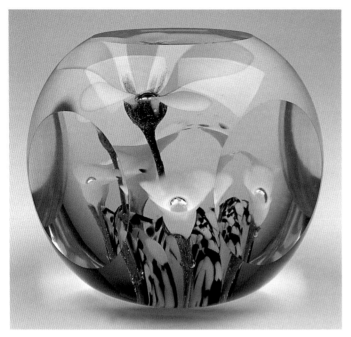

With an ebony and milk glass base, the center of this weight is a single flower with five petals, green stem, surrounded by five single petal flowers with green stems. This one cut with five facets, by Wilford Baker. 3.5" diameter. **$345+**.

Fred W. Wilkerson, Glass Artist

Fred W. Wilkerson was born June 22, 1940. He followed in his father's footsteps and entered the glass trade at Fostoria October 2, 1958. Initially he worked on the labor gang and other jobs as needed. In 1967 he started serving an apprenticeship as a gathering boy. He pressed ware for about two years and then finished ware until 1976, at which time the factory began moving towards automation. Fred Wilkerson continued to work on automated machines until the Fostoria plant closing in 1984. His talents in glassmaking flourished over his thirty years of working at Fostoria.

Wilkerson was the second artist at Fostoria to begin making paperweights in his free time in 1970. Wilkerson quickly became known for his unique spider design paperweights, his birds in flight, and whimsical personalized designs.

Fred W. Wilkerson found a certain magic in the transformation of base materials, sand with potash and lead with soda and lime and transformed this through heat and fire, into molten glass and into another dimension in his fascination of glass paperweights.

Wilkerson had read about the space program and the United States putting a spider in space to see if it could spin webs in space. Wilkerson was intrigued with this challenge and was inspired to spin a spider web inside the molten glass. This design has become his signature Spider Ball, a sought after treasure for today's collectors of Fostoria paperweights. Wilkerson did his artwork of the spider web for a mould and created his mould in the mould shop at Fostoria on his off hours. Wilkerson also did his own cutting of facets in the paperweight designs he made.

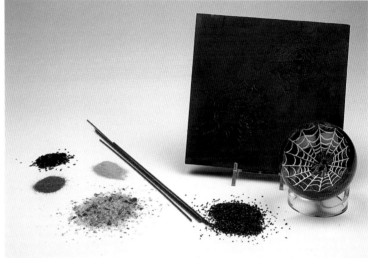

Fred W. Wilkerson's Spider Design Plate, shown with original carved plate, and frit glass ready to fill mould. The frit would be put in the mould and design is picked up in the gathering process.

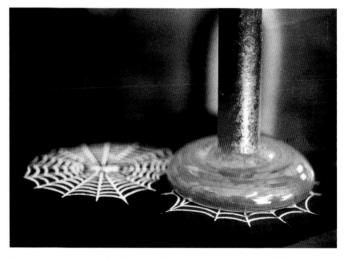

After a second gather, Fred picking up spider design. The artist gets another gather of molten glass and works quickly to reshape the weight.

Incredible view of the spider design just picked up in the hot molten glass. Another gather of crystal is required at this stage to encase the design in the glass.

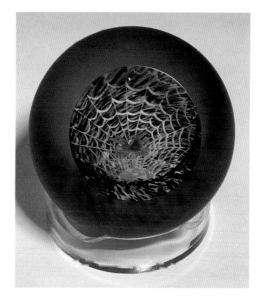

One of Wilkerson's first spider balls created with ebony base, white milk glass web and spider. Fire polished. Signed F. Wilkerson 1970. 3" tall, 2.5" diameter. **$245.**

There is an incredible amount of work in the design layout for the spider ball. The web and spider are spun out of grains of ground glass that is laid out into the mould. Often the web is of opaque white glass. The spiders are found in a variety of colors in the web; they can be ebony, green, blue and/or red. The spider's eyes are normally a different color than the body. The spider web design seems to be marching into infinity.

David Dalzell, Sr. and many of the older factory workers enjoyed watching Wilkerson create his magic in paperweight designs and encouraged him to create more. In 1971 David Dalzell, Sr. had presented Wilkerson with a new furnace that had been assembled for him at the Fostoria factory and then moved to Wilkerson's home so he would be able to set up a shop and create weight orders on his own time. Eventually Fred acquired some old glass moulds and he was given two old presses no longer in use at Fostoria. With these tools, Fred Wilkerson started a small glass shop at his home in Moundsville in 1972. However he continued working at Fostoria full time until the factory shut down in 1984.

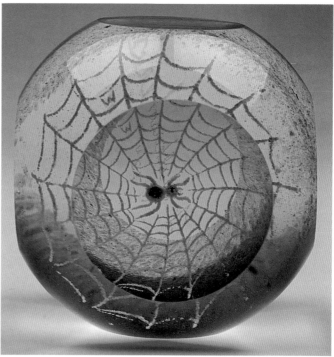

A striking spider weight, light green base color, white web, green glass spider. Total of five facets, one on top and four sides cut into this beauty. Signed inside glass with Wilkerson signature "W" and 1972. 3" tall, 3" diameter. **$425+.**

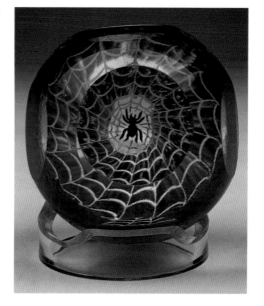

Cobalt Blue base spider weight with black glass spider. Cut with five facets, one top and four sides. Signed Wilkerson. 3" tall, 3" diameter. **$375+.**

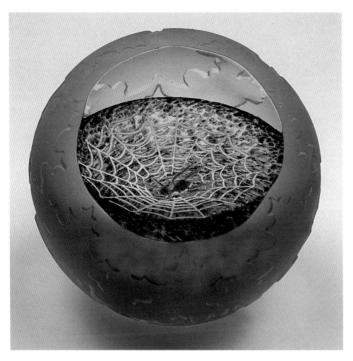

Sampled early spider ball, unique in this is a mix of green and ebony base color, green spider. This weight has been sand blasted outside, with sand carving etched design. Very unique details and many hours of work, one of a kind. Signed Wilkerson. 2.5" diameter. **$515+.**

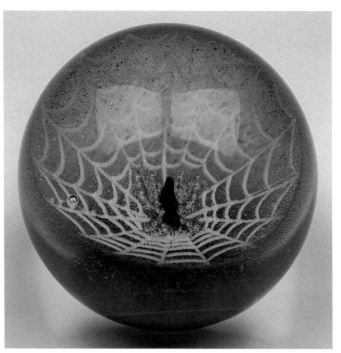

Spider ball with light green base, white web, and green spider. Signed Wilkerson 72. Perfectly round 2" diameter. **$225.**

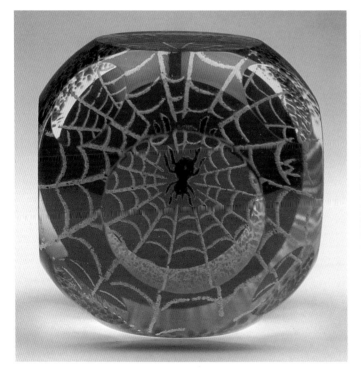

Very scarce spider weight with ruby base and ebony spider. An unusual detail in this one is the cut with a total of eight facets, on the sides, beveled, and top cut. Signed inside the glass with "W," Wilkerson signature and dated 1971. One of two known made in this style design cut. 3" tall, 3" diameter. **$545+.**

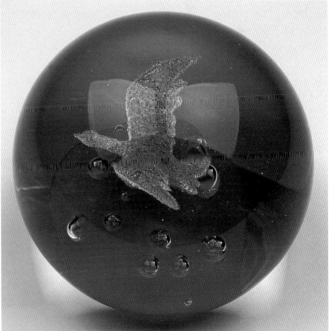

Murphy was the first man to discover how to swell up the glass inside the weights. Wilkerson was the second man use this process he calls "swell up" of birds inside the weight. This is a great example of ruby base and bird in flight, a favorite. This early example of swell up gives a three-dimensional look to the bird in flight. Signed Wilkerson 1970. 3" tall, 3" diameter. **$245.**

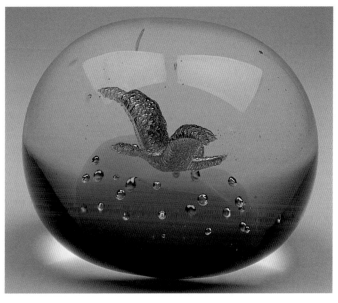

Bird in flight, blue vase with two tone milk glass and Jamestown Blue used on bird, with controlled air bubbles. Signed Wilkerson 1970. 3.5" tall, 3" diameter. **$245.**

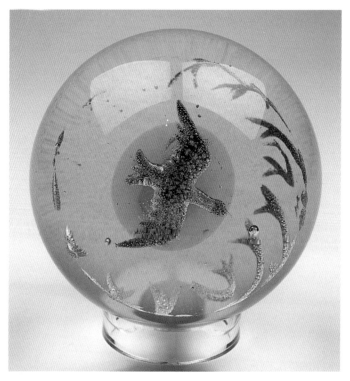

The bird in flight in this work of art is made with Jamestown Blue glass. Bird is actually flying over beautiful palm trees and tall grass that can only be viewed when holding and rotating the weight. Great effects. 3.5" tall, 3" diameter. **$335.**

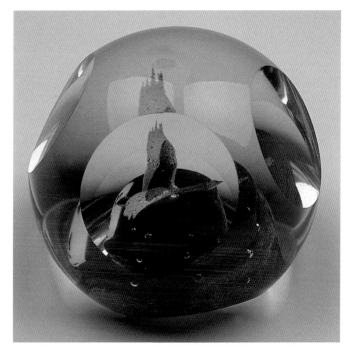

Bird in flight weight with four perfect faceted cuts to view the bird from all sides. Ruby base, brown and blue shades of glass bird. Signed Fred Wilkerson, 3" tall, 3" diameter. **$385+.**

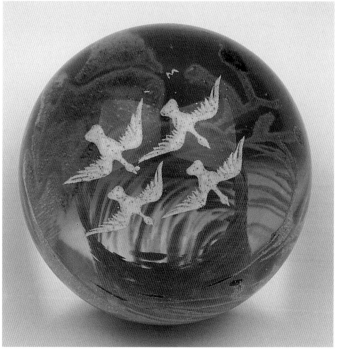

Sample weight, first grouping of several birds in flight. Orange base with green leaves around the outside, four birds in flight. Signed Wilkerson. 2.5" tall, 3.5" diameter. **$345.**

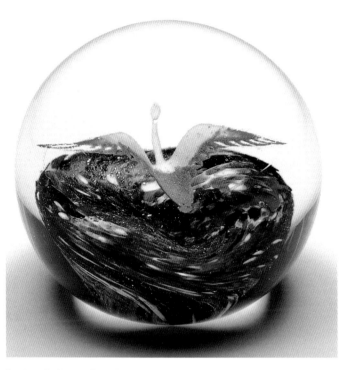

Bird in flight, multi-colored base with pink, blues, and greens. Bird is two tones blue and white. Signed Wilkerson 72. 2.75" tall, 3" diameter. **$265.**

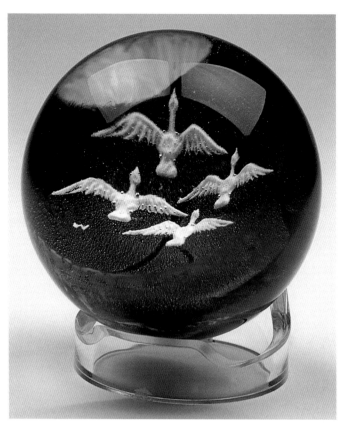

Four birds in flight, Jamestown Blue base artist signature, "W," inside the weight. Dalzell requested a weight like this be sent to Helen Dalzell as a gift. 2.5" tall 3" wide. **$255.**

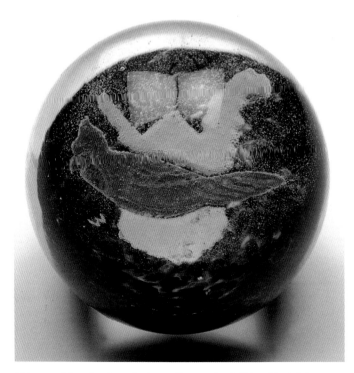

This special order item features the cardinal, West Virginia's state bird. Ebony base, green state, and ruby cardinal. Signed Wilkerson71. 2.5" tall, 2.75" diameter. **$235.**

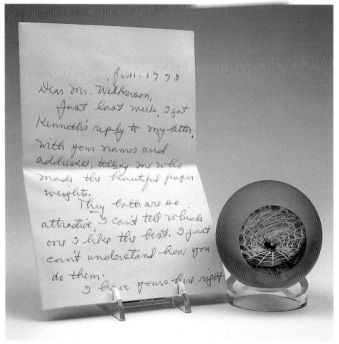

A letter from Mrs. Helen Dalzell to Fred Wilkerson thanking him for two weights he created for her.

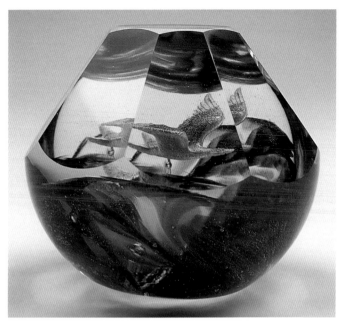

This incredible paperweight has characteristics that cannot be captured in the photograph. Created by Wilkerson using the Fostoria Emerald Green glass cullet used at the factory 1964-1966. Outstanding bird in flight shows three dimensional when viewed through one of the facets. Wilkerson did all the facet work himself. Stunning total of nine facets on this beautiful weight. $855+.

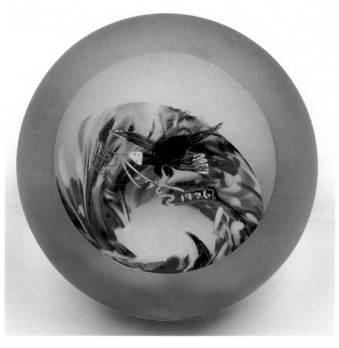

American Eagle bicentennial sample features a blue and ruby base gather, eagle in flight, 1976. It has one large facet window, then frosted to allow clear view of the interior design. Signed Fostoria on bottom, 3.5" tall, 3.5" diameter. $495+.

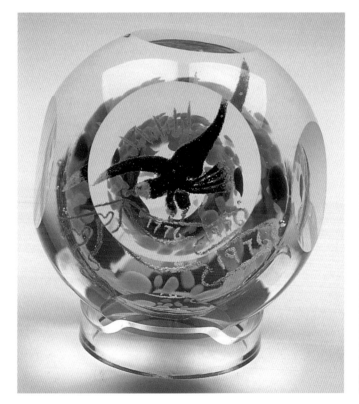

American Eagle weight created at the request of David Dalzell, Sr. for the Bergstrom Museum of Art Bicentennial celebration. This weight is a stunning design of an American Eagle in flight with ribbon dated 1776-1976. Blue base and ruby gather. Total of five facets cut in this weight by Wilkerson. 3.5" tall, 3.5" diameter. $635+.

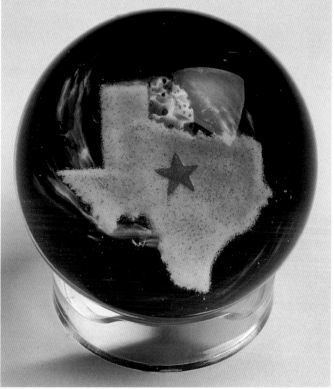

State of Texas paperweight. May have been special order for a group of Texas Fostoria collectors. An ebony black base, with milk glass Texas and Jamestown Blue glass star. Signed Wilkerson 1978. 2.8" diameter. $235.

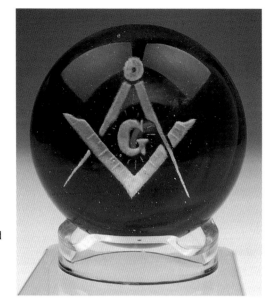

Special design request, Masonic paperweight. Cobalt blue base, milk glass Masonic emblem. Signed Wilkerson 76. 2.8" diameter. **$215.**

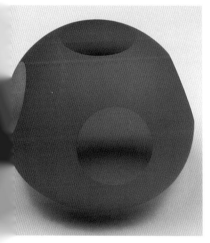

One of the last paperweights Fred made at Fostoria the plant itself. This is a simple elegant design from Jamestown Pink glass, five facets cut, one top and four sides, frosted. Signed Wilkerson, 3.5" diameter. **$225.**

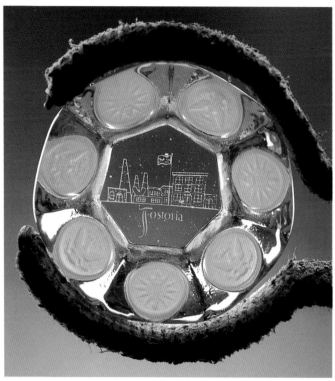

Fine example of a design Wilkerson is currently making from an original coin mould of Fostoria. This was a special coin paperweight produced as a commemorative for Fostoria collectors. This color green was created with actual cullet from the Fostoria factory. Wilkerson signature "W" etched in the flag flying over the factory. This original Fostoria green cullet provided enough glass to make only a limited few of these items. This is new item from old green Fostoria cullet, circa 2002. **$125.**

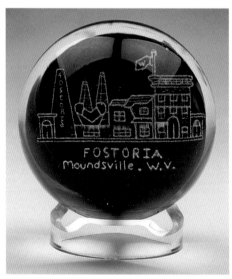

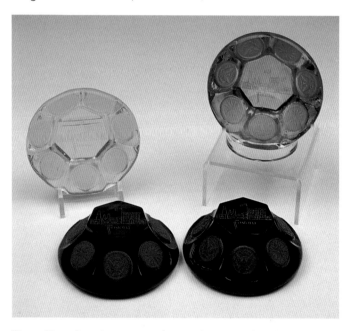

Fred Wilkerson created this design after the close of the Fostoria Glass factory to preserve the heritage of Fostoria Glass. This commemorative paperweight had several made with an ebony base, and the Fostoria Factory outlined in frit glass, encased inside. These were not made at the Fostoria factory from Fostoria crystal, but produced after the factory closing at Wilkerson Glass. Wilkerson signature is a "W" etched into the flag that is flying over Fostoria Factory. **$150.** Not shown: A limited edition of 100 commemorative Fostoria paperweights was created with cobalt blue base and five facets for Fostoria Glass Collectors fundraiser circa 1991. Each of these weights is signed Wilkerson, dated and the production number on the bottom, i.e. 10 of 100. **$150.**

These Fostoria coin paperweights are being produced as a commemorative for Fostoria collectors today. Current commemorative design by Wilkerson Glass, Wilkerson signature "W" etched in the flag flying over the factory. They are made in a variety of colors including canary, light blue, green, purple, cobalt blue, ruby, and amber glass pressed in original coin mould, frosted coins, and etched with Wilkerson custom design of Fostoria Glass Factory. Circa 2003. **$60.**

Fred S. Wilkerson, Glass Artist

Fred S. Wilkerson was a third generation Fostoria employee and began experimenting in glass making at the age of twelve. Young Fred took full advantage of the furnace his father had set up at his home shop. He enjoyed learning skills from his dad and making weights with his dad. Some of their designs from the late 1970s include Butterflies, Birds in Flight and Fred's favorite: Rams Head. Fred S. has created many beautiful personalized paperweights for my family members and Fostoria friends commemorating special occasions.

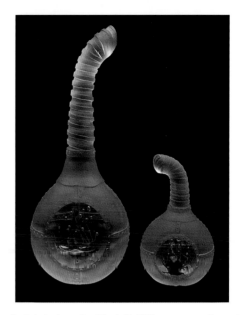

These wonderful designs by Fred S. Wilkerson are fantasies in glass that take the art of American made paperweights into a new realm of the imagination. Titled "Last Dive," this extraordinary design replica of antique diving helmets, sand carved and faceted with a view into the window reveals extraordinary sea life at the bottom on the sea. Limited editions. **Left:** Last Dive, large diving helmet, 8.75" tall, bottom diameter 4.25". **$975+; Right:** Last Dive, small diving helmet, 5" tall, 3" wide. **$425+.**

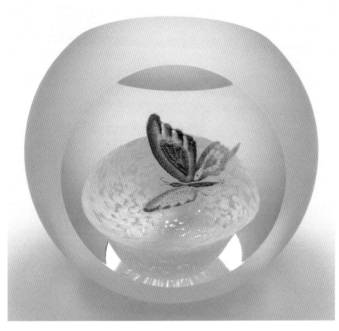

Current design, Butterfly features multi-colored butterfly, with double facets cut in the sides of the weight and frosted. Signed Wilkerson and dated. 2.5" diameter.

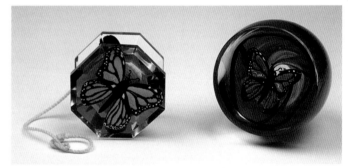

Incredible Butterfly glass yo-yo, created from two butterfly paperweights that have been custom designed with a monarch butterfly and multiple facets to create the extraordinary beveled edges; design of Fred S. Wilkerson, circa 2002. **Left:** Butterfly yo-yo. **$1000+; Right:** Limited edition Butterfly Paperweight. **$245+.**

Fred S. Wilkerson entered the glass trade at Fostoria after graduating high school in 1981. He worked there about a year before joining the Air Force in 1985. The father and son team of Fred W. and Fred S. Wilkerson turned their talents into Wilkerson Glass Company. Both father and son have demonstrated their talents at The Oglebay Carriage Glass House and Museum in Wheeling, West Virginia and have taught glassmaking classes there. Fred S. also instructs glass classes at The Pittsburgh Glass Center. Today the father and son team turn out the most stunning collectible art glass paperweights that are now sold to collectors in the United States, Europe, and Australia. They specialize in abstract art as found in these examples of their limited edition Millennium weight, unique undersea life creations, and limited edition custom designs. If collectors would be interested in current works of art, they may contact me via my web site for limited edition sales.

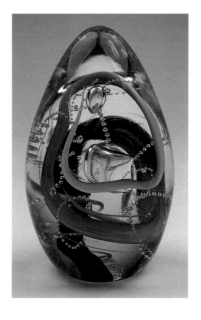

Limited to an edition of 1000 pieces, the Millennium paperweight, circa 2000, Signed F. Wilkerson, 2000. **$125+.**

Chapter Nine
The Subject of Stemware

Fostoria makes all types of wine glasses, cocktail glasses, parfaits, sherbets; champagne glasses in a variety of stemmed and footed shapes (both fragile and heavy). Plain, etched, engraved and decorated in enamel, gold and silver. Delight in the color of glass, the brilliance of crystal, its transparency, the play of light flickering through it, the glamorous reflections, is a joy multiplied because it is inherited from countless generations of beauty lovers. There has never been a time when glass has been a subject of such great interest and fascination as it is today- to collectors and to decorators and to every woman who takes pleasure in home making. And never before has really beautiful glass been so available and so reasonably prices as Fostoria. Quoted from *Fostoria, New Little Book About Glassware,* 1926.

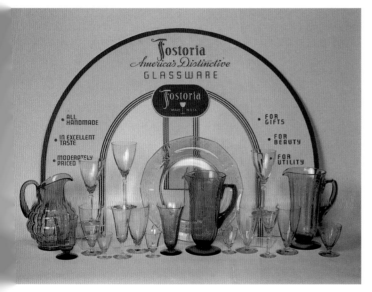

Examples of Fostoria's finest glassware shown pictured with original early dealer advertising display.

For many years, Fostoria stemware has been famous for its pure crystal quality, which you may easily test by the clear, resounding tone of the glass. The gracefulness of the designs, created to match the new dinnerware, will please you. Whether you use stemware to complete a dinner service of Fostoria, or to lend color and sparkle to other table appointments, you will take much pleasure in these fragile magic bubbles, made in crystal and Fostoria colors. When you are perfectly equipped to entertain formally at dinner, your glassware service should include in stemware: goblets, sherbet glasses, parfait glasses, grapefruit dishes (with liners), oyster-cocktail glasses, and whatever wine glasses your custom requires. Fostoria stemware was made for the Formal and Informal dinning needs of the housewife. Early stemware pattern blanks offered up to twenty-five different sizes of stems in the line. Lifestyle changes and casual dinning of the 1950s began a change in the amount of stems offered; most patterns at this time had less than sixteen stems in line, by the 1970s, only eight stems in line.

Collectors will find the catalog measurements for the glass stems and actual stemware when measured is not always matching. There is often a slight difference in height, even among the glassware in your china cabinets at home. Fostoria stemware was hand blown and hand-moulded one item at a time, each item is slightly different. Jon Saffell, Fostoria's Designer, told me that most often letters of inquiry regarding the Fostoria stemware were in the measurements of the stem sizes, the amount of ounces it was suppose to hold and how to properly measure the stem. At times, the height of the stem of the same size of handmade glass could vary by as much as one-quarter inch.

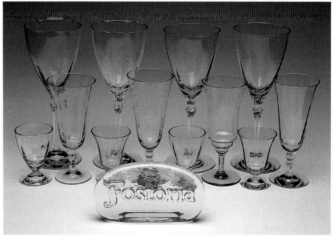

Fostoria stemware and tumblers offered simple elegance, whether you choose plain colors, or decorated in a variety of etchings, gold and/or silver applied trim.

Wedding Cake and Loop Optic Amber Foot Goblets. Fostoria produced many beautiful patterns for the Bride. Fostoria's designer, Jon Saffell provided a list of 1960s stemware patterns which reads like a love story: "First Love," "Engagement," "Announcement," "Bridal Shower," "Bridesmaid," "Chapel Bells," "Matrimony," and "Reception." Noting Fostoria had yet to produce a modern-day follow-up to those patterns, which could have been named "Annulment" and "Divorce!"

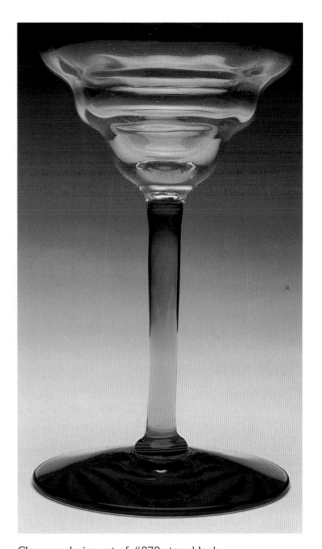

Close up design art of #870 stem blank.

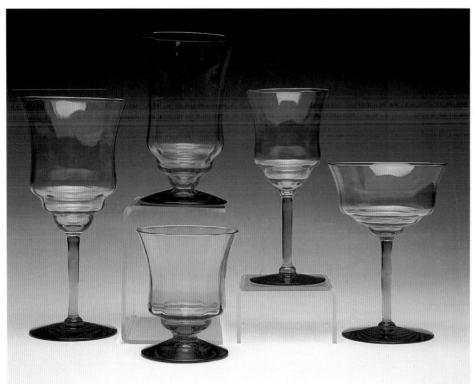

#870 Stems, Amber, 1926-1940. **Back row left to right:** 9 ounce Goblet, 7" tall. **$18**; 6 ounce Parfait, **$15**; 2.5 ounce Claret, 6" tall. **$20**; Champagne High Sherbet, 5.15" tall. **$15**; **Bottom Center:** 4.75 ounce Oyster Cocktail, 3.5" tall. **$14.**

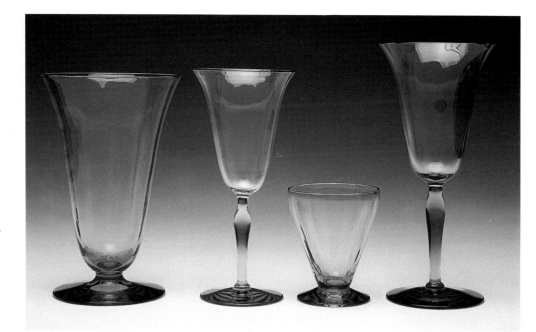

#877 Stems, Orchid, 1927-1928 only. **Left to right:** 12 ounce Footed Ice Tea, 6.5" tall. **$28;** 4 ounce Claret, 6.25" tall. **$32;** 4 ounce Oyster Cocktail, 3.5" tall. **$28;** 10 ounce Water Goblet, 7.25" tall. **$35.**

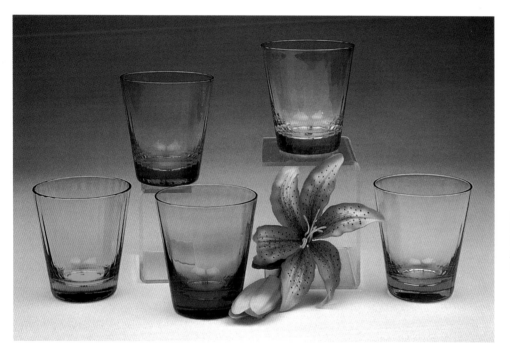

#1184 Narrow Optic, 7 ounce Old Fashioned Cocktail, 1934-1937. **Left to Right:** Green, Wisteria, Amber, Topaz, and Rose. 3.5" tall. **$16 each.**

#2321 Priscilla Footed Handled Custard, Canary, 1936 (not in catalogs). 4" tall. **$38.**

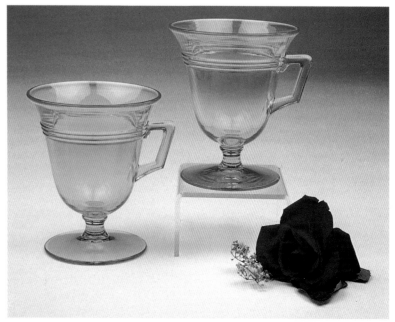

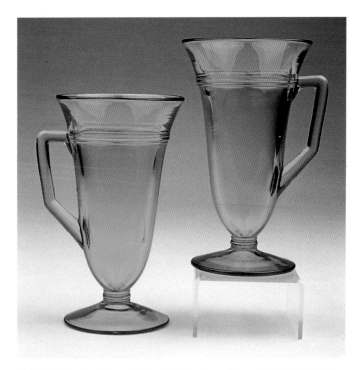

#2321 Priscilla Footed Handled Tumbler, Blue, 1925-1927, 6"
tall. **$35.**

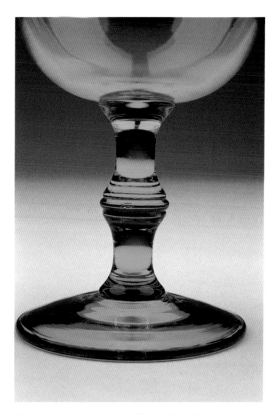

Close up design art of #2321 Priscilla stem.

#2321 Pricilla Saucer Champagne/Sherbet, Blue, 1925-1927,
4.5" tall. **$25.**

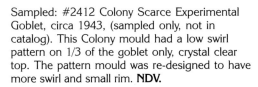

Sampled: #2412 Colony Scarce Experimental
Goblet, circa 1943, (sampled only, not in
catalog). This Colony mould had a low swirl
pattern on 1/3 of the goblet only, crystal clear
top. The pattern mould was re-designed to have
more swirl and small rim. **NDV.**

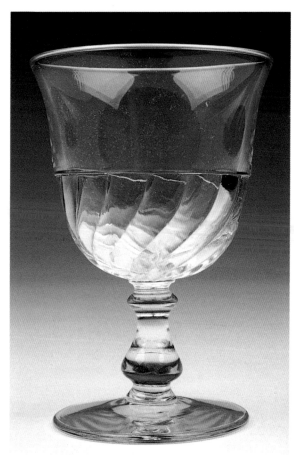

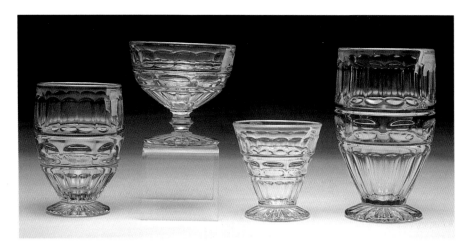

Left to right: #2449 Hermitage, Azure, 1932-1942, 9 ounce Table Tumbler, 4.75" tall. **$15;** #2449 Hermitage High Sherbet, Azure, 3.75" tall. **$20;** #2449 Hermitage 4 ounce Oyster Cocktail, Topaz/Gold Tint, 1932-1943, 3" tall. **$12;** #2449 Hermitage 12 ounce Footed Ice Tea, Topaz/Gold Tint, 5.25" tall. **$15.**

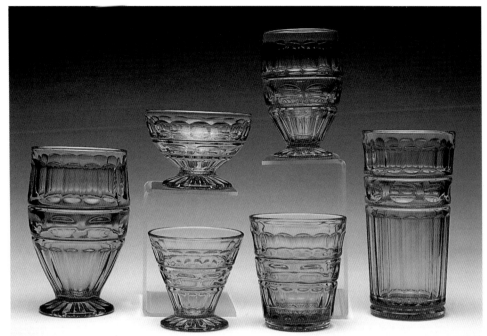

#2449 Hermitage, Amber, 1932-1941. **Back row left to right:** #2449 Hermitage Low Sherbet/Fruit Cocktail, 3" tall. **$12;** #2449 Hermitage 9 ounce Footed Tumbler, 4.75" tall. **$12; Front row left to right:** #2449 Hermitage 12 ounce Tumbler, 5.5" tall. **$15;** #2449 Hermitage 4 ounce Oyster Cocktail, 3" tall. **$12;** #2449 Hermitage 6 ounce Old Fashioned, 3.25" tall. **$12;** #2449 Hermitage 12 ounce Flat Tumbler, 5.75" tall. **$13.**

Sampled: #2496 Baroque blank, experimental Navarre Etching #327 extremely scarce, circa 1937. No records exist as to quantity sampled or produced. **Left:** Sampled, Navarre on 14 ounce Flat Ice Tea, 5.78" tall. **850+; Right:** Sampled, Navarre on 9 ounce Flat Tumbler, 4.25" tall **750+.**

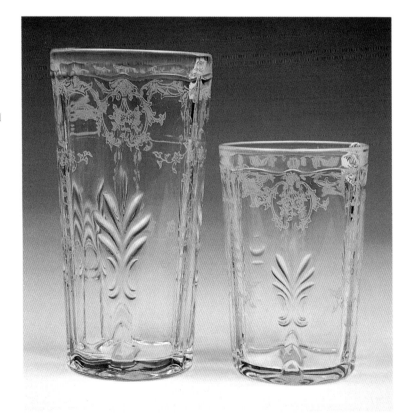

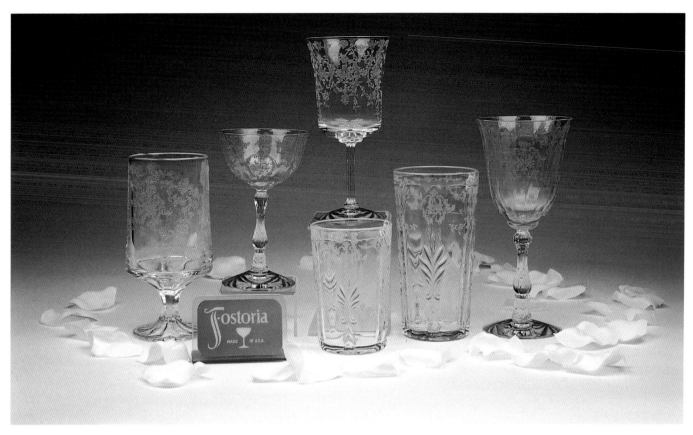

Sampled: Extremely scarce experimental items of Navarre Etching #327, design of Edgar Bottome. These samples on various stemware lines were found in the design morgue at the close of the factory. With the exception of the Gold Tint Navarre stem as noted, no known records exist with quantity sampled or produced. **Back row:** #6123 Princess stem, sampled circa 1972, 6.5" tall. **$585+; Front row left to right:** #2916 Fairlane stem, 14 ounce footed Ice Tea, circa 1976, 6.75" tall. **$585+;** #6016 Wilma stem, Azure Blue Bowl with unique Gold applied Navarre etching, circa 1937, 5.25" tall. **$950+;** #2496 9 ounce Flat Tumbler, sampled circa 1937, 4.25" tall. **$750+;** #2496 14 ounce Flat Ice Tea, circa 1937, 5.78" tall. **$850+;** #6016 Wilma stem, Gold Tint Bowl, sampled circa 1937, 10 ounce Goblet, 7.25" tall. A total of 12 of these Gold Tint stems are known to exist. **$1250+ each.**

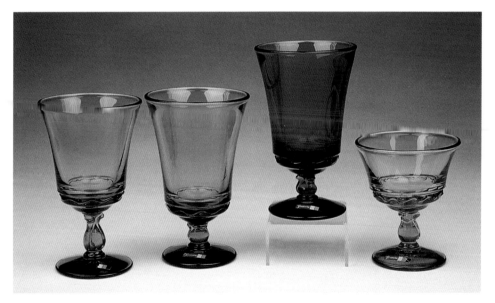

Sampled: #2630 Century blank, experimental unique colors. Century pattern was produced in Crystal only. No records have been found to determine how many were made. It is believed they were sampled and sold through the outlet stores; they were not added to the line or in catalogs. **Left to right:** 10.5 ounce Goblet, sampled Fern Green, circa 1968, 5.68" tall. **NDV;** 12 ounce Goblet, sampled Fern Green, circa 1968, 5.78" tall. **NDV;** 12 ounce Goblet, sampled Mocha, circa 1969, 5.78" tall. **NDV;** 5.5 ounce Sherbet, sampled Monaco Honey Gold, circa 1970, 4.25" tall. **NDV.**

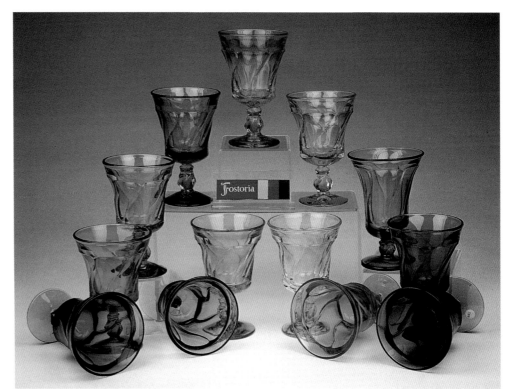

Sampled: #2719 Jamestown Goblets, 13 Experimental Colors sampled 1959-1972. Jamestown was designed by George Sakier. The Jamestown catalog colors include Blue, Green, Amber, Pink, Amethyst, Brown, and Ruby. This assortment of experimental colors is unique. No known records exist as to how many were produced. **NDV.**

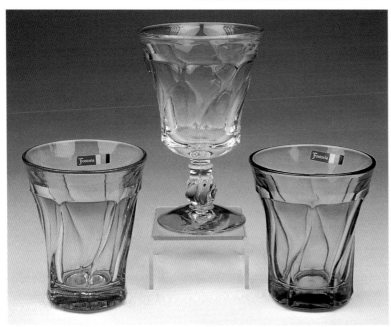

Left to right: #2719 Jamestown 9 ounce Goblet, Pink, 1961-1970, 4.75" tall. **$28;** #2719 Jamestown Goblet, Crystal, 1958-1970, 5.75" tall. **$22;** #2719 Jamestown 9 ounce Goblet, Green, 1958-1970, 4.75" tall. **$28.**

#2719 Jamestown, sampled colors. **Left to right:** 11 ounce Footed Tumbler, Pink, 1961-1970. **$30;** Experimental Ruby, circa 1965. **NDV;** 12 ounce Flat Tumbler, Ruby, 1965-1970, 5.25" tall. **$35;** 9 ounce Goblet, Blue, 1958-1970, 5.75" tall. **$28.**

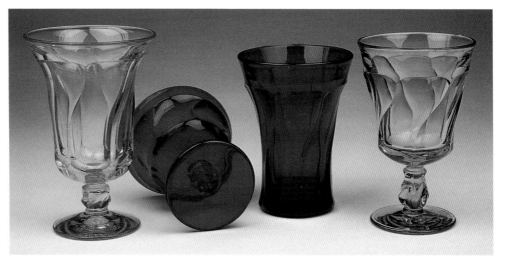

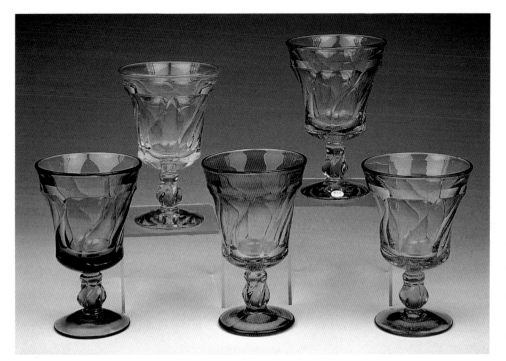

Sampled: #2719 Jamestown Goblets, experimental colors. **Left to right:** Smoke, circa 1965; Azure Blue, circa 1962; Bittersweet Orange, circa 1960; Champagne Pink, circa 1967; Honey Gold, circa 1970. All sample colors, not in line or catalogs. **NDV.**

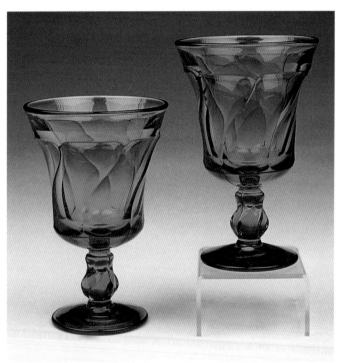

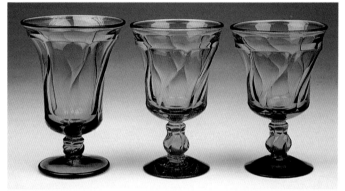

Sampled: #2719 Jamestown, experimental colors. All these goblets are marked on the bottom with date and sample numbers. It is not known if production was limited to only those sampled and/or if some were made and sold through the outlet stores. **Left to right:** Fern Green, sampled circa 1968. **NDV;** Monaco Honey Gold, sampled circa 1970. **NDV;** Fern Green, experimental lighter shade, trial run circa 1968. **NDV.**

Sampled: #2719 Jamestown Goblet, experimental color, Copper Blue, circa 1969. Not in line or catalogs. **NDV.**

Sampled: #2719 Jamestown Goblets, experimental colors, marked as samples on the bottom. It is not known if there is production run of these colors, not shown in catalogs. **Left:** Marine Blue, sampled circa 1964. **NDV; Right:** Smoke, Mocha, sampled circa 1969. **NDV.**

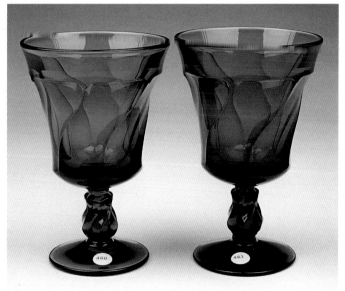

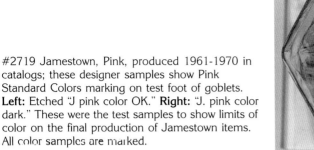

#2719 Jamestown, Pink, produced 1961-1970 in catalogs; these designer samples show Pink Standard Colors marking on test foot of goblets. **Left:** Etched "J pink color OK." **Right:** "J. pink color dark." These were the test samples to show limits of color on the final production of Jamestown items. All color samples are marked.

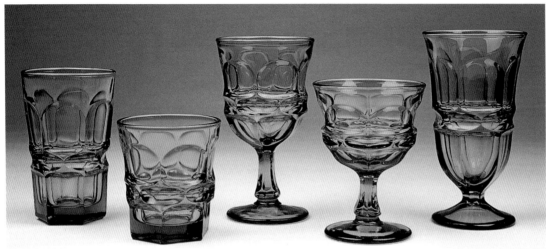

#2770 Argus Pattern, Olive Green, 1963-1982, Flint Glass, reproduction for Henry Ford Museum. **Left to right:** 12 ounce High Ball, 5.25" tall. **$18;** 10 ounce Old Fashioned, 3.75" tall. **$16;** 10.5 ounce Goblet, 6.25" tall. **$22;** 8 ounce Sherbet, 5" tall. **$18;** 13 ounce Footed Ice Tea, 6.75" tall. **$22.**

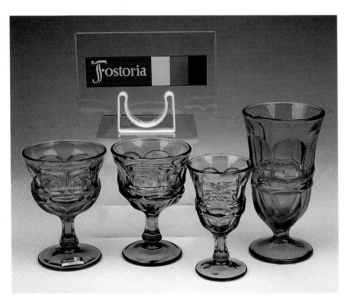

#2770 Argus pressed glass, exact replicas of priceless antiques in the Henry Ford Museum at Dearborn, Michigan. **Left to right:** Cobalt Sherbet, 5" tall. **$22;** Olive Green Sherbet, 5" tall. **$18;** 4 ounce Wine, Olive Green, 4.75" tall. **$18;** 12 ounce Footed Ice Tea, Cobalt Blue, 6.75" tall. **$24.**

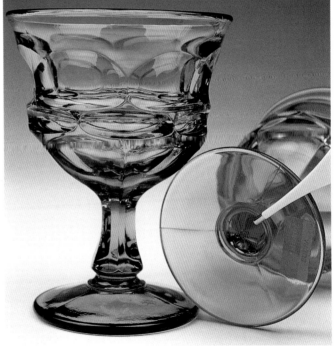

#2770 Argus, a flint glass reproduction by Fostoria. Argus is "hand pressed," just as the originals were in quality flint glass. This means that lead is used to give extra clarity, weight, and brilliance to these lovely pieces. Henry Ford Museum marking on each piece. HFM is marked on the side of goblet, and/or on the bottom, as shown.

Close up HFM making Argus. High heat in final polish sometimes burned off the HFM. #2770 Argus was produced in Crystal, 1963-1982, Cobalt Blue, 1963-1980, Ruby, 1964-1982, Olive Green, 1963-1982, Gray, (Smoke) 1972-1980.

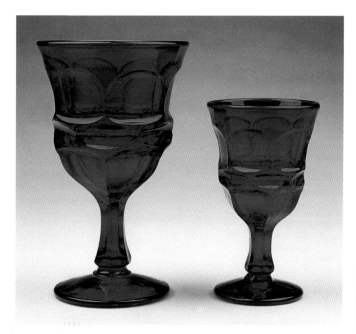

Left: #2770 Argus Goblet, Ruby, 1964-1982, 6.25" tall. **$25;**
Right: #2770 Argus Wine, Ruby, 4.75" tall. **$22**

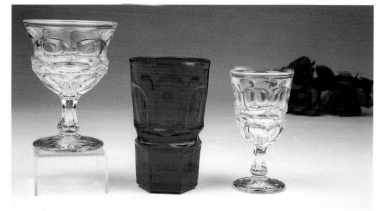

Left to right: #2770 Argus 8 ounce Sherbet, Crystal, 5" tall. **$16;** #2770 12 ounce Highball, Ruby, 5.25" tall. **$25;** #2770 Wine, Crystal, 4.75" tall. **$18.**

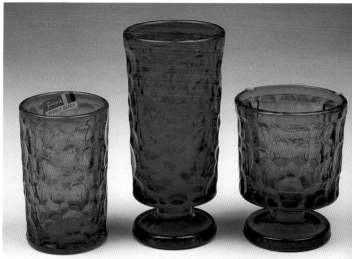

#2806 Pebble Beach, Flaming Orange, 1968-1973. **Left to right:** 7 ounce Juice, 4.75" tall. **$12;** 10 ounce Goblet, 6" tall. **$15;** 8 ounce On the Rocks/Wine, 4.25" tall. **$12.**

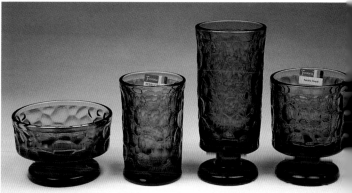

#2806 Pebble Beach, Black Pearl 1968-1973. **Left to right:** 7 ounce Sherbet, 2.75" tall. **$12;** 7 ounce Juice, 4.75" tall. **$12;** 10 ounce Goblet, 6" tall. **$15;** 8 ounce On the Rocks/Wine, 4.5" tall. **$12.**

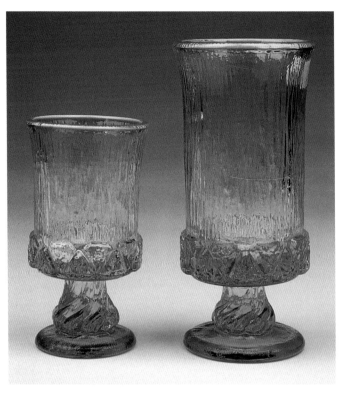

#2832 Sorrento Pressed Glass 1973-1974, made one year only.
Left: 9 ounce Footed Goblet, Pink. **$12; Right:** 13 ounce Footed
Ice Tea, Pink. **$12.**

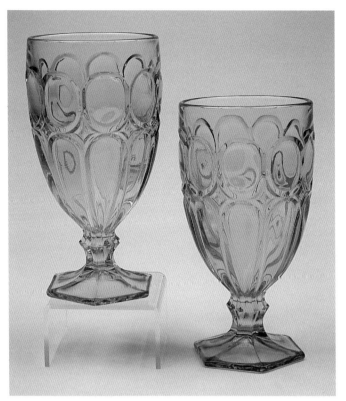

#2882 Moonstone, Apple Green, 1974-1982. 13 ounce Footed
Ice Tea, 6.5" tall. **$15 each.**

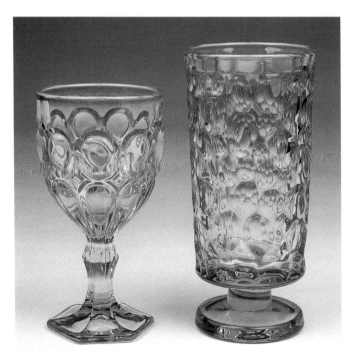

Left: #2882 Moonstone 10 ounce Goblet, Pink, 1972-1982,
6.5" tall. **$15; Right:** #2806 Pebble Beach 10 ounce Goblet,
Pink Lady, 1968-1970. 6" tall. **$15.**

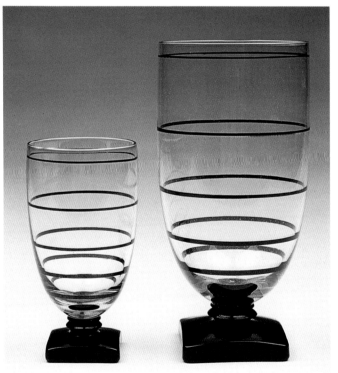

#4020 Saturn Pattern Ebony lines on Crystal 1931-1932 only.
Left: #4020 4 ounce Footed Juice, 3.5" tall. **$32; Right:** #4020
Footed Ice Tea, 6" tall. **$36.**

187

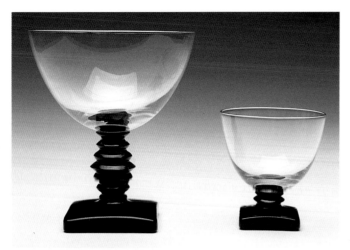

#4020 Ebony Foot w/Crystal Bowl, 1929-1939. Left: 1 ounce Cocktail, 3.5" tall. **$22**; 2 ounce, Whiskey, 2.25" tall. **$22**.

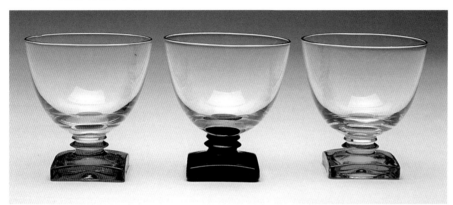

#4020 2 ounce Whiskey, each 2.25" tall. **Left to right:** Amber Foot, 1929-1940. **$25**; Ebony Foot, 1929-1940. **$28**; Green Foot, 1929-1940. **$25**.

Sampled, #4024 Victorian Stem, 10 ounce Goblet, Crystal, experimental etching circa 1940, 5.75" tall. Believed to be design art of Edgar Bottome. **NDV**.

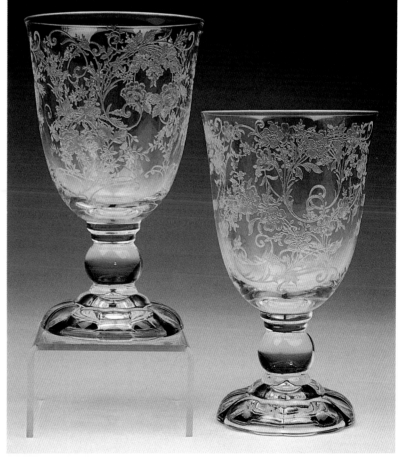

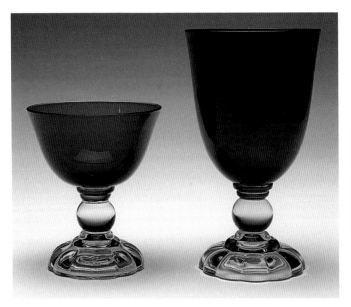

Left: #4024 Victorian, Sherbet, Burgundy, 1933-1942, 4" tall.
$22; Right: #4024 Victorian, 10 ounce Water, Regal Blue Bowl,
1933-1942, 5.75" tall. $42.

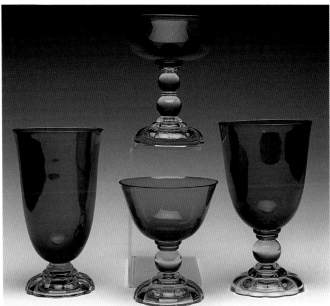

#4024 Victorian, Empire Green, 1933-1942. **Back Center:** 6.5
ounce Saucer Champagne, 4.5" tall. $28; Front row left to right:
12 ounce Footed Ice Tea, 6.75" tall. $28; 5.5 ounce Sherbet/
Cocktail, 3.75" tall. $25; 10 ounce Goblet, 5.5" tall. $35.

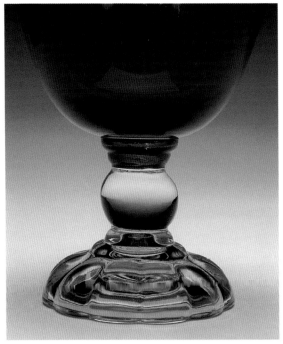

Close up design art of
#4024 Victorian stem

#4024 Empire Green, 1933-
1942. **Left to Right:** 5.5
ounce Sherbet/Cocktail,
3.75" tall. $22; 8 ounce
Footed Tumbler, 4.75" tall.
$22; 6.5 ounce Saucer
Champagne, 4.75" tall. $22;
1.5 ounce Footed Whiskey,
2.5" tall. $22; 3.5 ounce
Claret Wine, 4.5" tall. $28.
Not shown: Also made in
Burgundy, Regal Blue, and
Crystal. Similar values.

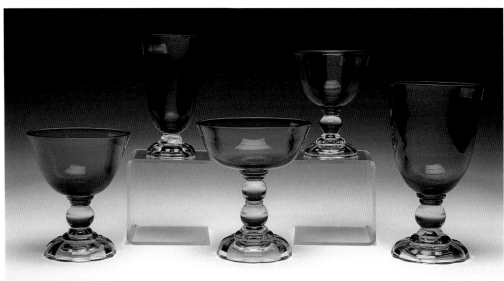

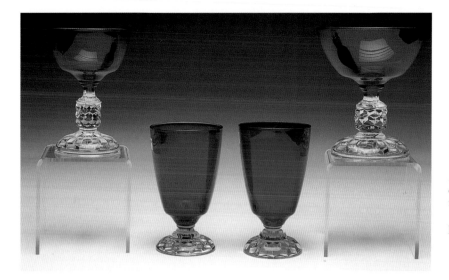

#5056 American Lady. **Left to right:** Cocktail, Burgundy Bowl, 1934-1943, 4" tall. **$35;** 5 ounce Footed Juice, Burgundy Bowl, 4.25" tall. **$38;** 5 ounce Footed Juice, Regal Blue, 1938-1943, 4.25" tall. **$56;** High Sherbet, Burgundy Bowl, 4.75" tall. **$38.**

#5082 Tumbler, Delphian Etching #272, Crystal Bowl with Blue Foot, 1925-1927.5.25" tall. **$28.**

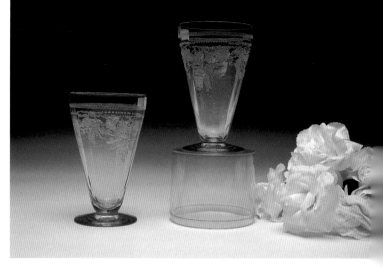

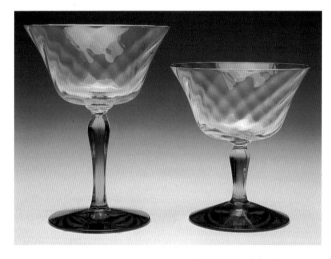

#5093 Blank, Green Base with Crystal Spiral Optic Bowl, 1926-1940. **Left to right:** 6 ounce High Sherbet, 5" tall, **$20;** 6 ounce Low Sherbet, 4" tall. **$18.**

#5098 Stems, June Etching #279. Rose Bowl 1928-1940; Topaz/Gold Tint Bowl 1929-1943; Azure Bowl 1928-1943. **Left to Right:** 9ounce Footed Tumbler, Rose. **$35;** 9 ounce Goblet, Rose, 8.25" tall. **$44;** 4 ounce Claret, Topaz/Gold Tint, 6" tall. **$68;** Oyster Cocktail, Topaz/Gold Tint, 3.25" tall. **$30;** 9 ounce Goblet, Azure, 8.25" tall. **$44;** 8 ounce High Sherbet, Azure, 6" tall. **$35.**

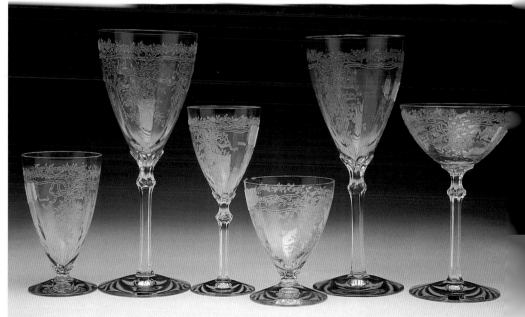

190

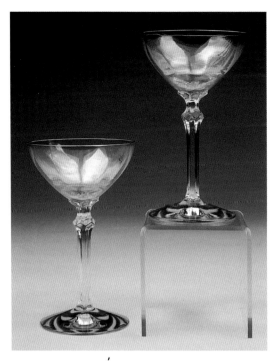

#5098 Cocktail, Mother of Pearl Iridescent on Azure, 1928-1935, 5.25" tall. **$28.**

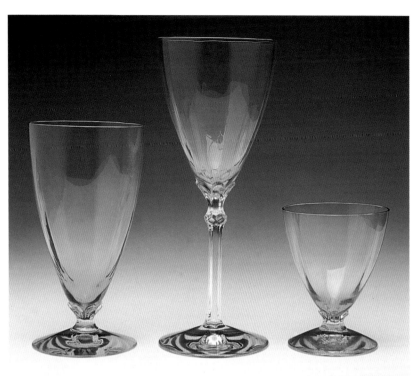

#5098 Blank, Green, 1928-1940. **Left to right:** 10 ounce Footed Ice Tea, 6" tall. **$26;** 9 ounce Goblet, 8.25" tall. **$28;** Oyster Cocktail, 3.25" tall. **$18.**

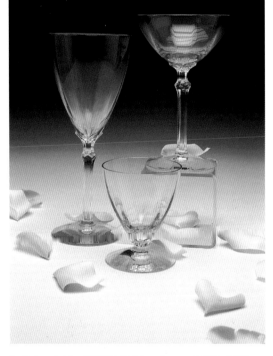

Left to right: #5098 Goblet, Azure, 1928-1943, 8.25" tall. **$38;** #5098 Oyster Cocktail, Azure, 3.25" tall. **$26;** #5098 Cocktail, 5.25" tall. **$36.**

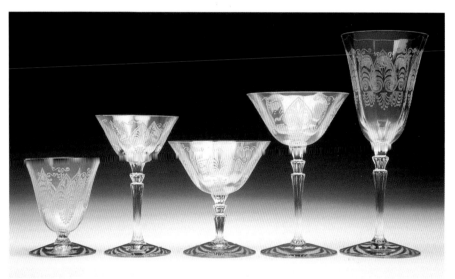

#5099 Blank, Trojan Etching #280 on Topaz/Gold Tint 1929-1943. **Left to Right:** 4.5 ounce Oyster Cocktail, 3.5" tall. **$26;** 3 ounce Cordial, 5.1" tall. **$28;** 6 ounce Low Sherbet, 4.75" tall. **$22;** 6 ounce Saucer Champagne, 5.5" tall. **$26;** 9 ounce Goblet, 8.25" tall. **$30.**

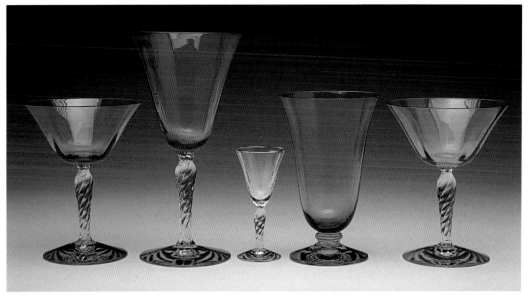

#5297 Stems, **Left to Right:** High Sherbet, Orchid, 1927-1929, 5" tall. **$32**; Water Goblet, Amber, 1927-1940, 7.25" tall. **$35**; Cordial, Crystal 1927, 1943 only, 3.5" tall. **$35**; Water Tumbler, Orchid, 1927-1928, 5.25" tall. **$45**; High Sherbet, Green, 1927-1940, 5" tall. **$28**.

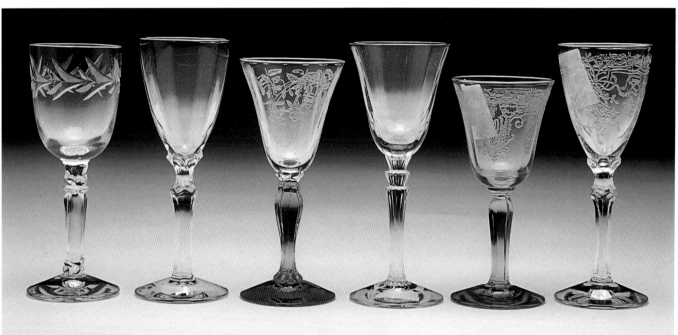

Unique little Cordials, simple elegance shows the art of Fostoria in miniature. **Left to Right:** #6030 1 ounce Cordial, Holly Cutting #815, 1942-1973, 4" tall. **$42**; #5098 Cordial, Topaz, 1928-1936, 3.75" tall. **$65**; #6004 Cordial, Fuchsia Etching #310, Wisteria Stem, 1933-1935, 3.5" tall. **$225+**; #5099 Cordial, Gold Tint, 1937-1940, 3.75" tall. **$85**; #5093 Cordial, Vesper Etching #275, 1926-1927, 3.5" tall. **$110**; #5098 Cordial June Etching #279, Crystal, 1928-1936, 3.75" tall. **$65**.

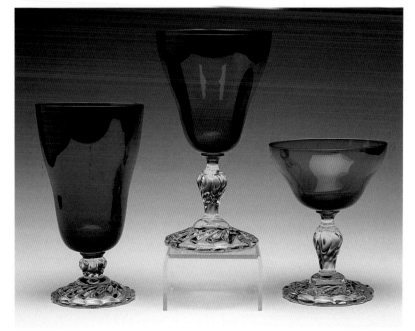

#5412 Colonial Dane. **Left to right:** 12 ounce Footed Ice Tea, Empire Green Bowl, 1948-1964, 6" tall. **$22**; 11 ounce Goblet, Empire Green Bowl, 6.75" tall. **$20**; 6.5 ounce Sherbet, Empire Green Bowl, 4.75" tall. **$15**. Not Shown: Colonial Dane was produced in Crystal, 1950-1965.

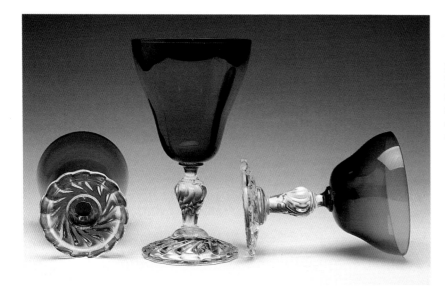

Design art of #5412 Colonial Dane. Original ads read: *The quaint and charming Colonial Dane dressed with a gorgeous Empire Green Bowl pendant to a swirling colony base.*

#6002 Diadem Stem, 6 ounce High Sherbet, New Garland Etching #284, Rose Bowl with Crystal base, 1931-1933. 4.75" tall. **$22.**

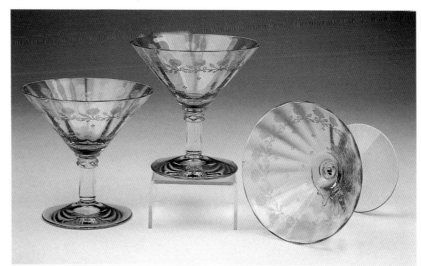

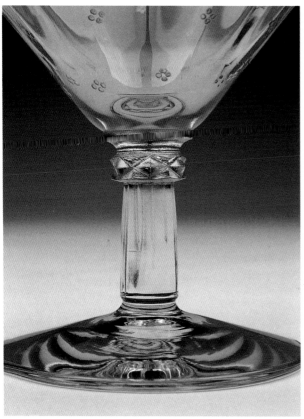

Close up design art of #6002 Diadem Stem.

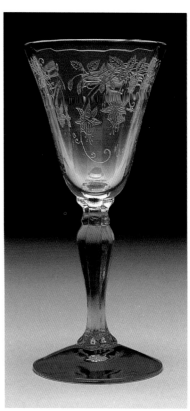

#6004 3/4 ounce Cordial, Fuchsia Etching #310, Wisteria Stem, 1933-1935. **$225+.**

193

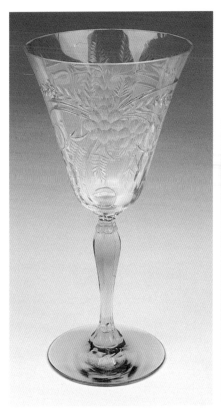

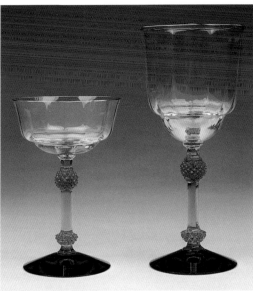

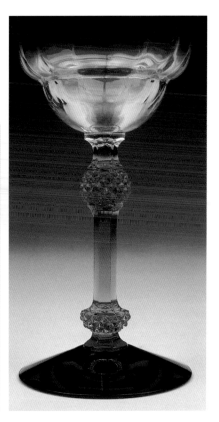

Sampled: Experimental design cutting on #6005 5 ounce Claret, Crystal Bowl, Topaz Base, circa 1936. Found in the designer morgue at the close of the factory. 5" tall. **NDV.**

#6007 Blank. **Left:** 5.5 ounce High Sherbet/ Cocktail, Amber, 1933-1936, 5.38" tall. **$24; Right:** #6007 10 ounce Goblet, Amber, 1933- 1936, 7.5" tall. **$28.**

Close up design art of #6007 Stem.

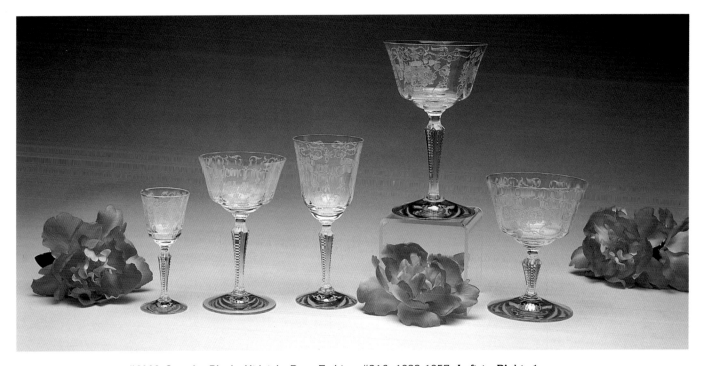

#6009 Camelot Blank, Midnight Rose Etching #316, 1933-1957. **Left to Right:** 1 ounce Cordial, 3.75" tall. **$45;** 3.5 ounce Cocktail, 4.25" tall. **$25;** 3.75 ounce Claret Wine, 5.1" tall. **$35;** 5.5 ounce High Sherbet, 5.3" tall. **$22;** 5.5 ounce Low Sherbet 4.38" tall. **$18.**

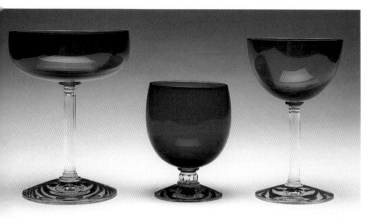

#6011 Neo Classic Blank. **Left to right:** Cocktail, Empire Green Bowl, 1936-1940, 4.75" tall. **$28;** Oyster Cocktail, Burgundy Bowl 1934-1943, 3.5" tall. **$24,** Champagne, Empire Green Bowl, 1936-1940, 4.75" tall. **$28.**

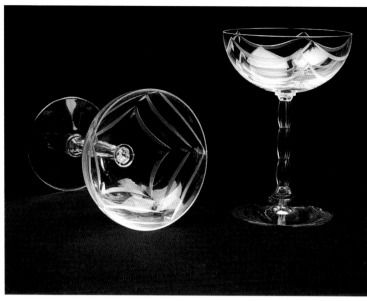

#6012 Westchester Blank, Saucer Champagne/High Sherbet, Regency Cutting #744, 1935-1943. Unique design art. **$22.**

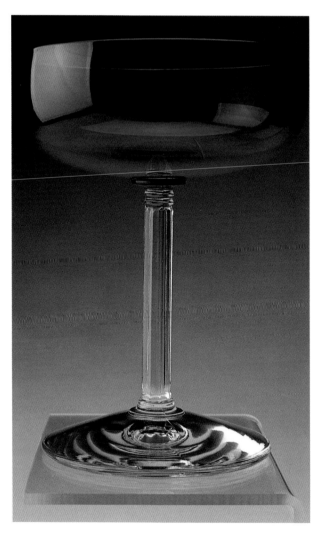

Close up design art of #6011 Neo Classic Stem.

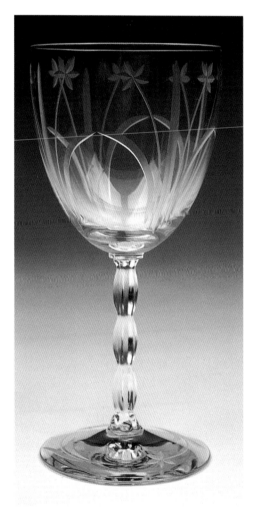

#6012 Westchester Blank, 10 ounce Goblet, Gossamer Cutting #746, 1935-1939, 6.75" tall. **$28.**

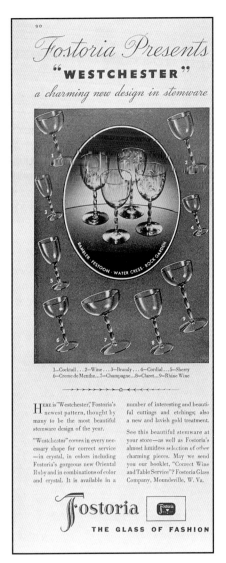

Original Advertisement for #6012 Westchester, introduced Fostoria's new "Oriental Ruby" color on the Westchester stem. Our research shows the color name "Oriental Ruby" was never listed in catalogs for this time period although shown in several advertisements and printed brochures for many products.

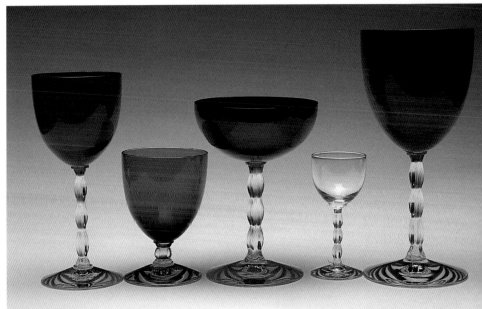

#6012 Westchester Stems, 1935-1942. **Left to Right:** Claret, Oriental Ruby 7" tall. **$32;** Cocktail, Burgundy, 3.5" tall. **$35;** Champagne, Regal Blue, 5" tall. **$32;** Cordial, Crystal 3.5" tall. **$22;** 10 ounce Water Goblet, Oriental Ruby, 6.75" tall. **$40.**

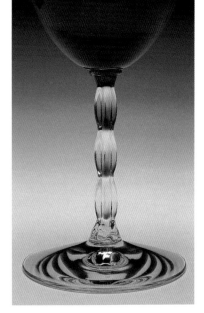

Close up design art of #6012 Westchester Stem.

#6012 Westchester Stems. **Left to right:** Low Sherbet, Burgundy Bowl, 1935-1943, 4" tall. **$42;** High Sherbet, Empire Green Bowl, 1935-1940, 5" tall. **$45;** High Sherbet, Regal Blue, 1935-1942, 5" tall. **$65.**

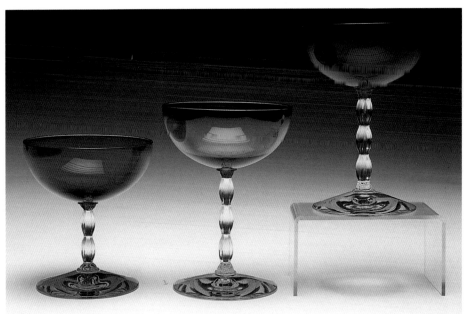

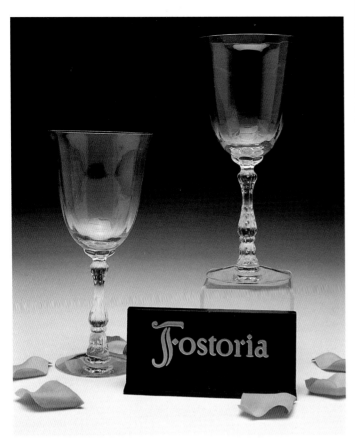

#6016 Wilma Blank, Claret, Pink Bowl 1974-1978, 6.25" tall. $28.

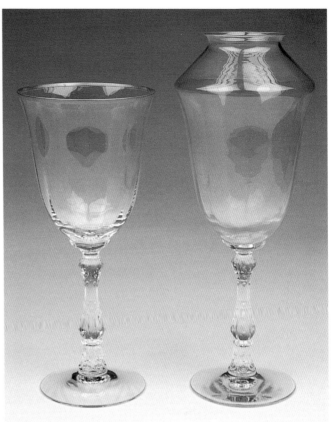

Samples: #6016 Wilma stem, blown. **Left:** Finished goblet with gold trim. **Right:** Sample production blown stem as appears before being cut and polished, finished. **NDV.**

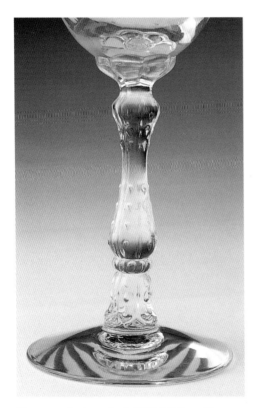

Close up design art of #6016 Wilma Stem.

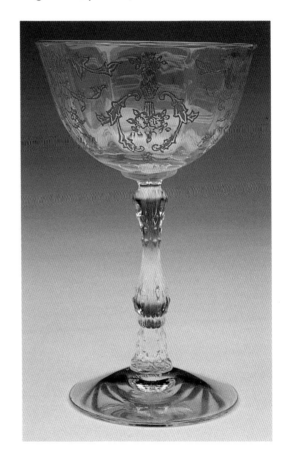

Sampled: #6016 Wilma Blank, 3.5 ounce Cocktail, Navarre Etching #327 Gold applied on Azure, circa 1937, extremely scarce. 5.25" tall. $950+.

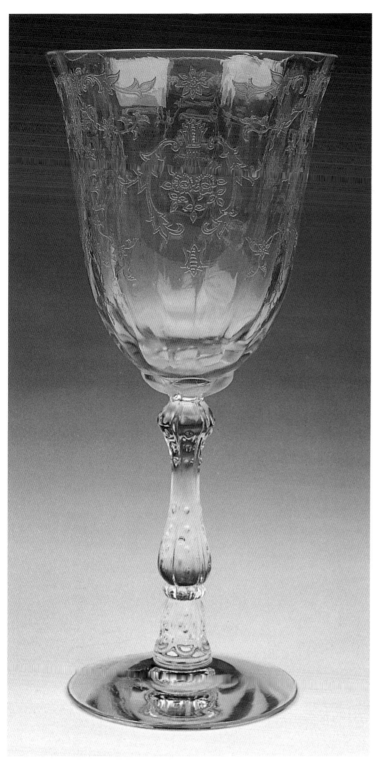

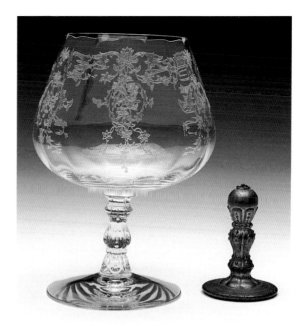

#6016 Wilma Blank, **Left:** 15 ounce Brandy Inhaler, Navarre Etching #327, introduced into line in 1984. 5.5" tall. **$115; Right:** Original metal plate mould model for this stem, from which the mould is made, circa 1983. **NDV.**

Sampled: #6016 Wilma Blank, experimental Navarre Etching #327, on 10 ounce Goblet, Topaz. Wilma blank was never produced in Topaz/Gold Tint color, not in line or catalogs. It is believed this was sampled at the request of William Dalzell, circa 1937. Never put into production. This is one of 12 known to exist. **$1250+.**

Sales Sample, #6016 Navarre Etching #327, marked etched on foot "Display Sample." Scarce item. **$550+.**

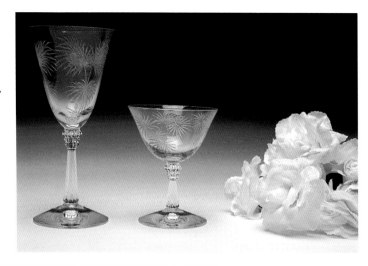

#6017 Sceptre Blank, Lido Etching #329, Azure Bowl, 1937-1943. **Left:** #6017 Goblet, 7.75" tall. **$35; Right:** #6017 Low Sherbet, 4.75" tall. **$32.**

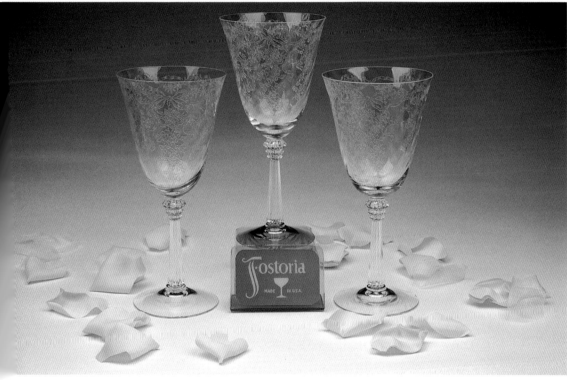

Sampled: #6017 Sceptre Stems, experimental circa 1942. No production data could be found on the Azure and Gold Tint Romance Etching #341 sampled circa 1942. Not listed in line or catalogs, very scarce. **Left to right:** #6017 9 ounce Goblet, sampled Romance Etching #341, Azure Blue Bowl, 7.75" tall. **$550+;** #6017 9 ounce Goblet Crystal, (standard production item, for comparison only) 1942-1971, 7.75" tall. **$35;** #6017 9-ounce Goblet, sampled Romance Etching #341, Gold Tint Bowl, 7.75" tall. **$550+.**

Close up design art of Romance Etching #341 on Azure blue. This exquisite sample is very unique, not found in line or catalogs.

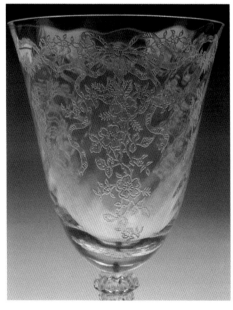

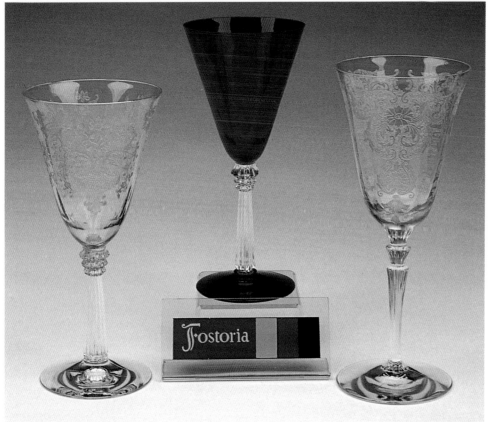

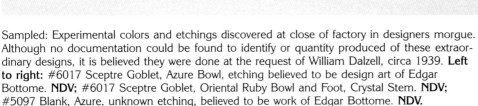

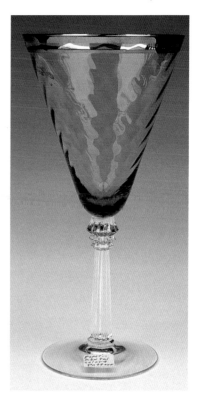

Sampled: Experimental colors and etchings discovered at close of factory in designers morgue. Although no documentation could be found to identify or quantity produced of these extraordinary designs, it is believed they were done at the request of William Dalzell, circa 1939. **Left to right:** #6017 Sceptre Goblet, Azure Bowl, etching believed to be design art of Edgar Bottome. **NDV;** #6017 Sceptre Goblet, Oriental Ruby Bowl and Foot, Crystal Stem. **NDV;** #5097 Blank, Azure, unknown etching, believed to be work of Edgar Bottome. **NDV.**

Sampled: #6017 Sceptre Goblet, experimental color treatment, Smoke Bowl with Platinum Trim. This stem combination was sampled only, never put into production. **NDV.**

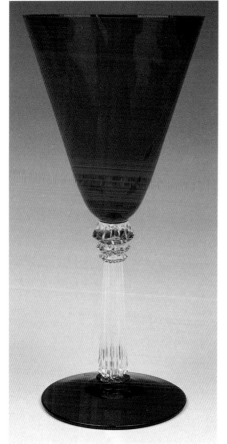

Sampled: #6017 Sceptre Stem, experimental color, Oriental Ruby, sampled circa 1939. Fostoria research shows advertising for "Oriental Ruby" to be introduced on several lines. However, this color and sampled stem is not listed in any sales catalogs. Note: #6017 Sceptre was produced in Crystal, 1937-1971; Azure Bowl, 1937-1943; and Gold Tint Bowl, 1937-1943. Ruby samples are very scarce. **NDV.**

Sampled: #6017 Sceptre Goblet, experimental Ruby Bowl, unknown floral and crown etching. This design was sampled only, never put into production because the Ruby color was too dark for the effect of the etching. Sampled, circa 1937. **NDV.**

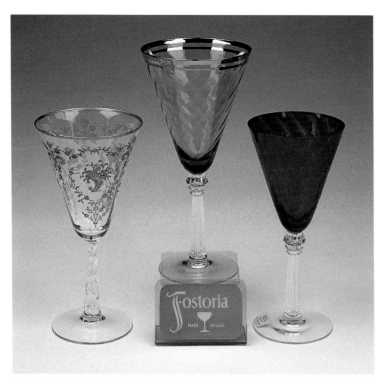

Sampled: Beautiful art of Fostoria, found in the design morgue of the factory, although featured individually, we enjoyed mixing them together in this photograph showcasing the graceful artwork: #6020 Mayflower Gold Etched on Crystal, #6017 Smoke with Platinum Trim and #6017 Oriental Ruby with unknown etching.

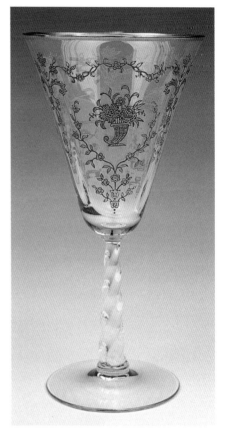

Sampled: #6020 Melody Blank, 9 ounce Goblet, experimental Mayflower Etching #332 Gold Decorated applied on Crystal Bowl, circa 1943. Sampled only, never went into the line or catalogs. $565+.

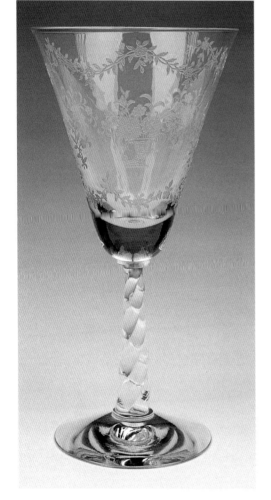

Sampled: #6020 Melody Blank, 9 ounce Goblet, experimental Gold Tint Bowl, Mayflower Etching #332, circa 1943. Very unique, this stem was never produced in Gold Tint. It is not known how many were sampled. $535+.

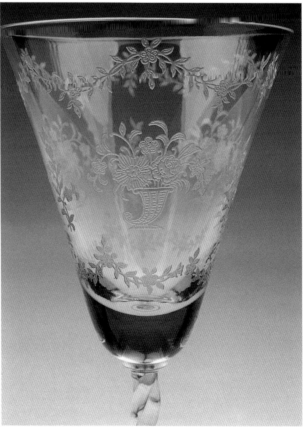

Close up design art of Mayflower Etching #332 on Gold Tint.

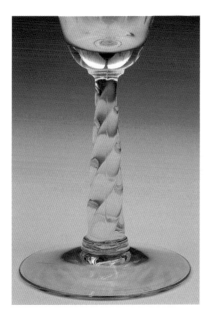

Close up design art of #6020
Melody Stem.

Sampled: Experimental stems, unique
color combination and elegant etchings,
sampled only, not in line or catalog, it is
unknown how many may exist, extremely
scarce. **Left:** #6097 Sheraton Blank, 10
ounce Goblet, Amethyst Bowl, Copper
Blue Stem, sampled circa 1965, 6.75"
tall. **NDV. Center:** #877 Stem, Orchid,
experimental etching believed to be
design of Edgar Bottome, circa 1927,
absolutely exquisite. **NDV. Right:** #867
1/2 Claret, Burgundy, 5.75" tall. Sampled
circa 1935. **NDV.**

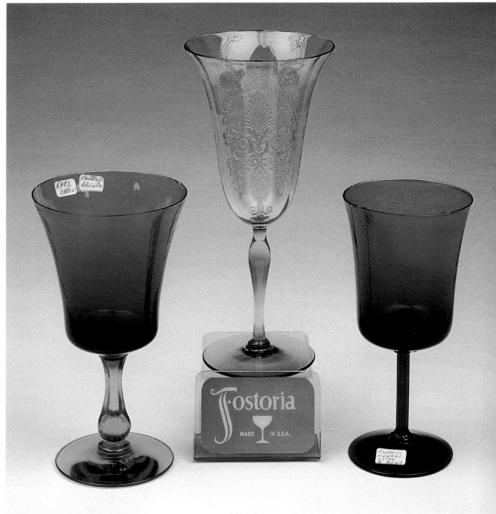

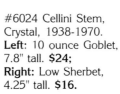

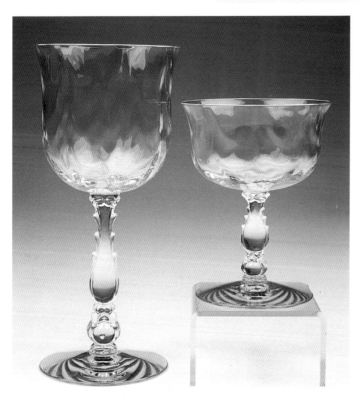

Close up design art of
#6024 Cellini Stem.

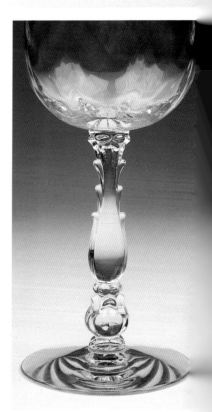

#6024 Cellini Stem,
Crystal, 1938-1970.
Left: 10 ounce Goblet,
7.8" tall. **$24;**
Right: Low Sherbet,
4.25" tall. **$16.**

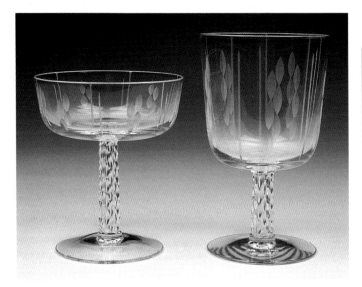

#6027 Envoy Stem, Salon Cutting #804, 1940-1943. **Left:** Saucer Champagne, 4.25" tall. **$24; Right:** 10 ounce Goblet, 5.25" tall. **$28.**

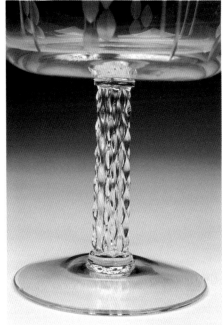

Close up design art of #6027 Envoy Stem.

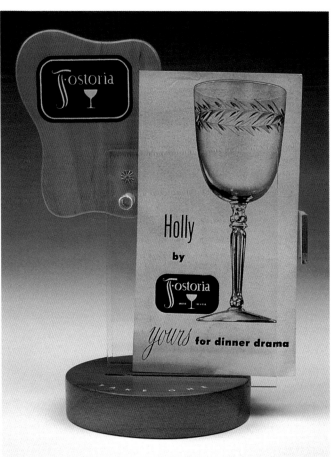

Original store display brochure rack and advertising brochure for stem #6030 Astrid Blank, with Holly Cutting #815. Customers could help themselves to a Fostoria brochure of their favorite pattern.

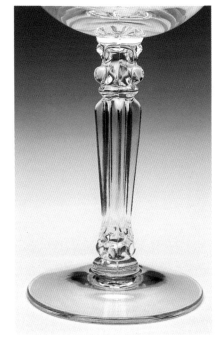

Close up design art of #6030 Astrid Stem.

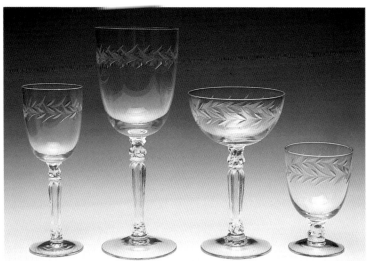

#6030 Astrid Blank, Holly Cutting #815 a beautiful combination rock cut – gray cut, one leaf is polished and opposite leaves gray cut, remains frosty gray. 1942-1980. **Left to right:** Claret/wine, 6" tall. **$30;** Water Goblet, 8" tall. **$26;** High Sherbet, 5.75" tall. **$22;** Oyster Cocktail, 3.5" tall. **$18.**

203

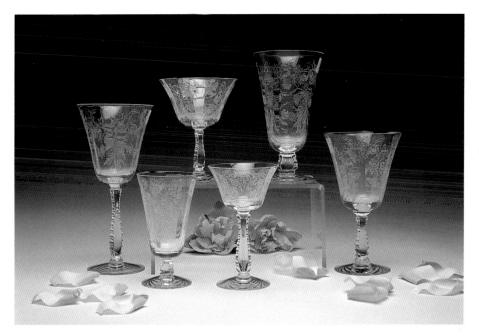

#6037 Silver Flutes Blank, Heather Etching #343, 1949-1971. **Top row left to right:** 7 ounce Low Sherbet 4.75" tall. **$24**; 12 ounce Ice Tea, 6.1" tall. **$22**; **Front row left to right:** 9 ounce Goblet, 7.25" tall **$28**; 5 ounce Footed Juice, 4.75" tall. **$22**; 4 ounce Cocktail, 5" tall **$24**; 9 ounce Low Goblet, 6.5" tall. **$22**.

#6045 Capri 4.5 ounce Cocktail, Bitter Green Base, 1952-1958, 3" tall. **$20.** Not Shown: also produced with Cinnamon Base; only six items in line: Goblet, Claret Wine, Cordial, Footed Ice Tea, Juice, and Sherbet.

Sampled: Experimental item, Stem #6051 1/2 Courtship Goblet, Decoration #626 Wedding Ring, Platinum Band on bowl, 1953-1970. Believed to be experimental with sterling silver parts to convert from a goblet to flower vase with taper candleholders. 6.5" tall to top of goblet, 7" tall height of the attached sterling side cups, as found. **NDV.**

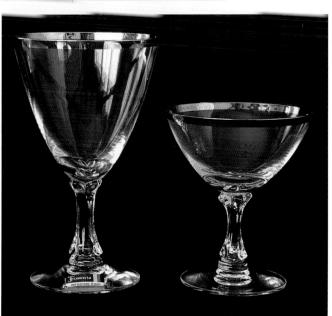

#6051 1/2 Courtship Blank, Wedding Ring Decoration #626, Platinum Band on Crystal Bowl 1953-1975. **Left:** 10.5 ounce Goblet, 6.35" tall. **$22**; **Right:** 6.5 ounce Sherbet, 4.75" tall. **$20.**

Close up look at the ceramic Pickard china foot and blown bowl with screw in stem. No known production records of this sampled item exist.

Experimental stem – perhaps a Fostoria Designer working with Pickard China. Unique blown glass bowl with peg foot inserted into Pickard china type foot. Found in design morgue at close of factory. 4" tall. **NDV.**

#6092 Priscilla Blank, Regal Decoration #693, stainless steel covering the Crystal. A unique design introduced July 1, 1972 and pictured in 1973 catalog only. Only four sizes were produced in this decoration: a 10.5 ounce Goblet, 4 ounce Wine/Cocktail, 7 ounce Sherbet and 14 ounce Luncheon Goblet/Ice Tea, extremely scarce pattern to find. **Left to right:** 4 ounce Wine/Cocktail, 5.25" tall. **$22;** 14 ounce Footed Ice Tea, 6.5" tall. **$25;** sampled, 1.5 ounce Cordial, #6089 stem, 3.5" tall. **NDV;** 10.5 ounce Goblet, 7.2" tall. **$25.**

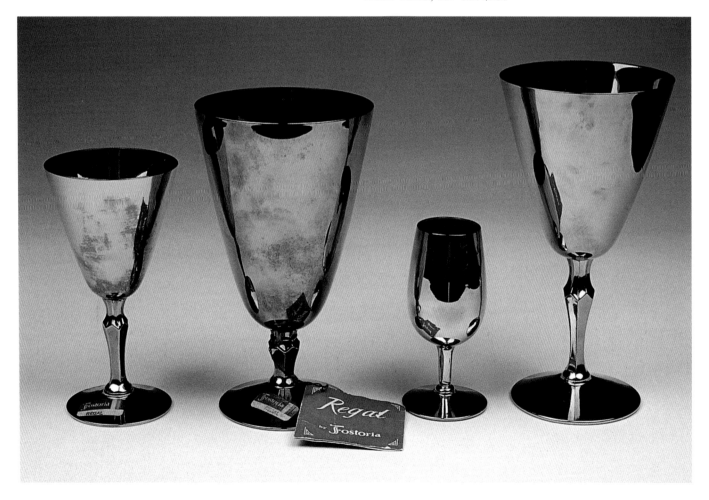

#6080 Fascination Blank, Goblet, Crystal Firelight Decoration #657, Mother of Pearl Iridescence on Bowl, 1962-1981. **$22.**

#6103 Glamour Blank, 12 ounce Goblet, Blue Bowl 1970-1982, 7.25" tall. **$22.**

Far right:
Close up design art of #6103 Glamour Stem.

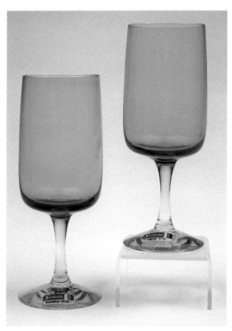

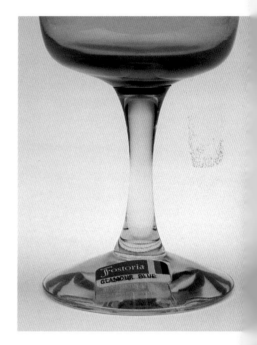

#6108 Precedence, Onyx Bowl, Crystal Stem 1967-1974. **Left to right:** 8 ounce Claret, 6.25" tall. **$38;** 14 ounce Footed Ice Tea, 6.50" tall. **$35;** 12 ounce Goblet, 7.5" tall. **$38.**

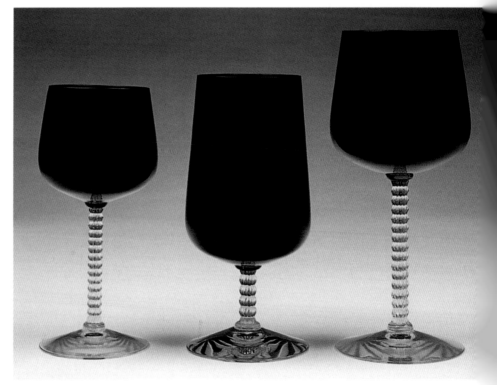

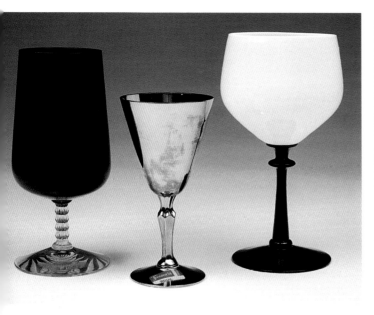

Left: #6108 Precedence, 14 ounce Ice Tea, 6.75" tall. **$35;**
Center: #6092 Regal Wine, 5.25" tall. **$22; Right:** #6120
Contrast, Onyx Stem, Milk Glass Bowl, 1970-1972. **$75+.**

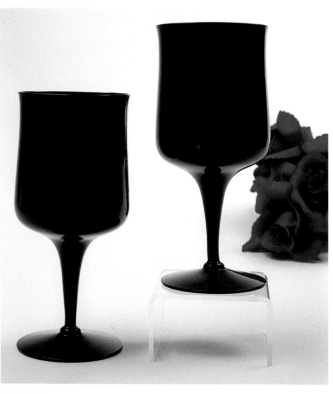

#6122 Biscayne, 11 ounce Goblet, Onyx-ebony, 1971-1973,
6.25" tall. **$28.**

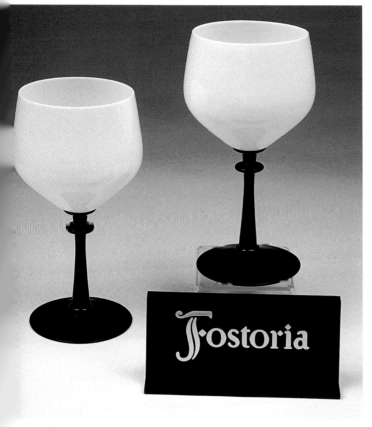

#6120 Contrast, 14 ounce Goblets, Onyx Stems with Opal Glass
Bowl, 1970-1972, 7" tall. **$75+.**

Close up design art of #6122 Biscayne Onyx Stem.

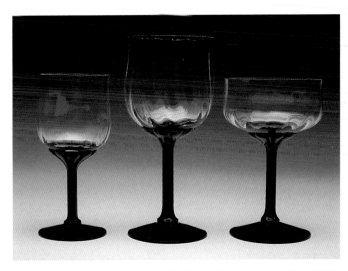

#6126 Gazebo Goblet, Crystal Bowl with Ebony Foot, 1980-1982. $28.

Close up design art of #6126 Wimbledon Stem, Gazebo pattern.

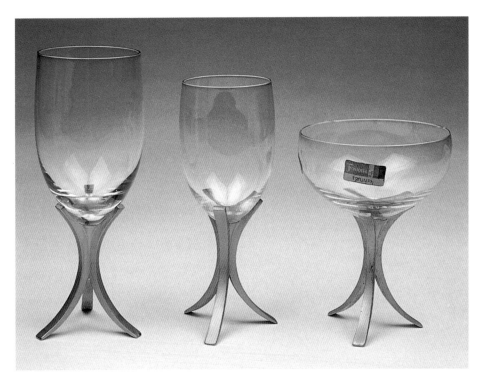

#6112 Gold Triumph Stems. The modern design of Triumph was produced 1968-1972 with crystal bowl, Gold Triumph as shown or Silver Triumph made with silver metal foot, not shown. **Left to right:** 14 ounce Footed Ice Tea, 7.25" tall. **$32;** 5.5 ounce Tulip Wine, 6.5" tall. **$28;** 6 ounce Sherbet, 5.25" tall. **$28.**

Sampled: #6123 Princess Blank, 8.5 ounce Goblet, experimental Navarre Etching #327, circa 1972, 6.5" tall. No known records of how many sampled Navarre on this blank exist, never went into production. **$585+.**

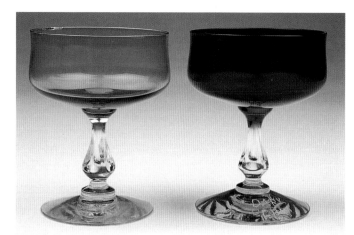

Left: #6125 Distinction, Cobalt Bowl, 1973-1974, Blue display sample. **$35. Right:** #6125 Distinction, Ruby Bowl 1972 only. Sample marking the dark limit of Ruby. **NDV.**

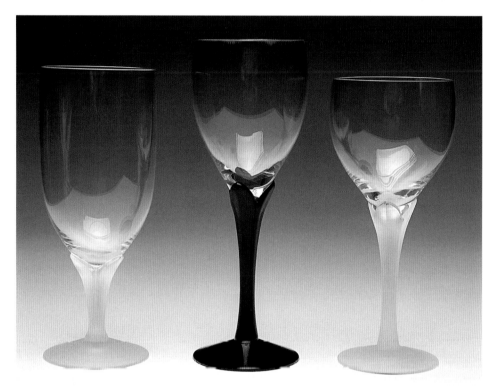

#6144 Lotus Stemware, designer Jon Saffell, introduced July 1980 in catalog until June 1982 when the hand blown shops were closed. This elegant pattern was produced with crystal bowl and stems offered in Ebony, Crystal Mist or Peach Mist. A very unique pattern and difficult to find. **Left to Right:** 14 ounce Footed Ice Tea, Crystal Mist, 7.5" tall. **$25;** 6 ounce Flute Champagne, Ebony Base, 1981 only, 8.5" tall. **$30;** 10 ounce Claret, Crystal Mist Base, 7.25" tall. **$25.**

#6149 May Pole, 12 ounce goblet, Light Blue, made 1982 only, 7.5" tall. **$20.** Note: Only four sizes of stems were produced in this pattern that include the Goblet, Footed Ice Tea, Champagne, and Wine. Not shown: also made in Yellow and Peach.

Modern Primitives, #4162 Congo, #4163 Inca, and #4162 Karnak. Introduced in 1955 and continued to 1965. Made in Crystal, Smoke, Pink, Marine, and Amber, etched "Fostoria" on the bottom. Designs are contemporary, but inspiration came from three ancient cultures. Thus with some poetic license, the names Congo, Inca, Karnak. **Left to right:** #4162 Congo, 14 ounce Beverage, Pink, **$12**; #4162 Karnak, 14-ounce Beverage, **$12; Right:** #4162 Congo, 21 ounce Cooler, **$14.**

#4162 Congo, 1955-1965. **Left to right:** Sherbet, Amber. **$10**; 21 ounce Cooler, Marine Blue. **$14**; 14 ounce Beverage, Marine Blue. **$12**; 21 ounce Cooler, Pink. **$14**; 14 ounce Beverage, Pink. **$12**; 14 ounce Beverage, Smoke. **$12**.

Sampled: #4183 Homespun 1959-1965, sample production broken off pontil before finishing and polishing. Experimental colors found in the design morgue at close of factory. **Left to right:** Teal Blue color too dark; Blue sampled; Moss Green sampled; Finished Goblet as produced in Teal Blue, color just right.

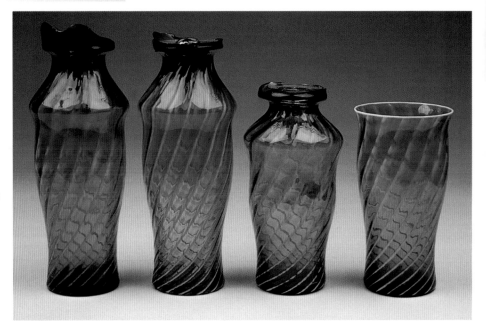

#4183 Homespun 15 ounce Ice Tea/ Highball. **Left:** Sample for production color match, bottom inscribed #3Lehr 940 degrees, 1-21-64 Color OK. **Right:** 15 ounce Ice Tea/Highball (produced in catalog). **$18.**

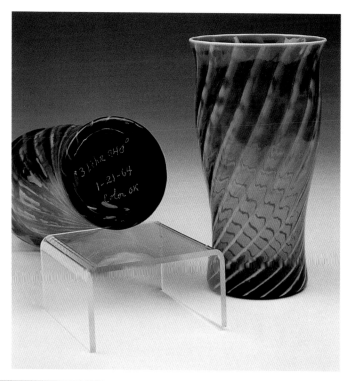

#5650 Horizon, 1951-1958 produced in four sizes only: Footed Juice/Cocktail; Sherbet/Old Fashioned; Water/Scotch and Soda; Ice Tea/Highball. All with Crystal Foot and Cinnamon and/or Spruce Green Bowl. **Left to right.** Original Pattern Brochure; Water/Scotch and Soda, Cinnamon Bowl. **$12;** Sherbet/Old Fashioned, Cinnamon Bowl. **$10;** Ice Tea/High Ball, Cinnamon Bowl **$12.**

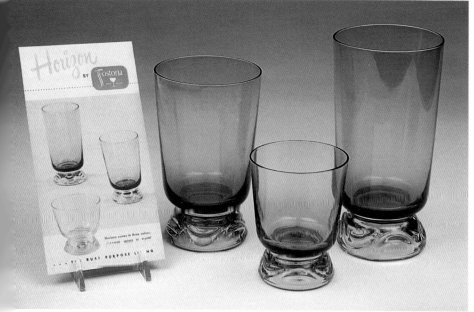

#6046 Catalina, 1951-1958, Blown Tumbler. Made in four sizes only and offered in three different color bowls, Cinnamon, Spruce and/or Chartreuse, all Crystal stems. **Left to right:** Sherbet/Old Fashioned. **$12;** Ice Tea/Highball. **$14;** Original Advertising Brochure.

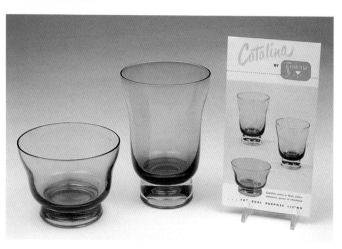

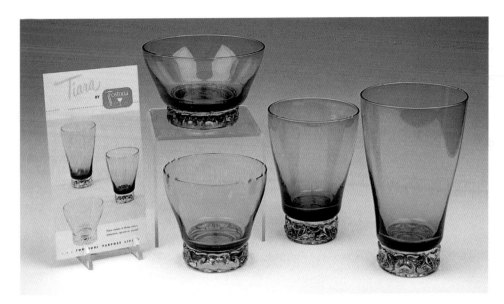

#6044 Tiara, 1951-1958. Made in four sizes only and offered in three different color bowls, Cinnamon, Spruce and/or Chartreuse. **Left to right:** Original Display Brochure; Sherbet/Old Fashion **$14;** Water/Scotch and Soda **$12;** Juice/Cocktail **$12;** Ice Tea/Highball **$14.**

Captiva, 13 ounce Goblet, Light Blue, 1983-1986. **$12;** Not shown: Also produced in Peach, 1983-1986. **$12.**

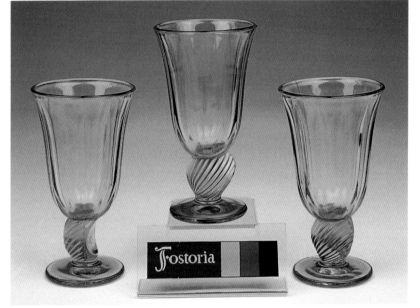

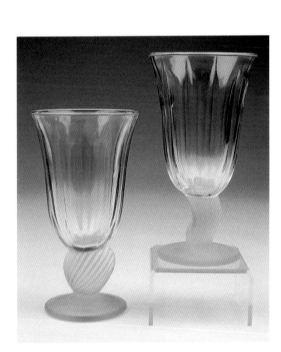

Captiva, Goblet/Ice Tea, Crystal, 1983-1986. Beautifully designed shell stem shown front view on the left and side view on the right to show detail of frosted shell stem. **$12.**

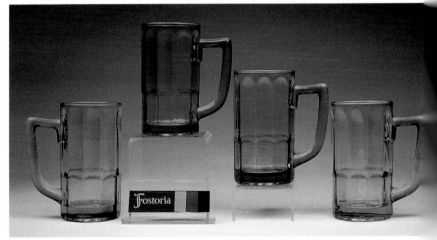

#2487 Handled Beer Mug, 14 ounces, made in 1934 only, 5.25" tall. **Left to Right:** Green, **$45;** Wisteria, **$65;** Amber, **$45;** and Topaz, **$45.** Not Shown: also produced in Rose and Crystal. 5.25" tall, 1934 only. **$45.**

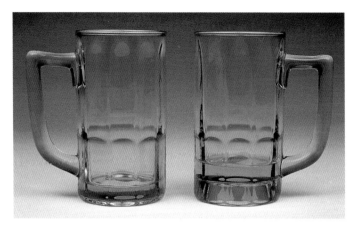

#2487 Handled Beer Mug, produced 1934 only. 5.25" tall. **Left:** Topaz 14 ounce capacity, **$45**; **Right:** Modified 12 ounce capacity, Topaz, same height, notice the thicker bottom in the glass. **$45.**

Fostoria produced a variety of beverage sets throughout its one hundred year history. The early jugs and matching tumblers were offered in crystal, with various cuttings. These jugs and water bottles were sold in various sizes such as 44 ounce, 60 ounce, 64 ounce and/or 80 ounce capacity. With the introduction of colored glass dinnerware in 1924, each dinnerware pattern offered its own line of matching bar and refreshment sets. The #5000 Footed Jug was the most popular to be found in your favorite etching design. Matching tumblers for lemonade, iced tea and/or stemware were offered in refreshment set combinations.

Fostoria production in color glassware from 1934 catalogs offered the most outstanding Bar and Refreshment sets in full color of Burgundy, Emerald Green, Regal Blue, and Ruby. In researching 1930s advertising, it is interesting to find the marketing of "Oriental Ruby" bar and refreshment items. However, no mention of this color has been found in catalogs. In comparing notes with a great Fostoria historian, it was determined that perhaps because of the timing and WWII starting, the color name "Oriental Ruby" advertising was dropped. Catalogs of the time period list only a Ruby color.

Fostoria's line #5000 Footed Jug was used most often for the full lines of color dinnerware and etched patterns. Most every etching offered this jug in the line and produced in the colors of Crystal, Azure, Rose, Topaz/Gold Tint, Amber, Green, can be found with a variety of cuttings and etchings; more than three hundred different options were produced on this one blank. Other lines used for dinnerware that had matching etchings and cuttings are the #300 Jug; #2040 Jug, #2666 Jug, #4140 Jug, #5084 Jug, and #6011 Jug. Many examples of the variety of Jugs and Beverage Sets are included in this chapter. No attempt was made to include every pattern and/or list colors produced. This sampling is a very limited look into the art of Fostoria Jugs. Values given are for the picture shown only.

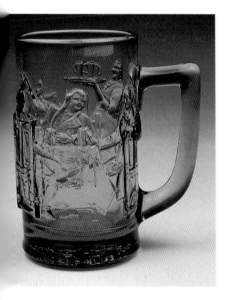

#2493 Tavern Mug, Amber 1933-1934, 14 ounce capacity. 5.5" tall. **$40.** Not shown: Made in Topaz and Crystal, 1933-1934. **$40;** Produced in Milk Glass 1974-1978, **$25.**

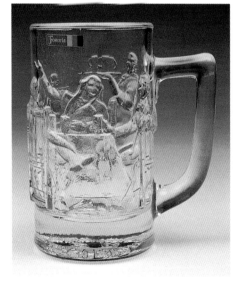

#2493 Bicentennial Tavern Mug, made in Crystal and dated on the bottom 1776-1976. Sold through the catalog and outlet stores 1974-1978. **$42.**

213

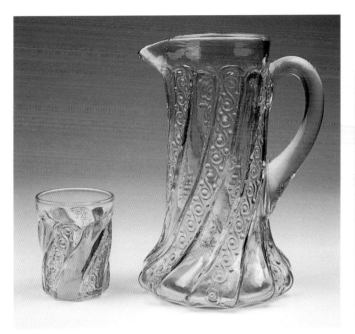

#789 Wedding Bells Ware, 1900-1903. **Left:** Gold Flash Tumbler, 4" tall. **$24**; **Right:** #789 Tankard, half gallon capacity, 10.5" tall. **$125.**

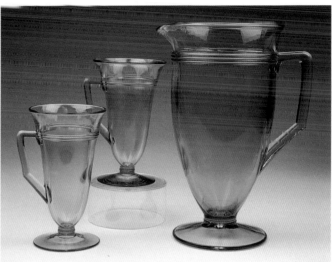

#2321 Priscilla, Footed Jug, Amber, 1925-1929, 3 pint capacity. **$115**; #2321 Footed Tumblers, Amber, 1925-1929, 6.5" tall. **$22.**

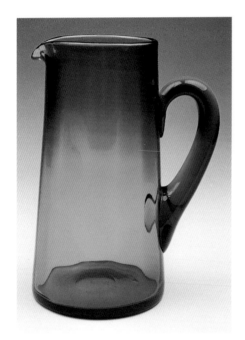

#300 Jug/Tankard, Blue, circa 1927, 10" tall. **$145.**

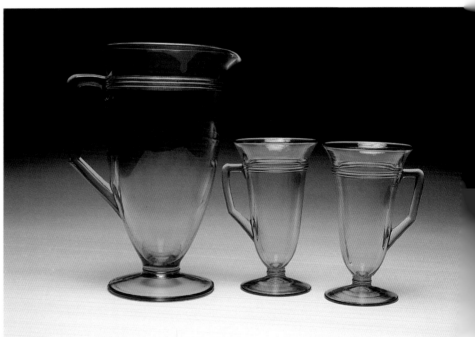

#2321 Priscilla, Footed Jug, Green, 1925-1929, 3 pint capacity. **$125**; #2321 Footed Tumblers, Green, 1925-1929, 6.5" tall. **$24**; Not shown: Priscilla Jug, Blue, **$145**; Priscilla Footed Tumblers, Blue, 6.5" tall. **$35.**

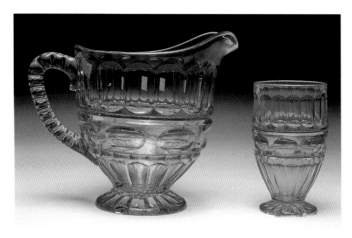

Left: #2449 Hermitage Jug, Wisteria, 1932-1936, 3 pint capacity, 7 3/8" tall. **$165+; Right:** #2449 Hermitage, 12 ounce Footed Ice Tea, Wisteria, 5.25" tall. **$22.**

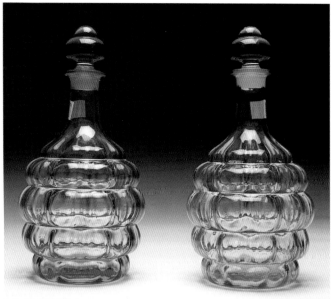

Left: #4101 Quart Decanter, Amber, 1928-1936, **$115; Right:** #4101 Quart Decanter, Green 1928-1937. **$125.** Not shown: produced in Azure and Rose. **$135.**

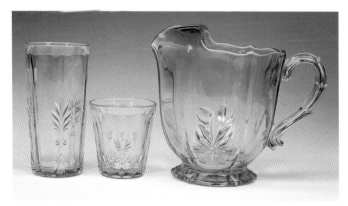

#2496 Baroque Ice Jug, Azure, circa 1937, 3 pint capacity. **$750+;**
Left: 14 ounce Flat Ice Tea, Azure, 1937-1943, 5.78" tall. **$55;**
Center: 5.5 ounce Old Fashioned, Azure, 1937-1943, 3.78" tall. **$45.**

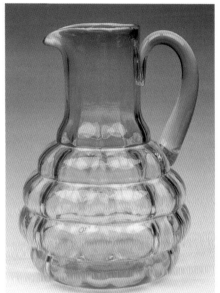

#4101 Jug, Azure Blue, circa 1936, this size not shown in catalogs, never before documented, 8" tall. **$125+.**

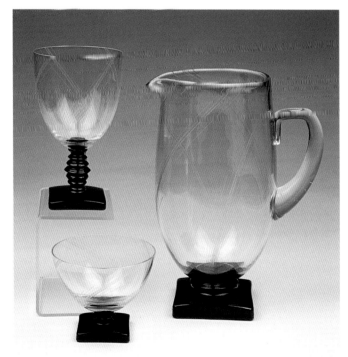

#4020 Jug, Comet Cutting #702, Ebony base 1930-1934, 9" tall. **$185;** #4120 11 ounce Goblet, 5.75" tall. **$35;** #4120 3 ounce Low Sherbet, 3" tall. **$32.**

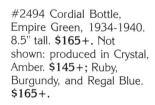

#2494 Cordial Bottle, Empire Green, 1934-1940. 8.5" tall. **$165+.** Not shown: produced in Crystal, Amber. **$145+;** Ruby, Burgundy, and Regal Blue. **$165+.**

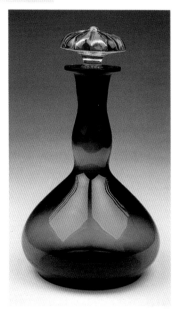

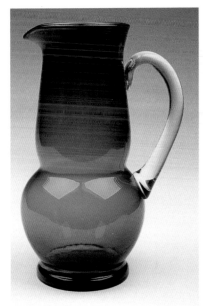

#2503 Wine Jug, Empire Green, 1934-1938, 33 ounce capacity, 8.25" tall. **$145;** Not shown: Produced in Ruby, Burgundy, and Regal Blue. **$145.**

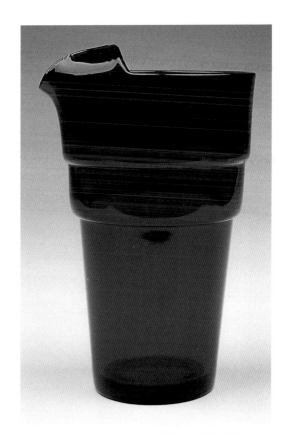

#2524 Cocktail Mixer, Regal Blue, 1934-1939, 7.25" tall. **$115.**

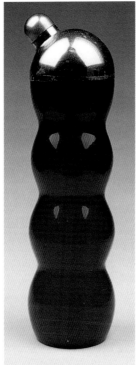

#2518 Cocktail Shaker, Ruby with metal top, 1934-1938, 38 ounce capacity, 12.75" tall. **$155+;** Not shown: also produced in Regal Blue, Empire Green, and Burgundy 1934-1938. **$155+.**

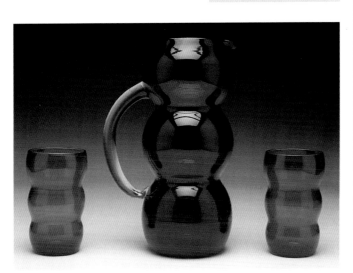

#2518 Jug, Burgundy 1934-1940, 44 ounce capacity, 9" tall. **$185.** #2518 10-ounce Tumbler, Burgundy, 4.75" tall. **$28;** Not shown: also produced in Empire Green, Regal Blue, and Ruby.

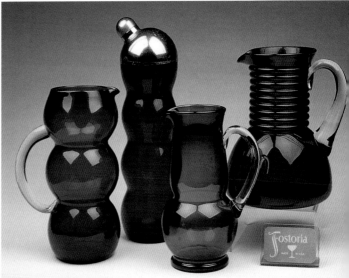

The bold and beautiful colors of Fostoria, Burgundy, Empire Green, Regal Blue, and Ruby 1934 1939. **Left to right:** #2518 Burgundy Jug; #2518 Ruby Cocktail Shaker; #2503 Empire Green Wine Jug and #4118 Regal Blue Jug.

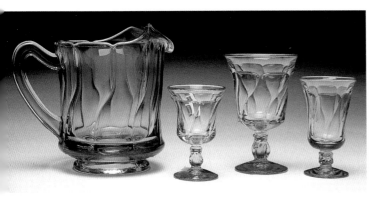

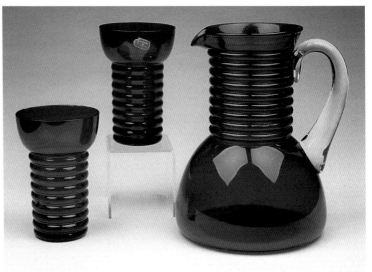

Left: #2719 Jamestown Jug, Blue, 1959-1970, 3 pint capacity, 7.75" tall. **$175**; Right: 4 ounce wine, 4.75" tall. **$24**; Goblet, 5.75" tall, **$28**; Footed Juice, 4.45" tall. **$18**.

#4118 Jug, Regal Blue, 1935-1938, 60 ounce capacity, 8.5" tall. **$185.** #4118 12 ounce Tumblers, 6" tall. **$22 each.**

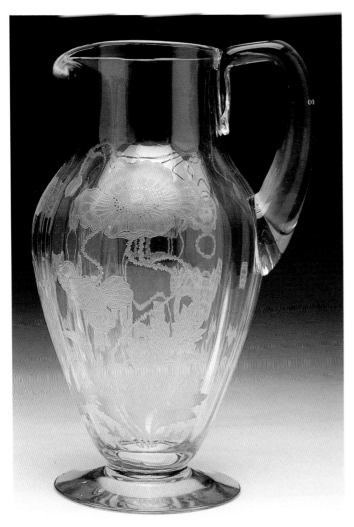

#4095/7 Jug, Crystal with Rogene Etching #269, 1924-1928, 9.75" tall. **$165.**

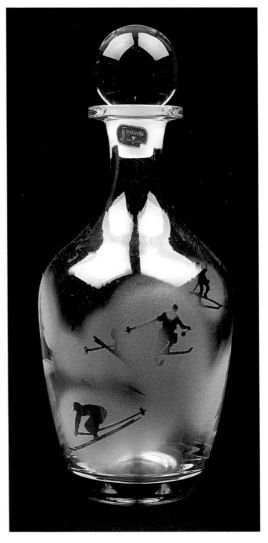

#4132 Decanter and Stopper, Ski Design Carving #2, 1938-1944, 9.75" tall. **$175+.**

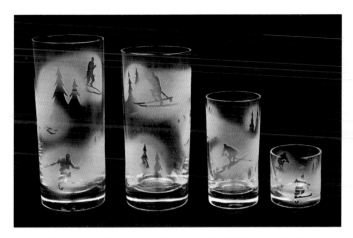

#4139 Tumblers, Ski Design Carving #2, 1938-1944. **Left to right:** 14 ounce Tumbler, 6" tall. **$32;** 10 ounce Scotch and Soda, 4.78" tall. **$32;** 5 ounce Old Fashion, 4" tall. **$28;** 1.5 ounce Whiskey, Sham, 2.1" tall. **$24.**

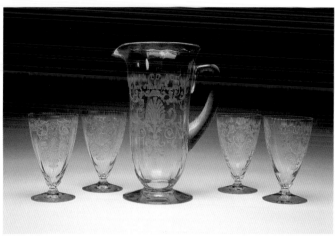

#5000 Footed Jug, Versailles Etching #278, Azure Blue, 1928-1939, **$825+;** With 12 ounce Ice Tea, Versailles Etching #278, Azure. **$45 each.**

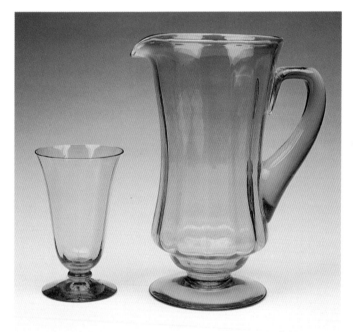

#5084 Footed Jug, Regular Optic, Green, 1927-1932. **$155+;** #877 Footed Tumbler, Green, 6" tall. **$14.**

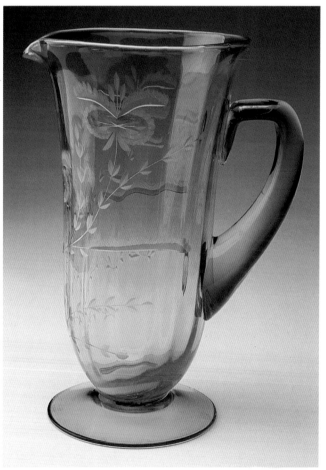

#5000 Footed Jug, Arvida Cutting #185, Green, 1928-1929 only. A very beautiful cutting produced one year only. **$365+.**

Chapter Ten
Vases- The Harmony of Glass and Flowers

Fostoria is a friend of sunshine and color. A glass vase or jar or bowl makes possible the perfect arrangement of flowers. From morning till night, as light mysteriously changes, the magic of this fine glass crystallizes each moment's mood. In the sun's full glory, in the soft glamour of candlelight, Fostoria and flowers make an exquisite picture! The transparency of glass, filled with water, shows flowers to the most advantage. For the slender green stems of flowers is a great part of their grace. Seen through crystal or colored glass, simple flowers take on a new interest. You can work out amazingly artistic effects- yellow flowers in a blue bowl; splashy red flowers in a green glass jar; the subtler combination of blue and pink flowers in an azure-colored vase; gay zinnias in an amber tumbler, you will be astonished and extremely pleased with the new arrangements your fancy will dictate. Fostoria makes jolly little flower bowls; the big flip glasses that are so smart now and so satisfactory; several types of centerpieces with flower blocks (these have candlesticks to match); footed tumblers of course; Oriental jars; and decorative formal vases. Don't be afraid to be lavish with candles and flowers- including flowers of the common garden variety, nasturtiums and asters, when the last roses of summer are gone! Quoted from *The New Little Book About Glassware*, 1926.

In Victorian days when a young man was courting a girl, the flowers he sent her on St. Valentine's Day had a language of their own. Every girl held her breath, hoping for white roses, which meant "I Love You." Today, the language of flowers has all but disappeared. Our lives are too fast-paced for the leisurely niceties of by gone era.

Fostoria Glass provided many a Valentine's Day gift for the ladies of the house, beautiful flower vases for any occasion, always the perfect choice gift for romance and telling someone special how much we love them. Fostoria encouraged the use of candlelight with the flower vases. The early vases were crystal pressed patterns, hand blown vases, and bouquet holders with deep etchings and hand cut designs. Vases were offered in a variety of sizes from 6 inch height up to the 24 inch height. The offerings at the turn of the century were a selection of hand painted opal ware vases in a variety of designs. The most popular was floral decorated, some Indian designs, animal scenes, and Arab vases were offered circa 1902 to 1906. Most often seen on these vases are hand painted backgrounds of green and brown; great finds are yellow, blue, and/or orange hand painted backgrounds with unusual floral and fruit motif. These early turn of the century hand painted vases came in ten different sizes.

Large Victorian Hand Painted Fostoria Vase, circa 1902.

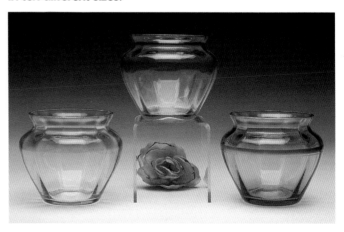

Fostoria Vases, new colors introduced in 1920s era.

An exquisite find is the Fostoria #1120 Vase that is shown in this chapter. It is pre-1920s and measures in at 50 inches in height, there are two pieces to this magnificent vase. The 1920s introduction of colors Azure, Rose, Green, Topaz, Orchid, and Ebony offered an exciting choice for the homemaker, although most all the vases offered in this time period were produced for less than four years. The #1681 Wall Pockets, produced between 1925-1927, and elegant Brocade acid etched patterns produced between 1927-1929 are going to be the most difficult to find of this era.

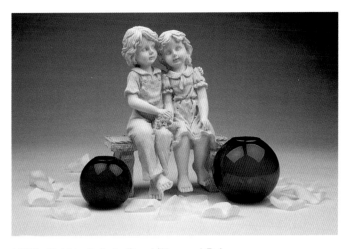

1930's Bubble Balls in Regal Blue and Ruby.

The colors of glass continued into the 1930s with bold colors being introduced in Ruby, Empire Green, Regal Blue, and Burgundy. The years between 1934 and 1938 were the most popular years for these. With the bold colors came choices of thrilling new designs, art deco, bubble balls, and many etched patterns. By the 1940s we see the decline in color choices and the brilliance of crystal beginning to come into the forefront again. Most all lines of elegant Master Etchings were offering vase choices in at least three different sizes for every pattern. Pressed patterns popular of American, Colony, Century, and Coronet had vase styles to meet the changing trends. In the 1950s and 1960s, Fostoria's new glassware with a fashion flair began the reintroduction of colors to several of the lines. Milk glass vases, short lived in Peach and Blue, Heirloom pattern vases in Yellow, Green, Blue, Pink, Orange, and Ruby were popular with Heirloom vases in several sizes swung from the same moulds. The style of the decade 1970s was contemporary. The Designer Series of vases included Impromptu, Interpretations, Impressions, and Images. These were the design of Jamie Carpenter, introduced into the catalog in 1977. These vases were uniquely created. The process consisted of pouring the molten glass over bits of color glass which melted and swirled into an abstract design. Each vase was unique, signed by the artist, and dated Fostoria 77 on the bottom. As several of these were in the catalog in the beginning of 1978, some were signed, and dated Fostoria 78.

The sheer number of vases produced during the one hundred year history at Fostoria could fill many volumes. Shown here is a representation of the art of Fostoria; vases that fall into the criteria of being produced for less than five years. Because most of the styles of vase shown can be found in a similar size, with different treatment variations of acid etchings and various colors, no attempt was made to value the variety of hundreds of possible etchings or colors that one can find. Values are for the color, size, and style of vase shown in the portrait only, unless otherwise noted.

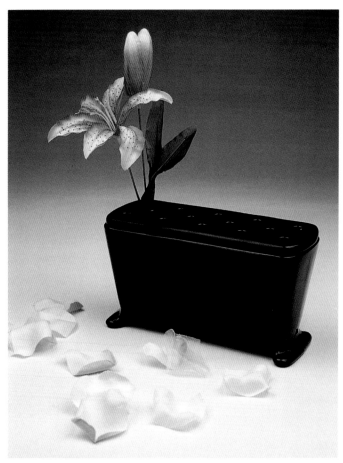

#2373 Window Garden, Ebony, 1928-1932. Offered in catalog with or without cover, in all colors. *One of the very loveliest new ideas in interior decorations is the glass-gardens, or window gardens. You can keep summer all winter in your breakfast room, or bring the country to the city.* Quoted from *The Little Book About Glassware,* 1925. Large Ebony Box/Cover. **$195+.**

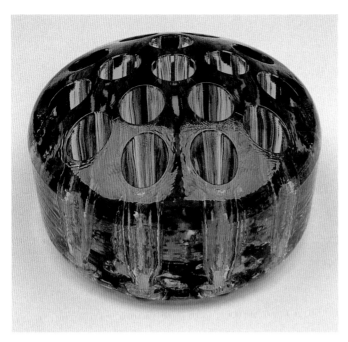

#2309 Flower Block, Green for use in Centerpiece Bowl, 1929-1939. 3.75" diameter. **$35;** Not shown: Produced in Crystal, Amber, and Rose, 1929-1939. **$35;** Azure Blue, 1929-1934. **$45.**

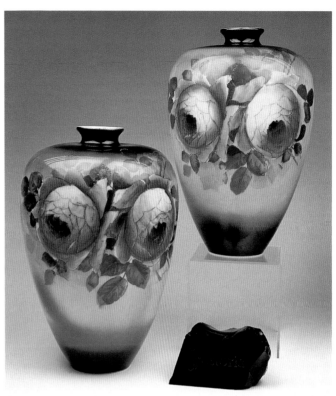

Beautiful examples of large Hand-Painted Floral Vases circa 1902, 14" tall. **$155 each.**

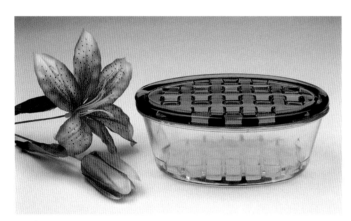

#2371 Flower Holder Insert for 13" Centerpiece Bowls. 2 pieces, bottom and lid, Orchid and Crystal, made 1928 only. **$145+.** Not shown: also produced in Crystal, Amber, Azure, and Rose. Bottom glass Crystal, top color to match the Centerpiece Bowl. 1928-1930. **$110 .**

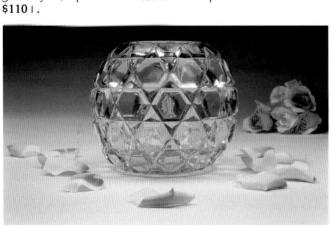

#140 Foster Block Rose Bowl, Crystal, circa 1891. According to Melvin L Murray, Fostoria Ohio Glass II: "Foster" was named for Charles Foster, secretary of Fostoria. The pattern is more commonly called "Foster Block" , perhaps named for Foster's then comparatively new downtown bank building, called appropriately "The Foster Block" this pattern was a nice gift for the lady of the house who opened new accounts at the Foster Bank. 7" diameter. **$115.**

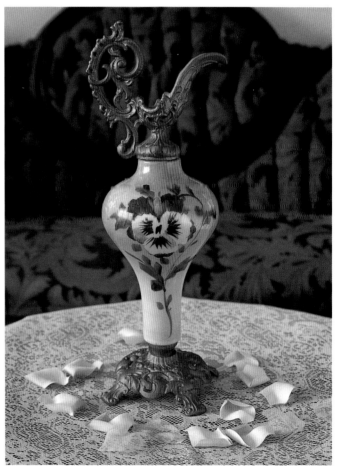

Milk Glass Vase with Pink Floral Decoration, mounted as a ewer with metal base, handle, and spout. Circa 1904 18" tall. **$155+.**

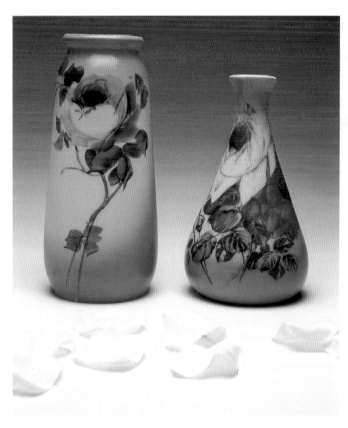

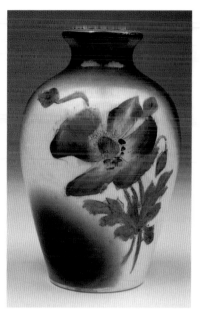

Milk Glass Vase, Floral Poppy Decoration, unusual flower to find, 6.5" tall. **$45.**

Milk Glass Vases with Blue background, Rose Floral Decoration. The color Blue is scarce, circa 1902-1906. **Left:** Blue Floral Vase, 8.5" tall. **$85; Right:** Blue Floral Vase, common shape, 7" tall. **$55.**

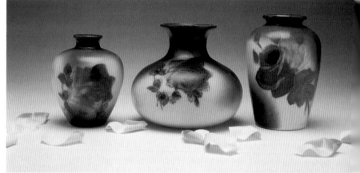

Milk Glass Vases, Green background vases in common sizes to find, circa 1902-1910. **Left to right:** Green Floral, round shape, 4.5" tall. **$25;** Green Floral, Green is most commonly found, 5" tall. **$35;** Floral Green, 5.5" tall. **$35.**

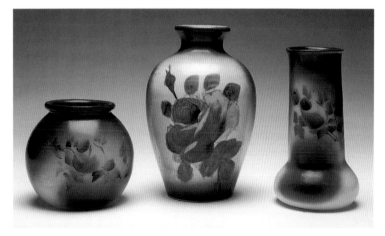

#1120 Loop Optic Vase, Amber, 1925-1926 only, 18" tall. **$175+.**

Sample of three sizes most commonly found in these Vases, with Brown background being most common. **Left to right:** Floral Vase, small round 3.75" tall. **$28;** Floral Vase, most common size found, 6.5" tall. **$35;** Floral Vase, 5.75" tall. **$35.**

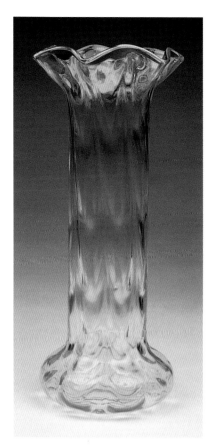

#1120 Loop Optic Vase, Crystal,
1925-1927, 14" tall. **$95+.**

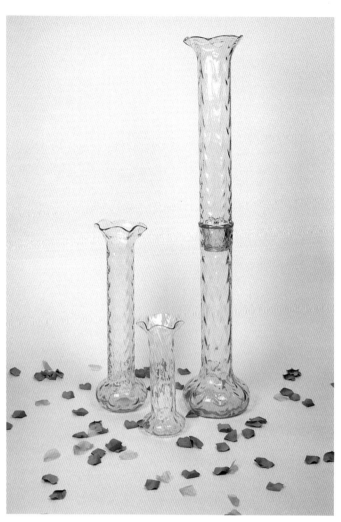

Left to right: #1120 Loop Optic, Crystal, 1925-1927, 24" tall.
$165+; #1120 Loop Optic Vase, Crystal, 1925-1927, 14" tall.
$95+; #1120 Loop Optic Vase, Crystal, circa 1920, extraordinary 50" tall. **$1255+.**

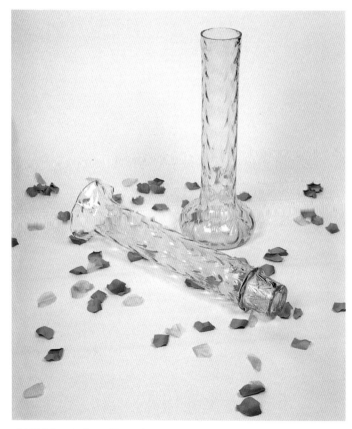

#1120 Loop Optic Vase, Crystal, circa 1920, 50" tall. A most
remarkable vase that is made in two pieces; the bottom height is
24" Loop Optic, the top has a 3" peg insert moulded into the
vase, top vase height is 27.5" , when complete the overall height
is 50" tall. Extraordinary Design. **$1255+.**

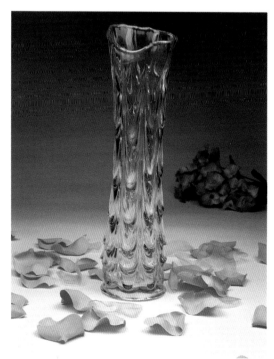

#1300 Heavy Drape Vase, Crystal, 1904-1906,
simple elegance. 12" tall. **$125+.**

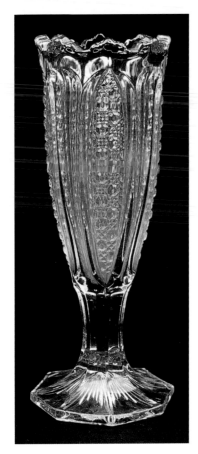

#1578 Tuxedo Pattern, great example of the early pressed glass seldom seen, Crystal, 1908-1910. 8" tall. **$85.**

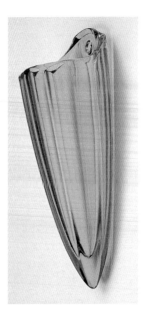

#1681 Wall Vase, Blue, 1925-1927, 8" tall. **$125.**

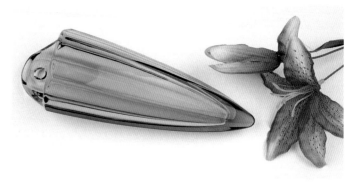

#1681 Wall Vase, Green, 1925-1927, 8" tall. **$125;** Not shown: also made in Ebony, Blue and Crystal. **$125.**

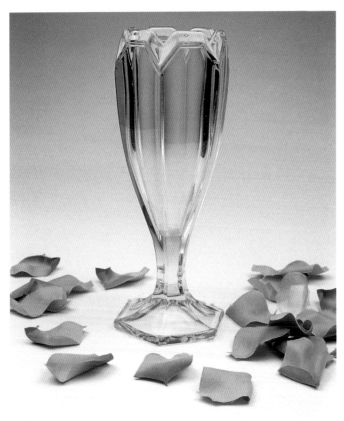

#1630 Alexis Vase, Crystal, 1909-1925, 9" tall. **$75.**

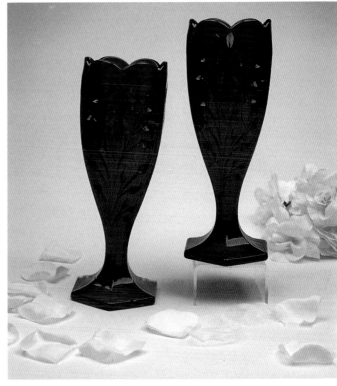

#1827/801 Rambler Footed Vase, Centennial II Collection, Ruby 1970-1973, 9" tall. **$210 each.**

#2056 American Flare
Footed Bud Vase, Milk
Glass, 1954-1965. 8.5"
tall. **$65.**

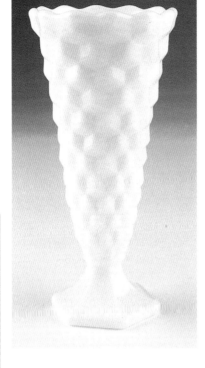

#2454 Footed Vase,
Ruby, made in 1936
only. Exquisite, 8" tall.
$185+.

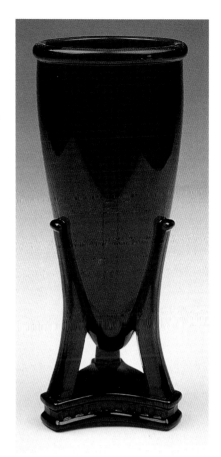

#2056 American Flare Footed
Bud Vase, Ruby, sold through
Fostoria Outlet Stores 1982. It was
reproduced for several years by
Dalzell/Viking after the factory
closed and sold through the outlet
stores. 8" tall **$55.**

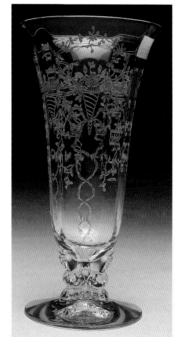

#2470 Vase, Corsage Etching
#325, Crystal, produced
1935-1943. 10" tall. **$215.**

#2288 Tut Vase,
Rose Cutting,
Amber, 1925-1931,
8.5" tall. **$65.**

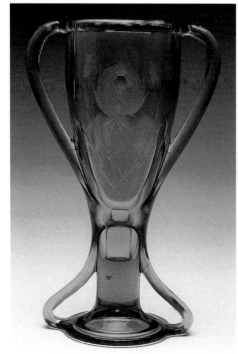

Sampled: #2470 Vase,
experimental color, Smoke with
Satin Finish, not listed in
catalog and never put out,
sampled only. 10" tall. **$425+.**

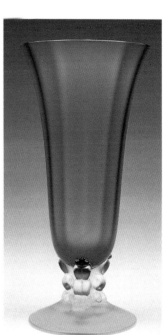

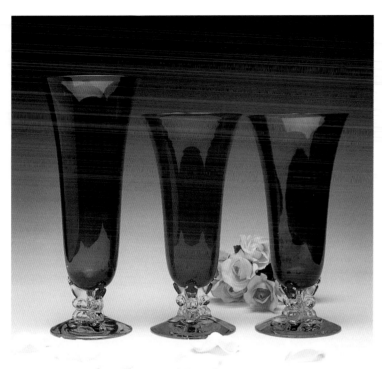

#2470 Vases. **Left to right:** #2470 Empire Green, 1935-1938, 11.5" tall. **$285;** #2470 Ruby, 1935-1939, 9.5" tall. **$225;** #2470 Empire Green, 1935-1940, 9.5" tall. **$225.**

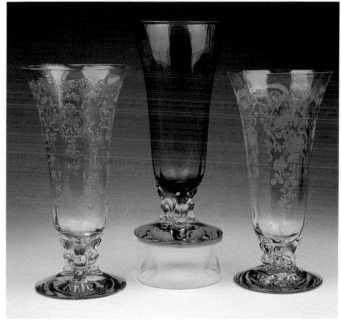

Left to right: #2470 Vase, Navarre Etching #327, produced 1936-1943, 1950, 1952-1958. 10" tall. **$275;** #2470 Vase, Spruce, 1952-1958, 10" tall. **$115;** #2470 Vase, Romance Etching #341, produced 1942-1943, 1952-1958. 10" tall. **$225.**

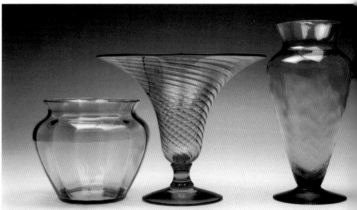

Left to right: #4103 Vase, Amber 1927-1943, 5" tall. **$40;** #2292 Spiral Optic Vase, Amber, 1927-1930, 8" tall. **$75;** #4095 1/2 Vase, Amber, 1925-1927, 8" tall. **$85.**

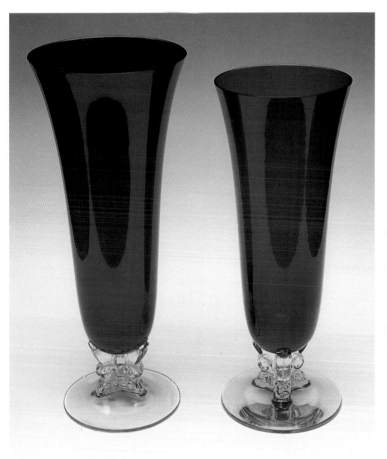

Left: #2470 Vase, Regal Blue, 1935-1938, 10" tall. **$255; Right:** #2470 Vase, Burgundy, 1934-1942, 8" tall. **$225.**

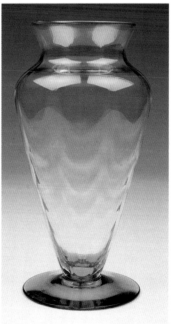

#4095 1/2 Vase, Crystal with Amber Foot produced 1925-1927, 9" tall. **$75.**

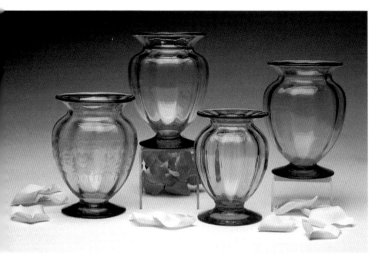

Left to right: #2369 Vase, Green with Cutting, 1927-1929, 7" tall. $85; #2369 Vase, Orchid , 1927 only, 7" tall. $95; #2369 Vase, Amber, 1927-1929, 7" tall. $85; #2369 Vase, Blue, 1927 only, 7" tall. $95.

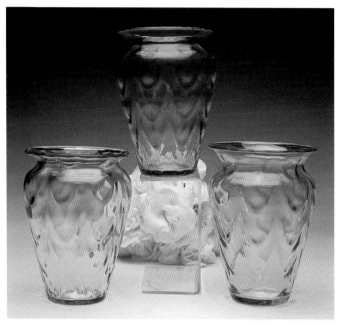

Left to right: #4105LO Loop Optic, Rose, 1928-1930, 8" tall. $85; #4105 Vase, Green, 1928-1930, 8" tall. $85; #4105 Vase, Azure Blue, 1928-1930, 8" tall. $85.

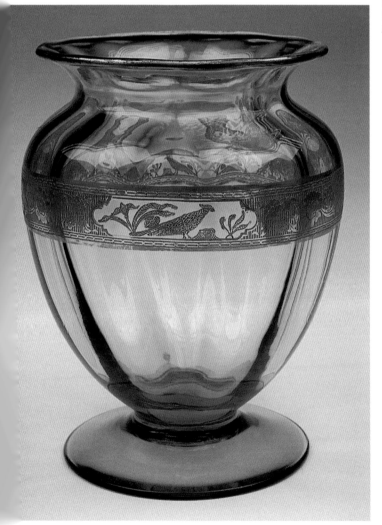

#2369 Vase, 14 Panel, Orchid, 1927 only. Pheasant and Stump Decoration Plate #259, Wheeling Decorating Company. 8" tall. $155.

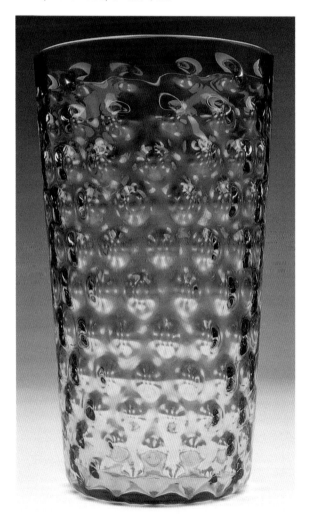

#4100 Hammered Vase, Rose, 1929-1932, 12" tall. $115.

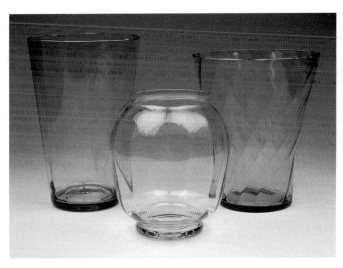

Left to right: #4106 Vase, Orchid, 1927, 8" tall. **$85;** #4106 Vase, Topaz, 1931-1934, 6" tall. **$75;** #4106 Vase, Amber, 1931-1934, 7" tall. **$75.**

#4107 Vase, Butterfly Decoration 508, Black Enamel on Topaz, 1931 only. 9.5" tall. **$165+.**

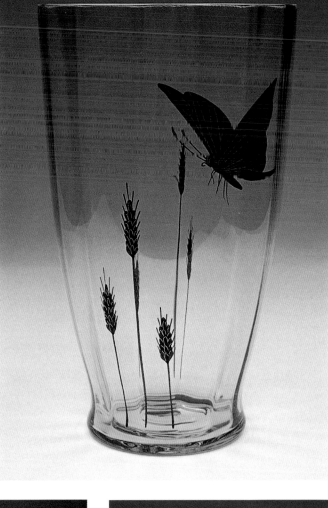

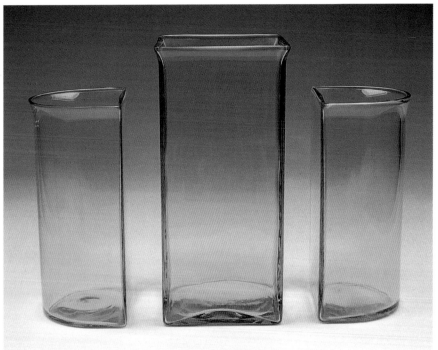

Extraordinary 3-piece Vase Centerpiece, consisting of one #2486, 9" Square Vase and two #2487, 7" Crescent Vases. Extremely scarce in catalog 1933-1934 Not shown: produced in Green and Crystal. **Individually priced left and right:** #2487 Crescent Vase, Topaz, 1933-1934, 7" tall. **$265+ each; Center:** #2486 Square Vase, Topaz, 1933-1934, 9" tall. **$325+;** Price for 3 piece set together as shown: **$855+.**

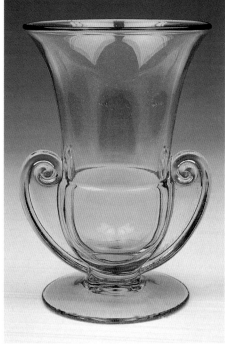

#2467 Vase, Topaz, 1934-1938, 7.5" tall. **$68;** Not shown: Produced in Crystal and Green, 1934-1937 **$68;** Ebony, 1934-1938 and 1953-1958. **$75.**

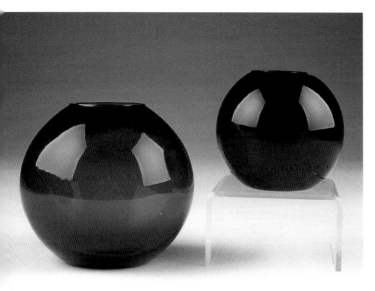

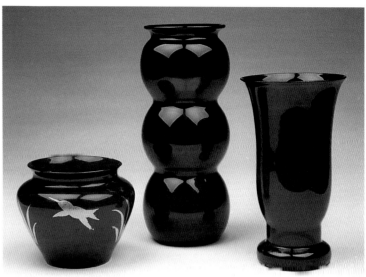

Bubble Balls appeared in the Fostoria catalogs 1934-1942. They were made in Ruby, Regal Blue, Empire Green and were intended for use in containers as decorative alternatives for floral arrangements. Bubble Balls were produced in sizes 2.5", 4", 5", 6", and 7" diameter. They are one of the least recognized gift items of Fostoria. #4116 Bubble Ball, Regal Blue, 1934-1938, 4" diameter. **$45+**; #4129 Bubble Ball, Ruby, 1934-1942, 2.5" diameter. **$35+.**

Left to right: #4103 Vase, Regal Blue, Gold Decoration, 1934-1939, 4" tall. **$65**; #2518 Vase, Regal Blue, 1935-1938, 10" tall. **$145+**; #4110 Vase, Regal Blue, 1934-1938, 8" tall. **$85.**

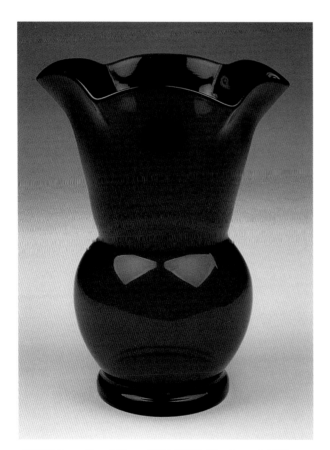

#2503 Vase, Regal Blue, 1934-1936, 7" crimped **$155.**

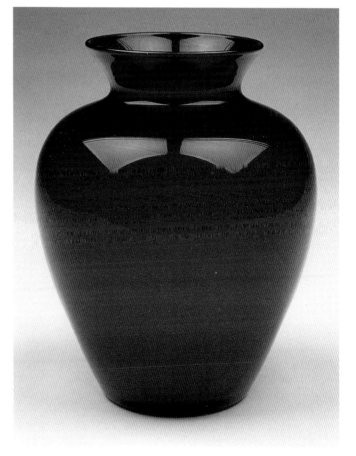

#4121 Vase, Oriental Ruby, circa 1935, scarce. This vase was produced with advertising literature introducing Fostoria's new Oriental Ruby. Several gift items were included in the advertising flyer of this new color. The color was never listed in the catalogs, although scarce advertising does exist. Vase 6" tall. **$175+.**

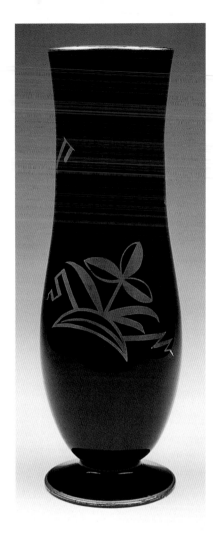

#2421 Vase, Ebony with Gold Floral Decoration, 1930-1932, 9" tall. **$175.**

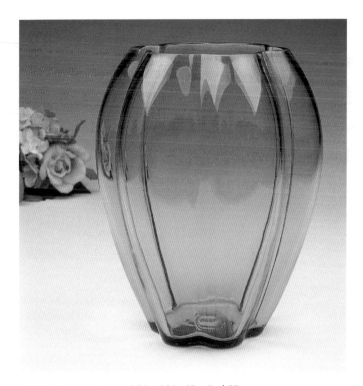

#2408 Vase, Amber, 1929-1932, 8" tall. **$65.**

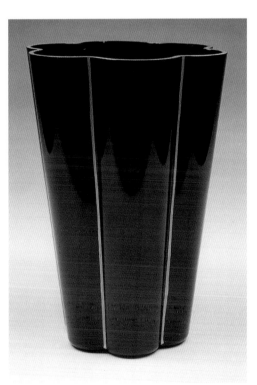

#2387 Vase, Ebony with Gold Decoration, 1930-1932, 8.5" tall. **$85+.**

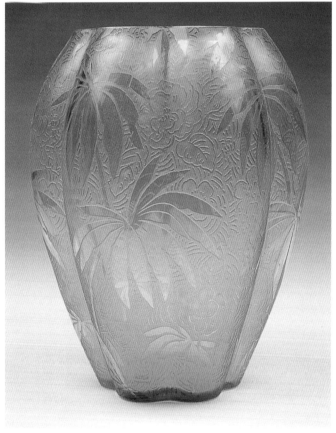

#2408 Vase, Palm Leaf Brocade Etching #291, Green, produced 1929-1932, 9" tall. **$375+.**

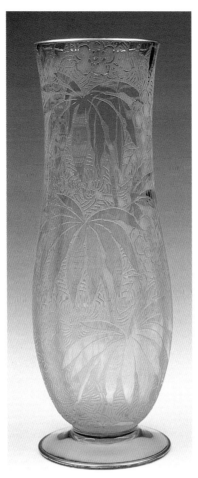

#2421 Vase, Palm Leaf Brocade Etching #291, Green, made 1929 only, extremely hard to find. 11" tall. **$500+**

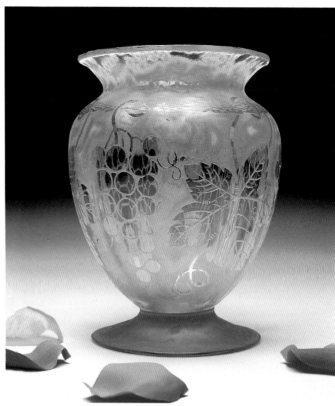

#2369 Vase, Grape Brocade Etching #287, Orchid, 1927-1929, 8" tall. **$175+.**

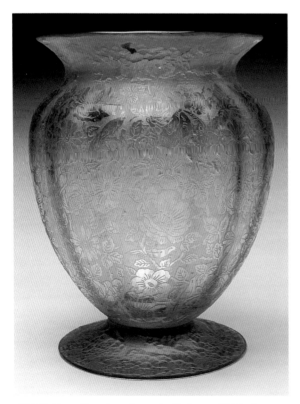

#2369 Vase, Paradise Brocade Etching #289, Green, 1927-1930. 9" tall. **$185+.**

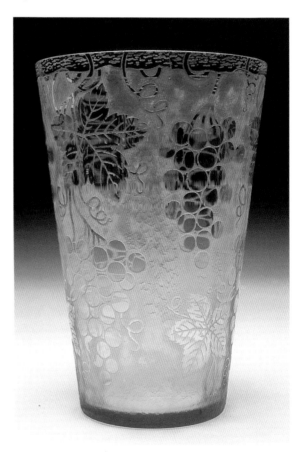

#4100 Vase, Grape Brocade Etching #287, Green, 1927-1930. 8" tall. **$165+.**

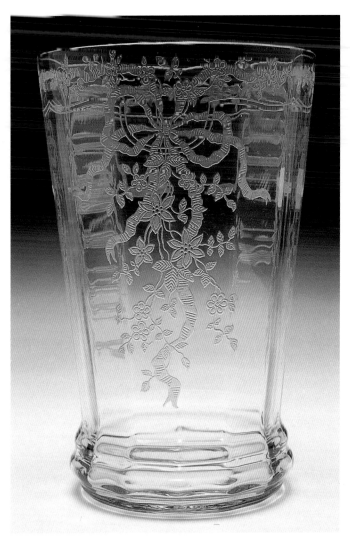

#2417 Vase, June Etching #279, Topaz, 1931-1932 only, 8" tall. **$485+.**

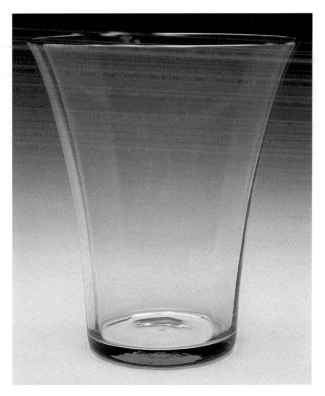

#4128 Flip Vase, Azure, 1937-1939, extremely scarce, 5.5" tall. **$155+.**

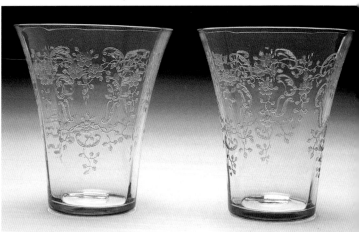

#4128 Flip Vase, Meadow Rose Etching #328, Azure, 1937-1939, 5" tall. **$265+.**

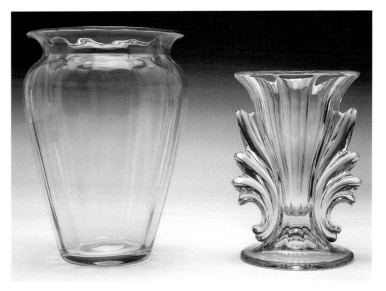

Left to right: #2417 Vase, Azure, made one year only 1929, 8" tall. **$185+**; #2484 Baroque Vase, Azure, 1937-1939, 8" tall. **$175+.**

232

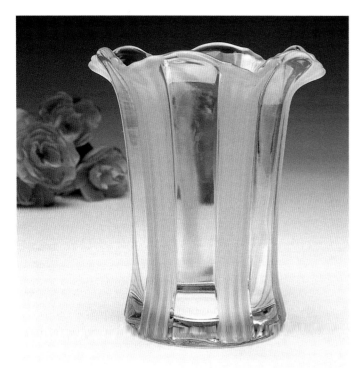

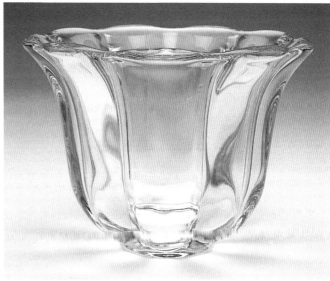

#2510 Vase, Sunray/Glacier with Silver Mist Ribs (called "Glacier" in catalog), 1936-1938, 7" tall. **$75.**

#2550 1/2 Spool Vase, Crystal, 1937-1943, 5" flared. **$75.**

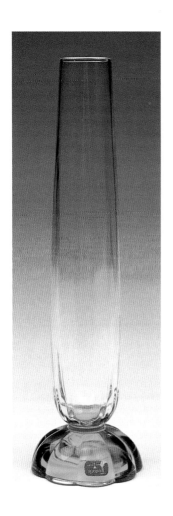

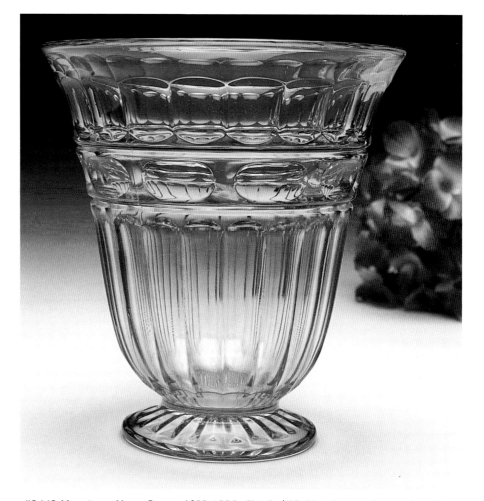

#5088 Bud Vase, Crystal with Green Base, 1936-1939 with original label. 8" tall. **$95.**

#2449 Hermitage Vase, Green, 1932-1936, 6" tall. **$68;** Not shown: also produced in Crystal, Amber and Topaz/Gold Tint. **$65.**

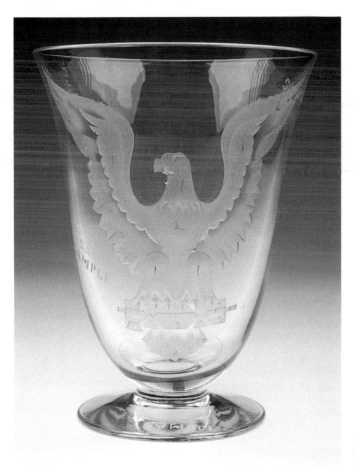

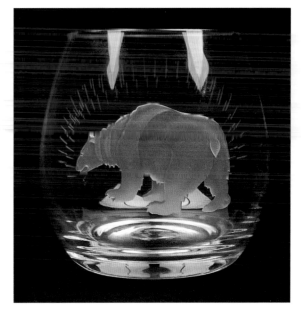

#2577 Vase Sample, Polar Bear Carving #29, 1941-1943. 6" tall. Original art master sample of designer Robert Coconhougher. **NDV.** Not shown: #2577 Vase, Polar Bear Carving #29, 1941-1943, production item, in line catalog, 6" tall. **$185.**

Sand Carvings are designs of Robert Coconhougher. The carving process used sandblasting to deeply cut a pattern in three dimensions into the glass. Using a series of art stencils the design was cut into the thick glass in the order of the deepest area first and working up to the shallow area. #4143 1/2 Sample vase, Spread Eagle Carving #32, 1941-1943. This sample from design department to shows how deep to cut the carving. You can clearly see are marked 'sample' in three places on this footed vase and the depth of carving marked showing carving depth for the glass craftsman to learn from. 7.5" tall. Original art master sample. **NDV.** Not Shown: #4143 Vase, Spread Eagle Carving #32, 1941-1943, production item, in line catalog, 7.5" tall. **$245+.**

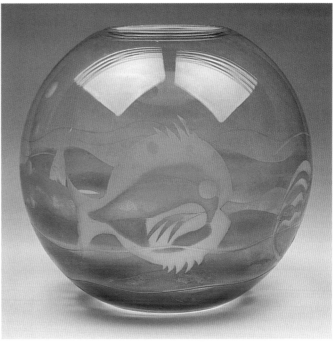

Sampled: Found in the design morgue at close of the factory, this Bubble Ball Vase believed to be the work of Robert Coconhougher, circa 1942. Unique sand carving design of sea life, with fish surrounding the vase, and color die decoration applied. It is not know how many were sampled. 7" diameter. **NDV.**

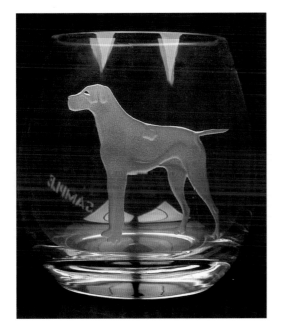

Sampled: #2577 Vase, Dog Carving, sampled 1939, not in catalogs, never put into production. Sand Carvings are designs of Robert Coconhougher. Very few sample vases with the Dog Carving are known to exist. 6" tall. Original art master sample. **NDV**

Untitled Experimental Spiral Optic Vases, not in catalogs, found in designers morgue at close of factory. It is believed some could have been made and sold through the Fostoria outlet stores, no record of catalog sales. **Left to right:** Golden Tint/Topaz, Spiral Optic, 9.5" tall. **$125+;** Ruby/Milk Glass Spiral Optic, 9" tall. **$125+;** Blue Spiral Optic, 9" tall. **$125+.**

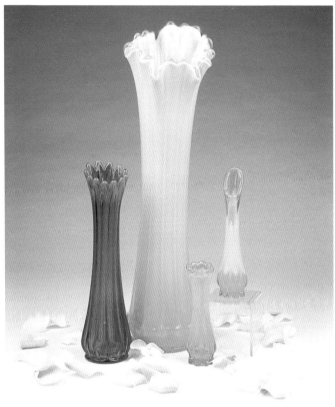

Left to right: #1515 Heirloom Vase, Bittersweet Orange, 1960-1962. 11" tall. **$65;** #1002 Heirloom Vase, Blue, 1960-1962, 22" tall. **$165+;** #1229 Heirloom Bud Vase, Green, 1959-1970, 6.5" tall. **$38;** #1229 Heirloom Bud Vase, Blue, 1959-1970, 6.75" tall. **$38.**

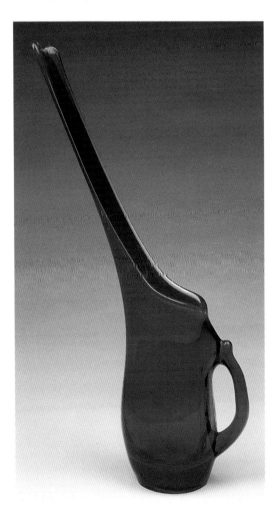

#2666/807 Decorator Collection Vase, Ruby Pitcher, 1964-1970. 10" tall. **$85.**

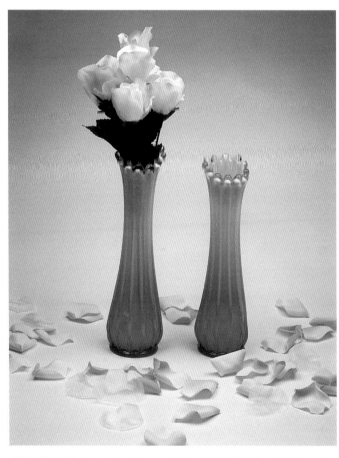

#1229/757 Heirloom Bud Vases, Pink, 1959-1970. 6" tall. **$38 each.**

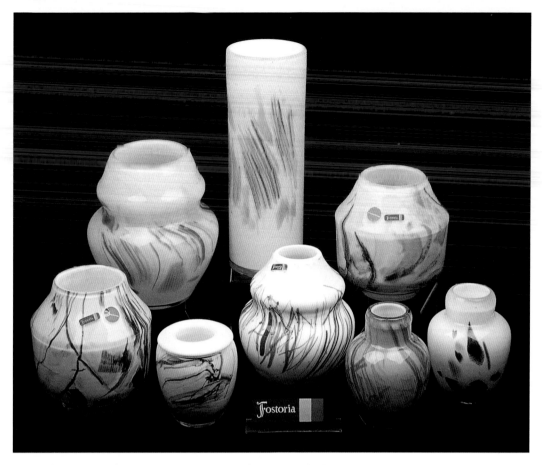

Fostoria's Designer Collection Vases by Jamie Carpenter, 1977.

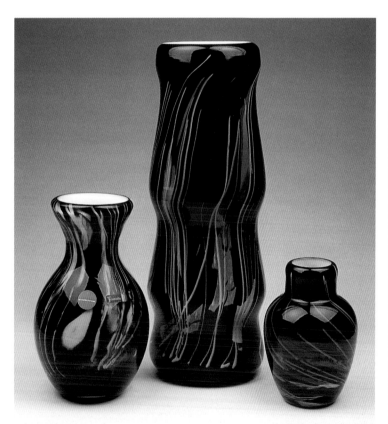

Designer Collection Vases. **Left to right:** #IN03/747 Interpretations, Onyx, Fostoria 77. 8.5" tall. **$250;** #IM03/741 Impromptu, Onyx, Fostoria 77. 15.5" tall. **$285+;** #IM02/750 Images, Onyx, Fostoria 78. 5.5" tall. **$225.**

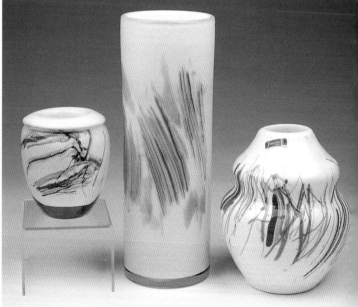

Left to right: #IMO2/272A Impressions, Blue/Orange/Opal, Fostoria 77, 5" tall. **$225;** #IM03/711A Impressions, Opal/Brown/Green, Fostoria 77, 12" tall. **$250;** #1M01/714D Impressions, Opal/Brown/Orange, 7" tall. **$225.**

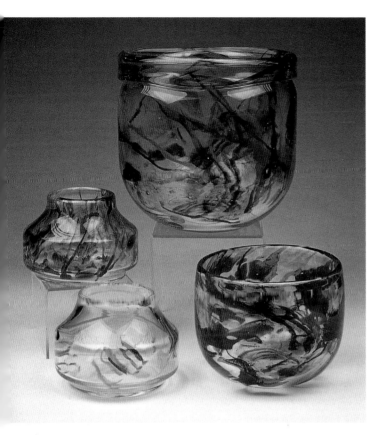

Top row left to right: #IM02/731 Impressions, Orange/Brown/Crystal, 3.5" tall, Fostoria 78. **$225;** #IM01/712B Impressions, Brown/Orange/Green/Crystal, Fostoria 77, 8" tall, 6" diameter top opening. **$250; Front row left to right:** #IM02/731 Impressions, Brown/Green/Crystal, Fostoria 77. 3.25" tall. **$225;** #IM02/724L Impressions, Brown/Orange/Crystal, Fostoria 77. 5" tall, 6" diameter top opening. **$250.**

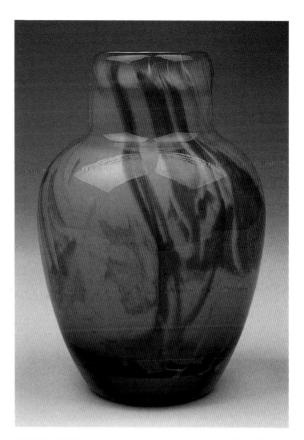

#IM02/728R Images Designer Collection called Rust shades of Amber/Rust/Orange, Fostoria 77. 6" tall. **$250.**

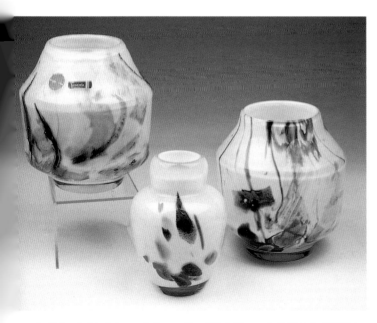

Left to right: Interpretations, Opal/Pink/Brown/, 7.5" tall. **$250+;** Interpretations, Green/Teal/Pink/Opal. **$225;** Interpretations, Opal/ Brown/Pink/Green/. **$250+.**

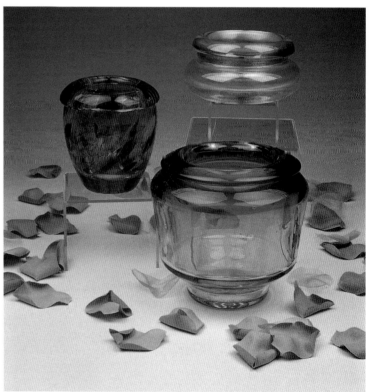

Designer Collection 78, Impressions Art Glass by Jamie Carpenter. **Left:** #IM02/727N Impressions, Purple Opaque, Fostoria 78. 4" tall. **$285+; Back:** #IM02/727O, Impressions, Opaque White, Fostoria 78. 3" tall. **$225; Right:** #IMO2/740T Impressions, Opaque Blue, Fostoria 78, 6" tall. **$250+.**

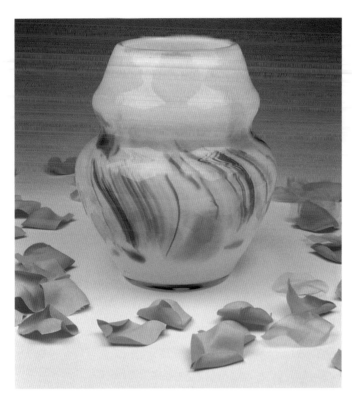

Designer Collection, #IN03/7191
Interpretations, Opal/Gray/Pink/Purple,
Fostoria 77. 9" tall $250.

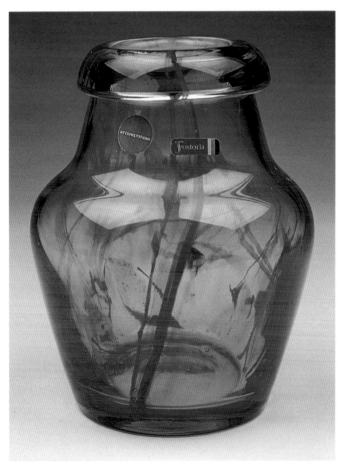

Left: Impressions, Purple/Blues/Crystal, 8.5" tall. **$265+; Right:**
Impressions, Fostoria 77, Teal/Green/Crystal. 3.5" tall. **$225.**

#IN03/721-J, Interpretations, Purple/Blue/
Crystal signed Fostoria 77. 8" tall. **$265+.**

Fostoria Glass "Lunch Hour" Whimsies

Fostoria Glass Company Whimsies belong in a class by themselves. Glasshouse whimsies from other glass companies were popular in its heyday in the 19th century and extended into the 20th century. Glasshouse whimsies are referred to as Friggers in England and as End-of Day glass in other areas. This terminology implies that the glass left over at the end of the workday often times would be mixed together and a mould pressed with the glass. The final product would result in a whimsical mixture of colors in the glass. Some people call this mixture of milk glass and colors slag glass. **Neither term applies to Fostoria Glass Whimsies.** Many Fostoria collectors believe that since the whimsy items were never produced and sold by Fostoria, the "Lunch Hour Whimsies" are not considered Fostoria and therefore not worth collecting. After my research and understanding of the Fostoria whimsies and the people who created them from the outstanding pots of crystal glass at Fostoria, it is my opinion that no Fostoria collection would be complete without one factory whimsy made just for the fun of making it, by the talented men and women glassworkers at Fostoria.

From the beginning of Fostoria, the glassworkers were allowed to be clever and create on their lunch and dinner hours. The first Fostoria whimsy, a four-petal lily of red speckled glass, mounted on an opaque white background enclosed in a clear glass dome, can be traced as far back as 1887 to Fostoria, Ohio. The last whimsy was made in the early 1980s, when the factory no longer allowed its workers to create on their own time. This was due to the automation and quality control of the pots of glass.

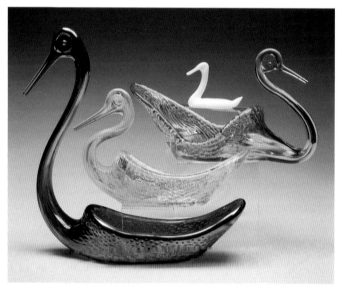

Fostoria Glass Whimsies Swans: Back to front: Swan free hand, Milk Glass, 2.25" tall 2.75" long, circa 1972, made by Kenny Robinson. $45; Swan free hand, Blue, 5.25" tall 10" long, circa 1920s. $95; Swan free hand, Topaz and Clear, 5.25" tall, 8.25" long, circa 1950s, $85; Swan free hand, Carnival, 10.25" tall, 9.75" long, circa 1960-1970s. $125.

Much time has been spent researching and collecting Fostoria lunch hour whimsies. Information obtained from old glassworkers relate that the various shops had long, hard hours on each turn of a work day. A "Shop" consisted of about six to eight men working closely together; this would include a gathering boy, a glassblower, a cut down boy, a carry in boy, and a carry over boy. The finishing shop was a team that included a foot-setter and a finisher. A "Turn" refers to the length of time, usually four hours on a shift. During that turn, the shop had to produce a certain amount of items for the day; this was referred to as a "Move." The number of items a shop had to move in a turn was derived from negotia-

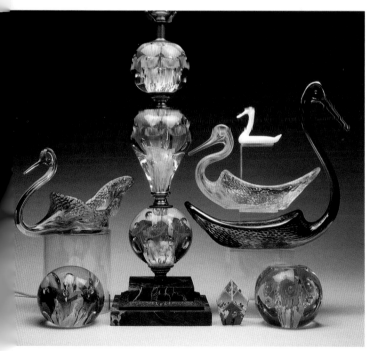

Group samples of Fostoria Glass Whimsies, Lamp, Swans, and Paperweights.

tions between the union and the glass company. The workers informed me that they most often got hired on by the shops oldest workers if they liked the work you did and/or you had family members employed by the shop. The work was long and difficult with the heat, smoke and dust around the factory. The only way a person could get a job was to wait around to try to catch a turn if one of the workers in a shop would become ill and unable to work. The workers had to stay productive throughout their turn to move the limit set for the shop for that day, therefore, there was not time to amuse themselves during the working hours.

Collection of Fostoria Glass Whimsies. Notice the variety of items that left the factory daily.

Life at the factory was difficult; employees were constantly exposed to heat, smoke and dust. Pay scales were equated to the volume of products they produced in a turn. Often, at the end of the day, the workers in the shop would take the time to make a useful item for the home or make a fanciful gift for a family member or friend. This was one of the benefits of working at Fostoria; glassworkers were allowed to create from the pots of glass. The popularity of creating something special grew through the years, and no worker at Fostoria was left out of the fun. The hot metal workers, glass blowers, foreman, and union presidents made whimsies; they all shared a joy in creating something unique and quaint. Most whimsies were given as gifts to the wife, mother, other family member, or friends. Often with a small batch of colored glass left from regular production, a worker would pour it into a mould of his choice, sometimes creating one of a kind gifts from the popular American, Baroque, Flame, Colony, and other popular pressed lines of glass. It is not unusual to find beautiful pieces in major lines never listed in the catalogs. There were many prototypes and morgue items at the close of the factory that began life as a lunch hour whimsy. These are great treasures to be found today.

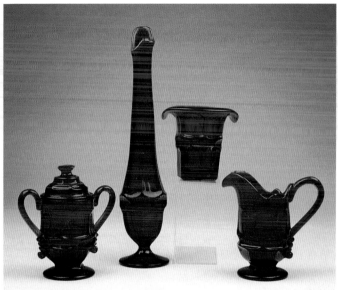

Samples of the types of whimsies made from Ruby Argus moulds, including beautiful pulled and swung vases. Shown individually within this chapter with values.

The variety of clever glass pieces that left the factory daily were limited only to ones imagination. Whimsy seemed to change with the seasons, birds in the spring and summer, decorations such as ornaments and canes for the tree in winter. Hand blown ornaments and glass chains for the tree were fun to make in the early years. More fanciful gifts included swung vases in beautiful colors created by taking an item from a regular line, such as a 10 inch Coin Urn, and swinging this out of the mould; it could stretch to heights of 18 to 22 inches. Flower vases made from Argus, Colony, Coin, and American pattern goblets were created by stretching out the goblet while hot out of the mould, elongating it to double the size and shaping into a vase. Fanciful top hats created from Coin, American, and Mesa pattern goblets were plentiful, and today are extremely hard to find.

All glass items made during lunch hours and off hours at the factory had to be cooled in the lehr overnight. A major problem with the fanciful whimsies made by the workers is that often times the most prized treasures created were not there in the morning when they returned to get the item from the lehr. Often times the first one to get to work in the morning had the opportunity to snatch the whimsies from the lehr. Most often these items traveled home in someone's lunch box.

Other lunch hour pieces included experimental glass. This included taking an item from a popular line at the time and making it in a different color of glass and/or etching a pattern on a blank not offered to the public in a particular pattern. Experimental animals and paperweights free flow into a mould that never went into production were popular among the workers. Most experimental items made by the workers do not have markings on them. An experimental piece of glass or color

that was produced by the design department would have been marked as such; there would be a "E" representing Experimental and/or noted markings with regards to test production color engraved into the bottom of the test item. It is important for collectors to understand that a whimsy is different than an official factory sample or trial piece, as they were called. Official trial pieces are engraved with a number made by a diamond tipped stylus. The number represented an identification of a special color. Most often when testing the color, the engraving would be dated on the bottom with remarks, such as "color too light" or "color too dark." When a color was just right and chosen to be included into the line, this was noted on the item, so the workers would have an exact color match to strive for.

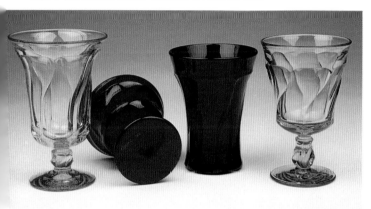

Experimental color, Jamestown factory test sample. Engraved on bottom, Ruby Glass, "Color OK." Factory test samples have engraving on bottom; many of these items sold off at close of factory, if you find unique colors of stemware with engraving on bottom, this is not a whimsy.

Experimental colors, Argus factory test samples, engraved on bottom. This would not be a whimsy. The engraved number P104 refers to the color batch number sampled, and Std. refers to "Standard" color. **Left:** P103, Olive Green, Std. **Right:** Cobalt Blue P104 Std. (Many of these experimental color items were sold off at the close of the factory, and do appear on the marketplace today.)

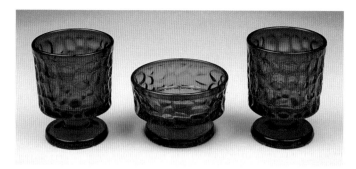

Experimental color on Pebble Beach, factory test sample. These include the experimental engraved information on bottom, as shown in next photo.

Experimental sample engraving on Pebble Beach: **Left:** F. Orange Std. (Flame Orange standard color). **Right:** F. Orange Std. lt. limit (indicated this sample color was too light). These are not a whimsies item, but a sampled color on a popular pattern.

Paperweights were extremely popular throughout the years. Early free flow lunch hour paperweights are shown in this chapter. These items were simply made by floating a hot gather of molten glass into the design dish that had been freed from the mould. These items would include weights made from American Almond dishes, Coin Nappies and American Nappies. Coin glass silver dollars and Coin checkers were also popular items for the workers to make during lunch hour.

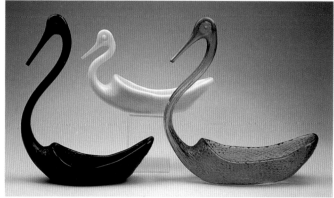

Popular Swan Whimsies. **Left to right:** Black Swan created by Fred Wilkerson, circa 1982. 11.25" tall, 9.75" long. **$135;** Milk Glass Swan created by Paul Myers, circa 1950s, 5.25" tall, 7.45" long. **$75;** Argus Cobalt Blue Swan, circa 1960s, 10.25" tall, 9.45" long. **$125.**

The most popular whimsy items made were the birds and/or swans. It seems these were made in every size, shape, and color. Most of the workers enjoyed making the birds in pairs. So many of these birds left the factory, they couldn't give them away. Today they are a sought after treasure for their uniqueness and are very hard to find.

Often times David Dalzell Sr. would request the workers to make special whimsy items to present to visiting dignitaries and special family members as gifts. I was told by many former factory workers that David Dalzell, Sr. enjoyed joining the men in creating something special from the excellent pots of Fostoria crystal, and he encouraged their efforts.

Most glass houses did not allow workers to make any items during lunch hours. Fostoria was a leader, Fostoria allowed its workers to explore with glass, explore their ability to create and design something new, they encouraged the workers to be unique. If you don't have a whimsy in your Fostoria collection, no matter how odd or unique, treat yourself to one when you get the opportunity. Owning a Fostoria Whimsy is like owning a little piece of the factory history and sharing in the joy of the person who made it—it will touch your heart and become a treasure.

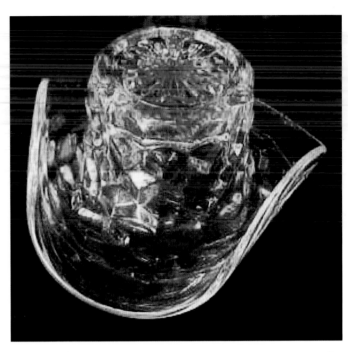

American Cowboy Hat Whimsy, created from #2056 American 8 ounce Tumbler, 3.5" tall. **$165+.**

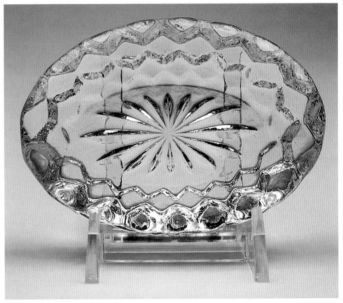

American Paperweight, created by William Robinson, from #2056 Almond, circa 1930-1940, 3.75" oval. **$85.**

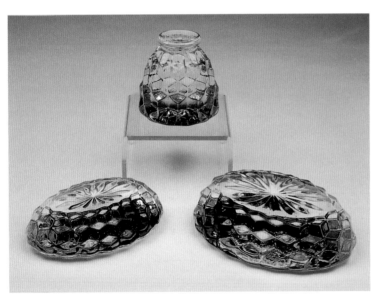

American Whimsies, created from #2056 American moulds, 1930-1960s. **Left to right:** America Almond made into a paperweight by William Robinson, 3.75" oval, **$85**; American Oyster Cocktail made into a paperweight. Many of these were made by factory workers and used for doorknobs at home, 2.5" tall. **$75**; American Almond made into paperweight by Kenneth Robinson, 4.5" oval. **$95.**

American Paperweight, created by Kenneth Robinson, from #2056 Almond, circa 1960s, 4.5" oval. **$95.**

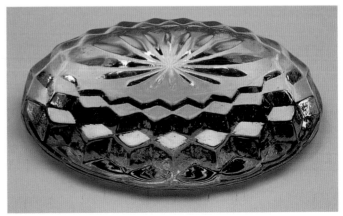

242

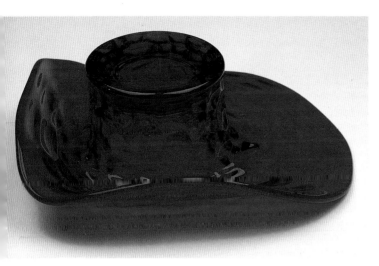

Unique Hat created from #2806 Pebble Beach, 7 ounce Juice Tumbler, Flaming Orange, circa 1969. This was not quite flared into a cowboy hat, rather styled to resemble a ladies hat, blown up and then pulled out elongated backside. It could be used as a mint dish. 3.25" tall, 7.5" diameter. **$175+.**

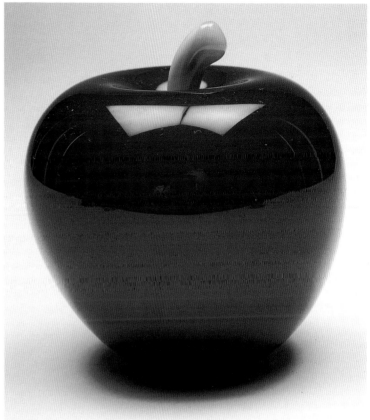

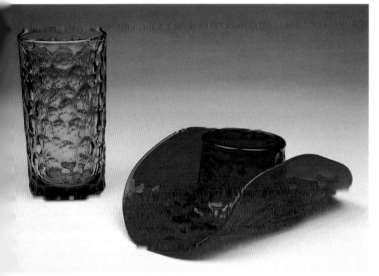

Cowboy Hat created from #2806 Pebble Beach, 14 ounce Ice Tea Tumbler, shown here for comparison. **Left:** Pebble Beach Tumbler, Lemon Twist, 1968-1973, mould used to create the whimsy hat. **Right:** Cowboy Hat, Pebble Beach, Flaming Orange, 1968-1973. **$225+.**

Red Delicious Apple, created with solid Ruby. It took many gathers of Ruby to create this apple by gravity flow; no blocking tools were used. Circa 1970-1972 by John Murphy. These outstanding apples will bear the artist signature, J Murphy, extremely sought after by collectors for their quality and perfection. Approximately 3.25" tall, absolutely delicious at **$175+.**

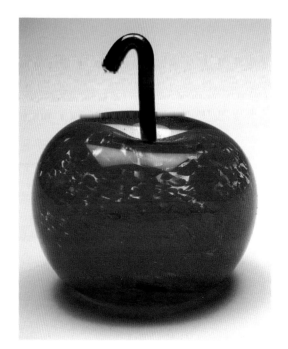

Apple Whimsy created with a crystal gather rolled into crushed Ruby Frit. Applied stem. Created by Kenneth Robinson, circa 1971, 2.5" tall. **$85+.**

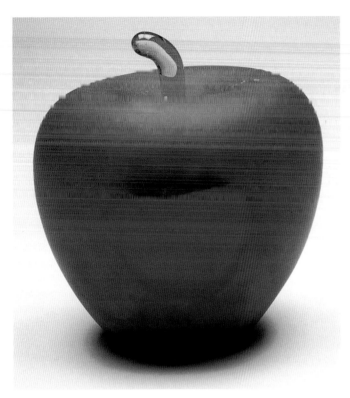

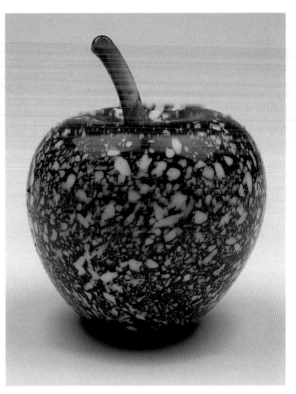

Ruby Apple satin finish and polished. Applied Green Stem. Four or five gathers required make this size apple. This example created by Paul Myers and finished by Bill Suter. These apples bear the signature of both men, Paul Myers and B.N. Suter. Circa 1970, 3.25" tall. **$145+.**

Ruby Apple, small, with Ruby Stem, rolled in Milk Glass. It took three gathers to create this apple by Kenneth Robinson, circa 1971. 3" tall. **$125+.**

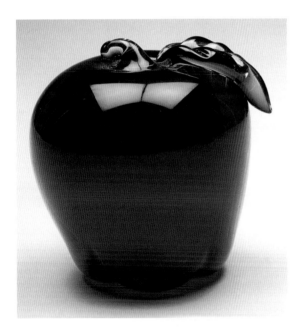

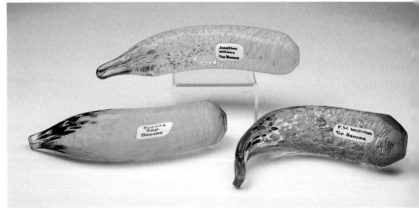

Ruby Apple created with up to four gathers of Crystal glass, encasing the Ruby in between gathers and shaping the apple. Created by Fred W. Wilkerson. **$95+.**

Top Bananas personalized and created by Fred W. Wilkerson. Fostoria's Yellow was difficult to work with. These top bananas were popular items created with Yellow Frit gathered over Fostoria's Crystal, personalized with a small plate of Milk Glass. **Back top:** Jonathan Williams Top Banana (made for my youngest son), 6.75" length. **Left:** Juanita Top Banana (made for me for my collection of whimsies) circa 1970s. 6.25" length. **Right:** F.W. Wilkerson Top Banana, (the top banana in our Fostoria whimsies collection). 6.5" length. Bananas can be found of Fostoria's Yellow Frit over Crystal, some personalized, some not. **$85 each.**

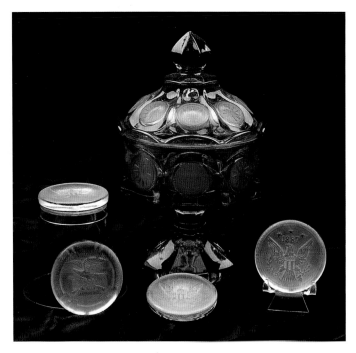

Crystal Silver Dollars created from the #1372 Coin Ashtray, taking the largest coin center, circa 1960s. These examples created by Kenneth Robinson and friends at the factory. Measure 2.75" diameter. **$55 each.**

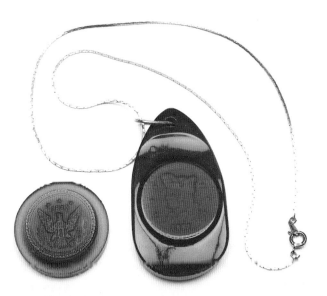

Whimsies created from #1372 Coin pattern, 1967-1982. **Left:** Coin Checker, Ruby. Checkers were created in Ruby and Green by floating glass into the small coins of the candy coin mould. Workers made complete sets of these tiny Ruby and Green glass checkers for home entertainment. **$35 each; Right:** Ruby Coin necklace – created from the large coin from the oval bowl. These can be found in Ruby, Green, or Amber Coin, styles will vary. **$85+.**

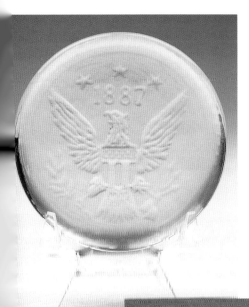

Close up Coin Silver Dollar 1887 with Eagle. **$55.**

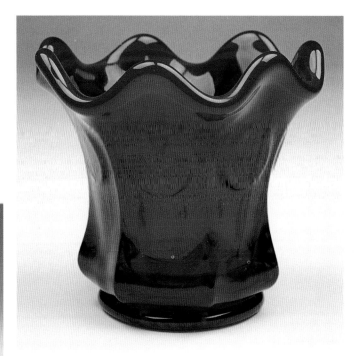

Close up Coin Silver Dollar with Eagle/ Rifle. **$55.**

Coin Whimsy Vase, Ruby, created from the #1372 Coin Sugar Bowl; the top was flared out and pulled to create this wonderful vase, circa 1976. Fostoria's Ruby glass was of exceptional quality. 4.5" tall, 5" top diameter. **$255+.**

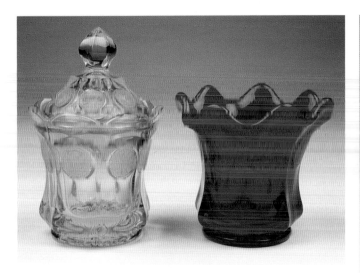

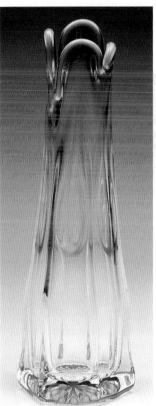

Coin Swung Vase, Crystal, created from a #1372 Coin Water Goblet swung out of the mould, circa 1972. The coins become elongated in the stretch center of the vase. 9.5" tall. $115.

Coin Whimsy Vase, Ruby shown with the #1372 Sugar Bowl, Azure, to show the mould this whimsy was created from. 4.5" tall, 5" top diameter. $255+.

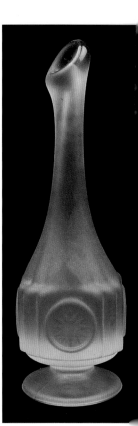

Coin Platter, Ruby, created from the #1372 Coin 9" Oval Bowl, circa 1976. This was extremely hard to create, as the worker had to work quickly to roll the pontil around the bottom and smooth the glass into a perfect oval platter. Very few of these left the factory, a real prize if you can find one in Ruby. 14" Oval. $335+.

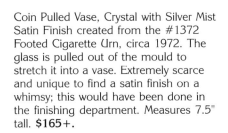

Coin Pulled Vase, Crystal with Silver Mist Satin Finish created from the #1372 Footed Cigarette Urn, circa 1972. The glass is pulled out of the mould to stretch it into a vase. Extremely scarce and unique to find a satin finish on a whimsy; this would have been done in the finishing department. Measures 7.5" tall. $165+.

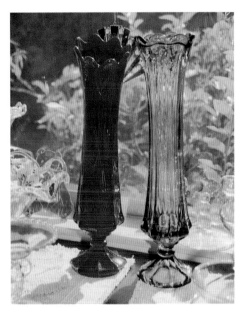

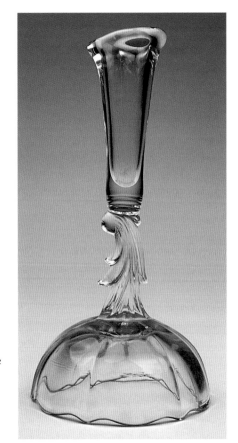

Coin Swung Vase, created from the #1372 Coin Footed Urn. The Vase was swung out of the mould. The fast swing of the hot molten glass elongates it and stretches out to fantastic heights. You can find Coin Swung Vase Whimsies in heights of 14" to 22" tall. Circa 1975. **Left:** Swung Vase, Ruby Coin, 19" tall. **$325+.** **Right:** Swung Vase, Green Coin, 19.5" tall, **$275+.**

Unique Baroque Pulled Stem Vase, created from #2496 Baroque 5.5" Comport, turned upside down out of the mould, the foot was pulled up to form a vase. Made by Paul Myers circa 1949. $135.

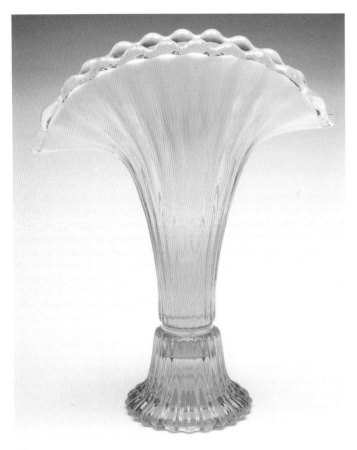

Heirloom Candle Vase, circa 1961, created from the #2730 Heirloom 6" Candlestick. Yellow Heirloom made 1960-1962 only. Vase was created when pulled out of the mould; the candlestick was turned upside down becoming the base and sides crimped in to form a Fan Vase. This whimsy is one of a matching pair known to exist. **$245+.**

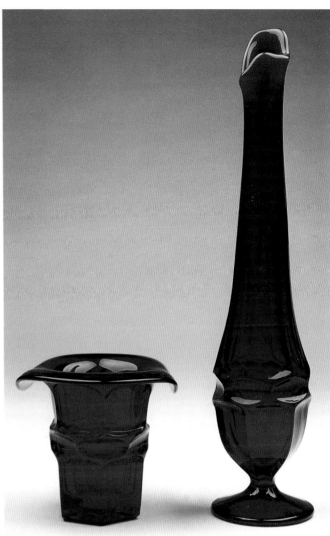

Henry Ford Museum Whimsies, signed HFM. **Left:** Top Hat Vase, Ruby, was created from a #2770 Argus, 10 ounce Tumbler/Old Fashioned, the rim pulled out and down from the mould, perfectly even all around, circa 1968. Marked on bottom HFM. 4.5" tall. **$255+; Right:** Exquisite Stretch Vase, Ruby, created from #2770 Argus, Footed Tumbler, circa 1968, beautiful detail on this one of a kind whimsy, 14" tall. **$315+.**

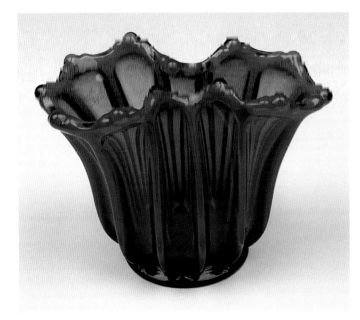

Heirloom Unique Fan Vase, this whimsy vase was created from #2727 Heirloom Bowl, and a test color trial run of Lavender color, circa 1961. 4.75" tall, 7.5" long. **$260+.**

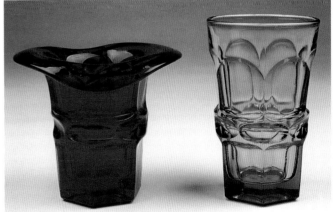

Comparison: #2770 Argus Goblet, to show the mould used to create the Ruby Top Hat Vase, circa 1968.

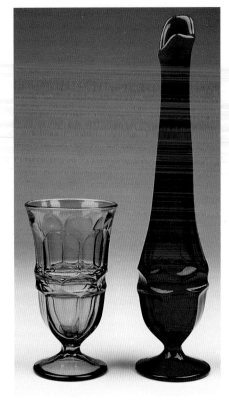

Comparison: #2770 Argus Footed Goblet, to show the mould used to create the exquisite Ruby Stretch Vase, circa 1968.

Glass Sword, created by Fred W. Wilkerson, circa 1978. A popular whimsy among the union workers to make. 13.75" long. **$135.**

This magnificent swag chain was found at the close of the factory packed in a box with a signature card: "Made by Robert Newell" and dated 1947. Hung in his office doorway to represent the union workers. The chain is 8 to 9 feet long and was created from glass links in various sizes. Sometimes made by union workers to signify their bonding together. When hung over the doorway, the triple swag chains drape to a 14" length overall. Many of the union workers made similar swag chains for the doorway at their homes. **NDV.**

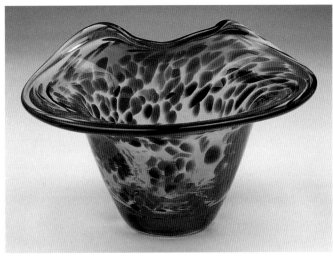

Unusual Jack in the Pulpit Vase, created from the Interpretations Designer Series of Vases by Jamie Carpenter circa 1977. This one-of-a-kind whimsy features Lavender with random dots of Orange and Brown glass. 4" tall 7" wide. **$325+.**

Glass Candy Canes for the Christmas tree, circa 1930s created by William Robinson. Many workers created glass canes at holiday time to hang on the tree at home for decorations. Shown here a variety of sizes, 5.5 inches to 14 inches. A fair value for Candy Canes is about $4 per inch, priced individually. **Not Pictured:** Larger Glass Canes or Walking Sticks, were made at Fostoria, 1920 through 1940s by some of the older glassworkers. Large Cane or Walking Sticks with height of 30" tall or more. **$165+.**

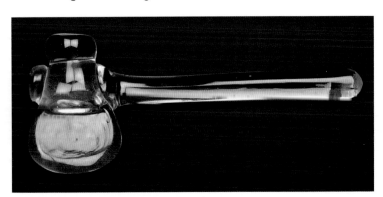

Glass Hatchet, created by Fred W. Wilkerson, circa 1968. Sometimes the men would like to make whimsies in tool or toy shapes of hatchet, sword, or hammer. These were fun to create, not intended for use. 12.5" long. **$125.**

248

Ruby and Crystal Canes, created by William Robinson, circa 1930's. **Left to right:** Peppermint Candy Cane, Ruby and Crystal gather twist, 14.5" long. **$58;** Peppermint Cane, Ruby and Crystal gather, 5.5" long. **$22;** Peppermint Cane, Ruby and Crystal gather, 11" long. **$44.**

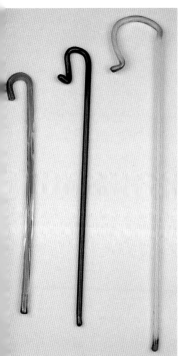

Holiday Canes of various designs created by the Kenneth Robinson family, circa 1930s. These items were probably made for the holiday tree. **Left to right:** Azure Blue and Crystal Cane, 10" long. **$40;** Empire Green Cane, 11.5" long. **$46;** Crystal Opalescent Cane, 14" long. **$56.**

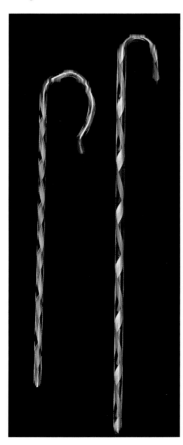

Candy Canes for the tree, created by William Robinson, circa 1930s. **Left to right:** Azure Blue and Crystal swirl, 11" long. **$44;** Azure Blue and Crystal swirl, 14" long. **$56.**

Some people refer to these wonderful birds as lunch hour swans, others think of them as birds. The majority of the workers, such as the talented Dave Fry, Paul Myers, Freddie Wilkerson, Roy Trueax, Jack Wayne, and many others made the pair of swans in similar height and length, so as to be attractive when displayed together. However, you will also find that some workers, such as Kenny Robinson, enjoyed making one large bird and one small bird as he called them, the mama and baby set. Kenny liked his birds to have the same color, but different size as a pair. The swans left the factory in pairs. Often times the sets have been split when people find them in yard sales, flea markets, or antique malls—they seem to have lost their mates. However, if you look around the area or store, most likely you can find a matc of similar color and design not too far away!

Paul Myers (on left) with round glass plate and pontil rod, the beginning of a Glass Swan and Fred W. Wilkerson (on right) holding a finished Swan that would have been created from this round glass plate. Circa 2002

These unique treasures are formed free hand, and it takes a total of three men working quickly together to form one of these swans. The swan started with a round 6 inch plate, one man held down on the marver with a plunger. The second man had to crimp and pull out the body to elongate and form this. The third man quickly used his pinchers to grab the gather of glass in front, pulling upwards to quickly form the neck. The pinchers leave the markings for the eyes on the swans head. He would then finish it off by pulling out the beak. The three men working together have less than one minute to form the entire swan and get it into the lehr to cool down. Is it any wonder that with this pulling and crimping and shaping quickly to form the swan, no two are exactly alike? You will find there are some with short bodies and long necks, and others with wide bodies and short necks and still others that seem to be a graceful elegant pair, almost perfectly made for each other.

249

These Fostoria whimsy swans have been made through the years at Fostoria; the earliest ones I have are circa 1920. Collecting and studying whimsies for so many years, one comes to recognize the glass by years produced and the quality of whimsy designs. If you are a Jamestown collector, one is to be found in Jamestown Pink or Blue; for the Heirloom collector, a great find would be a swan in Heirloom Yellow or Green; Ruby and Ebony Swans are a prize if you like Milk Glass in color, and there is a swan or two out there for you in Peach or Aqua and Milk Glass too! These really are unique treasures simply because they are Fostoria, created from the excellent pots of crystal at Fostoria, and made from the heart of one of the workers.

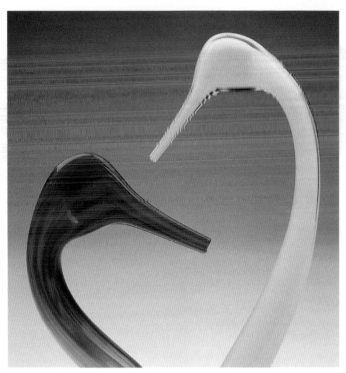

Close up eyes of the Swans. These were created using the regular glass pinchers at the factory. The pinchers were used to quickly grab the gather of glass and pull out the birds neck and then quickly pull down to form a beak. Notice the flat square appearance where the pinchers crimped the glass in the area of the eyes.

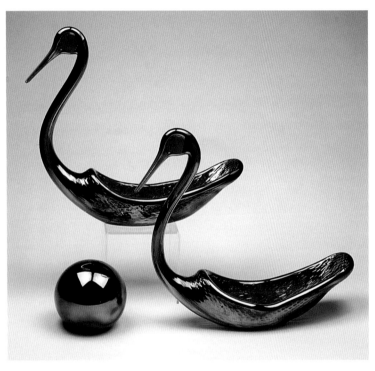

Fabulous Swans and Paperweight whimsies created from Ebony with Iridescent Carnival Finish. Created by John Murphy, circa 1980. These are truly unique, with this outstanding finish over Ebony. **Back:** Swan, free hand, 12.25" tall, 9.75" long. **$185+**; **Front left to right:** Swan, free hand, 12.25" tall, 9.75" long. **$185+**; Paperweight, one of-a-kind. **$225+.**

The eyes of this Swan were custom created by one of the best glass-workers, Dave Fry, utilizing standard washers attached to his pinchers. The eyes form when bits of glass fill in the holes in the washers, when the swan head was pulled out. Dave Fry was known for his outstanding swans (birds), both at the factory and throughout the community.

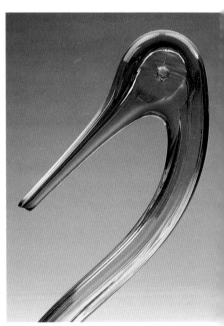

The Blue Swan body shows detail of crimped glass. The pattern was created by use of a screen attached to the tool used to crimp the body, leaving an impression on the hot glass. The Crystal Swan body is elongated and smooth, this type of body is typically found.

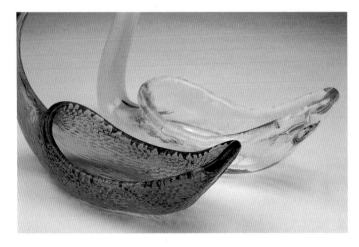

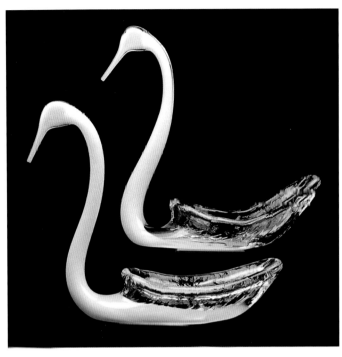

Tall, stately Swans in Milk Glass and Crystal gather, circa 1950. **Left:** 12" tall, 7.5" long. **$135; Right:** 11.5" tall, 7.5" long. **$135.**

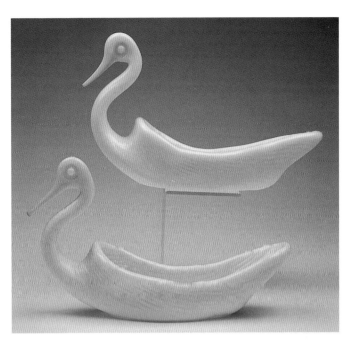

Short Neck Swans, created free hand by Dave Fry, Milk Glass, circa 1970. Notice the fine detail of the eyes and excellent precision crimped body, exacting size. **Back:** Short Neck Swan, 5.25" tall, 8.25" long. **$85; Front:** Short Neck Swan, 5.25" tall, 8.25" long. **$85.**

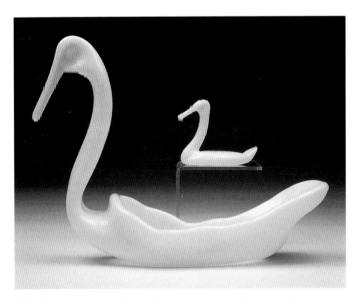

Milk Glass Mama and Baby Bird, created free hand by Kenneth Robinson, circa 1972. **Left:** Mama Bird, free hand, Milk Glass, 6.75" tall, 8.5" long. **$85; Right:** Baby Bird, Milk Glass, 2.25" tall, 2.75" long. **$45.**

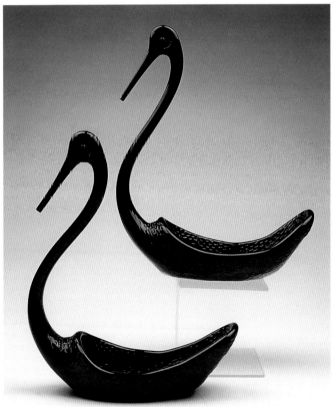

Ebony Swans, an outstanding, elegant design by Wilkerson, Trueax, and Fry. Circa 1982. Fostoria items found in Ebony glass are extremely scarce. This pair features crimped body and crimped washer eyes. 10.5" tall, 8.5" long. **$175+ each.**

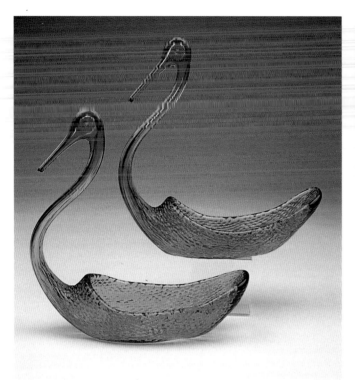

Argus Blue Swans, created by Fry, Myer, and Wilkerson. Tall stately pair with crimped body and crimped washer eyes. 10.5" tall, 7.25" long. **$145 each.**

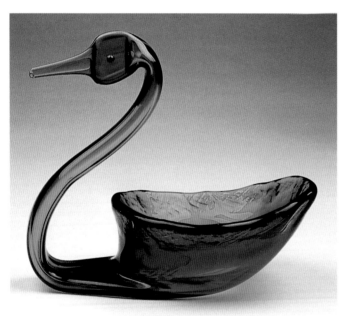

Argus Blue Swan, long neck, unusual smaller size body and finished shape. 7.25" tall, 8.25" long. **$85.**

Back: Variegated Swan, Bittersweet Orange and Crystal, circa 1962. (Damaged, broken beak). **NDV; Front left to right:** Bittersweet Orange Swan, short neck, circa 1962. 4.5" tall, 8.5" long. **$75**; Green Swan, short neck, circa 1964. 4.8" tall, 8.25" long. **$75.**

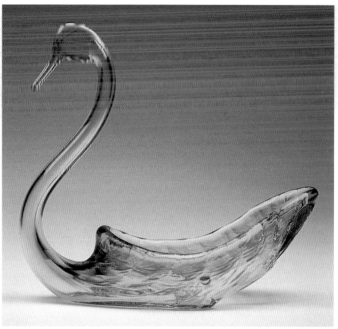

Canary Swan, created by Kenneth Robinson family member, circa 1930, 5.75" tall 8.5" long. **$85.**

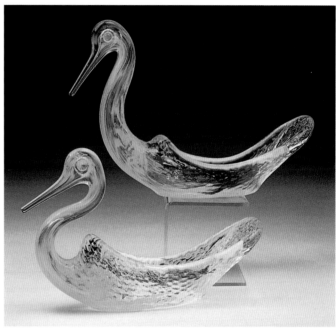

Yellow and Crystal Swans, crimped washer eyes, created by Dave Fry. These left the factory daily in pairs, this combination gathers of Crystal and Topaz. **$85 each.**

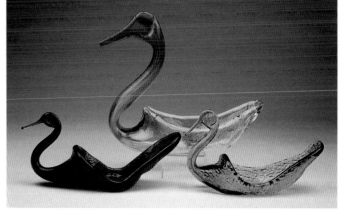

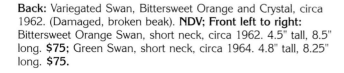

Glossary

There are many different terms that are used throughout this book. To help the collector understand different terminology, I am providing this reference page. This glossary includes original Fostoria terms as listed in factory catalogs, terms of production and tools used, and terms used in describing the glasshouse whimsies.

After Dinner Cup and Saucer - footed small size used for cappuccino, also referred to as demitasse.

Air Trap - interior weight bubble between layers in the glass.

Annealing - a process that toughens glass and eliminates internal stress by heating and gradual cooling in an annealing oven or lehr.

Applied Glass - glass added from a separate gather and attached to the main gather during blowing and shaping or just after pressing.

Art Glass - blown or pressed glass, usually shaded from one color to another, often with varied and novel surface decorations.

Banana Stand - footed oval dish with two sides turned up, used as a center piece by placing the bananas with the curled end down and radiating out forming a fan shape.

Base - the bottom of a paperweight.

Base Color - layer of color closest to the paperweight bottom or foot on a stem.

Batch - a mixture of ray materials ready for melting in the pots.

Beverage - tumbler: flat, no stem or a short stem, usually holding more than 13 ounce.

Bitters - flat spherical bottom with narrow short or long neck; looks like a small barber bottle but was used for spirits or liquor.

Block - hollowed apple or cherry wood tool used to shape crown of paperweight.

Blown Glass - glassware shaped by blowing air into a gather of molten glass using a blow pipe.

Blown-Moulded - glassware shaped by blowing air into molten glass which has been placed in a mould for forming a design.

Blow Pipe - a hollow iron tube usually four to six feet long, wider and thicker at the end on which the gather of glass is collected.

Boboches - a piece of glass that has prisms attached to it by a wire hook, which can be attached, set on or part of the candle holder itself changing it into a candelabra.

Bon Bon - flat small dish with two handles turned up, usually 5" to 6" diameter.

Bouillon Cup - two handled bowl for serving soup; smaller than a cream soup.

Brandy - goblet having a tall stem, usually holding .75 to 1.25 ounce.

Brandy Inhaler - goblet having a short stem, usually holding 12 to 40 ounce.

Bread and Butter Plate - plate usually around 6" diameter.

Breakoff - rough area of glass at base of paperweight left when pontil is broken off; act of striking weight from pontil by sharp blow to pontil.

Bubble Mould - a hollow, metal-hinged mould with evenly spaced interior spikes used to create minute air traps in paperweights.

Cake Plate - flat plate with two opposing handles, used for serving cake, from 9.75" to 11.75" diameter.

Cake Salver - short footed plate used for serving cake or desserts.

Cake Stand - tall footed plate used for serving cake or desserts

Candelabra - candle holder having two or more candleholders with boboches and prisms.

Candle Bowl - bowl made into a candle holder.

Candle Lamp - candle holder with glass shade or chimney also referred to as a hurricane lamp.

Celery - oval or rectangular shaped relish dish designed to accommodate celery sticks.

Celery Vase - flat cylindrical straight sided; used to serve celery.

Center Handled Tray - used in serving cut up sandwiches, also referred to as a sandwich tray or lunch tray.

Chain Design - an applied decoration formed from parallel threads of glass tooled together, intermittently to form a chain design.

Chair - a wooden bench with wide long arms at which the gaffer rolled a blow pipe or pontil rod forward and backward while fashioning an object.

Charge - putting the batch into the melting pot.

Cheese Comport - low footed dish, bowl, or plate with a stem used to serve cheese and made to fit into the center indent of a cracker plate as a two piece serving set.

Cigarette Box - flat rectangular or cylindrical (upright or on side) covered container for holding cigarettes (old cigarettes were shorter), usually had individual ashtrays to form a smoking set.

Cigarette Holder - flat or footed, open container that is rectangular or oval open for holding cigarettes (old cigarettes were shorter).

Claret - goblet having a tall stem, usually holding 4 to 4.5 ounce.

Cocktail - goblet having a tall stem, usually holding 3 to 3.5 ounce.

Cocktail Mixer - flat or footed cylindrical vessel with metal or glass lid, with or without a handle, also referred to as a cocktail shaker.

Cocktail Shaker - flat or footed cylindrical vessel with metal or glass lid, with or without a handle, also referred to as a cocktail mixer.

Collar - metal cylinder used to surround die (design) plate.

Comport - footed dish, bowl, or plate with a stem also referred to as compote in some sales material.

Confectionery Box - flat covered container for use in holding chocolates.

Console Bowl - large bowl (several shapes, footed or flat) used as a center piece.

Console Set - large bowl (several shapes, footed or flat) used with two candle holders to form a three piece center piece.

Controlled Bubbles - an air bubble imprisoned in the glass for decorative purposes, usually in a symmetric design.

Cordial - goblet having a tall stem, usually holding .75 to 1.25 ounce.

Cornucopia - flat open center piece arranger also can be a footed short stem, tapered from wide opening down to a pointed tall (sometimes with a ball on the end)

Crab Meat Insert - cylindrical vessel slightly flared at top used to keep the juice from mixing with the ice that would keep it chilled, usually 4 ounce.

Cracked Ice - extra large ice tub holding 1/2 gallon of ice, used by hotels.

Cracking Off - the process of removing an object from the pontil rod. After it has been scored in the desired place, and cooled, the rod is tapped gently; allowing the object to break away from the rod.

Crackle - produced by plunging molten glass in and out of cold water, followed by reheating which develops an appearance of tiny fractures.

Cream Soup - two handled bowl for serving soup, larger than a bouillon cup.

Crimped - top edge will be reworked by the glass artisan to create several different finishes, such as ruffle, pie crimp, tri corner, etc..

Crown - final gather of glass which is blocked to enclose design of paperweight.

Cruet - bottle with a stopper, most often handled, also referred to as oil or vinegar bottle.

Crystal Glass - a brilliant, colorless glass containing a large amount of lead oxide and used for the finest tableware.

Cullet - clean broken glass which was used as part of the formula of a new batch of glass. The cullet promoted fusion of the basic materials and improved the quality of the glass.

Cutting - a method of decorating glass using a rapidly rotating thin stone or metallic wheel, fed with an abrasive mixture such as sand; exterior decorative motifs added to paperweights by use of abrasives and wheel grinding to make facets, windows.

Cut-Down Tools - metal tools used to reduce size of glass gather at pontil breakoff point, also called *pucellas*.

Design - interior motif in paperweight.

Design Morgue - This was a large cage area outside the Fostoria designers office where sampled items were locked up and stored, waiting consideration for production.

Dessert Plate - plate usually around 7" to 8.5" diameter (small center).

Diameter - most widely used measurement in weight description.

Die - design incised in metal plate.

Dinner Plate - ranges from 9" to 9.5" diameter for small size dinner and 10" to 10.5" for large size dinner plate (large flat center).

Dinner Water - goblet having a tall stem, usually holding 8 to 10 ounce.

Duo Candleholder - a candleholder with two branches or arms, usually of the same height with no boboches or prisms

Encased - having an overlay of clear glass.

End-of-Day Glass - an American term from "frigger" also called off-hand glass and referred to as a whimsy. Made from remnants of various types of glass left in the pots at the end of the work day.

Engraving - cutting design in glass with the aid of a copper cutting wheel.

Etching - effecting the surface of glass with hydrofluoric acid.

Facets - flat or plane cuts on paperweight exterior.

Finger Bowl - flat, flared out (looks like a large custard cup) usually blown.

Finial - glass decorative design used at top of shade on paperweight lamps. The decorative or plain knob on a piece of glass, particularly sugar bowls or covered butter dishes, the finial allows for easy grasp and lifting of the lids.

Fire Polishing - the reheating of a finished object in order to obtain a smooth surface and remove any marks left by tools or moulds.

Flip Vase - flat, straight sides that taper out to the top (top wider than the base) named for a 1920s popular drink that was served in this shape tumbler.

Floating Garden - usually oval straight sided bowl or center piece flower arranger, used to float flowers in.

Flower Block - used in bottom of a bowl to arrange flowers or at the top of some vases for arranging flowers also referred to as a flower frog.

Flower Frog - used in bottom of a bowl to arrange flowers or at the top of some vases for arranging flowers also referred to as a flower block.

Flower Weight - natural or stylized flower or flowers used as predominate weight motif.

Free-Blown Glass - glass objects formed by using a blow pipe, pontil rod and hand tools rather than a mould.

Frigger - an old term used to describe glass made as an experimental piece or made by a glass worker during his own time for his own amusement.

Frit - small pieces of glass that adhere to the outside of a gather of glass and then become integral into the piece of glass. Usually this is done on blown glass while the item is still being formed and the gather is rolled into the small pieces of glass. Usually frit is of a different color than the main body of the item and so provides a contrast in color as well as surface texture.

Fruit Bowl - round flat bowl, smaller than a cereal bowl.

Fruit Cocktail - goblet having a short stem, usually holding 5 to 5.5 ounces.

Fruit Cocktail Insert - cylindrical vessel flaring out wide from almost the bottom of the piece used to keep the fruit cocktail from mixing with the ice that would keep it chilled, 5 ounces.

Furnace - a pot, day tank, or continuous tank fabricated for melting the glass batch.

Gaffer - master blower; head of the shop in the glassworks.

Gaffer's Bench - a cradle where a gaffer sits to rotate his pontil and work or finish a glass product.

Gather - a gob of glass taken from the molten glass in a furnace or tank and secured on the end of the blow pipe or pontil rod.

Gatherer - a worker who used a rod or blowpipe to "gather" a gob of molten glass on the end of the rod from the furnace, it then is transferred to a mould or is given to the blower to form the final shape.

Glory Hole - name for the small furnace used for reheating the object when needed or the fire - polishing.

Glove Box - covered container for holding ladies dress gloves, sometimes used as part of a dresser set or vanity set.

Grapefruit Icer - flat bowl with three raised rays to hold insert, to keep it from separated from the ice that would keep it chilled.

Gravy Boat - spouted bowl, usually handled and oval; can be round, even with an attached liner.

Hair Receiver - covered container for holding ladies hair, when saved up could be used as a added adornment for hair styling.

Hand Cooler - a small oval or egg - shaped paperweight.

Handkerchief Box - covered container for holding ladies handkerchiefs, sometimes used as part of a dresser set or vanity set.

Honey Jar - flat covered jar.

Horseradish Bottle - flat or footed small covered container, usually having a spoon that fits through the slot in the lid.

Humidor - flat cylindrical covered container, used for tobacco or cigars, usually lid was metal.

Hurricane Lamp - candle holder with glass shade also referred to as a candle lamp.

Ice Bucket - flat cylindrical container for ice with tab handles or metal bail (handle) also referred to as ice tub.

Ice Dish - flat bowl with three raised rays to hold liners and ice, to keep food chilled.

Ice Dish Liner - the special shaped vessel that is put inside the ice dish.

Iced Tea-Tumbler - flat, or a short stem, usually holding 11 to 13 ounces.

Ice Tub - flat cylindrical container for ice with tab handles or metal bail (handle) also referred to as ice bucket.

Jack In Pulpit Vase, has top edge pulled down and back pulled up to look like a tulip. Also called tulip vase.

Jelly - flat or footed dish, smaller than a candy, it also can be covered.

Jewel Box - covered small size container for holding ladies jewelry.

Jug - large flat or footed handled vessel for serving water also referred to as a water pitcher.

Juice-Tumbler - flat, or a short stem, usually holding 4 to 5 ounces.

Lead Glass - less fragile than soda glass. This type used a high percentage of lead oxide in the batch. This gave the glass a higher dispersive power; that is the property of trans- parent surfaces to blend light rays of some colors more than rays of other colors. This results in an enhanced brilliance and made glass more suitable for cutting and engraving.

Lehr - the annealing oven which allowed the glass to cool under slow controlled conditions.

Lemon dish - flat shallow covered dish with two handles.

Lemon Plate - flat small dish with two handles, usually 5"to 6" diameter.

Lily Pond - shallow bowl, cupped in at the edge for floating flowers.

Liner - underplate for a serving vessel or term used for the insert that would hold item being served keeping it from mixing with the ice that would keep it chilled.

Lunch Plate - plate usually around 9"to 9.5" diameter (large flat center).

Lunch Tray - center handled tray for use in serving cut up sandwiches , also can be referring to a two handled serving tray or sandwich tray.

Lunch Water - goblet having a short stem, usually holding 8 to 10 ounces.

Magnum Weight - any paperweight of three or more inches in diameter.

Marmalade - flat small covered container, usually blown with necked in lip at the top.

Marver - a polished metal or stone slab used for forming the molten glass.

Mayonnaise - bowl for serving mayonnaise, many shapes: flared, cupped, rolled edge, round, heart, oval, handled and square.

Miniature Weight - any paperweight two inches or less in diameter.

Mint Dish - flat flared dish with two handles.

Mould Mark - a seam or mark that results from a joint in the mould.

Mushroom Shape - shape found on bowls and also candle holders.

Nappy - another name for bowl, this is an old English glass term. Nappies may be large or small shapes and with handle or with out.

Off-Hand - another term used for "free-blown" meaning hand fabricated with the use of a mould.

Oil Bottle - bottle with a stopper, most often handled, but not always, also referred to as cruet.

Old Fashion Tumbler - flat, or a short stem, usually holding 6 to 8 ounces.

Olive - oval or rectangular shaped relish dish designed to accommodate olives.

Opaque - a cold glass color that cannot be seen through and will not transmit light.

Oval Vegetable Bowl - serving bowl usually flared at top or with a rim used for vegetables or other foods also referred to as a baker by glass companies.

Oyster Cocktail - goblet, no stem or a short stem, usually holding 4 to 4.5 ounces.

Paperweight - heavy glass object, usually decorative, used to secure papers.

Parfait - goblet having a short stem and tall bowl, usually holding 4.5 to 6.5 ounces.

Pedestal - raised glass stem usually applied between foot and body of a paperweight.

Pickle - oval or rectangular shaped relish dish designed to accommodate pickles, cut lengthwise.

Piercing Tools - sharp metal picks used to punch hot metal to secure air - trap designs.

Pin Tray - open oval or rectangular shaped dish, sometimes used as part of a dresser set or vanity set.

Plate - thin, opaque - glass plaques upon which names or scenes are painted or decals attached for enclosure in paperweights.

Platter - flat oval serving plate.

Pontil (Pontil Rod) - a long iron rod used to hold a vessel during the finishing process and after it has been released from the blowpipe.

Pontil Mark - a scar or mark left on the finished article where it has been snapped off the pontil rod.

Powder Box - covered container for holding ladies facial powder, used as part of a dresser set or vanity set also referred to a puff box.

Preserve - open or covered handled dish, usually smaller than a candy.

Puff Box - covered container for holding ladies facial powder, used as part of a dresser set or vanity set also referred to a powder box.

Rhine Wine - goblet having a extra tall stem, usually holding 4 to 4.5 ounces.

Rim - refers to the flat rim which is parallel to the table, that can be found on certain pieces.

Rose Bowl - flat spherical or ball shaped vase.

Salad Dressing Bottle - flat or footed bottle with stopper, usually concave sided, rolled lip and spouted, 7 to 8 ounces; also called French salad dressing.

Salad Dressing Bowl - divided for serving two types of sauce, many shapes: flared, cupped, rolled edge, round, heart, oval, handled and square.

Salad Plate - plate usually around 7" to 8.5"diameter.

Salt Dip - flat individual open salt, usually less that 2"diameter.

Salver - footed plate used for serving cake or desserts.

Sand Box - sand filled container into which pot workers strike finished weight from a pontil rod.

Sandwich Plate - round two handled, usually 11"to 14"diameter.

Sandwich Tray - center handled tray for use in serving cut up sandwiches also can sometimes be referring to a two handled serving tray or lunch tray.

Saucer Champagne - goblet having a tall stem, usually holding 5 to 6.5 ounces also referred to as a high or tall sherbet.

Service Plate - plate usually larger than 11"diameter (small center).

Servitor - the blower who was first assistant to the gaffer.

Setup - design or motif prepared by weight maker for inclusion in a paperweight.

Shards - small pieces and fragments of broken glass.

Sham - refers to the base of a vessel, denotes that it is weighted (thick like bar ware).

Sherbet - goblet having a short stem, usually holding 5 to 6.5 ounces also referred to as a low sherbet, ice cream or sundae.

Sherry - goblet having a tall stem, usually holding 1.5 to 2 ounces.

Shop - consisted of a gaffer, a gatherer, a servitor and a boy, usually called a carry in and/or carry over, also called a taker-in, and a finisher. Others were used if the work required more help.

Spiral Weight - a weight containing twisted glass rods in spiral form.

Spooner - flat, cylindrical straight sided, made to hold spoons.

Straw Jar - flat cylindrical straight sided covered jar, tall enough to hold drinking straws.

Striking - the process of reheating glass after it has cooled, in order to develop a color or an opalescence.

Sugar Cuber - flat cylindrical straight sided container with sugar tongs built into the chrome plated lid, used for serving sugar cubes.

Sundae - goblet low footed no stem, usually holding 5 to 6.5 ounces also referred to as a ice cream or sherbet.

Sweet Pea Vase - flat wide flared, looks like a deep flared bowl.

Sweet Meat - flat small deep flared dish with two handles, usually 5" to 6" diameter.

Swung Vase - any vase swung by the glass artisan, using centrifugal force to pull the vase into a longer form than it came out of the mould (distorts the pattern in the center).

Syrup - flat handled pitcher, usually with cover.

Table Goblet - water short stem, usually holding 8 to10 ounces.

Table Tumbler - water: flat, or a short stem, usually holding 8 to 10 ounces.

Tidbit - two plates or two bowls with a metal center handle to hold them apart for serving finger food.

Tomato Juice Insert - cylindrical vessel slightly flared at top used to keep the juice from mixing with the ice that would keep it chilled, usually 5 ounces.

Tooling - the process of shaping the molten glass using pincers, paddle shears and other tools to make such features as the handle, rim, foot, stem, and applied decorations.

Toothpick - flat or footed cylindrical vessel designed to hold toothpicks, for table use.

Urn - footed tall covered container, usually twice the size of a footed candy jar.

Warm-In - the act of heating or reheating glass for ease in manipulation while working.

Wedding Box - pedestal covered square container.

Whiskey - tumbler: flat, no stem or a short stem, usually holding 2 to 2.5 ounces.

Window - flat or plane facet or cut on paperweight for viewing, also referred to as cutting, facet or punty.

Wine - goblet having a tall stem, usually holding 3 to 4 ounces.

Bibliography

Archer, Margaret and Douglas. *The Collector's Encyclopedia of Glass Candlesticks*. Paducah, Kentucky: Collector Books, 1983.

Bellaire Public Library, Archival material used in research, 2003. Bellaire, Ohio.

Bergstrom, Evangeline H. *Old Glass Paperweights*. Crown Publishers, Inc.: New York, NY 1940, 1968 4th printing.

Blake, Joyce. *Glasshouse Whimsies*. East Aurora, New York 1984.

Blake, Joyce and Dale Murschell. *Glasshouse Whimsies, An Enhanced Reference*. Author published, 1989.

Coe, Debbie and Randy. *Elegant Glass, Early, Depression and Beyond*. Atglen, Pennsylvania: Schiffer Publishing Ltd. 2001.

Coe, Debbie and Randy. *Glass Animals and Figurines*. Atglen, Pennsylvania: Schiffer Publishing Ltd. 2003.

Cloak, Evelyn Campbell. *Glass Paperweights of the Bergstrom Art Center*. Crown Publishing McMLXVI, by the city of Neenah Municipal Museum Foundation, Inc.

Corning Glass Museum. Archival material and microfiche. Corning, New York: Corning Museum of Glass, 1995.

Elville, E.M. *Paperweights and Other Glass Curiosities*. London, UK: Spring Books, 1954.

Echo Newspaper, Moundsville, West Virginia. Archival materials July 2002.

Fenton Art Glass Company. Personal interviews and correspondences with Frank M. Fenton, Nancy and George Fenton, James Measell, and Jon Saffell, 2002.

Flemming, Monika and Peter Pommerencke. *Paperweights of the World*. Atglen, Pennsylvania: Schiffer Publishing Ltd., 1993.

Florence, Gene. *Collectors Encyclopedia of Depression Era Glass*. Paducah, Kentucky: Collector Books, 2000.

Florence, Gene. *Elegant Glassware of the Depression Era*. Paducah, Kentucky: Collector Books, 1995.

Florence, Gene. *Very Rare Glassware of the Depression Era*. Paducah, Kentucky: Collector Books, 1988.

Fostoria Glass Company. Company catalogs. Moundsville, West Virginia. Fostoria Glass Company 1901 - 1984.

Fostoria Glass Company Advertising 1920 - 1986. Fostoria advertising booklets, *The Little Book About Glass, The New Little Book About Glass, The Glass of Fashion, 50 Ways to Decorate with Fostoria, Every man's Work, The Master Etchings*, from author's personal collection, used by permission of Lancaster Colony.

Fostoria Glass Society. *Facets of Fostoria* newsletters. Moundville, West Virginia. Fostoria Glass Society of America.

Fostoria Ohio Public Library. Archival material and correspondence. 2000.

Gallagher, Jerry. *Handbook of Old Morgantown Glass*: Minneapolis, Minnesota. Merit Printing, 1995.

Gorham, C.W. *Riverside Glass Works of Wellsburg, West Virginia, 1879-1907*. Springfield, Missouri, 1995.

Greentown Public Library, Greentown, Illinois. Archival research material. 2002.

Hollister, Paul Jr. *The Encyclopedia of Glass Paperweights*. New York, NY: Carkson N. Potter Publishing, 1969.

Huntington Museum of Art. Archival materials and personal correspondence, Eason Eige, Huntington, West Virginia. 1994.

Kerr, Ann. *Fostoria*. Paducah, Kentucky: Collector Books. 1994.

Kerr, Ann. *Fostoria Volume II*. Paducah, Kentucky: Collector Books. 1997.

Liebmann, Henry J. *Fostoria Glass, Carved Glassware Produced by the Fostoria Glass Company 1938-1944*. Henry J. Liebmann, 1991.

Liebmann, Henry J. *Fostoria Glass Factories*. Henry J. Liebmann, 1991.

Liebmann, Henry J. *Fostoria Glass Silver Deposited Glassware 1910-1920*. Henry J. Liebmann, 1992.

Lindbeck, Jennifer A. and Jeffrey B. Snyder: *Elegant Seneca, Victorian, Depression, Modern*. Atglen, Pennsylvania: Schiffer Publishing, Ltd., 2000.

Long, Milbra and Emily Seate. *Fostoria Useful & Ornamental*. Paducah, Kentucky: Collector Books, 2000.

Long, Milbra and Emily Seate. *Fostoria Stemware*. Paducah, Kentucky: Collector Books, 1995.

Mauzy, Barbara and Jim. *Mauzy's Depression Glass*. Atglen, Pennsylvania: Schiffer Publishing, Ltd., 1999.

McGrain, Patrick H. *Fostoria, the Popular Years*. Frederick, Maryland: McGrain Publications, 1982.

Measell, James and Berry Wiggins. *Great American Glass of the Roaring 20's and Depression Era*. Marietta, Ohio: Antique Publications, 1998.

Melvin, Jean S. *American Glass Paperweights and Their Makers*. New York: Thomas Nelson, Inc. 1967; revised edition, 1970.

Murray, Melvin L. *Fostoria, Ohio Glass II*: Fostoria, Ohio, 1992.

National Imperial Glass Collectors Society. *Imperial Collectors Gazettes*. Bellaire, Ohio National Imperial Glass Collectors.

National Toothpick Holder Collector's Society. *Toothpick Holders: China, Glass and Metal*. Marietta, Ohio: Antique Publications, 1992.

Oglebay Institute Museum of Glass, Wheeling West Virginia. Archival materials and personal correspondences. Holly McClusky 1994-95, 2002-2003.

Pacific Northwest Fenton Association. *Nor'Wester* newsletters. Tillamook, Oregon: Pacific Northwest Fenton Association.

Pina, Leslie. *Fostoria, American Line 2056*. Atglen, Pennsylvania: Schiffer Publishing Ltd., 1999.

Pina, Leslie. *Fostoria Designer George Sakier*. Atglen, Pennsylvania: Schiffer Publishing Ltd., 1999.

Pina, Leslie. *Fostoria, Serving the American Table 1887-1986*. Atglen, Pennsylvania: Schiffer Publishing Ltd., 1995.

Seligson, Sidney. *Fostoria American, A complete Guide*. Wichita Falls, Texas: Sidney Seligson, 1994.

Snyder, Jeffrey B. *Morgantown Glass: From Depression Glass Through the 1960s*: Atglen, Pennsylvania: Schiffer Publishing Ltd., 1998.

Times-Leader Newspaper, Bellaire, Ohio. Archival Materials, Bellaire, Ohio: July 2002.

Weatherman, Hazel Marie. *Colored Glassware of the Depression Era*. Springfield, Missouri: Weatherman Glass Books, 1974.

Weatherman, Hazel Marie. *Fostoria, The First 50 Years*. Springfield, Missouri: The Weathermans, 1972.

Webster, James L. *Wheeling Decorating Co. Identification & Value Guide*. Paducah, Kentucky: Collector Books, 2003.

West Virginia Museum of American Glass. *Glory Hole* newsletters. Weston, West Virginia: West Virginia Museum of American Glass.

Williams, Juanita L., Therese Mellrath, and Maryanne Roberts. *Fostoria Master Etchings 1935-1972*. Chatsworth, California: Fostoria Glass Society of Southern California, 1993.

Williams, Juanita L. and Christopher George. *Fostoria By Ye Candlelight*. Jacksonville, Oregon: Juanita L. Williams, 1998.

Williams, Juanita L. and Christopher George. *Fostoria Chintz, A Study Guide for Collectors*. Jacksonville, Oregon: Juanita L. Williams 1996.

Williams, Juanita L. *Fostoria the Glass of Fashion*. Jacksonville, Oregon: Juanita L. Williams, 1997.

Williams, Juanita L. and Jonathan Williams. *Fostoria Glass Co. Study Guide to Patterns*. Jacksonville, Oregon: Juanita L. Williams, 1996.

Williams, Juanita L. and Christopher George. *Fostoria Popular Plate Etchings*. Jacksonville, Oregon: Juanita L. Williams, 1998.

Z-best Fostoria friends and collectors I have known. Thanks for sharing.

Index